Islands and Communities

Islands and Communities
Perspectives on Insularity, Connectivity, and Belonging

edited by
Anastasia Christophilopoulou

COLLECTIVE WORK OF THE *BEING AN ISLANDER*
RESEARCH NETWORK 2019–2023

Oxford & Philadelphia

Published in the United Kingdom in 2024 by
OXBOW BOOKS
81 St Clements, Oxford OX4 1AW

and in the United States by
OXBOW BOOKS
1950 Lawrence Road, Havertown, PA 19083

© Oxbow Books and the individual contributors 2024

Paperback Edition: ISBN 979-8-88857-151-4
Digital Edition: ISBN 979-8-88857-152-1

A CIP record for this book is available from the British Library

Library of Congress Control Number: 2024943530

An open-access on-line version of this book is available at: https://www.oxbowbooks.com/9798888571514/islands-and-communities/. The online work is licensed under the Creative Commons Attribution 3.0 Unported Licence. To view a copy of this license, visit http://creativecommons.org/licenses/by/3.0/ or send a letter to Creative Commons, 444 Castro Street, Suite 900, Mountain View, California, 94041, USA. This licence allows for copying any part of the online work for personal and commercial use, providing author attribution is clearly stated.

Some rights reserved. No part of the print edition of the book may be reproduced or transmitted in any form or by any means, electronic or mechanical including photocopying, recording or by any information storage and retrieval system, without permission from the publisher in writing.

Materials provided by third parties remain the copyright of their owners.

Printed in the United Kingdom by Short Run Press

For a complete list of Oxbow titles, please contact:

UNITED KINGDOM
Oxbow Books
Telephone (0)1226 734350
Email: oxbow@oxbowbooks.com
www.oxbowbooks.com

UNITED STATES OF AMERICA
Oxbow Books
Telephone (610) 853-9131, Fax (610) 853-9146
Email: queries@casemateacademic.com
www.casemateacademic.com/oxbow

Oxbow Books is part of the Casemate Group

Front cover: Boat-shaped vessel from Urulu-Orgosolo from LA SARDEGNA NURAGICA 2014
Back cover: View of the Kamares port, Siphnos, from Agios Symeon summit. Image copyright: Dr Dimitrios Bouras for *Being an Islander* documentary, 2023. Figurine of a crawling baby Copper alloy, 1600 BC–700 BC. From the Psychro Cave, Lasithi plateau, East Crete. Copyright: Ashmolean Museum no. AN1938.1162.

The
Fitzwilliam
Museum
CAMBRIDGE

Contents

Contributors...vii
Acknowledgements...xi
Summary .. xiii

1. Understanding islands in the *longue durée*: Stories of insularity,
 community, and maritime heritage from the Mediterranean 1
 Anastasia Christophilopoulou

2. Big and small islands: Rethinking insularity in the ancient Greek world 19
 Christy Constantakopoulou

3. Roll up for the Mystery Tour: Islands of the transition and their
 contribution to 'western' civilisation.. 31
 Louise A. Hitchcock, Laura Pisanu, and Aren M. Maeir

4. Contextualising Cypriot writing overseas: Cypro-Minoan and
 Cypro-Syllabic inscriptions found in Greece ... 51
 Giorgos Bourogiannis

5. A Late Iron Age sword from Tamassos: Biography of an exceptional object......65
 Susanna Pancaldo, Ema Baužytė, and Julie Dawson

6. Island metallurgy: A case study of two Early Bronze Age toggle pins from
 the Cypriot Collection of the Fitzwilliam Museum..83
 Jana Mokrišová, Susanna Pancaldo, and Ema Baužytė

7. Insularity and Mediterranean networks in the collections of the National
 Museums of Cagliari from prehistory to the contemporary age97
 Francesco Muscolino

8. Being an Islander in the 3rd millennium BC Small Cyclades in the central
 Aegean: Connectivity, food networks, and sustainability of resources.............117
 Evi Margaritis, Michael J. Boyd, and Colin Renfrew

9. When our world became Christian: Crete and Cyprus during Late Antiquity ... 137
 Salvatore Cosentino and Georgios Deligiannakis

10. Conclusions: Mediterranean rhapsody: Of island histories and identities 153
 Helen Dawson

Index .. 163

Contributors

Anastasia Christophilopoulou

Dr Anastasia Christophilopoulou is the Senior Curator of the Ancient Mediterranean at the Fitzwilliam Museum, a member of the McDonald Institute and a member of the D Caucus (Art and Archaeology) Faculty of Classics, Cambridge, where she also completed her PhD thesis in 2007. Previously she worked for the Freie Universitat, Berlin and Birkbeck College, London. She currently leads the *Being an Islander* Interdisciplinary project and her research focuses on Mediterranean and Island Archaeology, Archaeology and Public Engagement, contemporary perspectives on Mediterranean Heritage and perspectives of Heritage responsibility and Museums. Anastasia co-directs the West Area of Samos Archaeological Project (WASAP).

Giorgos Bourogiannis

Dr Giorgos Bourogiannis is a postdoctoral fellow at the University of Harvard, Center of Hellenic Studies. He completed his PhD on classical archaeology at the University of Athens in 2008. His main research interests are the Early Iron Age in the Aegean and the eastern Mediterranean, the use of scripts in the Aegean and Cyprus, as well as the religious and political landscape of ancient Cyprus. He is a senior research associate of the *Being an Islander* project, University of Cambridge, since 2019.

Michael Boyd

Dr Michael Boyd is a Senior Research Affiliate at The Cyprus Institute, Research Officer at the British School at Athens, and Director of the Keros Foundation. He has previously held posts in Cambridge, Sheffield, and Athens. His main research interests lie in the prehistoric Aegean where he has worked in the Cyclades and the Peloponnese. He is co-director of the Keros-Naxos Seaways project, and co-editor of the Keros publications series.

Christy Constantakopoulou

Professor Christy Constantakopoulou is Researcher in the National Hellenic Research Foundation and Professor Emerita in Classics and Ancient History in Birkbeck College, London. Her research interests are the history of the archaic and classical Greek world, and specifically the history of the Athenian empire, the Aegean islands, and notions of insularity.

Salvatore Cosentino

Professor Salvatore Cosentino is a Professor of Byzantine Civilization at the University of Bologna, Italy. He earned his PhD from the University of Turin in 1990. His primary research interests revolve around the social and economic history of late antiquity and early Byzantium.

Helen Dawson

Dr Helen Dawson is Research Fellow at the Institute of Prehistory, Early History and Medieval Archaeology at the University of Tübingen and Adjunct Professor at the Department of History and Culture at the University of Bologna. Originally from Sicily, she specialises in comparative island archaeology with a focus on the prehistory of the central Mediterranean and has written extensively on island colonisation and abandonment, networks, and identities. She is a member of the advisory board of the Small Island Cultures Research Initiative (SICRI) and of the editorial board of the journal *Shima*.

viii *Contributors*

JULIE DAWSON
Julie Dawson is an archaeological conservator. She retired from the post of Head of Conservation and Scientific Research at the Fitzwilliam Museum, University of Cambridge in 2021. Since then, she has been a Leverhulme Emeritus Fellow (2021–2024) and Affiliated Researcher at the Museum working on the ancient Egyptian coffins project.

GEORGIOS DELIGIANNAKIS
Professor Georgios Deligiannakis is Associate Professor in Late Antiquity at the Open University of Cyprus. He is author of two books and editor of a *Companion to Late Antiquity*. His main research interests are the eastern Roman Empire, Greek epigraphy, Christianization, Greek archaeology, and humour in antiquity.

LOUISE HITCHCOCK
Professor Louise A. Hitchcock is former Professor of Aegean Bronze Age Archaeology at the University of Melbourne. She has written and collaborated on over 100 works on interactions between the Aegean, Cypriot, and Philistine Archaeology and served as an area supervisor at the Philistine site of Tell es-Safi/Gath in Israel.

AREN MAEIR
Professor Aren M. Maeir is a professor of archaeology at Bar-Ilan University in Ramat-Gan, Israel. He completed his PhD at the Hebrew University in 1997. His main research interests are the Bronze and Iron Age of the eastern Mediterranean. For the last 30 years, he has directed the Tell es-Safi/Gath Archaeological Project.

EVI MARGARITIS
Professor Evi Margaritis is Associate Professor in Environmental Archaeology at the Cyprus Institute, Nicosia. She is an expert in the field of Mediterranean Archaeobotany; her research involves olive oil and wine production; ritual use of plants in prehistoric and early historic Europe; first states in 2nd millennium BC Europe; Greek and Roman agriculture; culinary practices and agricultural history of Cyprus. She collaborates with more than 30 Universities and research institutions across the world. Currently she is the assistant director of environmental studies of the Keros Excavation Project. Her publication record is extensive and she is the editor of three volumes.

JANA MOKRIŠOVÁ
Dr Jana Mokrišová is Research Associate in the Faculty of Classics at the University of Cambridge. Her research focuses on the archaeology of mobility, culture contact, and technology from the Bronze Age to the Archaic period in Anatolia and Greece.

FRANCESCO MUSCOLINO
Dr Francesco Muscolino is Director of the Museo Archeologico Nazionale di Cagliari. He completed his PhD at the University of Messina in 2008 and has been working as a ministry archaeologist in Italy since 2010 in Lombardy, Campania, and Pompei. He regularly publishes in the fields of ancient pottery, epigraphy, topography, and the history of collections and of archaeological research. He is a senior research associate of the Being an Islander project, University of Cambridge.

SUSANNA PANCALDO
Susanna Pancaldo is a Senior Conservator at the Fitzwilliam Museum, University of Cambridge. She received degrees in History of Art and Conservation from the Institute of Fine Arts, New York University and has worked for museums and archaeological excavations in the USA, the UK, and across the Mediterranean. She specialises in the conservation and care of archaeological objects, with a research focus on metal objects and their technologies.

Laura Pisanu

Laura Pisanu is an archaeologist trained at the Postgraduate School of the University of Cagliari in 2020, and a current PhD candidate at the University of Melbourne. Her main research interests are Nuragic Sardinia and Bronze Age Mediterranean.

Colin Renfrew

Professor Colin Renfrew (Lord Renfrew of Kaimsthorn) was formerly Disney Professor of Archaeology and Director of the McDonald Institute for Archaeological Research in the University of Cambridge, and Master of Jesus College, Cambridge 1986–1997. He has excavated prehistoric sites in the Orkney Islands and in Greece, most recently on the Cycladic Island of Keros. He is the author of many publications, including *The Emergence of Civilisation* (1972), *The Archaeology of Cult* (1985), and *Prehistory: The Making of the Human Mind* (2007). He is Fellow of the British Academy, Foreign Associate of the National Academy of Sciences of the USA, and was the recipient of the Balzan Prize in 2004.

Peer reviewers

Abigail Baker

Dr Abigail Baker is Research Associate on the *Being an Islander* research project and was Project Curator of *Islanders: The Making of the Mediterranean* at the Fitzwilliam Museum. She is the author of *Troy on Display: Scepticism and Wonder at Schliemann's First Exhibition* (2020) and has written on a range of topics in the history of museum objects and how to interpret them today. She is trustee and membership secretary of the Classical Collections Network.

Rafael Laoutari

Dr Rafael Laoutari has recently completed his PhD at the Department of Archaeology, University of Cambridge, focusing on diverse datasets for obtaining material and behavioural signatures for exploring the social dynamics and connectivity in prehistoric Bronze Age Cyprus. He is a core member of the *Being an Islander* research project as well as the Qued Beht and the Kissonerga-Skalia Archaeological Projects. His specialisation is in the study of ceramics, metal, and mortuary practices from prehistoric Bronze Age Cyprus.

Robin Osborne

Professor Robin Osborne is Professor of Ancient History in the University of Cambridge and a Fellow of King's College, Cambridge and of the British Academy. His work ranges widely over Greek history and archaeology, and the history of Greek art. His most recent books are *The Transformation of Athens: Painted Pottery and the Creation of Classical Greece* (2018) and *Athens and Attica: Volume 2 The Oxford History of the Archaic Greek World* (2023).

Acknowledgements

This volume would not have been possible without the support and constant encouragement of our research and engagement colleagues across the vast *Being an Islander* project network. Across our research network we worked on the shared major research themes that transcend the project, insularity, mobility, materiality, migration, accessibility to heritage, and decolonial practice within the discipline of Mediterranean Archaeology; but we also invested in practice and community co-creation, translating these research themes into dialogue and active representation of individuals and communities, and co-created project outcomes. Therefore, the list of major contributors who are engaged with this volume extends beyond the group of active project researchers and includes community representatives and individuals. First and foremost, I am indebted to the Anastasios G. Leventis Foundation who funded the production of this volume exclusively. The Foundation has also fiercely supported the research conducted during the 5 years of the project's operation, as well as many of the research partners and associates of the project, who also led other projects with the support of the Anastasios G. Leventis Foundation. This has led to a strong sense of collaboration and interaction between similarly minded project clusters. The Stavros Niarchos Foundation (SNF), the Cyprus High Commission in the United Kingdom, and the Adonis Pouroulis Foundation, have also provided generous support to the diverse operations of the project, all contributing to the development of ideas presented in this volume. We are equally indebted to the contributors of this volume, Professor Christy Constantakopoulou, Dr Helen Dawson, Professor Evi Margaritis, Dr Michael Boyd, Professor Colin Renfrew, Ms Julie Dawson, Mr Susanna Pancaldo, Professor Louise Hitchcock, Dr Giorgos Bourogiannis, Dr Jana Mokrišová, Dr Ema Bauzyte, Dr Francesco Muscolino, Professor Salvatore Cosentino, Professor Aren Maeir, Mrs Laura Pisanu, and Professor Georgios Deligiannakis. I am also very grateful to Professor Robin Osborne, Professor Marcos Martinon-Torres, Dr Abigail Baker, and Dr Rafael Laoutari for peer reviewing chapters of the volume.

I am also indebted to academic colleagues Professor Mary Beard, Dr Lucilla Burn, Professor Carrie Vout, Professor Marcos Martinon- Torres, Professor Michael Squire, Professor Yannis Galanakis, Professor Ianthi Tsimpli, and Professor Simon Stoddard who have provided crucial support and feedback to the research underpinning this volume, as also to Dr Rafael Laoutari and Dr Giulia Mutti who, as long-term research associates and supporters of the project, have provided much support to the edition of this volume. Outside Cambridge, we are indebted to academic colleagues Professor John Bennett, Professor Thilo Rehren, Professor Giorgos Artopoulos, Dr Achilleas Hadjikyriacou, Professor Katerina Kopaka, Professor Nena Galanidou, Dr David Evans,

Dr Miranda Stearn, and Professor Daniel Pett. Mr Marios Theocharous, and Dr Marios Psaras in their capacity as current and former Cultural Counsellor of Cyprus to the United Kingdom have participated to many actions and research outcomes of the project and have supported our research wholeheartedly; the project team is indebted to them.

The research and production team of the *Being an Islander* documentary, has played a crucial role to the shaping or research themes and ideas presented in this volume as well as for much inspiration provided by the interaction between the documentary team and the rest of the research clusters of the project; we are very grateful to Dr Dimitrios Bouras, Mr Orestis Seferoglou, Mrs Amalia Symeonidoy, Dr Nikolas Anastasopoulos, Ms Christina Tsevi, Dr David Evans, Mr Jack Stephenson, Dr Dimitrios Kostopoulos, Dr Christos Lynteris, Dr Nikos Panagiotou, Mr Manos Makrygiannakis, Mr Kostas Grountas, Ms Andriana Theochari. We are also incredibly grateful to the Greek and Cypriot Diaspora communities in the United Kingdom, in Australia, and the United States, as well as the Mayor of Sifnos, Mrs Maria Nadali, and communities of the island of Sifnos and Samos where important public engagement activities related with the research presented in this volume have taken place. A pioneering community of young artists, led by contemporary artist Mr Yorgos Petrou, has extended and transformed our research enquiries in the project and we are truly indebted to them. They are Omar Suleyman, Zakria Elgharably, Yara Means, and Sarrah Ibrahim.

We are equally indebted to the core exhibition partners of the project, namely the Department for exhibitions and Museological Research of the Ministry of Culture and Sports, Greece, the Deputy Ministry of Culture, Cyprus, the National Archaeological Museums of Cagliari Sardinia, the Museum of Archaeology and Anthropology Cambridge, the Museum of Classical Archaeology, Cambridge, and the Ashmolean Museum. We are further indebted to Dr Polyxeni Adam-Veleni, Director General of Antiquities, Greece, Dr Marina Solomidou-Ieronymidou, Director of Department of Antiquities Cyprus, Dr Despina Pilides, former Curator of Antiquities (Department of Antiquities, Cyprus), Dr Eftychia Zachariou, Curator of Antiquities (Department of Antiquities, Cyprus), and Dr Francesco Muscolino, Director of the National Archaeological Museums, Cagliari for their support and steer during the development of the exhibition *Islanders: The Making of the Mediterranean* and several research initiatives of the project. We would also like to thank our international archaeology and curatorial colleagues; Dr Alexandra Alevizou, Ms Efthymia Alphas, Dr Kostis Christakis, Dr Manuela Puddu, Dr Federica Doria, Dr Andrew Shapland, Dr Anna Satraki, Dr Eustathios Raptou, and Dr Thomas Kiely who have tirelessly supported the planning and organisation of the exhibition and the production of this volume. Our colleagues at the Fitzwilliam Museum, Dr Adrian Popescu, Ms Helen Strudwick, Mrs Elena Saggers, Mrs Jacqueline Hay, Mrs Amy Jugg, Mr Michael Jones and Mrs Emma Darbyshire have substantially supported the content of this volume, practical and financial arrangements, as well as providing images and permissions induced included in this publication. We are truly indebted to them.

Summary

Islands and Communities: Perspectives on Insularity, Connectivity and Belonging, is one of the research outcomes of the *Being an Islander* project, an interdisciplinary research and public engagement project conducted at the University of Cambridge, with the collaboration of many research partner institutions in Greece, Cyprus, and Italy, as well as with the support of the Embassies of Greece and the Cyprus High Commission in London and the diasporic communities they represent in the United Kingdom. The volume includes ten innovative contributions that debate and expand on the notions of Mediterranean island identity, mobility, and connectivity. They do so with specific temporal, geographical, and historiographic case studies from the three large islands of the Mediterranean, Cyprus, Crete, and Sardinia who played central part in the *Being an Islander* research project, as well as other island environments and clusters, for example the Cyclades. All chapters expand on the ideas of mobility and connectivity as important features of island life, motivating and maintaining informal and formal connections, as well as elucidating the effect of these two notions in making some communities more resilient than others at specific times within their history.

Contributions in this volume also elaborate on patterns of evolution and cultural change in the Mediterranean islands and the effect these had on how islands have been perceived historically, archaeologically, and anthropologically. The volume ultimately offers a re-appraisal of the study of insularity in the Mediterranean as it has developed in the past five decades and introduces the contribution of *Being an Islander* project to this debate. Islands were first studied from an environmental perspective and were considered as ideal units of analysis due to their circumscribed local environments, finite resources, and the uniqueness of their ecosystems. Early island studies drove the archaeological explorations of island societies, but they also carried a somewhat deterministic view of island life based on geographic boundaries and cultural relativism. Later, the study of insularity was seen as a dynamic concept dependent on specific socio-historical conditions rather than mere geography, resulting in definitions of insularity as form of social identity – one's sense of belonging to a group based on perceived social similarities and differences. This volume contributes to extending today's definitions and explorations of insularity and island identity, including perceptions that insularity (ies) also include a large degree of cultural strategy and not just a reflection of the islanders' ability to connect, influence and be influenced themselves by the people and lands that surround them.

Chapter 1

Understanding islands in the *longue durée*: Stories of insularity, community, and maritime heritage from the Mediterranean

Anastasia Christophilopoulou

This chapter serves as an introduction to the overall volume and its goals, as well as conveying the relevance of the Being an Islander *project (2019–2024) to the field of island studies, for example with reference to the cross-overs between research conducted in museums and academic departments. It provides details on the choice of the following thematic chapters and connects them to the three overall themes of the volume and research project: the study of insularity, mobility, and the cross-disciplinary study of Mediterranean island identities. Ultimately this chapter summarises long-standing theories on the distinctiveness or not of islands from mainlands. It also elaborates on patterns of evolution and cultural change in the islands and the effect these had on how Mediterranean islands have been perceived historically, archaeologically, and anthropologically. From the development of notions such as the longue durée and the influence they had in understanding protracted cultural, economic, ecological, and even biological processes as well as social practices in the Mediterranean islands, to theories that regarded islands as 'laboratories of culture change'; in this chapter we take a retrospective look at what has influenced and shaped research in the islands and where museum research perspectives fit in.*

Introduction

Throughout history, islands have been treated as distinct places and with this, the idea of insularity – *belonging to/being of an island* – has been romanticised and associated with 'otherness' (Constantakopoulou 2007; Cadogan *et al.* 2012, 19). But insularity can also be a story of connections; the sea can be a linking rather than a dividing body, motivating and maintaining informal and formal connections both to other islands and to the mainland (Braudel 1972; Horden and Purcell 2000; Broodbank 2013). For five years, an interdisciplinary research project based at the University of Cambridge

considered how architecture, material culture, burial practices, and non-material heritage from large Mediterranean islands such as Crete, Cyprus, and Sardinia reveal aspects of shifting island identities and connectivity over time (Figs 1.1 and 1.2).[1]

Being an Islander focused on tracing insular identities of the large islands of the Mediterranean, particularly Cyprus, Sardinia, and Crete. These three islands, notable for their size and having borne witness to strong indigenous cultural traditions, demonstrated complex transitions between prehistoric to historic cultures, and, later, the Roman systems, and significant restructuring of their social and political systems, tied in various ways to wider developments in the Mediterranean region (Dawson 2019, 451–465). They also bear evidence of utilising their ecosystems and geological wealth in distinctive, yet complex ways which guaranteed the long-term survival of their societies and communities. Issues of cultural interaction, hybridisation, and migration were also central to the identity of these islands from early antiquity to the present day (Tronchetti and Van Dommelen 2006; Fappas 2011). For this reason, the project employed an archaeological, ecological, and social anthropological lens to the surviving evidence from these islands, as reflected across all the different outputs from our research, including a major temporary exhibition held at the University of Cambridge, Fitzwilliam Museum (24 February–4 June 2023), a multi award-winning documentary film and research publications.[2]

This chapter presents the theoretical and methodological journey of the project and a selection of case studies from our research, public engagement, and exhibition experience. All explore how insularity affected and shaped cultural identity using the examples of Crete, Cyprus, and Sardinia and explore their relationship with small island clusters over a long-term perspective. Conceived in 2018, the project includes research clusters encompassing Insular and Mediterranean Archaeology, Social and Visual Anthropology, archaeological analysis, a large public engagement project in collaboration with the diasporic communities of Cyprus, Greece, and Italy in the United Kingdom, the inclusion of contemporary art displays, installations, and performance art, the exhibition *Islanders: The making of the Mediterranean* at the Fitzwilliam Museum, and the production of an award-winning documentary. Through the medium of the large exhibition and the documentary we extended our discourse beyond the topic of the ancient Mediterranean, incorporating the current perceptions of and discourses about island versus mainland cultural identities for example, including Britain's own, debated island identity.

Historically in the Mediterranean, some islands rose to the role of mini-continents due to their size and economic and political importance (Rackham and Moody 1996; Constantakopoulou 2007, 12–15; Cadogan *et al.* 2012, 18–19). Ancient Greeks, for example, considered Sicily a continent (Constantakopoulou, this volume Chapter 3; Muscolino, this volume Chapter 7). Likewise, the large Mediterranean islands of Crete, Cyprus, and Sardinia were often given a special status due to their size, as they occupy an intermediate position between small island worlds such as the Aegean islands network and the surrounding mainlands. However, islands have often been deemed to have

1. Understanding islands in the longue durée

different histories from the mainland and have been associated with more isolated social, cultural, and economic episodes (see also Dawson, this volume Chapter 10). Yet connection is an important part of island life, since the sea can be a linking rather than a dividing body, motivating and maintaining informal and formal connections with other islands and the mainland (Knapp and Van Dommelen 2010).

One of our key objects in the Cambridge exhibition, a Final Bronze Age–Iron Age model of a bronze boat

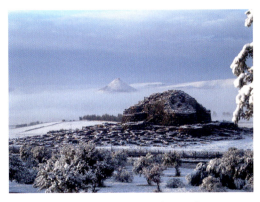

Figure 1.1. The Bronze Age site of Nuraghe Barumini (© Dr Horsch, CC BY-SA 3.0. and The Fitzwilliam Museum 2023).

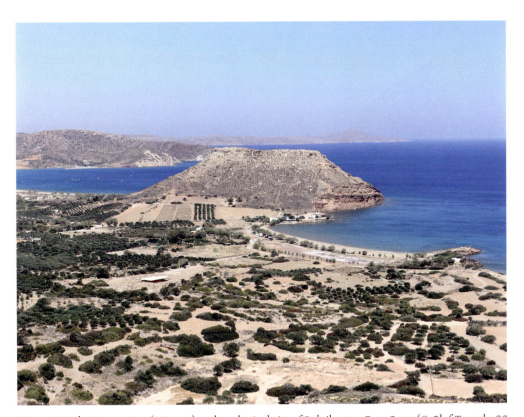

Figure 1.2. The Bronze Age (Minoan) archaeological site of Palaikastro, East Crete (© Olaf Tausch, CC BY 3.0 and The Fitzwilliam Museum 2023).

from Orroli (Muscolino, this volume, Chapter 7, Fig. 7.2), Sardinia, gives a unique example of the importance of seafaring, trade, and communication the large islands of the Mediterranean developed in the Bronze Age and beyond, and how these practices are symbolically reflected in the creation of material culture. The drawing of a dolphin on a naturally curving rock, together with a short inscription in Greek, from the Fitzwilliam Museum's collections but originally from Erimoupolis, Crete and dated around 525 BC, reveals the special bond islanders had with the sea, that is also heavily represented in Greek art and myth (Fig. 1.3) (Christophilopoulou 2023, 40–41).

Across the diverse in discipline project team, we understand identity, art, and cultural expression in the islands as a dynamic interplay shaped by social and historical episodes rather than geography. Objects from the islands' early history, such as the unusual figurine from the Chalcolithic site of Salamiou-Anephani Cyprus representing two divinities joined to form a cross (Department of Antiquities of Cyprus, no 1959/XI-3/6, ca. 3500–2500 BC), show the imaginative power of these active cultural choices (Christophilopoulou 2023, 44). The same can be said of much later iconic objects, such as the statue of Aphrodite Anadyomene (Cyprus Department of Antiquities, no: Sal. St. 20A, ca. 300–100 BC), a sculptural type showing the birth of the goddess from the sea that had a long influence on ancient and later art and became the symbol of Cyprus's ancient connection to Aphrodite during the rise of the island's tourist industry in the 1960s (Christophilopoulou 2023, 64–65).

Being an islander can be a physical or imagined concept, yet inhabitants of the same island might not have shared the same type of identity; rather, island identities might have shifted depending on daily lives and experiences as well as connections beyond their immediate surroundings (Iacovou 2008). Material culture analysed and re-assessed by the project's research team, such as the model of a quadriga from the Sanctuary of Agia Eirini, Cyprus (Cyprus Department of Antiquities, no: AI 1781+798, ca. 750–600 BC), speak of periods where the island was much fragmented in social and political terms and divided into seven city-kingdoms (Christophilopoulou 2023, 59). And while the inhabitants of each of these kingdoms would identify and

Figure 1.3. Drawing of a dolphin on grey spiritic limestone, from Erimoupolis, Crete ca. 525 BC (Fitzwilliam Museum, Cambridge, GR.1.1854, h. 64 × w. 33 × d. 20 cm; © The Fitzwilliam Museum 2023).

1. *Understanding islands in the* longue durée

associate with a common, island-wide, identity of the Cypriots (the Kyprioii) at the same time they would reveal local, community-driven identities. In Sardinia, during the Late Bronze Age at the height of the Nuragic culture, communities shared a common sense of identity based on the repetition of island-wide architecture, practices, and lifeways (Knapp *et al.* 2022).

The Nuragic culture on Sardinia lasted from around 1800 BC (Middle Bronze Age) up to the Roman colonisation of the island in 238 BC. During its heyday, communities of the Nuragic culture shared a distinctive type of architectural construction: megalithic stone towers called *nuraghi* (sg. *nuraghe*). Archaeologists estimate that over 10,000 nuraghi once existed throughout Sardinia, although only a few thousand survive. Nuragic communities also shared common types of tomb architecture and cult places as well as ceramic styles, agricultural and food processing equipment, and household objects (Blake and Knapp 2005). These all testify to a great interaction among Nuragic communities which probably also included trade, inter-marriage, and shared rituals. However, identity was a product of social choices and Nuragic people would have constantly renegotiated their self-perception, their interactions with the Sardinian landscape, and others within it. Ultimately, we regard identity as a form of social expression, one's sense of belonging to a group based on similarities and differences. Our case studies, and the material culture examined as part of this project, reveal that 'being an islander' is a highly fluid state of being, whether consciously or not, both in the past and the present (Randall 2021; see also Dawson, this volume Chapter 10).

The complexity and variability of cultural identity led our group to establish a broad diachronic scope for the project, a multi-scalar approach to past human interaction within continental and island environments and the application of an integrative analytical approach. We were also majorly inspired by looking at the research and results of other large-scale projects urging us to comparatively rethink notions of insularity, connectivity, and migration across island cultures outside the Mediterranean horizon. One such notable example, also paired with a major exhibition presented at the Chau Chak Wing Museum, University of Sydney in Autumn 2023, was the project *Tidal Kin: Stories from the Pacific*.[3] Like *Being an Islander*, *Tidal Kin* investigates shifting cultural identities of the Pacific islands and islanders, shaped by millennia long episodes of interaction, migration, and colonisations (Fig. 1.4). Both projects ask those questions through material culture, but also surviving non-material culture, and aim to reclaim histories of past community, ancestral heritage, and individual identities in the present day (see also Dawson, this volume Chapter 10; Nunn 2020).

Our third methodological and research pillar was the integration of inquests and findings from scientific fields within archaeology, such as ceramics studies, archaeobotany, and archaeometallurgy, with methodological approaches and findings from social anthropology, ethnography, visual anthropology, and documentary studies, as well as sensory archaeology. Both our research work and our corresponding public engagement programme also engage works of contemporary artists whose creations contemplate what belonging to an island means.[4]

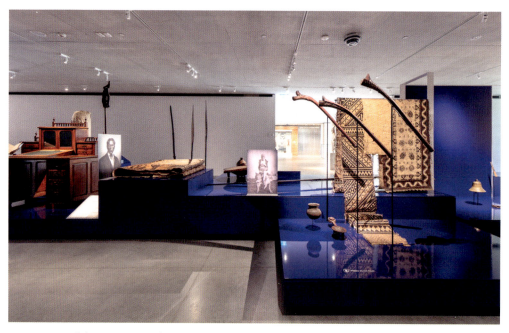

Figure 1.4. Tidal Kin: Stories from the Pacific *exhibition view, Chau Chak Wing Museum, Sydney, November 2023. Research and the exhibition project reclaimed the stories of eight Pacific Islander visitors to Sydney during the 18th and 19th centuries AD and revealed close relationships between Tonga, Fiji, Niue, Samoa, Tokelau, and Australia (© Jude Philp, Chau Chak Wing Museum, University of Sydney 2023).*

Case study 1: Island resources, mobility, and interaction

One of our main aims was to reframe mobility, connectivity, and migration as the defining characteristics of the ancient Mediterranean insular societies. While the intensity of mobility may have varied through time and space, and not all members of any particular community or island may have shared equally in it; mobility – and the connectivity it engendered – endowed the region with its characteristics (Kotsonas and Mokrišová 2020). Contributors to the project, this volume, the conference, and other outputs debated and expanded on the notions of mobility and connectivity, with specific temporal and geographical case studies from the three islands, arguing that both mobility and connectivity are important features of island life, motivating and maintaining informal and formal connections, as well as elucidating the effect of these two phenomena in making some communities more resilient than others at specific times within their history (Christophilopoulou 2022). Specific nodes of research within the project expanded through the study of mobility and interaction, what Broodbank has characterised as the 'island effect', the process by which islanders constantly redefine their identity by preserving, deviating, or letting go specific

cultural features in relation with mainlands or other islands (Broodbank 2000, 20). Other contributions to the project provide perspectives of interaction between small island cluster communities and their respective mainlands, expanding our understanding of patterns of mobility, connectivity, and hybridisation. For example, the long-standing research teams investigating Dhaskalio on Keros (Margaritis *et al.*, this volume Chapter 8) offer crucial insights into role of Dhaskalio, as a hub within a vast network of small cluster island resources, crucial for sustaining craft production and overall viability. They do so by combining environmental and archaeological data (e.g. marble figurines, pottery, metal ores, and obsidian use) to demonstrate how this small island settlement acted as a central node in an Aegean network for the movement of goods and people (Margaritis *et al.*, this volume Chapter 8). Research nodes, such as the Dhaskalio-Keros project, also offer considerable insight to the variations between large Mediterranean island and small Mediterranean island clusters, particularly when it comes to what happens when long-standing networks of connectivity are disrupted or cease to exist. For example, they highlight different sets of consequences between large and small islands, and different coping mechanics for settlements and manipulation/distribution of resources. All these different case studies underscore the variability of interconnectedness of ancient communities and their differences in mobility and connectivity patterns, a central node of enquiry for the entire project (see also Knapp 2007). Finally, other contributors to this volume, demonstrated by looking at the intensity of maritime connections, in Nuragic Sardinia for instance and at the material culture 'footprint' of those interactions in the island (metalworking, circulation of raw materials) as well as local expressions of identity (e.g. display of warrior identity, repetition of rituals and offering practices), how such activities and behaviours display evidence of increased connectivity and ultimately enhance the emergence of hybrid cultures at the end of the Bronze Age and during the course the 1st millennium BC (Lo Schiavo and Usai 1995; Hitchcock *et al.*, this volume Chapter 3).

Part of our research teams engaged in investigating issues of mobility and connectivity also worked on the concept of island migration in the *longue durée*, acknowledging that issues of mobility and connectivity are closely linked with a variety of migration phenomena. Whether we consider it from an island or a mainland perspective, the theme of migration in archaeology remains divisive and elusive (Mac Sweeney 2016; Christophilopoulou 2022). In fact, it remains divisive in other disciplines as well, whether we examine the phenomenon in an organised and substantial way, or when we observe it in its 'Brownian motion' (borrowing the term from the study of population movements in sociology). No matter its definition, migration remains a crucial characteristic of both ancient and modern words. Today migration is a defining global issue and documenting it requires huge amount of quantitative and qualitative aspects, many of them needing to be interdisciplinary by nature. Recent evidence of large-scale migrations shows that, when these flows are undocumented, it is very hard to prove that they happened when the transition is over, as they leave very

little material trace. Our project work brought together ancient and contemporary examples of migration, both in our research and the exhibition's space. Through this approach, we argued that interpretations of the incredibly rich Mediterranean island archaeological record could benefit enormously from comparative approaches around insularity, connectivity, and migration.

A central methodological application of the project which contributed to our research focus on reframing mobility, connectivity, and migration, was the application of archaeological science to a specific body of material from the collections of the Fitzwilliam Museum. A team of researchers, conservators, and archaeological scientists dedicated 18 months to the study of metal objects ranging from the Middle Bronze Age to the beginning of the Classical period (ca. 2000–500 BC) as case studies for understanding island life and cultural identities of the three large Mediterranean islands, as well as issues of mobility of people and objects (Dawson *et al.* this volume Chapter 5; Mokrišová *et al.*, this volume Chapter 6). In the past, scholarship of ancient metallurgy has focused on identification of sources, centres of production and innovation, the reconstruction of trade networks, and modes of transmission, and provides a rich body of evidence to explore (Knapp 2009). While both Cyprus and Sardinia had rich metal sources exploited in antiquity, Crete had no significant sources and thus possessed a very different metallurgical trajectory. Objects forged from various metals (primarily bronze, copper, iron, gold, silver) presented an important part of life of ancient communities on all three islands, and include vessels, weapons, tools, symbolic and cultic objects, jewellery, and coins. Our dedicated research group, led by Julie Dawson, Susanna Pancaldo Ema Bauzyte, and Jana Mokrišová, conducted analysis of metal objects using a combination of non-invasive (pXRF) and invasive quantitative methods (LAQ/HR-ICP-MS) as well as the qualitative analytical techniques of elemental and microstructural characterisation (SEM-EDX, micro-hardness, metallographic examination) in order to identify technology, both bronze metallurgy and processing techniques, between 2020–2023 (Dawson *et al.*, this volume Chapter 5; Mokrišová *et al.*, this volume Chapter 6).[5] They were particularly engaged with questions such as whether there is a connection between island identities, metallurgical practices, and use of metals in everyday life and as part of funerary culture; and to which extend we can discern different island identities represented when we look at metals and metallurgical practices from the three islands.[6] This led to the development of broader questions about the identities of people in the ancient world and the relationships between metalworking communities of the ancient Mediterranean, which contributes in turn to the project's wider questions on mobility and connectivity.

Case study 2: Identity through documentary studies

The undertaking of the *Being an Islander* documentary was one of the most creative research and community participation outcomes of the entire *Being an Islander*

project. Museums rarely produce documentaries and, when they do, they tend to be monodisciplinary, or designed to accompany an exhibition. *Being an Islander* documentary was conceived as an interdisciplinary research and engagement project that greatly extended the original core questions of the *Being an Islander* project. The documentary used the case of Sifnos, Cyclades, as a research model and employed methodology from the fields of visual anthropology, sensory archaeology and anthropology, experimental archaeology, and ethnographic approach to island studies. Its content, interweaved researchers, and a variety of community members of Sifnos, answering the same set of key questions, e.g.: 'What does it mean to be an islander?', 'What role do the natural environment and the island's resources play in the shaping of island life and culture?', 'How important is non-material culture, and how is it manifested in the island setting?' (Fig. 1.5).

Filming on location included numerous case studies of key ancient monuments and over 40 interviews with experts in archaeology, anthropology, architecture, seafaring, and mobility, as well as members of the local communities engaged in diachronic crafts and economies of the island (potters, stonemasons, former mine workers, farmers, shepherds), local artists and representatives of the island's authorities (the mayor of Sifnos, heads of the education and cultural associations, etc.). We included filming in the region of the ancient towers of Sifnos (phryctories), a system of communication and signalling designed initially to protect the silver mining area of the island. During the period of the island's peak in antiquity (around the 6th century BC), the Sifnians began to build a tower network system throughout the whole island. Originally the towers were built near mines (gold, silver, iron), but later extended to the entire landscape of the island, intended to control agricultural landscapes, thus exemplifying the continuity of landscape use and resources in the island's metalliferous regions (Fig. 1.6; Berg 2019). These fortifying and defensive structures served as shelters for the rural population during sudden pirate raids and also as observatories and outposts which ensured communication for the island. They are generally round with an outside diameter of 4–13.2 m maximum. A number are also accompanied by wells, millstones, and olive presses, denoting that they exercised control over surrounding lands and their economic activity.

Today, more than 77 recorded ancient towers exist in Sifnos, which equates to more than one tower per square kilometre. Several of them still preserve walls to high elevation, like the Cade tower located on the side of the modern road to Vathi and dated to the 4th century BC. Since 2003, almost two and a half thousand years after their first use, dozens of local volunteers revive the ancient system of 'Phryctories' every year on Sunday of the Pentecost. The festival demonstrates an important aspect of continuity of use and of contemporary public engagement with the ancient heritage, which is consistent with the long, diachronic presence and use of the towers.

Another case study of the documentary included filming evidence of the island's over 600 years old pottery industry, an industry almost exclusively dedicated to the

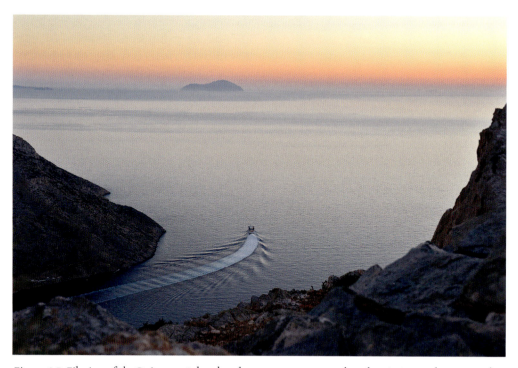

Figure 1.5. Filming of the Being an Islander *documentary was undertaken in November–December 2021 with additional scenes filmed in August 2022. The production team included Dimitrios Bouras and Anastasia Christophilopoulou (executive producers), Orestis Seferoglou, Manos Makrigiannakis, Kostas Grountas (co-producers), Orestis Seferoglou, Dimitrios Bouras (directors of photography), and Manos Makrigiannakis (editor). The complete list of the production team and scientific advisory committee is available on the project's website: https://islander.fitzmuseum.cam.ac.uk/resources/documentary (© Dimitrios Bouras for* Being an Islander *Documentary 2022).*

production of cooking vessels (*tsikalia*; tsikalario: the workshop producing cooking vessels). Filmed interviews with the master potter of the Atsonios pottery workshop, located in Vathy, revealed important aspects of the relationship between the location of the pottery workshops in proximity to good quality clay beds and by the seashore, ensuring swift transportation of the finished cooking vessels to trading destinations, to other Cycladic islands, the north and east Aegean, and of course Attica and the mainland. Before the arrival of tourism, locations by the seashore in Sifnos were almost exclusively used to house pottery workshops, revealing a dual habitation pattern, with pottery workers residing by the seashore during the working week and retreating to the main settlements inland, where their permanent households were located, during weekends and holidays. Antonios Atsonios, the master potter of the Atsonios workshop, described in his interview how the factory and the heritage of pottery making had been passed down from generation to generation for over 150

years in his family's workshop, and how traditional pottery workshops in Sifnos implemented a sustainable model of resource and water manipulation to support the craft for centuries (Fig. 1.7). The craft and heritage of pottery making in Sifnos, entangled in the island's connectivity, idiosyncrasies, and its resources, demonstrates how important and dynamic the relationship between natural recourses, settlement location, and island communication networks were in the ancient world and up to the introduction of industrial practices in the island.

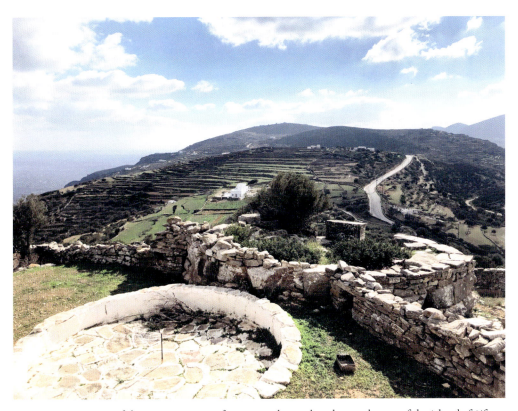

Figure 1.6. Overview of the ancient tower of Kastanas, located at the north part of the island of Sifnos, entirely constructed of local grey-veined Sifnian marble. The tower dates to the classical period (5th-4th centuries BC) and was undoubtedly related to the nearby silver mines of Agios Symeon, by the seashore. Kastanas tower provides the best example of diachronic use and meta-use of these architectural complexes, starting with facilitating a communication network between mining areas located by the sea and communities in the hinterland, most importantly Kastro, the classical capital of the island, and later acting as landmarks for agricultural and pastoral control. This function continued uninterrupted until the middle of the 20th century AD, when the island's economy was dramatically transformed to accommodate the tourism industry. Several interventions such as the addition of 19th century threshing floors testify to the long-term use of the space around the ancient tower (© Anastasia Christophilopoulou for Being an Islander *Documentary 2022).*

Residents of the Cycladic islands today, such as Sifnos, continue to practice centuries-old crafts like pottery, glass production and, jewellery making. 'When we researched the islands, we found the people' noted Dimitrios Bouras, director, producer, and lead researcher of the *Being an Islander* documentary. Under the principle of Visual Anthropology, we employed the documentary to 'engender' the diverse types of material culture we researched during the project's work, narrated by the island protagonists. Behind ceramics, metalware, glass, or other categories, are the people who made, traded, and used those objects.

Case study 3: Understanding islands through participation, community, and co-creation

Public engagement and advocacy of the diverse groups that make the *Being an Islander* community was at the heart of our practice. Our programme rethought the major research themes that transcend the project, insularity, mobility, materiality, migration, accessibility to heritage, and decolonial practice within the discipline of Mediterranean Archaeology; and invested in practice, community co-creation, and sensory experience, translating these into dialogue, active representation of individuals and communities, contemporary art projects and performances, film making, and co-curated content. Engagement with the major themes of the project was not driven only by its research teams; rather, it was informed, shaped, and debated together with our numerous island communities in Greece, Cyprus, and Italy, the diverse diasporic communities of these lands in the United Kingdom and beyond, the queer community, and the artists inspired by the past of the large Mediterranean islands.

Through our programme we make the collections, objects, and their histories relevant to what matters to all of us today, whether that might be their provenance and the way they were acquired, or the context of their archaeological discovery, as well as their histories as they navigated through different institutions. As a community of researchers and practitioners we strive for the project to lead to the creation of innovative, immersive, and groundbreaking projects and exhibitions, ones that also ask difficult questions and do not rely on just the curators and researchers to answer them; ones that engage our diverse audiences to their interpretations (Fig. 1.8).

Since 2019 we have implemented over 100 public engagement actions, events, art installations, creative commissions, workshops, seminars, performances, and community events, nationally and internationally, in addition to learning activities carried out inside and outside the Fitzwilliam Museum. One strand of our actions included our formal learning offer, for school children aged 4–18, and an extensive programme with vision impaired and deaf children: this entailed group visits of children aged 6–11 in collaboration with Cambridgeshire County Council's Sensory Support Unit. The children enjoyed exploring the Islanders exhibition, made use

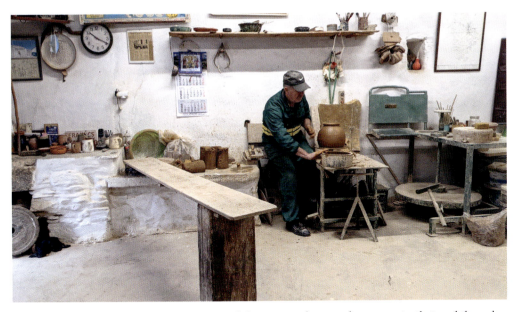

Figure 1.7. Filming in the Atsonios pottery workshop, November 2021 (© Anastasia Christophilopoulou for Being an Islander *Documentary 2021).*

of the related handling objects, and took part in creative activities inspired by the objects they discovered. They also worked with animators to create a short animation of a Greek myth, which centres around a journey by sea and, together with their teachers, they signed the story in British Sign Language used to create content for primary schools studying Ancient Greece as part of the National Curriculum for History.[7]

Screenings of the *Being an Islander* documentary for general audiences were carried out in the United Kingdom, Greece, Cyprus, Italy, Australia, and the United States in 2023–2024, while the film's premiere was presented in the island of Sifnos (October 2022) honouring the participation of the members of the community who enabled it. The documentary had also significant impact as part of a prison engagement programme led by the film producer, and co-researcher Dr Dimitrios Bouras. The programme took place in eight different prisons and juvenile institutions across Greece, in 2023–2024, provoking enthusiastic responses and discussions after projections between the participants and presenters.

Being an Islander also examined the relationship between art and archaeology and explored the notion of islands as places that encourage creativity. Through various research by-projects and installations, we questioned our traditional approaches to ancient visual culture and we sought alternative interpretations to archaeological material and heritage. A pioneering project, led by visual artist Yorgos Petrou supported by the *Being an Islander* research community, and funded

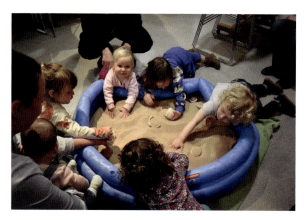

Figure 1.8. A sensory session for babies, as part of the Being an Islander project engagement programme, May 2023 (© The Fitzwilliam Museum 2023).

by Arts Council England, titled *Dust and Butterflies*, created an experimental art film that celebrates the creative histories to emerge from the Middle East and North Africa region, past and present. Through the project, Petrou worked on the theme of islands as a spatial figure, articulating contradictory conceptions of the world, but also on the self and the body as an island and fragmentation, and a metaphor for political renewal. The project also celebrated the interconnectivity and complexity of life as a migrant in the United Kingdom, from a uniquely queer and artistic perspective, grounded in the historical context of the Fitzwilliam Museum's collections (Fig. 1.9).

Following on our commitment to translate our research focus on mobility and migration into additional meaningful and impactful engagement actions, highlighting the effect of contemporary migration to present-day Mediterranean island communities, we launched in 2023 an engagement programme for refugees and asylum seekers, currently hosted on the island of Samos, where the recently established facility for refugees is currently one of the largest operating in Greece, under funding of the European Union. Our programme on the island took the form of providing learning and wellbeing support to families of recently arrived immigrants and refugees in the camp, a programme we delivered with the collaboration of two non-government organisations, operating on the island (Movement On The Ground and the Samos Volunteers-run Alpha Land, both located just outside the formal camp). A team comprised of researchers and Cambridge University undergraduate and graduate students, supported the delivery of learning sessions for young refugees. These sessions included topics on mobility, migration, and human movement from Africa and Anatolia through the Aegean and Italy to Europe, from antiquity to the present day. The young people attending the sessions (mostly from Palestine, Afghanistan, and Pakistan) were particularly interested in the themes of the project and exhibition and shared their own, incredibly moving stories of the difficult journey across the Aegean Sea from Turkey. Simultaneously, in Cambridge, we continued to deliver engagement sessions on the theme of migration, with an international workshop shared across the Fitzwilliam Museum, the Centre for Global Human movement, and the Lauterpracht Centre for Law studies in Cambridge, hosted on World Refugee Day (June 2023), comprising presentations from researchers

working on the legal side of current human migration, to anthropologists and archaeologists working on aspects of ancient migration. At the Fitzwilliam Museum, continuing our formal delivery for families and the general public, we led public workshops aimed at young people in collaboration with the Refugee Council and the Cambridge Refugee Resettlement Campaign (CRRC), all aimed at resettled refugee families in Cambridge.

These examples and actions of the project give a flavour of the project's research and engagement strategy as it was developed across the last four years of the project, based on the island cultures we investigated across the Mediterranean; their landscapes, material and non-material heritage, and their social phenomena in the *longue durée*. As a community of researchers and engagement practitioners we argue that what drives the engagement actions of this project is our interaction with the diverse groups that make the *Being an Islander* community. All engagement actions of the project (e.g. contemporary art installations, film making, co-curated by projects) and the choice of exhibition themes, were part of collaborations and exchange of ideas between lenders, archaeology practitioners and community advocates. Our practice also reflects recent methodological changes in contemporary museum practice, as well as practice in the field of Mediterranean Archaeology. For our team, the practice of active audience inclusion and co-creation was an active choice on decolonising museum practice; *Being an Islander* project is a project shaped by the active protagonists in the lands we included in our research, the field archaeologists and museum professionals in Sardinia, Crete, and Cyprus, the community members, their diasporic and descendent communities, and their contemporary artists.

Figure 1.9. Dust and Butterflies *experimental film, 2022 (© Giorgos Petrou 2022).*

We believe that this aspect of it contributed to it being different and was reflected in the many positive reviews the exhibition received in 2023, even well beyond its closure. Many of these emphasised on the nature of the collaborations and agency of the project's local protagonists in Sardinia, Cyprus, and Crete. Returning to David Lowenthal's (Lowenthal 1985) and Vilsoni Hereniko's work (Hereniko 2022) who saw the island cultures investigating social phenomena in

the *longue durée*, and emphasised that islanders' cultural identities are always in a state of becoming, a journey in which we never arrive; and that cultural identity is a process, not a product; through the example of this project we believe we offered a perspective on history that extends deep into the past. This perspective also focused on the longstanding and slowly changing relationships between people and the world of the Mediterranean islands and their surrounding continents. What we aim to suggest is that exhibitions and Museum projects can and should include this discourse. We witness an exciting time for museums and cultural institutions but, indeed, also a time of great change and re-appraisal of our goals and ambitions. Our research concludes, among other things, that the role of cultural heritage collections in promoting social cohesion and a sense of belonging is very important and should be fostered. Designing projects, exhibitions, and displays in a way that integrates community input, engagement, and even co-creation and co-curation, should be at the heart of every institution's policy and, indeed, a defining factor of national and international heritage policy.

Conclusions

The cultural history of the Mediterranean islands and the voices of the islanders revealed either through linguistic, historic, or material culture evidence, re-assessed by the research clusters of this project and presented in the major exhibition *Islanders: The Making of the Mediterranean,* or exemplified through the documentary's enquiry, demonstrate how creative, adaptable, and inventive islanders are. They have adapted to environmental and cultural changes, assimilations, invasions, and appropriations of their physical landscapes and their cultural horizons throughout millennia. All these events and processes, whether sudden or gradual, intense, or subtle, contribute to creating and maintaining their sense of place and identity. And beyond antiquity, material culture traditions and crafts, as narrated by the documentary, can serve as a springboard to discuss aspects of identity in the Mediterranean islands today, or beyond the Mediterranean, including Britain's own debated island identity and connectivity. We believe that this project's collective research enquiry and the diversity of its participants, allowing contributions outside its research teams, active community participation,n and co-creation, offered a chance for us all to reflect on our own sense of place and identity.

Acknowledgements

I am entirely grateful to the *Being an Islander* research and engagement communities and to the documentary production teams for their work and dedication to the project. I am also very grateful to colleagues at the Fitzwilliam Museum, University of Cambridge, for their ongoing support to the project.

Notes

1 Being an Islander project website: https://islander.fitzmuseum.cam.ac.uk/.
2 Documentary film: https://islander.fitzmuseum.cam.ac.uk/resources/documentary.
3 Research and exhibition led by Dr Jude Philp, University of Sydney, see: https://www.sydney.edu.au/museum/whats-on/exhibitions/tidal-kin.html.
4 See also: https://islander.fitzmuseum.cam.ac.uk/research/.
5 See also a video animation of the Tamassos sword: https://www.youtube.com/watch?v=ICc34zau0ds and details of the analytical methodology here: https://www.eng.cam.ac.uk/uploads/pages/files/1183-engineering-newsletter-33-web.pdf.
6 See also: https://islander.fitzmuseum.cam.ac.uk/research/metals.
7 Video animation: https://www.youtube.com/watch?v=_UrFlovLKQI.

Bibliography

Berg, I. (2019) *The Cycladic and Aegean Islands in Prehistory*. Abingdon: Routledge.

Blake, E. and Knapp, A. B. (2005) *The Archaeology of Mediterranean Prehistory*. Oxford: Wiley Blackwell.

Braudel, F. (1972) *The Mediterranean and the Mediterranean World in the Age of Philip II*. London: Harper Collins.

Broodbank, C. (2000) *An Island Archaeology of the Early Cyclades*. Cambridge: Cambridge University Press.

Broodbank, C. (2013) *The Making of the Middle Sea: A History of the Mediterranean from the Beginning to the Emergence of the Classical World*, London: Thames and Hudson.

Cadogan, G., Iacovou, M., Kopaka, K. and Whitley, J. (2012) *Parallel Lives: Ancient Island Societies in Crete and Cyprus*. London: British School at Athens 20.

Christophilopoulou, A. (2022) Ancient migration or ancient mobility? Perspectives from Cyprus. In G. Bourogiannis (ed.), *Beyond Cyprus: Investigating Cypriot Connectivity in the Mediterranean from the Late Bronze Age to the End of the Classical Period*, 273–287. Athens: AURA Supplement 9 http://dx.doi.org/10.26247/aurasup.9.

Christophilopoulou, A. (ed.) (2023) *Islander. The Making of the Mediterranean*. Cambridge: University of Cambridge in association with Paul Holberton Publishing.

Constantakopoulou, C. (2007) *The Dance of the Islands. Insularity, Networks, the Athenian Empire, and the Aegean World*. Oxford: Oxford University Press.

Dawson, H. (2019) As good as it gets? 'Optimal' marginality in the Longue Durée of the Mediterranean islands. *Journal of Eastern Mediterranean Archaeology & Heritage* 7(4), 451–465.

Fappas, I. (2011) Exchange of ideas in the eastern Mediterranean during the 14th and 13th centuries BC: The case of perfumed oil use and ideology. In K. Duistermaat and I. Regulski (eds), *Proceedings of the International Conference at the Netherlands-Flemish Institute in Cairo, 25th–29th October 2008*, 495–510. Leuven/Paris/Walpole MA: Orientalia Lovaniensia Analecta 202.

Hereniko, V. (2022) Editor's note: Interdisciplinarity reimagined. *The Contemporary Pacific* 34(2), ix–xvii.

Horden, P. and Purcell. N. (eds) (2000) *The Corrupting Sea*. Oxford: Blackwell.

Iacovou, M. (2008) Cultural and political configurations in Iron Age Cyprus: The sequel to a protohistoric episode. *American Journal of Archaeology* 112, 625–658.

Knapp, B. (2007) Insularity and island identity in the prehistoric Mediterranean. In S. Antoniadou and A. Pace (eds), *Mediterranean Crossroads*, 37–62. Oxford: Oxbow Books.

Knapp, A. B. (2009) Metallurgical production and trade on Bronze Age Cyprus: Views and variations. In V. Kassianidou and G. Papasavvas (eds), *Eastern Mediterranean Metallurgy and Metalwork in the 2nd Millennium B.C.*, 14–125. Oxford: Oxbow Books.

Knapp, A. B. and Van Dommelen, P. (2010). Material connections. Mobility, materiality and Mediterranean identities. In A. B. Knapp and P. Van Dommelen (eds), *Material Connections and the Ancient Mediterranean. Mobility, Materiality and Identity*. 1–10. London/New York: Routledge.

Knapp, A. B., Russell A. and Van Dommelen, P. (2022) Cyprus, Sardinia and Sicily: A maritime perspective on interaction, connectivity and imagination in Mediterranean prehistory. *Cambridge Archaeological Journal* 32(1), 79–97.

Kotsonas, A. and Mokrišová, J. (2020) Mobility, migration, and colonization. In I. Lemos and A. Kotsonas (eds), *The Wiley Companion to the Archaeology of Early Greece and the Mediterranean*, 217–247. Oxford: Wiley-Blackwell.

Lo Schiavo, F., and Usai, L. (1995) Testimonianze cultuali di età nuragica: La grotta Pirosu in località Su Benatzu di Santadi. In V. Santoni (ed.), *Carbonia e il Sulcis. Archeologia e Territorio,* 147–186. Oristano: Editrice S'Alvure.

Lowenthal, D. (1985) *The Past Is a Foreign Country.* Cambridge: Cambridge University Press.

Mac Sweeney, N. (2016) Anatolian-Aegean interactions in the Early Iron Age: migration, mobility, and the movement of people. In B. Molloy (ed.), *Of Odysseys and Oddities: Scales and Modes of Interaction Between Prehistoric Aegean Societies and Their Neighbours*, 411–435. Oxford: Sheffield Studies in Aegean Archaeology.

Nunn, P. D. (2020) In anticipation of extirpation: How ancient peoples rationalized and responded to postglacial sea level rise. *Environmental Humanities* 12(1), 113–131.

Rackham, O. and Moody, J. (1996) *The Making of the Cretan Landscape.* Manchester: Manchester University Press.

Randall, J. (2021). *An Introduction to Island Studies.* Charlottetown: Island Studies Press.

Tronchetti, C. and Van Dommelen, P. (2006) Entangled objects and hybrid practices. Colonial contacts and elite connections at Monte Prama, Sardinia. *Journal of Mediterranean Archaeology* 18(2), 183–209.

Chapter 2

Big and small islands: Rethinking insularity in the ancient Greek world

Christy Constantakopoulou

The purpose of this paper is to examine notions of insularity in Classical Greece. The dominant understanding of insularity was associated with small places. Large islands, such as Crete, Sicily, or Sardinia, were not necessarily understood as insular places. Rather, the dominant context for the development of the concept of insularity was the geographic reality of the Aegean Sea, with the multitude of small islands forming interconnected clusters. Understanding insularity as 'small' places was also related to the imperial control of islands by the Athenian empire over the course of the 5th century BC. Imperial practices of control essentially turned islands into small, manageable places, weak and feeble, unable to resist a naval power such as Athens. When this imperial notion of insularity was imposed on the big island of Sicily during the Sicilian expedition of 415–413 BC, the results were catastrophic for Athens. Big and small insularity, therefore, played a key part not only in shaping the geographic understanding of space but also in real political events in the Classical period.

What is an island? This may appear to be a simple question but it is one that has multiple and complex answers which, in turn, have real repercussions for the history, culture, and politics of insular and non-insular places. In this chapter, I aim to explore notions of insularity in the ancient Greek world (during the Archaic, Classical, and Hellenistic periods). My main argument is that for the ancient Greeks, whose experience of insularity was mostly related to the Aegean islands, the dominant perception of insularity was that of a small place. I argue that this understanding of islands as 'small' had real consequences for the imperial policy of Athens during the 5th century BC. Big and small insularity played a key role not only in shaping the geographic understanding of space but also in real political events during the Classical period.

A working definition of an island can be that of a piece of land completely surrounded by water. Natural conditions, such as the presence of tides or the alluvial

deposits of rivers, may alter the insular landscape by creating islands whereas there was none before or by connecting islands to the mainland. The absence of noticeable tides in the Mediterranean, at least, takes away this particular complication; islands in the Aegean remain insular throughout the lunar cycle (Diodorus 5.23.3).[1] Rivers, on the other hand, have the potential of altering the landscape, with spaces changing from islands to peninsulas and back, depending on the rivers in the area (Thucydides 3.51; Strabo 9.1.4; Pausanias 1.44.5).[2] Despite the complications that tides and rivers potential pose, we can assume that, for the Greeks, islands were spaces surrounded by water with normally clear boundaries: the island ended where the sea began.

The history of the islands and of ancient notions of insularity has been shaped by some important recent shifts in scholarship. First, we are experiencing a true 'spatial turn' in ancient history, classics, and classical archaeology. This may be seen as the result of a 'spatial turn' in the social sciences and the humanities (Guldi 2010), where space is no longer considered as a concept or entity outside human cultural constraints and ideology (Cosgrove 1984). The importance of space and place, whether it is cultural, gendered (Kümin and Usborne 2013), environmental, geographical, or other, is now at the heart of debates about history. The 'spatial turn', and a critical approach to space and place, are therefore already transforming our discipline. At the same time, we have witnessed the emergence of a new narrative about the past. Scholarship on the Mediterranean, pioneered by the publication of Horden and Purcell's *The Corrupting Sea* (2000), has put the environment and landscape at the heart of ancient history narratives.[3] The paradigm put forward by the *Corrupting Sea* stresses the geographic fragmentation of the Mediterranean which, in turn, makes it prone to increased risk. This is mitigated by the presence of increased maritime mobility, connectivity, which allows societies to respond to risk and crisis. The ancient Mediterranean experienced both fragmentation and connectivity. Within that context, insularity contributed both to the fragmentation and to maritime connectivity.

Indeed, Mediterranean insularity is one of the factors that has been understood as pivotal in creating Mediterranean uniqueness (Horden and Purcell 2020, 12). Insularity, on the whole, moves in a spectrum between isolation and connectivity, with islands functioning both as 'bridges' connecting places and as landscapes prone to isolation and island distinctiveness (cultural, environmental, etc.). Indeed, oceanic insularity may be primarily understood as synonymous to isolation – one thinks of Darwin's island laboratories as a prime example of this. Mediterranean islands, on the other hand, very rarely experienced absolute isolation. Mediterranean islands, and indeed the Aegean islands which are the focus of this chapter, were active nodes in networks of interaction for most of the periods of the last three millennia (as discussed in Constantakopoulou 2007, 1–10).

The presence of so many islands in the Aegean Sea, in particular, created specific contexts for the understanding of insularity of the Greeks. Braudel called the Aegean islands under Venetian rule a 'stationary fleet', stressing in this way not just the great number of islands but also their important role for a sea power, such as Venice, that

2. Big and small islands: Rethinking insularity in the ancient Greek world

aimed to control the sea (Braudel 1972, 149). In antiquity, we find multiple articulations of the idea of island connectivity as a dominant feature of insularity. Aelius Aristeides, writing in the 2nd century AD, praised the Aegean in a prose hymn; for him, the presence of islands was a defining feature of the Aegean and a source for celebration: 'as the sky is decorated with stars, the Aegean Sea is decorated with islands' (Aelius Aristeides 44.14). The praise for the beauty of the Aegean is intrinsically linked with the presence of islands: the Aegean

> is not barren nor by opening an endless vista does it cause depression and despair. But the Aegean is made up of many seas and many gulfs, and in each place, there is a different kind of sea. You might stop your journey even in the midst of the sea and find land, cities and countryside, as it were, little seagirt continents. (Aelius Aristeides 44.10)

For Aelius Aristeides, the islands created choruses, making the Aegean the most musical of all seas:

> The sea is naturally musical, since right at the start it raised up a chorus of islands like any other chorus. And they have divided up the sea, many close to one another, and to sailors and passengers appear as a more sacred sight than any dithyrambic chorus. (Aelius Aristeides 44.12)

Four centuries before Aelius Aristeides, Callimachus encapsulated in his poetry the image of inter-connected islands. In his *Hymn to Delos* (20–28), Callimachus described the islands of the Cyclades 'dancing' around Delos:

> the islands gather and she [ie. Delos] ever leads the way. Behind her footsteps follow Phoenician Cyrnus, no mean island, and Abantian Macris of the Ellopians, and delectable Sardo, and the isle whereto Cypris first swam the water and for fee of her landing she keeps safe (...) Delos beloved. Now if songs full many circle about you, with what song shall I entwine you.

The image of the dance of the islands is repeated at the end of that poem, making an allusion to the opening of the hymn: 'Asteria, island of incense, around and about you the islands have made a circle and set themselves about you as a choir' (*Hymn to Delos* 300–301). The circling islands, the Cyclades, dance around Delos-Asteria, bringing the themes of connection, sacred dance, and patronage of Apollo, main deity at Delos, all into sharp focus at the start and at the end of the hymn.

Ancient Greek perceptions of insularity, therefore, were closely related to the idea of island connections, which led to the beautiful poetic image of the islands dancing in a chorus or a circle around the sacred island of the Aegean and birthplace of Apollo and Artemis, Delos. The geographic reality of the Aegean islands affected the ways that insularity was understood. In that context, another important feature of the Aegean islands that inescapably shaped ancient perceptions of insularity was their size. In our working definition of an island as a piece of land surrounded by water, both Crete and Sikinos (to use examples from the two ends of the spectrum) are considered islands, but was this the case in the ancient Greek world?

One way to understand the issue is to try to count the islands of the Greek world. The official tourist board of Greece webpage claims that Greece has over 6000 islands and islets, of which 227 are inhabited (https://www.visitgreece.gr/islands/ accessed 4.5.23). Kolodny, who visited the Greek islands in the 1960s, counted 169 inhabited islands in 1966 (Kolodny 1974, 41; list of islands in Brun 1996, 28–29). However we count the islands in the Aegean (which form the majority of islands in the Greek world), we can definitely say that the vast majority of them are smaller than 300 km² in size: indeed only 15 islands in the Greek world and only 11 in the Aegean are over 300 km².[4] Philostratus, writing in the late 2nd/early 3rd century AD, is explicit in equating insularity with the notion of the small island. In his chapter on islands in his *Imagines*, he embarks on an imaginary journey on a ship in springtime. While onboard the ship, he tells his interlocutor to:

> perceive that the sea is large, and the islands in it are not, by Zeus, Lesbos, nor yet Imbros or Lemnos, but *small* islands herding together like hamlets or cattle-folds, or by Zeus, like farm-buildings on the sea-shore

> ἡ μὲν θάλαττα, ὡς ὁρᾷς, πολλή, νῆσοι δ'ἐν αὐτῇ μὰ Δί'οὐ Λέσβος οὐδ ' Ἴμβρος ἢ Λῆμνος, ἀλλ' ἀγελαῖαι καὶ μικραί, καθάπερ κῶμαί τινες ἢ σταθμοὶ ἢ νὴ Δία ἐπαύλια τῆς θαλάττης. (Phil. *Imag.* 2.17.1: my emphasis)

Athenaeus too, writing in the same period, classified 'insular wine' as a separate category from wine originating from large islands such as Rhodes, Chios, Lesbos, or Thasos (Ath. 1.32e). It is clear, then, that for Athenaeus, insular wine originated from small islands; insularity was related to a small size.

Ancient notions of insularity are intimately linked with the act of floating, emerging, and disappearing. Delos famously floated before becoming stable through the act of divine agency (and the birth of the twin gods) and Aeolia was a floating island in Homer's *Odyssey*.[5] A number of islands called Plotai or Planesiai attest to an understanding of floating as an element of insularity (Moret 1997). The scholiast to Apollonius Rhodius commented that 'in old times, all the islands were wandering and did not have any foundation' (3.41.3). Floating islands therefore were part of the package of geographic instability that characterised insularity: in ancient sources, the mainland was considered stable while the insular space was considered unstable.[6] Emerging islands too are dominant in ancient narratives of insularity: Rhodes emerges in Pindar's *Seventh Olympian* (7.54-64), while Anaphe appears suddenly in Apollonius Rhodius (*Arg.* 4.1684-730). Islands also disappeared, in reality (the volcanic islands in Pliny *NH* 2.202) and in imagination (the neighbouring islands to Lemnos in Onomacritus' collection of Musaeus' prophecies in Herodotus 7.6.3). Geographic instability, therefore, through the emergence, disappearance, and floating of islands was an important element of ancient concepts of insularity. Within that context, Strabo's comment when he describes the creation of islands through the act of emerging is particularly pertinent. In his description of geological movements, such as earthquakes and volcanic eruptions, and their impact on geography, he makes a

2. Big and small islands: Rethinking insularity in the ancient Greek world

distinction between large and small islands. According to him, small islands can rise from the bottom of the sea, but large islands cannot (1.3.10). Small islands, therefore, are for Strabo more 'insular' as they can become emerging, whereas large islands lack this defining element of insularity.

Thucydides to clearly understands insularity as essentially a quality of small islands. This is important not simply because it confirms our working hypothesis about ancient perceptions of insularity but also because it has real implications for his presentation of the history of the Athenian empire and of Athenian imperial rule over the course of the 5th century BC. The most common use of the noun *nesos* (island) in Thucydides is for Sphacteria, the small uninhabited island off Pylos in the Peloponnese where, in 425 BC, 292 Peloponnesian hoplites, of which 120 were Spartans, were captured alive by the Athenian army.[7] This was truly one of the most remarkable episodes of the Peloponnesian war and significantly altered the course of the first phase of the war (i.e., the so-called Archidamian war, 431–421 BC). It was the first time that Spartan hoplites were taken hostage; this not only boosted Athenian morale but inevitably put a stop to the annual Peloponnesian invasions in Athenian territory, for fear of the Athenians executing their Spartan captives. Thucydides used the name Sphacteria only once in his narrative when he first introduced the island in his description of the landscape of Pylos and its surrounding territory (4.8.6). From then on, and throughout his narrative, he simply refers to Sphacteria as the 'island' and to the captives of Sphacteria as 'those on the island'. Thucydides expected his readers to immediately understand what island he was talking about – for him, the 'island' was Sphacteria, a small uninhabited island.

When we compare Thucydides' use of the word island for Sphacteria to his use of the same for Sicily, the implication about his and his audience's understanding of insularity becomes even more apparent. Thucydides uses the term 'island' for Sicily only three times; significantly all these occurrences are in the so-called Sicilian archaeology section, in the beginning of book 6, where he introduces Sicily and its history to his audience as a prelude and an explanation for one of the most important episodes of the Peloponnesian war, the Athenian expedition against Sicily in 415–413 BC, which ended with a complete Athenian disaster and arguably marked the beginning of the end for the Athenians during the war. The Athenians had engaged with Sicilian affairs before 415 BC, as is evident from Thucydides' own narrative of events in the 420s,[8] but Thucydides decided to introduce Sicily and discuss the history of the island and of Athenian western ambitions only in the beginning of book 6, in the beginning of the narrative of the great Sicilian expedition of 415 BC. The opening of book 6 is quite astounding as it clearly reveals Thucydides' aims and intentions, which elsewhere in his narrative are more elusive. In the winter of 415 BC, the Athenians, Thucydides tells us, were 'ignorant of the *size of the island* and of the number of its inhabitants, both Greek and barbarians' (Thucydides 6.1.1: ἄπειροι οἱ πολλοὶ ὄντες τοῦ μεγέθους τῆς νήσου καὶ τῶν ἐνοικούντων τοῦ πλήθους καὶ Ἑλλήνων καὶ βαρβάρων). It is in this context that Sicily is presented as an island for the first time.

Thucydides then proceeds to provide a section of the prehistory of Sicily, including the history of its colonisation by Greek cities. The second occurrence of the term 'island' is included in the section about Sicanian settlement on the island (Thucydides 6.2.2), while the third and last occurrence of the term is slightly later in the description of the presence of Sikels in Sicily (Thucydides 6.2.2: καὶ ἀπ'αὐτῶν Σικανία τότε ἡ νῆσος ἐκαλεῖτο ('and from them, the island was then called Sikania'). 6.2.6: ἔτι δὲ καὶ νῦν τὰ μέσα καὶ τὰ πρὸς βορρᾶν τῆς νήσου ἔχουσιν ('and even now they hold the central and the areas to the north of the island')). Thucydides includes the diversion on Sicilian history and prehistory to clearly differentiate between the Athenians' ignorance of Sicily and his own expert knowledge. He masterfully appears as the all-knowing narrator, and by sharing with us, his audience, his knowledge of the true size, the history and the complex ethnographic background of Sicily, he implicates us in a condemning judgment of the Athenians and their ill-conceived expedition against Sicily. The Sicilian prehistory, in that sense, serves as an important lesson in historical causation: it is because of the *size* of the island (my emphasis) and the multitude of people living there that the expedition is bound to fail.

With the exception of these instances Thucydides does not use the term 'island' to denote Sicily. A comparison with the use of the term to denote Sphacteria reveals an underlying assumption: for Thucydides, the term island can be applied to Sphacteria, a small, uninhabited island, but not to Sicily, because of its size. Indeed, Thucydides tells us that Sicily is 'almost a continent' (ἤπειρος, Thucydides 6.1.2). Insularity, therefore, is once again associated with a small size.

The use of the term island for the small-sized Sphacteria and the absence of the term for large Sicily are useful for highlighting Thucydides and his contemporary and later audience's understanding of insularity. But at the same time, the use of the term has real implications for understanding islands as essentially places prone to imperial control by a sea power, such as Athens was during the period of the Athenian empire. I have already mentioned how the reference to the large size of Sicily serves for Thucydides as an explanation for the Athenian failure to conquer the island. The Athenians' most astounding military victory was the capture of the Spartan and Peloponnesian hoplites in Sphacteria, the island *par excellence*; on the contrary, the Athenians' biggest failure was the Sicilian disaster, on the island that was almost a continent.

I believe that Thucydides' use and understanding of insularity as essentially a small place, prone to imperial control by a sea power, plays an important role in the narratological sequence of historical episodes in his narrative. It is time to turn our attention to another famous Thucydidean episode involving an island: Melos and the Melian dialogue, included right at the end of book 5 (Thucydides, Melian dialogue 5.84–116). The Athenians, Thucydides tells us in an earlier passage, 'wanted to subdue Melos, which, *although it was an island*, had refused to submit to Athens or even to join the Athenian alliance' (Thucydides 3.91.2: τοὺς γὰρ Μηλίους ὄντας νησιώτας καὶ οὐκ ἐθέλοντας ὑπακούειν, my emphasis). The inclusion of the participle and noun (*ontas*

2. Big and small islands: Rethinking insularity in the ancient Greek world

nesiotas) is truly chilling, especially if one knows the dreadful end that awaits the Melians. The implication here is clear: insularity is essentially equivalent to subject to Athenian rule. The Melians were outside Athenian control and therefore had to be subdued.

The insular fate of Melos reaches a tragic climax at the end of book 5, with the famous Melian dialogue. In what is perhaps one of the most famous passages of Thucydides, he juxtaposes anonymous Melian interlocutors with the anonymous Athenian representatives. The anonymity of the interlocutors is of crucial importance:[9] in this manner, the episode is not just a historical narrative of the events that led to the submission of the island to Athenian rule but a treatise on the brutality of imperial power, the role of morality in interstate relations, the role of justice and divine justice in war, and so much more. Melos' insularity is certainly used as an argument in the dialogue. The Athenians claim that the conquest of Melos was essential for their safety, as Melos was an island (Thucydides 5.97 and 5.99), while they refute the Melians' claim that the Peloponnesians will help them again, using insularity as an explanation: 'how likely is it that while we [i.e. the Athenians] are masters of the sea, they [i.e. the Peloponnesians] will cross over to an island?' (Thucydides 5.109).

The end of the Melian episode is well-known: the Athenians fail to convince the Melian representatives to submit to Athenian control and, therefore, the Athenians besiege and conquer the island. In the winter of 415 BC, after the fall of the island, the 'Athenians killed all the grown men whom they captured, and sold the women and children as slaves, and then sent out five hundred colonists and inhabited the place themselves' (Thucydides 5.116.4). This single sentence, with its truly chilling and sombre reference to a massacre,[10] ends book 5. The next sentence in the text is the one we already quoted and marks the beginning of book 6 with Thucydides statement highlighting the Athenian ignorance of Sicily and its inhabitants, as a prelude to his narration of the Sicilian expedition. I argue, therefore, that for Thucydides, the concept of insularity played an important role in shaping the sequence of his narrative. He chose to end his account of the winter of 416–415 BC with the episode of Melos and the Melian dialogue, where he highlighted the role of islands as imperial subjects. He then chose to begin his account of the events of 415 BC with the prehistory of Sicily, the non-island/almost continent, stressing its size as an explanation, I believe, of the consequent Athenian failure. The theme of island colonisation is also evident here, with the Athenian settlers sent off to Melos at the end of book 5, and the history of the Greek colonisation of Sicily as the opening of book 6 (Hornblower 2008, 256). The Melian episode can be seen as an *exemplum* of Athenian hybris, for which the Sicilian episode can be viewed as the inevitable nemesis, in this tragic account. What has been less appreciated is the role that insularity has played in this particular scheme of hybris/nemesis or rise and fall of Athenian power.

The understanding of islands as natural subjects of any sea power and, therefore, natural allies of the Athenians during the 5th century, had implications for places

that were not actual islands. This is certainly the case of Scione. Scione was a small polis in Chalkidike, which played an important role in the events of 424 when the Spartan general Brasidas's expedition to northern Greece transferred the war to the north. Thucydides refers to the people of Scione as 'islanders' in a number of occasions; first, in a speech delivered by Brasidas, where the general congratulated the Scionaians because 'although they were nothing else but islanders', they had joined his side seeking freedom (Thucydides 4.120.3). Further down, Thucydides expresses Brasidas's fears that the Athenians would send a force to Scione 'as if to an island' (Thucydides 4.121.2). And again, the Athenians themselves, according to Thucydides, were 'furious at the idea that now *even islanders* dared to revolt from them' (Thucydides 4.122.5, my emphasis). Scione, I repeat, was not an island, but a city on a peninsula in Chalkidike. It is transformed into an island in Thucydides' account exactly because it is understood as a 'natural ally' of Athens.

Scione's tragic fate perhaps sealed its identification as an island for Thucydides – and later for Arrian. In another short sentence, Thucydides narrates the events of 421 BC: in the summer of that year, 'the Athenians won the siege of Scione, killed the adult males and enslaved the women and children, and gave the land to the Plataeans to live' (Thucydides 5.32.1). The wording is remarkably similar to the fate of Melos later on; in a succinct sentence, Thucydides suppresses a truly horrible event. While he does not use the term 'island' in this context, the insular connotations of Scione repeated at key moments in the previous narrative, create a context for explaining the massacre. Scione and Melos become the key exemplars of Athenian atrocity.[11] The insular connotations of subjugation and consequent massacre may explain how Arrian later referred to the Scione massacre. In a passage discussing Athenian atrocities during the Peloponnesian war, he calls Melos and Scione 'island cities' (*Anab.* 1.9.5). For Arrian, Scione has been transformed into an island exactly because of its horrible fate as an 'insular' subject, which attempted to break away from Athenian imperial rule.

I have argued that the small-scale insularity that exists in the Aegean affected the ways that Greeks understood insularity more general. Islands were considered parts of an unstable geography, in contrast to the mainland or continent, which was stable and unchanged. As such places, islands could emerge, float, or disappear altogether, depending on the context and the narrative. Islands were also understood as prone to imperial control and subjugation, exactly because of their position within the context of the Athenian empire, as sea-power, which brought the entire Aegean and its littoral under its rule over the course of the 5th century. The need to control islands and use them as convenient stops for merchant and military use affected the way they were perceived. Islands became synonymous with weakness and subjugation even though they had experienced and continue to experience wealth and heavy traffic (Brun 1996; Constantakopoulou 2007; Rutishauser 2012; Bonnin 2015). The conceptual understanding of empire and sea-power transformed the image of insularity.

In all this conceptual expression of insularity in the classical Greek world, size was a key parameter. I have argued that ancient Greek authors considered a true

island a small island, that is an island typical of the Aegean, with an area sometimes as little as Sphacteria, outside Pylos, which has a surface of 3.2 km^2 or 1.2 square miles. Delos, the other famous island in the Aegean, which formed the conceptual, mythical religious, often economic and even, at times, political centre of the Cyclades (Constantakopoulou 2017), was equally small at 3.43 km^2 or 1.32 square miles. Yet, despite its size, Delos was the island around which the Cyclades formed a 'circle' (the Cyclades 'circling Delos' in Strabo 10.5.1; Pliny *NH* 4.12.65; Dion. Perieg. 526), and she was the centre of the dance of the islands in Callimachus's poetic imagination. Delos and Sphacteria were insular islands; Sicily or Crete were not.

The association of small size with insularity may be viewed as an intellectual game. But it was not just that: it had real repercussions for the lives of the islanders and for the choices made by external imperial power in their policies. I have discussed in detail how Sicily was presented in Thucydides, and the way that his narrative was framed by insularity, especially in the 'most tragic' of his historical episodes, the narrative about the Sicilian expedition and the consequent Athenian disaster in 413 BC, in books 6 and 7. For Thucydides and his audience and I would argue for contemporary Athenian political decision-making processes, the association of insularity with weakness, and with the understanding of islands as ideal subjects for sea-power was part of their context for understanding how things work in the world. The Athenians subjugated Melos, killed all the men, and enslaved all the women because Melos was an island. The Athenians mistook Sicily for an island and, as a consequence of this misunderstanding, they suffered a horrendous defeat. The understanding of small size as a feature of insularity did not just shape ancient perceptions of insularity. It created a context for imperialist control and ultimately paved the way for the Athenian imperial defeat at Sicily in 413 BC.

Notes

1 Diodorus 5.23.3 is aware of the transformation of islands into peninsulas through the presence of tides in his discussion of the islands between Europe and Britain.
2 The island of Minoa, off Megara, is an island in Thucydides 3.51, but a peninsula in Strabo 9.1.4, and an island again in Pausanias 1.44.5.
3 Indicatively, Harris 2005; Malkin 2005; Walsh 2014, Bekker-Nielsen and Gertwagen 2016; Ellis-Evans 2019; Horden and Purcell 2020; Kouremenos and Gordon 2020; König 2022; Ramgopal 2022. See also Weiberg and Finné 2022 for a bibliographical summary on research on human-environment dynamics, with an emphasis on archaeological research.
4 In order of size Crete, Euboea, Lesbos, Rhodes, Chios, Cephalonia, Corcyra, Lemnos, Samos, Naxos, Zakynthos, Thasos, Andros, Lefkas, Carpathos.
5 Delos floating in Pindar *Paean* 7b and *Hymn to Zeus* 243–252, Callimachus *Hymn to Delos* 36–52.
6 Nishimura Jensen 2000 for an excellent analysis of the trope of stability and instability and its deconstruction in Apollonius Rhodius's *Argonautica* and Callimachus's *Hymn to Delos*.
7 Description of the Sphacteria episode in Thucydides 4.3–38. The number of the Peloponnesian and Spartan captives included in 4.38.5.
8 Thuc. 3.86 for events in 427 and the first Athenian Sicilian expedition, 3.115 for events in 426/5, and 5.4–5 for events in 422.

9 See the excellent discussion by Fragoulaki 2013, 162–179, who explains the anonymity through the lens of ethnic affiliations.

10 See Hornblower 2008, 254–256 for an analysis of the passage and a comparison with Scione.

11 In addition to the episode of Mycalessos in 7.29–30, which however, is attributed to the Thracian mercenaries: for the important Homeric resonances of the episode, see Fragoulaki 2020.

Bibliography

Bekker-Nielsen, T. and Gertwagen, R. (eds) (2016) *The Inland Seas: Towards an Ecohistory of the Mediterranean and the Black Sea*. Stuttgart: Franz Steiner.

Bonnin, G. (2015) *De Naxos à Amorgos. L'imperialism athénien vu des Cyclades à l'époque Classique*. Bordeaux: Ausonius.

Braudel, F. (1972) *The Mediterranean and the Mediterranean World in the Age of Philip II*. London: Harper Collins.

Brun, P. (1996) *Les archipels Égéens dans l'antiquiteé Grecque (5e-2e siècles av. notre ère)*. Paris: Annales Littéraires de l'Université de Franche-Comté.

Constantakopoulou, C. (2007) *The Dance of the Islands. Insularity, Networks, the Athenian Empire, and the Aegean World*. Oxford: Oxford University Press.

Constantakopoulou, C. (2017) *Aegean Interactions. Delos and its Networks in the third Century*. Oxford: Oxford University Press.

Cosgrove, D. (1984) *Social Formation and Symbolic Landscape*. Totowa NJ: Barnes and Noble.

Ellis-Evans, A. (2019) *The Kingdom of Priam. Lesbos and the Troad between Anatolia and the Aegean*. Oxford: Oxford University Press.

Fragoulaki, M. (2013) *Kinship in Thucydides. Intercommunal Ties and Historical Narrative*. Oxford: Oxford University Press.

Fragoulaki, M. (2020) Thucydides Homericus and the Episode of Mycalessus (7.29–30): Myth and history, space and collective memory. *Histos* Supplement 11, 37–86.

Guldi, J. (2010) *The Spatial Turn in History* https://spatial.scholarslab.org/spatial-turn/the-spatial-turn-in-history/index.html. [Accessed 31 March 2024].

Harris, W. (ed.) (2005) *Rethinking the Mediterranean*. Oxford: Oxford University Press.

Horden, P. and Purcell. N. (eds) (2000) *The Corrupting Sea*. Oxford: Blackwell.

Horden, P. and Purcell. N. (eds) (2020) *The Boundless Sea. Writing Mediterranean History*. London: Routledge.

Hornblower, S. (2008) *A Commentary on Thucydides vol. 3*. Oxford: Oxford University Press.

Kolodny, E. (1974) *La population des îles de la Grèce: essai de géographie insulaire en Mediterranée orientale*. Aix en Provence: Edisud.

König, J. (2022) *The Folds of Olympus. Mountains in Ancient Greek and Roman Culture*. Princeton NJ: Princeton University Press.

Kouremenos, A. and Gordon J. M. (eds) (2020) *Mediterranean Archaeologies of Insularity in an Age of Globalization*. Oxford: Oxbow Books.

Kümin, B. and Usborne, C. (2013) At home and in the workplace: a historical introduction to the 'Spatial Turn'. *History and Theory* 52, 305–318.

Malkin, I. (2005) *Mediterranean Paradigms and Classical Antiquity*. London: Routledge.

Moret, P. (1997) Planesiai, îles erratiques de l'occident grec. *Revue des Études Grecques* 110, 25–56.

Nishimura-Jensen, J. (2000) Unstable geographies: the moving landscape in Apollonius' *Argonautica* and Callimachus' *Hymn to Delos*. *Transactions of the American Philological Association* 130, 287–317.

Ramgopal, S. (2022) Connectivity and disconnectivity in the Roman Empire. *The Journal of Roman Studies* 112, 215–235.

Rutishauser, B. (2012) *Athens and the Cyclades. Economic Strategies, 540–314 BC.* Oxford: Oxford University Press.

Walsh, K. (2014) *The Archaeology of Mediterranean Landscapes: Human-Environmental Interaction from the Neolithic to the Roman Periods.* Cambridge: Cambridge University Press.

Weiberg, E. and Finné, M. (2022) Human-environment dynamics in the ancient Mediterranean. *Opuscula, Annual of the Swedish Institutes at Athens and Rome* 15, 221–252.

Chapter 3

Roll up for the Mystery Tour: Islands of the transition and their contribution to 'western' civilisation

Louise Hitchcock, Laura Pisanu, and Aren M. Maeir

Our contribution as part of the Being an Islander project aims to consider the pioneering sociological roles that island and coastal cultures played in developing and disseminating the technologies of the Bronze and Iron Ages. We give particular attention to the large islands of Sardinia, Crete, and Cyprus. We intend to argue that these technological achievements complement scientific studies of island artefacts and that they played a key role in ancient globalisation or 'bronzization' through spreading culture along with commodities and technology. We argue that commodities were key drivers of maritime interaction bringing islands and coastal regions together. Further, we discuss how their acquisition and use imply the development and mastery of different technologies. Mobility and trade further resulted in new types of settlement structures and monumental buildings that advertise them as players on a cosmopolitan and global stage. As the intricate system of the 'brotherhood of kings' broke down in the 12th century collapse, it was the survival of technological knowledges that enabled the resilient cultures of the Iron Age to emerge and thrive. We conclude that rather than promoting insularity, island interactions promoted globalisation and connectivity, and contributed to stability in the post-collapse era of the Iron Ages.

Introduction

This chapter aims to consider the pioneering sociological roles that island and coastal cultures played in developing and disseminating the technologies of the Bronze and Iron Ages. We give particular attention to the large islands of Sardinia, Crete, and Cyprus, as well as giving some reference to coastal regions that interacted in ways analogous to islands. We propose that these achievements complement scientific studies of island artefacts, and that islands, objects, and coastlines played a key role in ancient globalisation through spreading culture, commodities, and technology. We

argue that the quest for commodities, particularly copper and tin, were key drivers of maritime interaction bringing islands and coastal regions together, promoting globalisation which Vandkilde (2016) characterised as 'Bronzization'. Further, we discuss how their acquisition and use imply the development and mastery of several different technologies. Mobility and trade further resulted in new types of settlement structures and monumental buildings that advertise themselves as players on a cosmopolitan and global stage. As the intricate system of the 'brotherhood of kings' broke down in the 12th century BC collapse, it was the survival of technological knowledge that enabled the resilient cultures of the Iron Age to emerge and thrive. We conclude that rather than promoting insularity, island interactions promoted globalised Bronzization and connectivity.

We note an artificial binary in that when the sea was connecting these areas, the role of coastlines was as important as that of the sea. River valleys extended the reach of maritime trade into different categories of connected hinterlands (Hitchcock *et al.* 2020). To bring the world of the Iron Age into focus, we will comment briefly on what came before. Thus, we will touch on four periods:

1. the globalised Mediterranean system, an organic 'Belt and Road', that precedes the collapse;
2. the collapse of the 12th century BC, contributing to worlds in disarray;
3. The post-collapse period of resilience and memory of the 11th century BC; and
4. A new world order, beginning approximately around 900 BC.

We acknowledge that these dates are approximate, with a different chronology in effect for the west Mediterranean, e.g., Sardinia. Indeed, concerning Sardinia, the Nuragic civilisation and its architectural expression and manufacturing capabilities can be dated in a range of periods that scholars dealing with it have articulated as Middle, Recent, Final Bronze, and Early Iron Age (see Depalmas 2009a; 2009b; Ugas 2017).

Furthermore, some island and coastal centres may have been more prominent at particular times than others, a phenomenon characterised by the Philistine pentapolis. Islands were particularly highly networked at times when major sites were near the coastline. If we consider the *longue durée* pioneered by Braudel (for archaeology, see Hodder 1987), this is not always the case. For example, Cypriot sites were inland and more isolated during the Early Bronze Age, major sites in the Cretan hinterland were more isolated in the Middle Bronze Age, then some abandoned perhaps in favour of more coastal routes in the Late Bronze Age, followed by a move to more defensible sites following the Bronze Age collapse.

The globalised Mediterranean system, the first Belt and Road

The Bronze Age Mediterranean can be characterised as the first era of globalisation, more recently termed Bronzization, an early version of what the Chinese refer to today

as 'Belt and Road' (Mações 2020). Globalisation is taken here to refer to cross-cultural flows of information, knowledge, technology, ideas, products, and people as well as the technological knowledge needed to take full advantage of these flows (Judis 2016; Bremmer 2018). Maritime networks composed of coastal ports and improving ship technology served to accelerate these flows. Economic drivers of these movements were primarily metals but also items of symbolic and prestige value such as exotic raw materials, items with 'distance value', and spices (Cline 1999; Feldman 2006a; 2006b; Fappas 2011). In addition, diplomatic gift exchange and marriage alliances among elites combined with relative economic equilibrium promoted a fragile stability that kept these networks relatively intact over hundreds of years. We acknowledge that mobility does not always mean migration; it may simply mean connectivity, exchange of ideas, trade, and/or a limited migration of those possessing special skills. For example, Cutler (2012; 2016) has convincingly argued that the presence of Minoan style loom weights at the site of Akrotiri on Thera indicates the presence of Minoan women. Her argument is based on the fact that the muscle memory needed to use a particular type of weaving technology is best transmitted to young people. A similar argument has been made for the ability to wield particular types of weapons (Skogstrand 2017). Thus, we can take the presence of foreign weaving and weapons technologies as evidence of limited migration. In the following we will consider each of the islands mentioned in the introduction in turn, starting with Sardinia, then Crete, and finally Cyprus.

Sardinia (16th century to 509 BC)

As with all the islands discussed here, globalisation reached Nuragic Sardinia. There, flows of goods, ideas, people, and technologies continuously influenced the development of communities situated on the island. Yet, as active agents, communities settled in Sardinia, indeed, developed a unique social identity as islanders, while having been part of connected networks from the Neolithic period onwards with enormous quantities of obsidian available in Pau (Tykot 1992; Lugliè and Lo Schiavo 2009; Melis 2009; Moravetti 2009; Russell 2011). From the 16th to the 13th centuries BC, Nuragic groups across the whole island planned and built a system of towers and settlements (see Depalmas 2009a; 2009b; 2009c), with nearby funerary areas characterised by collective and monumental 'Giants' Tombs' (see Bagella 2017). The visibility of towers and their symbolic influence on the local landscape were still known during the Punic and ancient Roman periods (Stiglitz 2005, 725). Their presence resulted in the creation and organisation of a specific geographic and social and cultural milieu, while participating in a broader economic sphere (Monroe 2009). Even though it can still be questioned if a monument-oriented island (Patton 1996, 135) such as Nuragic Sardinia might have produced its buildings as architectural expression of its unique cultural identity (Knapp 2007, 43), a localised deployment of cyclopean and corbelling techniques was part of a larger phenomenon of monumentality through

different forms in continental Europe and beyond, including the western islands such as the Balearics, Corsica, and Mycenaean Greece, and in Philistia. This phenomenon occurred broadly in Mediterranean societies, resulting in unique expressions for each area including nuraghes in Sardinia, casteddi and torre in Corsica (e.g., Maeir 2020), and talaiots in the Balearic Islands (Peche-Quilichini and Cesari 2017; Ramis 2017).

In terms of style and technology, Nuragic society had specific features. The manufacture of pottery with shared features began in the Early Bronze Age wares (Depalmas 2009a) and was characterised by shapes and production techniques shared among all the Nuragic groups since the Middle Bronze Age. Localised technological and stylistic differences between the northern and southern parts of the island existed during the Recent Bronze Age (ca. 1350–1100 BC; Campus and Leonelli 2000; Depalmas 2009b). Within this milieu, the discovery of eastern materials at Nuragic sites (Lugliè and Lo Schiavo 2009), as well as Nuragic pottery in overseas contexts in Sicily, Crete, and Cyprus (Shaw 1984; Watrous *et al.* 1998; Levi *et al.* 2006; Kostopoulou and Jung 2023), indicates a network of connectivity with trading nodes reflecting complex entangled systems that Mediterranean communities engaged with. The impact of Mediterranean connectivity on social development and the production of material culture in Sardinia throughout the Bronze Age continues to be debated with regard to frequency, human agents involved, and maritime routes travelled (Sabatini and Lo Schiavo 2020; Knapp *et al.* 2022). However, evidence of overseas connections has been found at nuraghe Antigori in southern Sardinia. That evidence takes the form of consumption of Aegean pottery (as detailed in Knapp *et al.* 2022; see also Lugliè 2005; Depalmas 2009b). Such trade led to the manufacture of Aegean style pottery, produced using local clays and artisans' traditions (Knapp *et al.* 2022, 87) and to the production of the so-called slate grey pottery. Similar practices occur all over the Mediterranean, not dying out until well into the Iron Age.

The slate grey ware is a style of Nuragic pottery manufactured through new techniques involving the use of long settling clays, the control of firing temperatures in a reducing atmosphere, but not the use of the wheel (Lugliè 2005). The sites of (production and) diffusion of Nuragic slate grey ware were mainly in the southern part of Sardinia. This may demonstrate that Nuragic communities settled there were more influenced by extra-insular connectivity. The local production of slate grey pottery can be also seen as part of a wider phenomenon spread in different Mediterranean areas. Grey pottery was manufactured locally in southern Italy and the Aegean area (Lugliè 2005; D'Agata *et al.* 2012). It is not surprising that, during the first age of internationalism (Fischer and Bürge 2017), Nuragic slate grey circulated across the Mediterranean reaching Cannatello (Sicily), Kommos (Crete), and Pyla-Kokkinokremos (Cyprus).

The southern part of Sardinia is even richer in metals (copper, lead-silver, and tin deposits; Matta and Vandkilde 2023). These commodities were traded with foreigners. The discovery of ingots, which were produced using lead from the Sulcis-Iglesiente area in south Sardinia, at Caesarea (Yahalom-Mack *et al.* 2022) witnesses the circulation

of Sardinian metals along the Levantine coast. The Cypro-Minoan marks on these ingots suggest a complex network of trade which may imply the involvement of different agents in the stages of managing and trading these resources.

In Iron Age Sardinia, some of the monumental Bronze Age towers were repurposed as cultic places, while new settlements were built. A similar phenomenon takes place in Iron Age Crete, where particular monuments were venerated in what Prent (2003; 2004) termed 'ruin cult'. This phenomenon is found in various times and places and is not specific to a particular culture, as illustrated by the 17th century AD palace of Casa Zapata (now a museum), whose foundations are sunk into the 'Nurax'e Cresia' Nuraghe associated with the site of Burumini (Fig. 3.1). It was during this time that Nuragic Sardinia developed more intense maritime interactions. Nuragic objects were transported westward to the Iberian Peninsula and eastward to Crete, Cyprus, the Levantine coast, and the Italian mainland. There intense interactions and alliances might have transpired with the Etruscans (Minoja 2015). The discovery, at Nuragic sites, of Baltic and eastern European amber (Angelini 2012) as a raw material and manufactured into objects, whose presence increased during the Final Bronze and Iron Age, demonstrate how complex and globalised the circulation of goods, people, and ideas was. In this scenario, Nuragic groups engaged with Phoenicians who settled in Sardinia as well as in Cyprus and in Crete at Kommos. The contacts between these groups might have further resulted in entangled objects and practices, such as the exaltation of local groups as indicated by statues (Tronchetti and Van Dommelen 2005; Minoja and Usai 2020) representing warriors, boxers, and archers. The display of the warrior identity was exhibited through the offerings of weapons at sanctuaries and caves used for ritual purposes and a similar phenomenon was occurring on Crete at this time (Tyree *et al.* 2020). In one of these sites, at the Pirosu-Su Benatzu Cave, the offering of Iberian daggers, Italic razors, and a Cypriot (or Cypriot style) tripod with Nuragic weapons (Lo Schiavo and Usai 1995) suggests the exaltation of groups that displayed their maritime connectivity. This connectivity enjoyed close contacts with foreign cultures, such as the Phoenicians, and might have also served as the basis for communal identity. This is illustrated through representations on pottery, in bronze figurines, and in stone sculptures of nuraghes, which became symbols of a shared past memory (Campus and Leonelli 2012). At the same time, cultural entanglements between Phoenician and Nuragic cultures took place in Sardinia. Communities mixing elements of the past with new traditions involving all the aspects of daily life from food consumption to the manufacture of pottery, as exemplified at S'Urachi site (Van Dommelen *et al.* 2020). Such activities promoted the emergence of new entangled cultures during the 1st millennium BC.

Crete (the Palatial Era of 1900–1450 BC)

Turning to Crete, permanent settlement took hold in the Neolithic era (ca. 7000 BC) at Knossos when migrants from Anatolia introduced the bread-wheat complex (Broodbank

Figure 3.1. View of Casa Zapata, with foundation and lower courses sunk into 'Nurax'e Cresia', Nuraghe, Sardinia (© Louise Hitchcock 2023).

and Strasser 1991). Settlements spread throughout the island by the Early Minoan Period (ca. 3000–2000 BC). Different local traditions, as illustrated by tomb types – such as house shaped in the north and east, and round in the south (Soles 1992) – along with numerous and distinct decorated pottery styles, indicate that cultural cohesion and integration were absent. This era sees the importation of copper and tin for making tools as well as exotic imported materials used to make prestige items, with some such as diadems and mace heads elevating the status of some individuals over others (Colburn 2008).

Around 1900 BC life changed on Crete as marked by the appearance of monumental buildings organised around central courts termed 'palaces' (Hitchcock 2000), the appearance of an early writing system known as Cretan hieroglyphic (Karnava 2014), the beginnings of wheel made pottery technology (Caloi 2021), and improved maritime technology with the deep-hulled ship with mast replacing the oared long-boat (Broodbank 2000, 342–343, fig. 115). This last allowed Minoans to shrink maritime space and take their place within the Near Eastern sphere of trade and influence. Evidence of this takes the form of an explosion of wealth on Crete some 100 years before the volcanic explosion of Thera ca. 1614 (Friedrich *et al.* 2014), with a proliferation of monumental buildings (Hitchcock 2000), bronze figurines (Hitchcock 1997), pictorial art as seen in frescoes and seals used for administrative and ritual purposes, along with a new writing system known as Linear A (Driessen and Schoep 1995). Minoan crafts and craftsmanship were valued abroad in the form of ceramic styles and technology, textiles in Egypt, and wall painting found at various Near Eastern sites including Alalakh, Qatna, Mari, Tel Kabri, and at Avaris in Egypt (Tapinos 2022). The Minoans also established coastal and island colonies abroad including at the peak sanctuary site on the island of Kythera, gateway to Lakonia, and in ancient Milawanda (Miletus) exhibiting the full Minoan cultural package including wall paintings, loom weights, Linear A, and ceramics (Hitchcock 2023). Peak sanctuaries have been discovered all over Bronze Age Crete and it is possible that they reference the Levantine fondness for high places, famously proscribed in the Old Testament. Although not all of them are published, enough is known to indicate that those with built structures and rich religious offerings such as bronze figurines had come under control of the palaces they were in close spatial association with, and that there are enough differences in their individual assemblages to indicate that different ritual

activities linked with different localised deities took place at each one (for a general discussion with further references, see Preziosi and Hitchcock 1999). Recently, Dewan (2022) made the intriguing suggestion that miniatures of all kinds, such as models, figurines, and pottery vessels, could be staged and manipulated in multiple ways in order to enact various types of ritual and cultural activities at peak sanctuaries. Her work has important implications for the study of miniatures found throughout the Mediterranean.

The destruction of the palatial architecture on Crete at the end of Late Minoan IB (ca. 1450 BC) except for Knossos, resulted in Mycenaean domination of Crete and of the colony at Millawanda. The Greek Linear B writing system replaced Linear A and Knossos continued as a production centre producing goods for export from textiles to chariots (Olsen 2014). Meanwhile oil was exported in large quantities from Chania in transport stirrup jars (Pratt 2016) and was possibly related to the perfumed oil industry on the Greek Mainland at Pylos (Shelmerdine 1985). Everything revolves around the acquisition of and trade in bronze, which creates the context for the transfer and exchange of other goods, symbolisms, peoples, and technologies.

The destruction of Mycenaean Knossos around the end of the 14th century BC, gave rise to prominence at Agia Triada in the south (Hayden 1987), Chania in the west

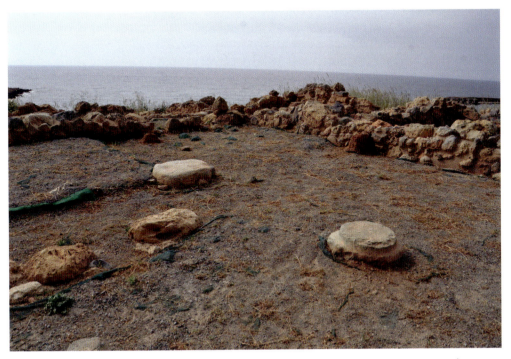

Figure 3.2. View of Sissi Promontory, Crete: Building C-D, Feasting Hall, Late Minoan IIIB (© Louise Hitchcock 2023).

(Hallager and Hallager 2000; 2003), and the emergence of modest new centres of the 13th century, such as Quartier Nu at Malia and Sissi a bit further to the east (Gaignerot-Driessen 2011; 2012; Gaignerot-Driessen and Letesson 2011; see also Hitchcock and Maeir 2017 for a broader discussion). Sissi is especially interesting as a centre for feasting and ritual and it possibly had a close connection to the emergence of piracy and the Sea Peoples, as tantalisingly hinted at by the cache of 60 spool style loom weights, the largest in the Aegean.

Other hints of the culture of the Sea Peoples with a small Italic component has been found at various post-palatial Early Iron Age sites on Crete. This component takes the form of an Italian razor and Naue II sword at Kastrokephala near Heraklion, while simple village dwellings in defensible sites in the mountains take the form of rectangular halls with hearths (Kanta and Kontopodi 2011), with Mycenaean 1- and 2-handled cooking jugs now known to occur alongside the more traditional Minoan tripods (Hallager and Hallager 2000, 159; Tsipopoulou 2012, 127). Sites such as Sissi (Fig. 3.2), that were situated on a promontory, and sites hidden in river valleys, such as the Gorge of the Dead at Kato Zakro, may be associated with the seasonal raiding activities of tribes of Sea Peoples (Nowicki 2001, 29).

Cyprus with an emphasis on the Late Bronze Age

In many ways Cyprus followed a trajectory similar to that of Crete, but materially it is expressed differently and there were chronological differences. For a long period of time, Cyprus was characterised primarily by inward looking villages, with the exception of Enkomi (Dikaios 1969; 1971) located in south-eastern Cyprus and, to a certain extent, Toumba Tou Skourou in the north (Vermeule 1974). The Neolithic era through the middle of the Early Bronze Age was remarkably stable, with villages composed of round houses with Khirokitia, Kalavassos-*Tenta*, and Lemba being among the most famous, though not all sites were active at the same time (see papers in Peltenburg 1989). These were followed by rectilinear structures introduced sometime around 2500 BC (Frankel and Webb 1998; see also Swiny 1986), a tradition continued in the Middle Bronze Age (ca. 1900–1600 BC) as seen at Marki-*Alonia* (Frankel and Webb 1997) and Alambra (Schaar 1985; Colemen *et al.* 1996). Although Knapp's (1990) approach regarding ethnicity and migration requires caution, his interpretations lack flexibility and are rigidly applied. In contrast, we might argue that the daily routines structured by a change in material culture through cultural appropriation (e.g., Giddens 1984, 1–23) suggest the embrace of a different identity by the Early Bronze Age. Both Middle and Late Bronze Age domestic structures followed a type of layout also seen on Crete (Hitchcock 2011), although such a flexible type of arrangement may indicate coincidence more than borrowing or influence.

By the 15th century BC the dominant site in Cyprus was Enkomi, characterised by monumental tombs exhibiting an early use of ashlar masonry and the earliest appearance in the Mediterranean of orthogonal town planning (Dikaios 1969; 1971).

The still undeciphered Cypro-Minoan writing system, which was clearly based on Linear A, seems to appear first at Enkomi at the end of the 16th century where it was found in a context with Minoan pottery (Dikaios 1963; Niemeier 1998). This is one of many symbolic elements adopted from the Aegean and we continue to wonder if it represents Minoan influence, or represented a conscious attempt by Cypriot scribes to maintain secrecy and exclusivity of the type seen in bureaucratic states found on Crete. Hitchcock argues for the latter because Cypro-Minoan continued to be used, even as cuneiform was used alongside it to undertake diplomatic communications with Egypt in the Amarna texts (Moran 1992; Hitchcock 2020).

Near Enkomi was the extra-urban cult and metallurgy site of Athienou which possibly served a role in copper ore processing at an extra-urban sanctuary (Dothan and Ben-Tor 1983) before becoming part of a supply chain network via Enkomi. Bernard Knapp (1986) has produced a detailed study of how cult and metallurgy became closely entangled with the building of temple complexes associated with metallurgical installations at Kition in south-central Cyprus. The later temples at Kition (Karageorghis and Demas 1985) also contained symbolism linked to maritime trade, as indicated by ship graffiti (Basch and Artzy 1985) on various orthostat panels at the site as well as the deliberate incorporation of anchors with no use-wear into the temple construction (Webb 1999, 184–187). Meanwhile Negbi (1988; see also Hitchcock 2005) sees the presence of double temples as exhibited in Temples 4 and 5 at Kition as well as at Mycenaean Phylakopi on Melos as reproducing a Levantine tradition. The significance of two pairs of so-called 'horns of consecration' at Kition and their Minoan connection has been downplayed in favour of the Mycenaean Aegean, particularly at coastal Ashkelon (Master and Aja 2011). However, the symbolism of bovine horns in various contexts is widely distributed throughout island, coastal, and hinterland cultures of the Mediterranean and the east going back to Neolithic Anatolia, pointing to a broadly held set of beliefs (Hitchcock 2002). In terms of their movement from Crete to Cyprus, Briault (2007: esp. 254–256, 259–261) has convincingly argued that pottery motifs may have served as the mechanism of transmission for horns of consecration. Supporting her thesis is the well-known depiction of a horned altar and shrine with the depiction of a goddess inside as known from its depiction on an LH IIIA2 Mycenaean krater from Kalavassos-*Ayios-Dhimitrios* (Steel 1994; Fig. 3.3). Although Steel concluded that the krater was produced in Greece, the closest archaeological parallel to the representation of the shrine is from Paphos. This is not the only example of images of one culture becoming entangled with the ceramic style of another, as seen in the depictions of Sardinian style figures on Mycenaean style kraters found at Hala Sultan Tekke (Fischer 2021). Such representations indicate strong intra- as well as inter-island connections on Cyprus. Aegean and later Aegean style ceramics were popular on Cyprus, whose traders likely transhipped them to the Levant and to Sardinia based on their co-occurrence with Cypriot ceramics, particularly the intriguing opium poppy pod shaped base ring jugs (Merrilees 1979; Collard 2011) and Cypriot 'milk bowls'. Phoenician and Phoenician style flasks, many

containing cinnamon from Asia, were being traded throughout the region by the Early Iron Age (Gilboa and Namdar 2015; Fig. 3.4).

As the emphasis on trade increased on Cyprus, particularly in copper, there was also an increase in the production of symbolically entangled artefacts rendered in an international style. An exemplar is a conical rhyton (Aegean shape) from a tomb at Kition, made of faience (in Egyptian technique but found in the Aegean and in the Levant), with Aegean and Near Eastern motifs (spirals as well as a depiction of a Smiting god figure) (Peltenburg 1972). The new wealth was manifested in new monumental administrative centres of LC IIC, that is the 13th century, at Alassa-*Palaiotaverna*, Kalavassos-*Ayios Dhimitrios*, and Maroni-*Vournes*. Both Kalavassos (Fig. 3.5) and Maroni were located near the shore and could quite possibly have served as emporia or dependencies on Alassa as we know of the existence of governors on Cyprus from the Amarna letters. Numerous Aegean design features rendered in a local style can be found at each of these buildings including organisation around a central court, pillared storage halls, masons' marks, a connected annex, and shallow tripartite porch at Maroni (also Hitchcock 2008).

Alassa is situated in the Kouros River valley north of Limassol and controlled access to the copper rich Troodos mountains. In addition to their role in copper production and distribution, all these sites were also heavily involved in the acquisition and redistribution of olive oil. Closer to Kition and just to the west of modern Larnaca, Hala Sultan Tekke took the form of a wealthy and seemingly independent trading centre displaying great wealth, with evidence of interconnections with a wide range of Mediterranean societies, including Nuragic pottery from Sardinia (Crielaard 1998; Gradoli *et al.* 2020; Bürge 2021; Fischer 2021).

Among all these sites as well as some not mentioned there were conscious attempts to appropriate Aegean, particularly Minoan, symbolism as well as symbolism from the Levant. Among examples of Minoan symbols found at Hala Sultan Tekke we see masons' marks, a stone seat similar to the bottom part of the throne at Knossos, and a complex of rooms from a merchant's house depicting a Minoan-style lustral basin incorporating bull symbolism and a weight engraved with a ligature of

Figure 3.3. Late Mycenaean IIIA2 (ca. late 14th century BC) Amphoroid Chariot krater with representation of a shrine, from Ayios-Dhimitrios, *Cyprus (© Louise Steel 2024).*

Figure 3.4. Barrel-shaped jug from Cyprus, unknown findspot, ca. 750–600 BC (The Fitzwilliam Museum collections, © The Fitzwilliam Museum, Cambridge, Loan Ant.103.97, on long-term loan from Corpus Christi College).

Figure 3.5. View of Kalavassos-Ayios Dhimitrios, Building X, Pithos Hall of West Wing, detail of pillar, Late Cypriot IIC (13th century BC), Kouros River Valley, Cyprus (© Louise Hitchcock and the Department of Antiquities, Cyprus 2024).

two Minoan signs (Hitchcock 2008, 21, fig. 3; 2009), trapezoidal blocks to create blank ashlar facades (Hitchcock 2024), a preference for finely cut monolithic stone pillars (Hitchcock 1999), and so-called horns of consecration. However, the typical Cypriot construction technique was purely local with blocks leaving a rusticated central panel and manoeuvring bosses in place, a practice rarely attested in the Aegean.

As noted, the wealth on Cyprus drove the production of items in an 'international style' or *koine* (Feldman 2006a; 2006b) producing luxury items combining materials and symbolisms from neighbouring regions to produce objects sought after by the elite brotherhood of kings that characterised club 'East Med'. Without a doubt, Cyprus was the centre of club 'East Med', as it was a major importer of decorated Mycenaean pottery, showing a particular preference for chariot kraters which they also often traded with Cypriot base ring jugs, likely containing opium, and white shaved ware juglets. What is more, the famous Ingot God figurine from Enkomi is more characteristic of Sardinian *bronzetti*, than iconography found in

the Aegean. Such borrowings need not imply any kind of large- or small-scale migration between the islands but it could very easily imply the appropriation of particular symbols of elite and/or religious power to heighten the connections of elites cross-culturally. The violent aftermath which marked the decline of some, but not all, these centres (e.g., Iacovou 2008) was also characterised by short-lived settlements on the promontory at Maa-*Palaeokastro* and at the settlement made of closely built square houses at Pyla-*Kokkinokremos* in the east, both sites serving as havens for piracy associated with multi-cultural seafarers showing a strong Aegean influence.

Maa is striking for its sighting on a promontory and combination of unusual features. These include megaron like (rectangular) halls with hearths, a local square-within-a-square house plan made with re-used ashlar blocks, and tripartite storage buildings that may have served as the inspiration for this type of building as seen at many later Israelite sites such as Megiddo and Beersheba (e.g., Herzog 1992). There has been a desire on the part of some of the excavators to see Pyla as a Minoan settlement as many Minoan items have been found in heirloom contexts, however numerous objects from other regions have also been found. It is quite possible that Pyla was also a pirate settlement that the inhabitants expected to return to. It is also important to note that Cyprus continued to enjoy far flung trading relationships as far away as Sardinia, possibly to gain access to Cornish tin via Sardinia or via the Iberian Peninsula (Berger *et al.* 2019). As we proceed into the Iron Age, there is increasing evidence for both Greek and Phoenician influence or presence on Cyprus which has always stood at a crossroads between different cultures.

Collapse, worlds in disarray

What caused the collapse and ensuing population movements that characterised the Bronze to Iron Age transition as a world in disarray (e.g., Hass 2017) for some but not for others? To answer this, we turn to Self-Organized Criticality, a model in applied physics developed in the late 1980s by Per Bak (Bak *et al.* 1987; Bak and Chen 1991), to understand the interaction between equilibrium and catastrophe in self-organising systems.

Self-organising systems may be viewed as the nodes or city-states and ports that make up the globalised exchange network of the Bronze Age. The self-organising system of this network can metaphorically be visualised as a sand-pile which continues to grow as more sand is added. As the pile undergoes tiny avalanches at particular stages, catastrophe is prevented, just as small foreshocks relieve the geological stresses that eventually lead to a major earthquake. However, at an unpredictable moment the addition of sand might result in cascading avalanches. This is the critical state of collapse, which might be viewed as destructions, abandonments, population movements, environmental catastrophes, or some combination of these.

Thus, the arrival at the critical state is a useful way of understanding social and cultural collapse. When change flows smoothly throughout a network, large-

scale differences tend not to accumulate, so that small avalanches prevent the likelihood of catastrophe affecting a system. When the system reaches a critical state, avalanches occur at all scales and the system collapses. This state is analogous to Eric Cline's (2021; 2024; also Middleton 2018) suggestion that a perfect storm of catastrophic events (plague, earthquake, human destruction, and climate change) characterise 'collapse' in the form of the destruction of palatial centres in Greece and, to a lesser extent on Cyprus, that ended the Late Bronze Age. Accepting the model of Self-Organized Criticality requires us to accept all or multiple possible causes of social collapse as contributing factors, like the grains of sand, to the critical state of instability but with the event that causes the final avalanche remaining unclear. Thus, it is the system that has become unstable and can no longer cope with accelerating changes.

Instead of viewing the end of the Bronze Age as a catastrophe, we can view its end as timely: making way for more nimble and mobile populations and more resilient systems, known from the Iron Age. It is also possible to regard some of the urban palatial centres that provided their elites with previously unknown wealth, luxury, and status, but functioned as 'dystopias', sites of oppression for rural workers, slaves, and servants that laboured on behalf of the palatial elite (Hitchcock pers. comm.).

It is important to note that not all regions are affected in the same way, with Assyria, Egypt, and many sites in Cyprus avoiding collapse. What Sten LaBianca (2009) calls polycentrism and Eric Cline (2024) calls panarchy, we might today view as rural populism, which also leaves areas with tribal structures relatively untouched, with some poised to re-emerge. Such a complex view of 'collapse' and how different societies and regions were affected in different ways, also emphasises that, while earlier research assumed that there was a total cessation of trade coinciding with this collapse, in fact, trade did continue, even if at a much smaller volume to our eyes, and it was likely that it was perfectly acceptable in the eyes of people living at the time with knowledge of many of the technologies and institutions from the Bronze Age continuing to exist and develop (Maeir 2023).

While the transition between the Bronze and Iron Age can be regarded as a period marked by the collapse of previous administrative, social, and economic systems in the eastern Mediterranean, we recognise that a similar need exists to attend to the western Mediterranean civilisations, including Sardinia and neighbouring areas such as Sicily and the Eolian islands. Such an undertaking would likely require a very targeted collaborative approach (e.g., Hitchcock 2022) to gain a clearer grasp of what changes and interactions were taking place. Furthermore, it is important to observe that a new wealth and re-emergence of complexity with new, independently developed ceramic styles emerges throughout the Mediterranean in the 9th century BC. But that is another story...

Acknowledgements

We are grateful to Anastasia Christophilopoulou for inviting us to contribute to the *Being an Islander Project* of the Fitzwilliam Museum in Cambridge, and for the extraordinary patience she has shown with regard to the completion of this paper.

Bibliography

Angelini, I. (2012) Ambre protostoriche della Sardegna: indagini archeometriche. In *Atti della XLIV Riunione Scientifica dell'Istituto Italiano di Preistoria e Prostostoria* 3, 1152–1161. Florence: Istituto Italiano Preistoria e Protostoria.

Bagella, S. (2017) Tombe di giganti e altre sepolture nuragiche. In A. Moravetti, P. Melis, L. Foddai and E. Alba (eds), *La Sardegna Nuragica. Storia e monumenti*, 277–290. Sassari: Carlo Delfino Editore.

Bak, P. and Chen, K. (1991) Self-organized criticality. *Scientific American* 264(1), 46–53.

Bak, P., Tang, C. and Weisenfeld, K. (1987) Self-organized criticality: an explanation of $1/f$ noise. *Physical Review Letters* 71, 4083–4086.

Basch, L. and Artzy, M. (1985) Ship graffiti at Kition. In Karageorghis and Demas, 322–336.

Berger, D., Soles, J. S., Giumlia-Mair, A. R., Brügmann, G., Galili, E., Lockhoff, N. and Pernika, E. (2019) Isotope systematics and chemical composition of tin ingots from Mochlos (Crete) and other Late Bronze Age sites in the eastern Mediterranean Sea: An ultimate key to tin provenance? *PLoS ONE* 14(6): e0218326 https://doi.org/10.1371/journal.pone.0218326.

Bremmer, I. (2018) *Us vs. Them: The Failure of Globalism*. New York: Random House.

Briault, C. (2007) High fidelity or Chinese Whispers? Cult symbols and ritual transmission in the Bronze Age Aegean. *Journal of Mediterranean Archaeology* 20(2), 239–265.

Broodbank, C. (2000) *An Island Archaeology of the Early Cyclades*. Cambridge: Cambridge University Press.

Broodbank, C. and Strasser, T. F. (1991) Migrant farmers and the Neolithic colonization of Crete. *Antiquity* 65, 233–245.

Bürge, T. (2021) Mortuary landscapes revisited: dynamics of insularity and connectivity in mortuary ritual, feasting, and commemoration in Late Bronze Age Cyprus. *Religions* 12(10), 877 https://doi.org/10.3390/rel12100877.

Caloi, I. (2021) Identifying wheel-thrown vases in Middle Minoan Crete: analysis of experimental replicas of plain handeless conical cups from protopalatial Phaistos. *Natural Sciences in Archaeology* 12(1), 201–216.

Campus, F. and Leonelli, V. (2000) *La tipologia della ceramica nuragica: il materiale edito*. Viterbo: BetaGamma editore.

Campus, F. and Leonelli, V. (2012) *Simbolo di un simbolo. I modelli di nuraghe*. Monteriggioni: Ara edizioni.

Cline, E. H. (1999) Coals to Newcastle, wallbrackets to Tiryns: Irrationality, gift exchange, and distance value. In P. P. Betancourt, V. Karageorghis, R. Laffineur and W.-D. Niemeier (eds), *Meletemata. Studies in Aegean Archaeology Presented to Malcolm H. Wiener as He Enters his 65th Year*, 119–123. Liège and Austin: Aegaeum 20(1).

Cline, E. H. (2021) *1177 B.C. The Year Civilization Collapsed*. Princeton NJ: Princeton University Press.

Cline, E. H. (2024) *After 1177 B.C. The Survival of Civilizations*. Princeton NJ: Princeton University Press.

Colburn, C. S. (2008) Exotica and the Early Minoan elite: Eastern imports in pre-palatial Crete. *American Journal of Archaeology* 112, 203–224.

Coleman, J. E., Barlow, J. A., Mogelonsky, M. K. and Schaar, K. W. (1996) *Alambra: A Middle Bronze Age Settlement in Cyprus*. Jonsered: Studies in Mediterranean Archaeology 118.

Collard, D. (2011) Altered States of Consciousness and Ritual in Late Bronze Age Cyprus. Unpublished PhD thesis, University of Nottingham.

Crielaard, J. P. (1998) Surfing the Mediterranean web: Cypriot long-distance communications during the eleventh and tenth centuries B.C. In V. Karageorghis and N. Stampolidis (eds), *Eastern Mediterranean: Cyprus-Dodecanese-Crete 16th-6th Centuries B.C.*, 187–206. Athens, University of Crete and the A.G. Leventis Foundation.

Cutler, J. (2012) Ariadne's Thread: The adoption of Cretan weaving technology in the wider southern Aegean in the mid-second millennium BC. In M. L. Nosch and R. Laffineur (eds), *KOSMOS: Jewelry, Adornment and Textiles in the Aegean Bronze Age*, 145–154. Leuven: Aegaeum 33.

Cutler, J. (2016) Fashioning identity: weaving technology, dress and cultural change in the Middle and Late Bronze Age southern Aegean. In E. Gorogianni and P. Pavúk (eds), *Beyond Thalassocracies: Understanding the Processes of Minoanisation and Mycenaeanisation in the Aegean*, 172–185. Oxford: Oxbow Books.

D'Agata, A. L., Boileau, M. C. and De Angelis, S. (2012) Handmade burnished ware from the island of Crete: A view from the inside. *Rivista di Scienze Preistoriche* 62, 295–330.

Depalmas A. (2009a) Il Bronzo Medio della Sardegna. In *Atti della XLIV Riunione Scientifica dell'Istituto Italiano di Preistoria e Prostostoria (Cagliari, Barumini, Sassari 23-28 novembre 2009* 1, 124–130. Florence: Istituto Italiano Preistoria e Protostoria.

Depalmas A. (2009b) Il Bronzo Recente della Sardegna. In *Atti della XLIV Riunione Scientifica dell'Istituto Italiano di Preistoria e Prostostoria (Cagliari, Barumini, Sassari 23-28 novembre 2009)* 1, 132–140. Florence: Istituto Italiano Preistoria e Protostoria.

Depalmas, A. (2009c) Il Bronzo Finale. In *Atti della XLIV Riunione Scientifica dell'Istituto Italiano di Preistoria e Prostostoria (Cagliari, Barumini, Sassari 23-28 novembre 2009)* 1, 141–160. Florence: Istituto Italiano Preistoria e Protostoria.

Dewan, R. (2022) Disrupting the scale: miniature pottery in Minoan ritual. Unpublished paper presented at the 13th International Congress of Cretan Studies, 5–9 October 2022, Agios Nikolaos, Crete.

Dikaios, P. (1963) The context of the Enkomi Tablets. *Kadmos* 2(1), 39–52.

Dikaios, P. (1969) *Enkomi, Excavations 1948-58. Volume I: The Architectural Remains, The Tombs*. Mainz am Rhein: Philipp von Zabern.

Dikaios, P. (1971) *Enkomi, Excavations 1948-58. Volume II, IIIa-b: Chronology, Summary and Conclusions*. Mainz am Rhein: Philipp von Zabern.

Dothan, T. and Ben-Tor, A. (eds) (1983) *Athienou*. Jerusalem: Qedem 16.

Driessen, J. and Schoep, I. (1995) The architect and the scribe, political implications of architectural and administrative changes on MM II–LM IIIA Crete. In R. Laffineur and W.-D. Niemeier (eds), *POLITEA: Society and State in the Aegean Bronze Age*, 649–664. Leuven: Aegaeum 12.

Fappas, I. (2011) Exchange of ideas in the Eastern Mediterranean during the 14th and 13th centuries BC: The case of perfumed oil use and ideology. In K. Duistermaat and I. Regulski (eds), *Proceedings of the International Conference at the Netherlands-Flemish Institute in Cairo, 25th-29th October 2008*, 495–510. Leuven-Paris-Walpole MA: Orientalia Lovaniensia Analecta 202.

Feldman, M. H. (2006a) Assur Tomb 45 and the birth of the Assyrian Empire. *Bulletin of the American Society of Overseas Research* 343, 21–43.

Feldman, M. H. (2006b) *Diplomacy by Design. Luxury Arts and an 'International Style' in the Ancient Near East, 1400-1200 B.C.E.* Chicago: University of Chicago Press.

Fischer, P. M. (2021) Hala Sultan Tekke, Cyprus, and Sardinia: Intercultural connections in the Bronze Age. In M. Perra and F. Lo Schiavo (eds), *Contatti culturali e scambi commerciali della Sardegna nuragica: La rotta meridionale (Sardegna, Sicilia, Creta, Cipro)*, 77–91. Cagliari: Arkadia editore.

Fischer, P. M. and Bürge, T. (2017) Reflections on the outcomes of the workshop: problems and desiderata. In P. M. Fischer and T. Bürge (eds), *'Sea Peoples' Up-To-Date. New Research*

on *Transformations in the Eastern Mediterranean in the 13th-11th Centuries BCE*, 11–20. Vienna: Österreichische Akademie der Wissenschaften.

Frankel, D. and Webb, J. M. (1997) Excavations at Marki-*Alonia*, 1996–7, *Report of the Department of Antiquities, Cyprus* 1997, 85–109.

Frankel, D. and Webb, J. (1998) Three faces of identity: ethnicity, community, and status in the Cypriot Bronze Age. In G. Clarke and D. Harrison (eds), *Identities in the Eastern Mediterranean in Antiquity*, 1–12. *Mediterranean Archaeology* 11.

Friedrich, W. L., Kromer, B., Friedrich, M., Heinemeier, J., Pfeiffer, T. and Talamo, S. (2014) The olive branch chronology stands irrespective of tree-ring counting. *Antiquity* 88, 274–277.

Gaignerot-Driessen, F. (2011) The excavation of Building CD: The excavation of Zone 3. In J. Driessen (ed.), *Excavations at Sissi II: Preliminary Report on the 2009–2010 Campaigns*, 89–101. Louvain: Aegis 4.

Gaignerot-Driessen, F. (2012) The excavation of Zone 3. In J. Driessen (ed.), *Excavations at Sissi III: Preliminary Report on the 2011 Campaign*, 69–79. Louvain: Aegis 6.

Gaignerot-Driessen, F. and Letesson, Q. (2011) The excavation of Building CD: Introduction. In J. Driessen (ed.), *Excavations at Sissi II: Preliminary Report on the 2009–2010 Campaigns*, 83–88. Louvain: Aegis 4.

Giddens, A. (1984) *The Constitution of Society: Outline of the Theory of Structuration*. Cambridge: Polity Press.

Gilboa, A. and Namdar, D. (2015) On the beginnings of South Asian spice trade with the Mediterranean: A review. *Radiocarbon* 57(2), 265–283.

Gradoli, M. G., Waiman-Barak, P. Burge, T., Dunshet, Z. C., Sterba, J. H., Lo Schiavo, F., Perra, M., Sabatini, S. and Fischer P. M. (2020) Cyprus and Sardinia in the Late Bronze Age: Nuragic table ware at Hala Sultan Tekke. *Journal of Archaeological Science: Reports* 33, 1–15.

Haas, R. (2017) *A World in Disarray: American Foreign Policy and the Crisis of the Old Order*. New York: Penguin Books.

Hallager, E. and Hallager, B. P. (2000) *The Greek-Swedish Excavations at the Agia Aikaterini Square Kastelli, Khania 1970-1987: Vol. II – The Late Minoan IIIC Settlement*. Stockholm: Paul Åströms.

Hallager, E. and Hallager, B. P. (2003) *The Greek-Swedish Excavations at the Agia Aikaterini Square Kastelli, Khania 1970-1987 and 2001: Vol. III.1-2 – The Late Minoan IIIB2 Settlement*. Stockholm: Paul Åströms.

Hayden, B. J. (1987) Crete in transition, LH IIIA–B architecture. *Studi Micenei ed Egeo-Anatolici* 26, 199–234.

Herzog, Z. (1992) Administrative structures in the Iron Age. In A. Kempinski and R. Reich (eds), *The Architecture of Ancient Israel: From Prehistoric to the Persian Periods*, 223–230. Jerusalem: Israel Exploration Society.

Hitchcock, L. A. (1997) Engendering domination: A structural and contextual analysis of Minoan neopalatial Bronze figurines. In E. Scott and J. Moore (eds), *Invisible People and Processes: Writing Gender and Childhood into European Archaeology*, 113–130. Leicester: Leicester University Press.

Hitchcock, L. A. (1999) Cult(ural) continuity and regional diversity: The encoding of Aegean form and function in Late Bronze Age Cypriote architecture. *Journal of Prehistoric Religion* 13, 11–21.

Hitchcock, L. A. (2000) *Minoan Architecture: A Contextual Analysis*. Jonsered: Studies in Mediterranean Archaeology Pocket Book 155.

Hitchcock, L. A. (2002) Levantine horned altars: An Aegean perspective on the transformation of socio-religious reproduction. In P. M. McNutt and D. M. Gunn (eds), *'Imagining' Biblical Worlds: Spatial, Social, and Historical Constructs: Essays in Honor of James W. Flanagan*, 223–239. Sheffield: Sheffield Academic Press.

Hitchcock, L. A. (2005) 'Who will personally invite a foreigner, unless he is a craftsman?': Exploring interconnections in Aegean and Levantine architecture. In R. Laffineur and E. Greco (eds), *EMPORIA: Aegeans in the Central and Eastern Mediterranean*, 691–699. Liège: Aegaeum 25.

Hitchcock, L. A. (2008) 'Do you see a man skilful in his work? He will stand before kings': Interpreting architectural influences in the Bronze Age Mediterranean. *Ancient West and East* 7, 17–48.

Hitchcock, L. A. (2009) Building identities: Fluid borders and an 'international style' of monumental architecture in the Bronze Age. In J. Anderson (ed.), *Crossing Cultures: Conflict, Migration and Convergence*, 165–171. Melbourne: Miegunyah Press.

Hitchcock, L. A. (2011) Fluid and flexible: Revisiting the vernacular tradition in Bronze Age Crete and Cyprus. In K. Glowacki and N. Vogeikoff-Brogan (eds), *STEGA: The Archaeology of Houses and Households in Ancient Crete from the Neolithic Period through the Roman Era. Hesperia* Supplement 44, 233–245.

Hitchcock, L. A. (2020) The Deep State in the Ancient World: Bureaucracies as Constraining and Enabling Socio-Political Structures, Poster presented at the American Schools of Oriental Research Virtual Annual Meeting, 12–15 and 19–22 November 2020, USA and Worldwide.

Hitchcock, L. A. (2022) 'There really are 50 Eskimo words for snow': 1177, big data, and the perfect storm of collapse. *Journal of Eastern Mediterranean Archaeology and Heritage Studies* 10(2), 200–203.

Hitchcock, L. A. (2023) Minoans and Mycenaeans in Anatolia – Millawanda. *Ancient History Magazine* 44, 24–27.

Hitchcock, L. A., Chapin, A. P. and Reynolds, J. (2020) The maritime and riverine networks of the Eurotas River Valley in Lakonia. *Journal of Eastern Mediterranean Archaeology and Heritage Studies* 8(3–4), 327–343.

Hitchcock, L. A. and Maeir, A. M. (2017) Lost in translation: Settlement organization in postpalatial Crete, a view from the east. In Q. Letesson and C. Knappett (eds), *Minoan Architecture and Urbanism: New Perspectives on an Ancient Built Environment*, 289–333. Oxford: Oxford University Press.

Hodder, I. (1987) The contribution of the long term. In I. Hodder (ed.), *Archaeology as Long Term History*, 1–8. Cambridge: Cambridge University Press.

Iacovou, M. (2008) Cultural and political configurations in Iron Age Cyprus: The sequel to a protohistoric episode. *American Journal of Archaeology* 112, 625–658.

Judis, J. B. (2016) *The Populist Explosion: How the Great Recession Transformed American and European Politics*. New York: Columbia Global Reports.

Kanta, A. and Kontopodi, D. Z. (2011) Kastrokephala (Crete): Strangers or locals in a fortified acropolis of the 12th century BC. In V. Karageorghis and O. Kouka (eds), *On Cooking Pots, Drinking Cups, Loom Weights and Ethnicity in Bronze Age Cyprus and Neighboring Regions*, 129–148. Nicosia: A. G. Leventis Foundation.

Karageorghis, V. and Demas, M. (1985) *Excavations at Kition V. The Pre-Phoenician Levels. Areas I and II, Part I*. Nicosia: Department of Antiquities of Cyprus.

Karnava, A. (2014) Cretan hieroglyphic script. In G. K. Giannakis (ed.), *Encyclopedia of Ancient Greek Language and Linguistics. 1: A–F*, 398–400. Leiden-Boston: Brill.

Knapp, A. B. (1986) *Copper Production and Divine Protection: Archaeology, Ideology, and Social Complexity on Bronze Age Cyprus*. Gothenburg: Studies in Mediterranean Archaeology and Literature Pocketbook 42.

Knapp, A. B. (1990) Ethnicity, entrepreneurship, and exchange: Mediterranean inter-island relations in the Late Bronze Age. *Annual of the British School at Athens* 85, 115–153.

Knapp, A. B. (2007) Insularity and island identity in the prehistoric Mediterranean. In S. Antoniadou and A. Pace (eds), *Mediterranean Crossroads*, 37–62. Athens: Pierides Foundation.

Knapp, A. B., Russell, A. and Van Dommelen, P. (2022) Cyprus, Sardinia and Sicily: A maritime perspective on interaction, connectivity and imagination in Mediterranean prehistory. *Cambridge Archaeological Journal* 32(1), 79–97.

Kostopoulou, I. and Jung, R. (2023) Observations on the pottery of 2014–2019 campaigns. In J. Bretschneider, A. Kanta and J. Driessen (eds), *Excavations at Pyla-Kokkinokremos. Reports on the 2014–2019 Campaigns*, 249–312. Louvain-la-Neuve: Presses Universitaires Louvains.

LaBianca, O. (2009) The poly-centric nature of social order in the Middle East: Preliminary reflections from anthropological archaeology. In P. Bienkowski (ed.), *Studies on Iron Age Moab and Neighbouring Areas in Honour of Michèle Daviau*, 1–5. Leuven: Ancient Near Eastern Studies Supplement Series 29.

Levi, S. T., Sonnino, M. and Jones, R. E. (2006) Eppur si muove...Problematiche e risultati delle indagini sulla circolazione della ceramica dell'età del bronzo in Italia. In *Atti della XXXIX Riunione Scientifica. Materie prime e scambi nella Preistoria Italiana, Firenze, 25-27 novembre 2004* 2, 1093–1110. Florence: Istituto Italiano Preistoria e Protostoria.

Lo Schiavo, F. and Usai, L. (1995) Testimonianze cultuali di età nuragica: La grotta Pirosu in località Su Benatzu di Santadi. In V. Santoni (ed.), *Carbonia e il Sulcis. Archeologia e Territorio*, 147–186. Oristano: Editrice S'Alvure.

Lugliè, C. (2005) Analisi archeometriche preliminari su elementi ceramici del Bronzo Recente dal Campidano meridionale. In *La civiltà nuragica: nuove acquisizioni (Atti del congresso, Senorbì, 14-16 dicembre 2000)* 1, 155–166.

Lugliè, C. and Lo Schiavo, F. (2009) Risorse e tecnologia: le rocce e i metalli. In *Atti della XLIV Riunione Scientifica dell'Istituto Italiano di Preistoria e Prostostoria (Cagliari, Barumini, Sassari 23-28 novembre 2009)* 1, 247–267. Florence: Istituto Italiano Preistoria e Protostoria.

Mações, B. (2020) *Belt and Road: A Chinese World Order*. London: Hurst and Co.

Maeir, A. M. (2020) Memories, Myths and Megalithics: Reconsidering the Giants of Gath. *Journal of Biblical Literature* 139(4), 675–690.

Maeir, A. M. (2023) Did trade stop in the early Iron Age? The evidence from Philistia and beyond. *Diacritica* 37(2), 82–90.

Master, D. and Aja, A. J. (2011) the house shrine of Ashkelon. *Israel Exploration Journal* 61(2), 129–145.

Matta, V. and Vandkilde, H. (2023) The State of the Debate: Nuragic Metal Trade in the Bronze Age and Early Iron Age. *Open Archaeology* 9(1), Article 20220280. https://doi.org/10.1515/opar-2022-0280

Melis, M. G. (2009) L'Eneolitico antico, medio ed evoluto in Sardegna: dalla fine dell'Ozieri all'Albeazu. In *Atti della XLIV Riunione Scientifica dell'Istituto Italiano di Preistoria e Prostostoria (Cagliari, Barumini, Sassari 23-28 novembre 2009)* 1, 81–95. Florence: Istituto Italiano Preistoria e Protostoria.

Merrillees, R. S. (1979) Opium again in antiquity. *Levant* 11, 167–171.

Middleton, G. D. (2018) *Understanding Collapse: Ancient History and Modern Myths*. Cambridge: Cambridge University Press.

Minoja, M. (2015) I Nuragici e gli Etruschi. In M. Minoja, G. Salis and A. Usai (eds), *L'isola delle torri*, 161–166. Sassari: Delfino.

Minoja, M. and Usai, A. (2020) Le sculture nuragiche di Mont'e Prama nel quadro dei rapporti mediterranei della Sardegna dell'età del Ferro. In *Rivista di Scienze Preistoriche. Italia tra Mediterraneo ed Europa: mobilità, interazioni e scambi* 70 (special issue), 401–410.

Monroe, C. M. (2009) *Scales of Fate: Trade, Tradition, and Transformation in the Eastern Mediterranean ca. 1350-1175 BCE*. Münster: Alter Orient und Altes Testament 357.

Moran, W. L. (ed. and trans) (1992) *The Amarna Letters*. Baltimore ML: Johns Hopkins University Press.

Moravetti, A. (2009) La cultura di Monte Claro e il Vaso Campaniforme. In *Atti della XLIV Riunione Scientifica dell'Istituto Italiano di Preistoria e Prostostoria (Cagliari, Barumini, Sassari 23-28 novembre 2009)* 1, 97–109. Florence: Istituto Italiano Preistoria e Protostoria.

Negbi, O. (1988) Levantine elements in sacred architecture of the Aegean at the close of the Bronze Age. *Annual of the British School at Athens* 83, 330–357.

Niemeier, W. D. (1998) The Minoans in the south eastern Aegean and in Cyprus. In V. Karageorghis and N. C. Stampolidis (eds), *Eastern Mediterranean: Cyprus-Dodecanese-Crete, 16th-6th Centuries BC*, 29–47. Rethymnon: University of Crete.

Nowicki, K. (2001) Sea raiders and refugees: problems of defensible sites in Crete In V. Karageorghis and C. Morris (eds), *Defensive Settlements of the Aegean and the Eastern Mediterranean after* c. *1200 B.C*, 23–40. Nicosia: A. G. Leventis Foundation.

Olsen, B. A. (2014) *Women in Mycenaean Greece: The Linear B Tablets from Pylos and Knossos*. London-New York: Routledge.

Patton, M. (1996) *Islands in Time: Islands Sociogeography and Mediterranean Prehistory*. London: Routledge.

Peche-Quilichini, K. and Cesari, J. (2017) Les architectures turriformes de l'âge du Bronze en Corse. Structure, chronologie, distribution. In A. Moravetti, P. Melis, L. Foddai and E. Alba (eds), *La Sardegna Nuragica. Storia e monumenti*, 171–190. Sassari: Delfino.

Peltenburg, E. J. (1972) On the classification of faience vases from Late Bronze Age Cyprus. In *Proceedings of the First International Cyprological Congress, Nicosia 14-19 April, 1969. Part 1. Antiquity*, 129–136. Nicosia: Etaireia Kypriakon Spoudon.

Peltenburg, E. (ed.) (1989) *Early Society in Cyprus*. Edinburgh: Edinburgh University Press.

Pratt, C. E. (2016) The rise and fall of the transport stirrup jar in the Late Bronze Age Aegean. *American Journal of Archaeology* 120(1), 27–66.

Prent, M. (2003) Glories of the past in the past: ritual activities at palatial ruins in Early Iron Age Crete. In R. M. van Dyke and S. E. Alcock (eds) *Archaeologies of Memory*, 81–103. Oxford: Wiley.

Prent, M. (2004) Cult activities at the Palace of Knossos from the end of the Bronze Age: Continuity and change. In G. Cadogan, E. Hatzaki and A. Vasilakis (eds), *Knossos: Palace, City, State*, 411–419. London: British School at Athens Studies 12.

Preziosi, D. and Hitchcock, L. A. (1999) *Aegean Art and Architecture*. Oxford: Oxford University Press.

Ramis, D. (2017) La arquitectura monumental en los inicios de la cultura talaiótica. In A. Moravetti, P. Melis, L. Foddai and E. Alba (eds), *La Sardegna Nuragica. Storia e monumenti*, 191–210. Sassari: Delfino.

Russell, A. (2011) In the Middle of Corrupting Sea: Cultural Encounters in Sicily and Sardinia between 1450–900 BC. Unpublished PhD thesis, University of Glasgow.

Sabatini, S. and Lo Schiavo, F. (2020) Late Bronze Age metal exploitation and trade: Sardinia and Cyprus. Materials and manufacturing processes. *Materials and Manufacturing Processes* 35(13), 1501–1518.

Schaar, K.W. (1985) House form at Tarsus, Alambra, and Lemba, *Review of the Cyprus Department of Antiquities* 1985, 37–44.

Shaw, J. W. (1984) Excavations at Kommos (Crete) during 1982–1983. *Hesperia* 53(2), 251–287.

Shelmerdine, C. W. (1985) *The Perfume Industry of Mycenaean Pylos*. Gothenburg: Studies in Mediterranean Archaeology Pocket Book 155.

Skogstrand, L. (2017) The role of violence in the construction of prehistoric masculinities. In U. Matić and B. Benson (eds), *Gender and Violence in Archaeology*, 77–102. Oxford: Oxbow Books.

Soles, J. S. (1992) *The Prepalatial Cemeteries at Mochlos and Gournia and the House Tombs of Bronze Age Crete. Hesperia* Supplement 24.

Steel, L. (1994) Representations of a shrine on a Mycenaean chariot krater from Kalavasos-Ayios Dhimitrios, Cyprus. *Annual of the British School at Athens* 89, 201–210.

Stiglitz, A. (2005) Il riutilizzo votivo delle strutture megalitiche nuragiche di età tardo punica e romana. In A. Comella and S. Mele (eds), *Depositi Votivi e Culti dell'Italia Antica dall'età Arcaica a quella Tardo Repubblicana*, 725–737. Bari: EdiPuglia.

Swiny, S. (1986) The Philia Culture and its foreign relations. In V. Karageorghis (ed.), *ACTS of the International Archaeological Symposium 'Cyprus Between the Orient and Occident'. Nicosia 8th-14th September 1985*, 29–44. Nicosia: Department of Antiquities of Cyprus.

Tapinos, L. (2022) Minoan Heterotopia Abroad: A Contextual Interpretation of the Meaning and Function of Aegean-style Wall-paintings in the Levant. Unpublished honours thesis, University of Melbourne.

Tronchetti, C. and Van Dommelen, P. (2005) Entangled objects and hybrid practices. colonial contacts and elite connections at Monte Prama, Sardinia. *Journal of Mediterranean Archaeology* 18(2), 183–209.

Tsipopoulou, M. (2012) The pre-palatial – early protopalatial cemetery at Petras, Siteia: A diachronic symbol of social coherence. In M. Tsipopoulou (ed.), *Petras, Siteia: 25 Years of Excavations and Studies*, 117–131. Aarhus: Monographs of the Danish School at Athens 21.

Tykot, R. H. (1992) The sources and distribution of Sardinian obsidian. In R. H. Tykot and T. K. Andrews (eds), *Sardinia in the Mediterranean. A Footprint in the Sea. Studies in Sardinian Archaeology Presented to Miriam S. Balmuth*, 57–70. Sheffield: Monographs in Mediterranean Archaeology 3.

Tyree, L., Barnett, C. and Hitchcock, L. A. (2020) *E-Qe-Ta*: Conceptions of warrior beauty and constructions of masculinity on postpalatial Crete. In B. E. Davis and R. Laffineur (eds), *NEWTOROS: Studies in Bronze Age Aegean Art and Archaeology in Honor of Professor John G. Younger on the Occasion of His Retirement*, 91–112. Leuven: Aegaeum 44.

Ugas, G. (2017) La Sardegna Nuragica. Aspetti generali. In A. Moravetti, P. Melis, P. L. Foddai and E. Alba (eds), *La Sardegna Nuragica. Storia e materiali*, 11–34. Sassari: Carlo Delfino Editore.

Van Dommelen, P., Ramis, D., Roppa, A. and Stiglitz, A. (2020) Progetto S'Urachi: Incontri culturali intorno ad un nuraghe di età fenicio-punica. In S. C. Pérez and E. Rodríguez González (eds), *Un viaje entre el Oriente y el Occidente del Mediterraneo/A Journey between East and West in the Mediterranean* 5, 1627–1636. Mérida: Mytra.

Vandkilde, H. (2016) Bronzization: The Bronze Age as pre-modern globalization. *Praehistorische Zeitschrift* 91(1), 103–123.

Vermeule, E. (1974) *Toumba tou Skourou: The Mound of Darkness*. Boston MA: Harvard University, Museum of Fine Arts, Cyprus Expedition.

Watrous, L. V., Day, P. M. and Jones, R. E. (1998) The Sardinian pottery from the Late Bronze Age site of Kommos in Crete: Description, chemical and petrographic analyses, and historical context. In M. S. Balmouth and R. H. Tykot (eds), *Sardinian and Aegean Chronology. Towards the Resolution of Relative and Absolute Dating in the Mediterranean*, 337–340. Oxford: Studies in Sardinian Archaeology 5.

Webb, J. M. (1999) *Ritual Architecture, Iconography and Practice in the Late Cypriot Bronze Age*. Jonsered: Studies in Mediterranean Archaeology Pocket Book 126.

Yahalom-Mack, N., Finn, D. M., Erel, Y., Tirosh, O., Galili, E. and Yasur-Landau, A. (2022) Incised Late Bronze Age lead ingots from the southern anchorage of Caesarea. *Journal of Archaeological Science: Reports* 41, 1–29 https://doi.org/10.1016/j.jasrep.2021.103321.

Chapter 4

Contextualising Cypriot writing overseas: Cypro-Minoan and Cypro-Syllabic inscriptions found in Greece

Giorgos Bourogiannis

Ancient Cyprus was an island where multiple scripts and languages were used within the framework of complex yet fruitful cultural interaction. This paper aims to consider the context, content, chronological range, and geographic distribution of inscriptions from Greek contexts, written in the two most distinctively Cypriot writing systems of the Late Bronze and Iron Ages, namely the Cypro-Minoan script and the Cypriot Syllabary. The attestation of these scripts in Greece is important given that both of them have been viewed as reliable markers/products of a distinctively Cypriot culture, even more so when they occur outside the island. The ultimate goal is to produce an overview of the Cypro-Minoan and Cypro-Syllabic inscriptions from Greek contexts and, through them, to further our understanding of how Cypriot scripts contributed to the diverse writing systems employed in the Aegean in the late 2nd and 1st millennium BC. Given that Cypriot syllabic scripts are highly distinctive but also largely epichoric, their occurrence in Greek contexts, albeit limited, is worthy of special attention and offers a reliable tool for the investigation of writing phenomena in ancient Greece.

Introduction

Cyprus was home to a multilingual population, archaeologically and epigraphically attested through the employment of different writing systems corresponding to different languages. This distinctively Cypriot plurality of scripts and languages, used within the fairly limited area of the island, has fuelled scholarly enthusiasm for the linguistic, epigraphic, and cultural identity of ancient Cyprus, an island that Olivier (1998a, 427) aptly described as a 'true laboratory of scripts' (*un véritable laboratoire d'écritures*). The study of the history of writing in ancient Cyprus and, by extension, of the Cypriot syllabic inscriptions found overseas, is severely hampered by the fact that not all versions of these scripts have been deciphered and not all languages

written in them have been identified. This shortcoming is even greater in the case of Cypro-Minoan inscriptions, written in one or more writing systems that remain mostly undeciphered. There are fewer linguistic limitations with the Cypriot Syllabary of the Iron Age, which is deciphered in the case of texts written in Greek language. However, we are not in the position to read and understand every text written in the Cypriot Syllabary, not only because many of these inscriptions are too short or damaged but, primarily, because a considerable number of them are written in one or more unknown languages.

In spite of these shortcomings, the linguistic and epigraphic history of Cyprus attests to language and writing as two separate institutions. One language can be written in different scripts, as in the case with Greek on Cyprus, written initially in the Cypriot Syllabary and, from the 5th–4th centuries BC, in the Greek alphabet. Moreover, one script can be used to write more than one language, as was the case of the Cypriot Syllabary, used for recording the Greek language in its Cypriot dialectal form, as well as at least one further unknown language, conventionally called 'Eteocypriot'. It seems, therefore, that our study and understanding of ancient Cyprus and its cultural identity(-ies) necessarily involves study and understanding of the island's multiple languages and writing systems. This has been reflected in the considerable revival of interest in Cypriot scripts and writing systems in the last decade or so (e.g. Egetmeyer 2010; Ferrara 2012; Steele 2013; 2019; Valério 2016).

Let me now proceed to the presentation and brief discussion of the extant epigraphic evidence from Greece (Fig. 4.1). Given that Greece is one of the areas where distinctively Cypriot writing systems are attested, the examination of these inscriptions contributes to the study of the history of writing and scripts both in Greece and in Cyprus.

Cypro-Minoan inscriptions found in Greece: the special case of Tiryns

Cypro-Minoan is a modern term that refers to a heterogeneous group of undeciphered syllabic inscriptions, dated roughly between the middle of the 16th and the 11th centuries BC. The term was coined by Arthur Evans (Evans 1909), based on visual affinities between Late Bronze Age Cypriot writing and the Aegean linear scripts, in particular Linear A of Minoan Crete. Two comprehensive, albeit still growing, collections of Cypro-Minoan inscriptions were published in 2007 (Olivier 2007) and 2013 (Ferrara 2013). In its present state and following recent additions, the corpus comprises almost 3000 signs spread between slightly more than 250 inscriptions (Valério 2014). These are dated over a very long period and their precise chronological assessment is often dubious, although the majority of datable inscriptions belong to the period Late Cypriot (LC) IIC–IIIA, around the 13th to mid-12th century BC (Steele 2013, 15–19). Notably, even the number of different signs used by the Cypro-Minoan scripts, usually oscillating between 84 and 125, is not yet securely defined (Hirschfeld

Figure 4.1. Map showing the Greek sites that produced Cypro-Minoan and Cypro-Syllabic inscriptions (© Giorgos Bourogiannis 2023).

2010, 375; Valério 2016, 73–80). In addition to the small number of inscriptions, the division of the Cypro-Minoan into three 'subscripts' supposedly created and used for different languages, the lack of consistency of subject matter of inscriptions, and the rare employment of ideograms that have assisted the decipherment of other linear syllabic scripts such as the Linear B, further hamper Cypro-Minoan decipherment (Steele 2013, 13). The geographic distribution of Cypro-Minoan inscriptions is fairly limited and includes Cyprus – with Enkomi being the most prolific source (Ferrara 2013, 21, fig. 1.1), Ugarit-*Ras Shamra*, and Tiryns (Valério 2016; Steele 2019, 201–207). Based on the extant evidence, therefore, Tiryns provides the westernmost attestation of this highly idiosyncratic script of Late Bronze Age Cyprus and the only secure source of Cypro-Minoan texts in Greece.

The clay ball
Tiryns has produced three Cypro-Minoan inscriptions (Donnelly 2022), not including several Cypro-Minoan potmarks – a Cypriot marking system partially based on Cypro-Minoan signs – on local Mycenaean pottery from Tiryns, which were a by-product of the dissemination of the Cypriot script in the Argolid (Hirschfeld 1999, 55–61). In

Figure 4.2. Inscribed clay ball from Tiryns (after Vetters 2011, 15, fig. 3; © Melissa Vetters 2011).

fact, Tiryns has produced the largest number of vases with post-firing Cypro-Minoan signs in Mycenaean Greece. So striking is the prominence of such vases that Tiryns may have functioned as the preferred port-of-call for Cypriots coming to mainland Greece. However, these Cypro-Minoan potmarks are associated with trade connections between the two areas rather than with Cypriot epigraphic practice abroad (Steele 2019, 202).

I start from one of the most distinctively Cypriot inscription types of the Late Bronze Age Cyprus, the clay balls (Steele 2019, 110–119; Fig. 4.2). These were spherical items, typically about 1.8–2.0 cm in diameter, with an inscription running around them. They range chronologically from the 14th to the 11th century BC, with the majority dating to the LC IIIA or IIIB period, approximately between 1200 and 1050 BC. Enkomi is the predominant source of these inscribed items, with over 80 examples. The clay balls from Enkomi were found primarily in the sanctuary of the Ingot God and in the Fortress Building, often in rooms associated with metallurgy (Donnelly 2022, 202). Even though the use of the clay balls remains uncertain, these may record names of the Cypriot individuals who carried them, presenting identity cards of some sort (Steele 2019, 114–115).

Given that inscribed clay balls are almost exclusive to Cyprus – there are a couple of similar objects from Ugarit but they are inscribed in cuneiform (Vetters 2011, 14, fig. 2) – the presence of a clay ball bearing a Cypro-Minoan inscription at Tiryns

4. Contextualising Cypriot writing overseas

is particularly noteworthy. Published by Vetters (2011) and included in Ferrara's corpus as an addendum (Ferrara 2013, 304, #ADD 244 TIRY Abou 001), the ball, with a diameter of 1.70–1.75 cm, was excavated in the post-palatial levels at the northern tip of Tiryns' Lower Citadel, close to the North Gate, in the levelled remains of the destroyed Building XI, square LXII 36/39, and in what was identified as a workshop of small-scale metallurgical activity (Vetters 2011, 20–22). The context of the ball was dated to the Late Helladic (LH) IIIC Developed, ca. 1170/1160–1150/1140 BC. The findspot of the inscribed ball, in a building associated with metallurgy, and its chronology in the early–middle 12th century are noteworthy, both recalling the Enkomi balls found in the Fortress Building.

The clay ball from Tiryns bears a pre-firing inscription consisting of three signs (right to left), 41–41–97, that may correspond to the sounds/values *pu-pu-ro* (Valério 2016, 654, 656). The clay ball is securely linked to the epigraphic and linguistic world of Cyprus, since the same sign-sequence is attested at least twice among the Late Bronze Age Cypro-Minoan corpus of the island: in lines 10–11 of an LC IIA–IIB inscribed clay cylinder from Enkomi (Ferrara 2013, 52, ##97), the text of which may represent a list (Ferrara 2012, 121); and on the rim of a large LC IIIC pithos from the west acropolis of Idalion-*Ambelleri* (Ferrara 2013, 64, ##123) that was unfortunately found mixed in the debris of a Hellenistic wall. Olivier (2007, 190) had read the third sign in the sequence of the pithos fragment as sign 68, though he admitted that 97 also was a possible reading. Noticeably, the fabric of the inscribed clay ball is most probably local (Vetters 2011, 18) and is similar to that of four uninscribed clay balls found at the Lower Citadel of Tiryns (Vetters 2011, 19, fig. 4). None of these locally made plain balls, however, derived from a clear Mycenaean stratum.

There are several reasons why the inscribed ball from Tiryns is important. It belongs to a distinctively Cypriot inscription type and it is the only one of its kind to have been found away from Cyprus, since the two similar items from Ugarit are inscribed in cuneiform. Its date and the context related to metallurgical activities are reminiscent of clay balls from Enkomi, whereas its sign sequence is repeated in the Cypro-Minoan record of Cyprus, confirming that whoever inscribed the ball had close connections with Cyprus. This Cypriot connection is even more important given that the ball was most probably manufactured and inscribed at Tiryns, after the Mycenaean palaces were destroyed and the Linear B administrative writing associated with them was lost, when literacy seems to have recently disappeared in Greece. The attestation of a Cypriot script within an increasingly illiterate Aegean therefore presents an exceptional epigraphic incident. The presence of the inscribed ball – alongside the uninscribed examples – raises the possibility of Cypriots living at Tiryns and practising their home-grown epigraphic traditions and writing habits there, at a time when Greek society had entered a long illiterate phase of its history. Within this framework, the inscribed clay ball from Tiryns presents a sound written mark of Cypriot identity.

The jug handle

The second addition to the Corpus of Cypro-Minoan inscriptions, also produced at Tiryns, was published in 2014 (Davis *et al.* 2014). Its designation, according to Olivier's 2007 classification system, is TIRY Avas 002, while its inventory number within Ferrara's 2012 Cypro-Minoan corpus is ADD #246. The inscription, a post-firing graffito, marks the upper face of the handle of a local jar, dated to the LH IIIB Final by context, which is equivalent to an absolute date between 1230 and 1210 BC (Davis *et al.* 2014, 103). The vessel was deposited at the time of the construction of the aforementioned Building XI that occupied the area near the North Gate of the Lower Citadel and served as a palatial workshop for skilled crafting.

The Cypro-Minoan inscription consists of three signs written vertically from top to bottom. They are followed by a stictogram, that is by a sign with no apparent phonetic or numeric purpose, in the form of an exclamation mark that functions as a word divider. The reading therefore is 87–50–05–! This sign sequence is not attested elsewhere in the Cypro-Minoan corpus (Davis *et al.* 2014, 96). Given that the signs of the inscription were added at Tiryns, their hitherto unique sequence is noteworthy.

Even though the reading of the sign sequence is secure, it has been postulated that sign 50 may actually represent a variant of Cypro-Minoan signs 51 and of 53–55 (Valério 2016, 126, 561; Donnelly 2022, 199), in which case the sequence of the first two signs of the inscription on the handle from Tiryns would be repeated also on a Late Cypriot IIA–IIC seal from Hala Sultan Tekke reading –87–53 (Ferrara 2013, 102–103, #201 HALA Psce 001) and on a Late Cypriot IIIA clay tablet from Enkomi (Ferrara 2013, 107–108, #208, ENKO Atab 003.A.12 that reads 87–51–09–82. However, there is no conclusive evidence that the aforementioned signs are variants of one another (Donnelly 2022, 199–200 n. 17). Regardless of the unique attestation of the sign sequence on the inscribed handle from Tiryns, this item matches the features of inscribed vessel handles from Cyprus in its vessel type, inscription method, and formatting, confirming the it is a product of the Cypro-Minoan script culture (Donnelly 2022, 200) and thus indicating that Cypriots at Tiryns were signalling their cultural affiliation by using their distinctive script while living and working away from home.

The inscribed handle is part of an exceptional series of objects of Cypriot and Levantine affiliation, found in and around the plot where Building XI stood, including faience rhyta in the shape of the head of a monkey or of the Near Eastern demon Humbaba, Cypriot type wall brackets, a 'Levanto-Mycenaean' chalice (Davis *et al.* 2014, 103–104), and, most importantly, an ivory rod inscribed in Ugaritic cuneiform (Cohen *et al.* 2010). Written from left to right, the latter combines Akkadian logographic numerical signs and at least one letter of the regular Ugaritic alphabet. Probably functioning as a measuring device or tally stick, it presents an exceptional case of Ugaritic text found outside of the Levant. When viewed in association, these items suggest that their users were acquainted with their special symbolic meaning and that they were employed in accordance with practices of Near Eastern or Cypriot origin (Cohen *et al.* 2010, 17). Moreover, the co-existence of the Cypro-Minoan inscribed handle and the Ugaritic text

4. Contextualising Cypriot writing overseas 57

from a LH IIIB Final context indicates that Tiryns was a setting where several languages and writing systems were used by specialists originating in the eastern Mediterranean and who were working on behalf of the palace.

The Canaanite amphora

The third Cypro-Minoan inscription from Tiryns is a post-firing graffito cut on the handle of a Canaanite amphora (Kilian 1988, 108; Maran 2008, 56, fig. 35). Its designation according to Olivier's 2007 classification system is TIRY Avas 001, while its inventory number within Ferrara's Cypro-Minoan corpus is ADD #245. The inscription was recently published by Davis *et al.* (2023), with a detailed note on the contextualization, morphology and fabric description of the imported vessel. The inscribed fragment was found in a destruction deposit, in the passageway leading to the North Gate of the Lower Citadel. Its context is dated to the very end of Late Helladic IIIB Final, c. 1200 BC (Davis *et al.* 2014, 103; 2023, 5). The inscription consists of two signs, 25-87. Although the sequence is otherwise unattested in the Cypro-Minoan corpus (Olivier 1988b, 255–256, no. 13 and 266–267), both signs have their closest parallels on Cyprus. Their positioning and the orientation of their tops indicate that the inscription is to be read from top to bottom on the handle, and from left to right in its normalized transcription (Davis *et al.* 2023, 18). Given that, unlike the other two inscribed items from Tiryns, the inscription is cut on an imported vessel originating in the coastal region from Southern Syria to Haifa, it could have been added almost anywhere and at any point after the vessel's firing (Donnelly 2022, 199), with Cyprus being the most likely candidate. Noticeably, the second handle of the jar is marked by a post-firing Cypro-Minoan potmark, sign 5, which is not related to the inscription (Davis *et al.* 2023).

Cypro-Minoan inscriptions from Greece: some thoughts

Previous discussion has shown the importance of Tiryns as the single source of Cypro-Minoan inscriptions in Greece and as the westernmost site where this highly idiosyncratic script of Late Bronze Age Cyprus is attested. Tiryns' prominence as the only hitherto confirmed source of Cypro-Minoan inscriptions west of Cyprus must be linked to its location, close to the coastline of the Argolic Gulf, and to its possible role as the preferred port-of-call for Cypriots coming to mainland Greece.

All three inscribed objects were found in the Lower Citadel, close to the North Gate, in the area occupied by Building XI that served as a palatial workshop for skilled crafting. With the exception of the Canaanite fragment, the other two inscribed items were most probably produced and inscribed locally by people acquainted with the use of the Cypro-Minoan script. Each of the three inscriptions comes from a slightly different chronological sub-phase that spans the LH IIIB Final and the LH IIIC Developed, dated approximately from the late 13th to the middle of the 12th century BC. This chronological range confirms the persistence of Cypro-Minoan writing at Tiryns during the aforementioned period and strongly advocates the presence of

Cypriots – the only ones who would employ the Cypro-Minoan script for writing – possibly engaged in specialised manufacturing techniques.

In addition to the use of the Cypro-Minoan script, the inscribed objects from Tiryns match the typology, inscription method, and formatting of similar inscribed items from Cyprus, confirming that they should be viewed as products of the same Cypro-Minoan script culture. Most distinctively Cypriot among the three is the inscribed clay ball dated to the early–middle 12th century. Apart from signalling Tiryns' strong ties with Cyprus, presumably with Enkomi, the predominant source of these inscribed items on the island, the post-palatial dating of the inscribed clay ball from Tiryns indicates that people of Cypriot origin would have been the last residents of post-palatial Tiryns to have retained their literacy, even after Linear B had become obsolete with the demise of the Mycenaean palaces.

Cypriot syllabic inscriptions found in Greece

Unlike the situation in the Aegean, it is clear that, although there are periods when writing was sparsely attested in Cyprus, especially between ca. 1050 and 750 BC, literacy continued unbroken on the island from the Late Bronze Age to the Early Iron Age (Steele 2019, 45–65). Moreover, despite some Late Bronze Age epigraphic practices being abandoned on Cyprus by the beginning of the Cypro-Geometric period, for example writing on clay balls, tablets and cylinders or marking vase handles with Cypro-Minoan potmarks, continuities in epigraphic practice are more striking than discontinuities (Steele 2019, 84). This is further supported by the fact that the Cypro-Minoan script continued to occur on Cyprus, primarily in the area of Palaepaphos, after the transition to the Early Iron Age. Although certain Cypro-Minoan texts are of uncertain date, at least ten Cypro-Minoan texts can be dated to the 11th or even 10th century BC (Steele 2013, 17–18), by which time the Cypriot syllabary might have produced its first written attestations on the island (Egetmeyer 2010, 690–691, Limni no. 1, broadly dated between 1200 and 900 BC, today lost). Therefore the epigraphic material is suggestive not only of a more-or-less continuous awareness of literacy in the late 2nd and early 1st millennium BC Cyprus but, most importantly, of the closely related writing systems of both periods, namely of the Cypro-Minoan and its direct Iron Age 'descendant', the Cypriot Syllabary, that was employed in Cyprus in the 8th–3rd centuries BC.

The palaeographical development of Cypro-Minoan into the Cypriot Syllabary yields an additional soundproof of the continuity of writing in Cyprus, further stressed by evidence for an overlap between the two scripts on the island in the Early Iron Age (Ferrara 2012, 10; Steele 2019, 56–64). Also known as the Classical Cypriot script, the Cypriot Syllabary employed a well-defined repertoire of 55 signs, in its more widely used variety of the 'Common' Syllabary, and 54 signs in a local variety, the 'Paphian' Syllabary, attested in south-west Cyprus. We know more about the Cypriot Syllabary than we do about the Cypro-Minoan script because it is deciphered, since, as stated

above, it was used to write Greek as well as to write at least one more unknown language (Eteocypriot). The Cypriot Syllabary was used primarily on Cyprus but is also attested in Greece, Cilicia, the Syro-Palestine, Egypt, and Italy (Steele 2019, 207–219).

The earliest securely identified inscriptions in the Cypriot Syllabary appear around the middle of the 8th century, at the very end of the Cypro-Geometric period. They are well-defined from an epigraphic perspective, as they conform closely with the repertoire of the script's signs, while also showing some innovations that distinguish them from the earlier Cypro-Minoan script (Steele 2019, 67).

Mende

One of the earliest attestations of the Cypriot Syllabary outside Cyprus is a sinistroverse post-firing graffito consisting of five signs, cut on the shoulder of an early Attic SOS amphora found at the Eretrian colony of Mende, in Chalcidice (Vokotopoulou and Christides 1995; Egetmeyer 2010, 841, no. 1; Karnava 2013, 160–163; Bourogiannis 2019, 173–174; Steele 2019, 67–68, 210; Halczuk 2022, 489–490). The vessel (Fig. 4.3) was in secondary use as a funerary urn at the seaside cemetery of Mende. The inscription was added before the final, funerary use of the amphora. Although any date from the 8th to the early 6th century would be possible for the SOS amphora, the fact that it contained the remains of an infant burial, together with a locally made one-handled cup that followed Euboean Sub-Geometric prototypes, advocates its dating to the late 8th century. This makes it one of the earliest inscriptions in the 1st millennium BC Aegean as a whole, regardless of the script employed (Bourogiannis 2019).

The inscription from Mende reads ?]-la-si-te-mi | se, thus probably preserving an abbreviated name – or names (Halczuk 2022, 490) – beginning with the element te-mi (Themi). The last sign, se, may correspond to the ethnic Selaminios (from Salamis) or, more likely, represent the final letter of the proper name in nominative case. The inscription has been associated both with the common and with the old Paphian Syllabary (Karnava 2013, 162; Halczuk 2022, 489–490). Even though the text is too incomplete to draw any final conclusions, the Cypro-Syllabic inscription from Mende seems to represent a declaration of ownership written by the Cypriot owner/trader of the amphora, in Greek language but in the only script he was acquainted with, the Cypriot Syllabary. Admittedly, it is difficult to define where the vessel was inscribed. However, given the Attic origin of the amphora, its appearance in a Euboean colony of the north Aegean, and the early epigraphic proliferation of the Thermaic Gulf – Mende is situated

Figure 4.3. Detail of the inscribed SOS amphora from Mende, Chalcidice (MΘ 18050; © Archaeological Museum of Thessaloniki, Hellenic Ministry of Culture 2023).

across the water from another Eretrian colony and major source of early inscriptions, Methone (Straus Clay *et al.* 2017) – it seems more likely that the inscription was added in the Aegean rather than in Cyprus.

Delphi

The second early inscription in Cypriot Syllabary was found at the sanctuary of Apollo at Delphi, at the entrance to the temenos. It consists of four signs written from right to left across the foot of a bronze tripod stand, shaped like a lion's paw (Rolley and Masson 1971; Egetmeyer 2010, 841, no. 2; Karnava 2013, 163–165; Bourogiannis 2019, 174–175; Steele 2019, 68, no. 3, 210). Based on stylistic criteria and comparisons with similar funerary finds from Salamis on Cyprus, the bronze fragment from Delphi was dated around 700 BC (to the Cypro-Archaic I period in terms of Cypriot chronology). This was a time when votive offerings originating in the eastern Mediterranean, including Cyprus, became plentiful at the sanctuary of Delphi (Partida 2003).

The inscription reads e-re-ma-i-[-jo, Ermai(ō), of Ermaios, a genitive marking the name of the person from whom the dedicated bronze object originated. It is unclear whether the inscription had a fifth sign that would account for the genitive ending of the name, since this would be at the position of a crack marking the left edge of the inscribed object. This prestigious votive item, offered by a Cypriot to the sanctuary of Apollo at Delphi, confirms the appearance of the Cypriot Syllabary in the context of international religious practices staged at one of the most celebrated Geek sanctuaries at about the end of the 8th century. The position of the inscription, which incorporates the text into a decorative arrangement by placing it between decorative bands, confirms that the inscription was part of the stand's manufacture, thus indicating that it was written in Cyprus.

Athens

Athens is the source of the other two inscriptions in the Cypriot Syllabary that were found in Greek contexts.

Acropolis

A poorly preserved fragment of a bronze bowl, excavated at the Acropolis in the late 19th century and dated before 480 BC, that is, before the destruction of Athens by the Persians, bears a sinistroverse inscription of three signs. The inscription was originally presented by Bather (1893, 129–130, no. 65), with minimal comment on its content, as '... forms from the Cypriote syllabary. They are not enough to transliterate into any intelligible Greek'.

It was reconsidered by Egetmeyer (2010, 841, no. 4) and Karnava (2013, 165). Written in the Common Syllabary, the inscription reads]-le-wo-se | [. The three surviving, syllables, le-wo-se correspond to the widely attested syllables at the end of the word pa-si-le-wo-se (βασιλέως) 'of the king'. In Cyprus, this genitive case of the word βασιλεύς, features in many votive inscriptions, mostly in stone, as well as on coins

(Karnava 2013, 165). Even though the contextual information of the inscribed fragment is patchy, it probably represents a votive offering made on the Athenian acropolis sent by a Cypriot king, whose name, however, does not survive. The technical features of the bronze bowl and of the inscription indicate that this was written in Cyprus, during the inscribed item's manufacture.

Figure 4.4. Inscribed kylix foot from the Athenian Agora, P17463 (© Ephorate of Antiquities of Athens City, Ancient Agora, ASCSA: Agora Excavations, Hellenic Ministry of Culture/Organization of Cultural Resources Development (H.O.C.RE.D.) 2023).

Agora
The last inscription in the Cypriot Syllabary produced in a Greek context was found in the Athenian Agora (Fig. 4.4). It is a post-firing graffito cut on the underside of the foot of a Black-Glazed kylix, dated around 475–450 BC by the vessel's type. Initially presented by Lang (1976, 34, F67, pl. 13), the inscription was reconsidered recently by Egetmeyer (2010, 841, no. 3) and Karnava (2013, 167).

Consisting of five signs neatly written from right to left, the inscription reads ku-pu-ro-ta-mo, of Kyprodamos. The name in genitive case suggests that this is a declaration of ownership. It was common in the Classical period for Cypriots to write graffiti on Attic Black-Glazed pottery in the Cypriot Syllabary and, from the 4th century, also in the Greek alphabet (Halczuk and Peverelli 2018; Karnava 2022).

Cypro-Syllabic inscriptions in Greece: some concluding remarks

The four Cypro-Syllabic inscriptions from Greek contexts yield an important contribution to the understanding of contacts between Greece and Cyprus and of how writing was employed in the two areas during the 1st millennium BC. Although the inscriptions treated here are incomplete, thus hampering any final conclusions, all have been read as sinistroverse, written from right to left, while their signs seem to correspond to those of the Common Cypriot Syllabary. The main potential exception is the graffito on the SOS amphora from Mende which, despite being retrograde, could be assigned to the old Paphian Syllabary. Even this attribution, however, is not definite and should be treated with caution.

The Cypro-Syllabic inscriptions range chronologically from the last quarter of the 8th to approximately the middle of the 5th century, that is, from the Late Geometric to the beginning of the classical period in Aegean terms. When associated with the Cypriot chronological sequence, the inscriptions on the amphora from Mende and on the bronze lion's paw from Delphi belong to the Cypro-Archaic I period. The inscribed

bronze bowl from Athens, dated before 480 BC, is probably a Cypro-Archaic II product, whereas the inscribed kylix sherd from the Agora corresponds to a Cypro-Classical I horizon. The absence in Greece of any Cypro-Syllabic inscriptions post-dating the middle of the 5th century may not be the mere result of archaeological coincidence but may also reflect writing practices in Cyprus itself. Although the Greek alphabet made its first hesitant appearance in Cyprus in the early 6th century, it was only in the late 5th and 4th centuries that Greek alphabetic inscriptions on the island began to proliferate, partly as a result of the employment of the Greek alphabet in royal inscriptions relating to the administration of Cypriot city kingdoms (Steele 2019, 223–231).

Greek, in its Cypriot dialectal form, is securely defined as the language of all four Cypro-Syllabic inscriptions discussed in this paper. None of the Cypro-Syllabic inscriptions found in Greece so far is associated with Eteocypriot, that is, with the other (unknown) language(s) for which the Cypriot Syllabary was employed. Although this predilection may seem obvious for the predominantly Greek-speaking Aegean, it is not a self-evident decision given that languages other than Greek were regularly recorded in the Aegean during the early 1st millennium BC (Bourogiannis 2019). Furthermore, although the language of the Cypro-Syllabic inscriptions excavated in the Aegean is Greek, it is hard to designate how many of their non-Cypriot viewers would be able to read them in an area where the Cypriot Syllabary occurred only sporadically and where Greek was written alphabetically, at least since the early 8th century.

Regarding their context and purpose, the bronze lion's paw from Delphi and the bronze bowl from the Athenian Acropolis are votive offerings – the latter seemingly a royal one – confirming the prestige of major Greek cultic sites among Cypriots. This would not be the only case of a Cypriot royal dedication to a Greek sanctuary. Herodotus (iv.162), for example, informs us that king Evelthon of Salamis dedicated a bronze thymiaterion to Apollo at Delphi in the late 6th century BC.

The inscriptions on the amphora from Mende and the Black-Glazed kylix from the Athenian Agora are best understood as declarations of ownership and as written glimpses related to trade and economic interaction between Cyprus and Greece. In spite of their chronological distance, both inscriptions were found in the two areas of the Aegean most prolific in terms of their written attestations: the Thermaic Gulf, an area dotted with Euboean colonies and trading posts, among which Methone is extraordinary for the number of its graffiti, and the Athenian Agora.

The four inscriptions in the Cypriot Syllabary are not the only written attestation of Cypriot presence in Greece in the 1st millennium BC. The presence of Phoenician speaking Cypriots is also confirmed epigraphically, often through bilingual and digraphic inscriptions written in the Phoenician abjad and the Greek alphabet (Bourogiannis 2021). From the 4th century onwards, by which time the alphabet had become the dominant script among the Greek speaking population of Cyprus, Cypriot presence in Greece is attested also alphabetically rather than syllabically. Inscriptions from Delos of the 4th century, for example, explicitly mention that the kings Pnytagoras and Nikokreon of Salamis made dedications to Delian Apollo

(Chavane and Yon 1978, 141, nos 295–296; 147, nos 311–312), whereas Androkles, king of Amathus, dedicated a crown to Apollo of Delos (*IG* xi. 135. 39–41). More similar cases could be cited but these are beyond the scope of this paper.

Acknowledgements

My warmest thanks are due to Dr Anastasia Christophilopoulou, for her kind invitation to participate in this volume and for our long and fruitful collaboration during the *Being an Islander* project. I am also grateful to Dr Melissa Vetters, Professor John Papadopoulos, Mrs Aspasia Efstathiou and Mrs Elektra Zografou for their prompt action regarding the use of Figs 4.2–4.4 of this chapter.

Bibliography

Bather, A. G. (1893) The bronze fragments of the Acropolis. *The Journal of Hellenic Studies* 13, 124–130.

Bourogiannis, G. (2019) Between scripts and languages: Inscribed intricacies from geometric and archaic Greek contexts. In P. Boyes and P. M. Steele (eds), *Understanding Relations between Scripts II: Early Alphabets*, 151–180. Oxford: Contacts and Relations Between Early Writing Systems 1.

Bourogiannis, G. (2021) Phoenician writing in Greece: Content, chronology, distribution and the contribution of Cyprus. In N. Chiarenza, B. D'Andrea and A. Orsingher (eds), *LRBT: Dall'archeologia all'epigrafia. Studi in onore di Maria Giulia Amadasi Guzzo*, 99–127. *Semitica et Classica* Supplementa 3.

Chavane, M.-J. and Yon, M. (1978) *Salamine de Chypre* X. *Testimonia Salaminia* 1. Paris: De Boccard.

Cohen, C., Maran, J. and Vetters, M. (2010) An ivory rod with a cuneiform inscription, most probably Ugaritic, from a Final Palatial workshop in the Lower Citadel of Tiryns. *Archäologischen Anzeiger* 2 Halbband, 1–22.

Davis, B., Maran, J. and Wirghová, S. (2014) A new Cypro-Minoan inscription from Tiryns: TIRY Avas 002. *Kadmos* 53, 99–109.

Davis, B., Maran, J., Prillwitz, S. and Wirghová, S. (2023) A Canaanite jar with a Cypro-Minoan inscription from Tiryns: TIRY Avas 001. *Kadmos* 62, 1–32.

Donnelly, C. M. (2022) Cypro-Minoan abroad, Cypriots abroad? In G. Bourogiannis (ed.) *Beyond Cyprus: Investigating Cypriot Connectivity in the Mediterranean from the Late Bronze Age to the End of the Classical Period*, 195–206. Athens: Athens University Review of Archaeology.

Egetmeyer, M. (2010) *Le dialecte grec ancient de Chypre*. Tome I, *Grammaire*, Tome II, *Répertoire des inscriptions en syllabaire chypro-grec*. Göttingen: De Gruyter.

Evans, A. (1909) *Scripta Minoa: The Written Documents of Minoan Crete with Special Reference to the Palace of Knossos*. Oxford: Clarendon Press.

Ferrara, S. (2012) *Cypro-Minoan Inscriptions*. Vol. I, *Analysis*. Oxford: Oxford University Press.

Ferrara, S. (2013) *Cypro-Minoan Inscriptions*. Vol. II, *The Corpus*. Oxford: Oxford University Press.

Halczuk, A. (2022) Paphians outside Paphos. Inscriptions in the Paphian syllabary found outside Cyprus. In G. Bourogiannis (ed.) *Beyond Cyprus: Investigating Cypriot Connectivity in the Mediterranean from the Late Bronze Age to the End of the Classical Period*, 485–495. Athens: Athens University Review of Archaeology.

Halczuk, A. and Peverelli, C. (2018) Inscriptions sur céramique attique de Palaepaphos. *Cahiers du Centre d'Études Chypriotes* 48, 55–76.

Hirschfeld, N. E. (1999) Potmarks of the Late Bronze Age Eastern Mediterranean. Unpublished PhD Dissertation, University of Texas at Austin.

Hirschfeld, N. E. (2010) Cypro-Minoan. In E. H. Cline (ed.), *The Oxford Handbook of the Bronze Age Aegean*, 373–384. Oxford: Oxford University Press.

Karnava, A. (2013) Κύπριοι της 1ης χιλιετίας π.X. στον ελλαδικό χώρο: η μαρτυρία των συλλαβικών επιγραφών. In D. Michaelides (ed.), *Epigraphy, Numismatics, Prosopography and History of Ancient Cyprus. Papers in Honour of Ino Nicolaou*, 159–169. Uppsala: Studies in Mediterranean Archaeology 179.

Karnava, A. (2022) Incoming goods and local writing. The case of classical Marion in Cyprus. In G. Bourogiannis (ed.), *Beyond Cyprus: Investigating Cypriot Connectivity in the Mediterranean from the Late Bronze Age to the End of the Classical Period*, 497–508. Athens: Athens University Review of Archaeology.

Kilian, K. (1988) Ausgrabungen in Tiryns 1982/83. *Archäologischen Anzeiger* 1988, 105–151.

Lang, M. (1976) *The Athenian Agora* Vol. XXI. *Graffiti and Dipinti*. Princeton NJ: The American School of Classical Studies at Athens.

Maran, J. (2008) Forschungen in der Unterburg von Tiryns 2000–2003. *Archäologischen Anzeiger* 2008, 35–111.

Olivier, J. P. (1998a) Le syllabaire chyproclassique: Un inventaire. *Bulletin de Correspondance Hellénique* 122, 426–427.

Olivier, J. P. (1998b) Tirynthian graffiti. Ausgrabungen in Tiryns 1982/83. *Archäologischen Anzeiger* 1988, 253–268.

Olivier, J. P. (2007) *Édition holistique des textes chypro-minoens*. Pisa-Rome: Fabrizio Serra.

Partida, E. (2003) Ανατολίτες στους Δελφούς από την ίδρυση του ιερού ως την ύστερη αρχαιότητα. *Corpus* 53, 38–49.

Rolley, V. and Masson, O. (1971) Un bronze de Delphes à inscription chypriote syllabique. *Bulletin de Correspondance Hellénique* 95, 295–304.

Steele, P. M. (2013) *A Linguistic History of Ancient Cyprus. The Non-Greek Languages and their Relations with Greek, c. 1600-300 BC*. Cambridge: Cambridge University Press.

Steele, P. M. (2019) *Writing and Society in Ancient Cyprus*. Cambridge: Cambridge University Press.

Straus Clay, J., Malkin, I. and Tzifopoulos, Y. Z. (eds) (2017) *Panhellenes at Methone. Graphê in Late Geometric and Protoarchaic Methone, Macedonia (ca 700 BCE)*. Berlin: De Gruyter.

Valério, M. (2014) Seven uncollected Cypro-Minoan inscriptions. *Kadmos* 53, 111–127.

Valério, M. (2016) Investigating the Signs and Sounds of Cypro-Minoan. Unpublished PhD dissertation, University of Barcelona.

Vetters, M. (2011) A clay ball with a Cypro-Minoan inscription from Tiryns. *Archäologischen Anzeiger* 2011, 1–49.

Vokotopoulou, I. and Christides, A. (1995) A graffito on a SOS amphora from Mende, Chalcidice. *Kadmos* 34, 5–12.

Chapter 5

A Late Iron Age sword from Tamassos: Biography of an exceptional object

Susanna Pancaldo, Ema Baužytė, and Julie Dawson

The Fitzwilliam Museum houses one of the best-preserved examples of a Late Iron Age/Cypro-Archaic period sword type. The sword, which presents similarities to elite weapons of the cultural era symbolically called the Homeric age (12th–8th century BC), was found in a Cypro-Archaic cemetery at the site of Tamassos in central Cyprus. The elaborately decorated weapon is significant not only in its role as a high status object, reflecting life and death rituals of the elite warrior class of the Cypro-Archaic Period (ca. 600–480 BC), but also as a complex artefact whose technological history offers insight into the cross-craft relationships amongst the people who created it. Using an object biography approach, this chapter presents the results of recent technical investigations carried out on the sword using various scientific methods, including stereo-microscopy, 3D microscopy, X-radiography, X-ray computed tomography (CT), micro-computed tomography (micro-CT), and scanning electron microscopy with energy-dispersive X-ray spectroscopy (SEM-EDS). Through these methods, our study has uncovered evidence for some of the materials and forming technologies employed in making the sword, including its iron structure, layers of silver and tin sheet applied to the edges of the hilt, and characterisation of the materials and technological steps employed to make and assemble silver-headed, copper alloy rivets in order to secure two carved ivory plates onto the iron hilt. The paper also suggests avenues for further research in which technological details such as these might be used to identify local craft-making workshops on Cyprus in the Cypro-Archaic period.

Introduction

The Fitzwilliam Museum houses one of the best-preserved examples of a Late Iron Age/Cypro-Archaic period sword type known to date (acc. no. GR.334.1892). In its form and appearance, the weapon recalls the 'silver-studded swords' of the Homeric warriors depicted in the *Iliad* and the *Odyssey* (Vonhoff 2021). The sword was excavated

in 1892 from Tomb 12 of the Royal Cemetery at Tamassos in central Cyprus, a well-built stone tomb with a rich assemblage which dates to the Cypro-Archaic (CA) II period (ca. 600–480 BC; Matthäus 2007; 2014). Amongst the materials related to warfare was this sword, an elite form of weaponry whose creation was deeply rooted in a long tradition of metallurgical production on the island of Cyprus (Vonhoff 2021).

In addition to its significance as a rare, high status object, the Tamassos Tomb 12 sword is technologically complex, presenting an invaluable opportunity to explore the materials and methods employed by the ancient craftsmen who created it. The sword was recently re-examined as part of The Fitzwilliam Museum's *Being an Islander* metals research project, which aimed to reveal the technological histories of metal objects from Cyprus in the collection (see also Christofilopoulou, this volume Chapter 1 and the project's website, https://islander.fitzmuseum.cam. ac.uk/research/metals). Today the sword is a fragmented and corroded version of its original self, but our programme of scientific research has resulted in a clearer understanding of how the sword might have been made, how it might have looked in its original state, and how it might have been used. The implications of our findings have also allowed a consideration of broader questions about the identities of people in the ancient world and the relationships between metalworking communities of the ancient Mediterranean, themes explored in the *Being an Islander* project (see Christofilopoulou, this volume Chapter 1). Following a brief review of Cypriot metalwork in the Iron Age, we present our scientific and technical investigations as a 'biography' of this magnificent object.

Cypriot Iron Age metalwork production – a brief overview

The significance of Cyprus's role in the development and dissemination of ironworking technologies during the transition from the Bronze Age to the Iron Age in the Aegean is the topic of a long-standing debate (Snodgrass 1980; 1981; 1982; Wertime and Muhly 1980; Muhly *et al.* 1982; 1985; Gale *et al.* 1990; Sherratt 1993; 2000; Waldbaum 1999; Muhly and Kassianidou 2012; Erb-Satullo 2019). It is nevertheless clear from the archaeological record that by the start of the Iron Age, around 1200 BC, Cypriot metal-smiths were already making objects from iron and, by 1000 BC, the island was an active centre for the production of a variety of iron object types (Snodgrass 1982, 292; Sherratt 2000; Muhly and Kassianidou 2012, 13). Some forms of Cypriot material culture changed very little from the Late Bronze Age through to the end of the Archaic period and this is the case for certain types of bladed objects, including knives, daggers, and swords (Snodgrass 1981, 131; Muhly and Kassianidou 2012, 13; Vonhoff 2013; 2019; 2021).

It has long been noted that the shape and form of the Fitzwilliam Museum sword closely conforms to the so-called Naue II type of weapon, which first appeared during the Bronze Age in central Europe (MacDonald 1992; Matthäus 2007; Vonhoff 2021). The earliest examples found in the Aegean were made in copper-alloy and the earliest examples in iron are from Cyprus (Snodgrass 1981, 130; 1982, 292; Stefani and Volaris

2020, 4–5). Vonhoff's recent study of the Fitzwilliam sword provides a detailed analysis of stylistically close parallels for it, which date from the Cypro-Archaic and preceding Cypro-Geometric periods (Vonhoff 2021).

Within this context, we present here a description of the sword followed by a detailed account of the sword's 'life-history,' focusing in particular on the materials and methods of its production.

Description of the sword

The iron structure of the Fitzwilliam sword is preserved today in three main sections, with the tip of the blade, the end of the grip, and small chips from the flanged hilt now missing (Figs 5.1 and 5.2). The blade – broken cleanly across its midpoint – is 'leaf-shaped' and has a raised, central rib. Where the bottom of the blade meets the hilt, there is, on one side of the sword at least (Side A), a small ledge in the iron which has a central, semi-circular notch. The third section of the sword, now assembled from five fragments, comprises the major extant portion of the hilt, including a semi-circular flange and roughly rectangular grip with lightly scalloped edges.

The iron hilt is elaborately decorated. Its outer edges are wrapped in metal foils – silver overlying tin – and there are remains of two carved ivory plates, one on each side of the iron structure, which are attached by means of six copper alloy rivets with silver heads. Remains of wood, mineralised wood, and possibly leather are embedded in the corroded surface of the sword's iron blade, suggesting that the blade had been encased in a scabbard at the time of deposition.

Raw materials

To begin the 'biography' of this complex object, we consider the raw materials used to make it. Sources of various metals on the island in the Early Iron Age have been extensively discussed and debated in the literature (for example, on iron: Waldbaum 1999; McConchie 2004; Maddin 2011; Kassianidou 2012; Muhly and Kassianidou 2012; Erb-Satullo 2019; on copper: Gale *et al.* 1990; Gale and Stos-Gale 2012; Jansen *et al.* 2018; on tin: Muhly *et al.* 1985; Berger *et al.* 2019; on silver: Kassianidou 2009; Stos-Gale and Gale 2010; Wood *et al.* 2019). While Cyprus is famous for its copper ore deposits, the question of whether significant amounts of iron metal were produced on the island is debatable. Tin and silver must have been imported to the island. The ivory would have been imported as well, most likely from the Levant (Ben-Schlomo and Dotan 2006). The corroded condition of the sword prohibited us from undertaking more detailed analyses of the chemical composition of the metals, which may have offered clues about their original sources. However, it is clear that most of the raw materials used in the sword's production would have reached Cyprus from regions both far and near, including the Aegean, Iberia, the Levant, Anatolia, Egypt, current day France, and Cornwall. Aside from the copper metal used to make the rivets, it is likely that all the materials used in the sword's construction were imported from outside Cyprus.

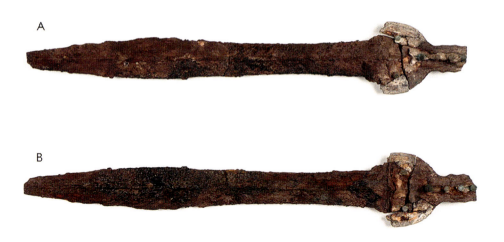

Figure 5.1 Sides A and B of the Fitzwilliam's sword from Tamassos Tomb 12 (GR.334.1892; © The Fitzwilliam Museum 2023).

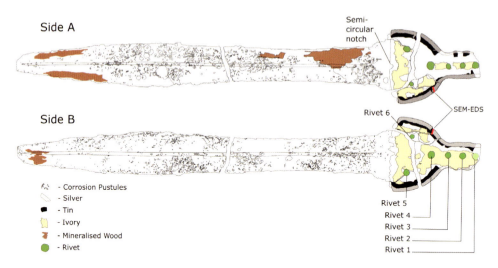

Figure 5.2. Diagram showing two sides of the sword, as preserved today (© authors and The Fitzwilliam Museum 2023).

Iron structure

The sword's iron structure – from its tip to its grip – was formed from a single iron bar through the application of a series of thermal and mechanical steps. These steps will have affected the micro-structure of the metal and microscopic studies of iron

artefacts can help reveal the forging processes. In this case, extensive corrosion has obscured much of the microscopic evidence. However, metallographic studies of other iron objects from the eastern Mediterranean suggest that, by 600 BC, hot hammering, carburisation, decarburisation, and quenching were all part of a blacksmith's skill set (Stech-Wheeler *et al.* 1981; Muhly *et al.* 1985). An Iron Age smith would have heated metal in a bed of charcoal to make it more pliable and then hot-hammered it into shape. Extensive hot-working and exposure to an oxygen-rich hot environment can cause decarburisation – loss of carbon from the iron's micro-structure. The smith might subsequently have carburised the metal by resting it in a bed of charcoal, so that the surface could absorb carbon from the fuel and become harder. The sword might also have been quenched – submerged in liquid after hammering – to rapidly cool and further harden the metal.

Although fully mineralised, the structure of the Fitzwilliam sword has two notable features which provide insight into some of the methods used in its manufacture. These features are observable at the blade's break-edges and also in micro-CT images (Fig. 5.3). One is a cavity which runs along the length of the sword at the core of the blade and the other is the iron's overall layered structure.

Both features may have partially resulted from the plastic deformation of the metal caused by hammering. At a micro-structural level, iron metal is made up of small metallic grains that become deformed, elongated, and form strain lines as the metal is hammered into shape. If the iron is subsequently annealed by application of heat, the grains become malleable and can reform, thereby relieving some of these stresses.

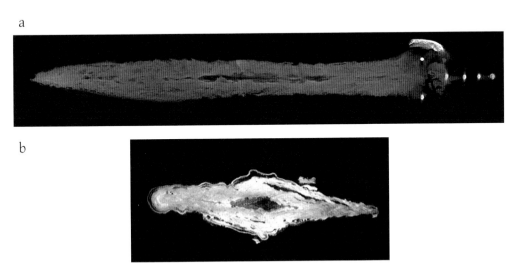

Figure 5.3. Micro-CT images of the sword: a. composite image showing the hollow centre of the corroded blade; b. cross-section 'slice' across the blade showing the layered condition of the iron. Rendered micro-CT images produced by Graham Treece, University of Cambridge, using Stradview software (© Graham Treece, University of Cambridge 2023).

However, areas of residual stress are corrosion prone and oxidation can propagate along metal grain boundaries. This causes separation along the boundaries and, ultimately, results in a layered, or lamellar, structure of the metal, as seen in Figure 5.3. Impurities in the iron used to make an object can exacerbate these corrosion phenomena. For instance, iron bars commonly contain small bits of slag, i.e., particles of clay and metal that melted together during metal production processes. As the iron is heated and hammered, bits of slag become viscous, elongated, and then locked along the grain boundaries of the iron, forming inclusions. Such areas of deformation can be accentuated by corrosion processes too, thus also contributing to delamination of the metal. The blade cavity and lamellar condition of the Tamassos sword, therefore, likely reflect both manufacturing processes and subsequent corrosion phenomena.

On Side A of the iron sword, there is a distinct ledge, or step, about 1–2 mm in height, with a semi-circular notch at its centre. Whether a similar ledge was also present on Side B is not possible to tell due to corrosion of the iron. A comparable ledge with central semi-circular notch can be seen on the fragment of a contemporary iron sword found in Tamassos Tomb 11, now in the Staatliche Museen, Berlin (Matthäus 2014, 111, fig. 7). It seems likely that this feature was made to accommodate a scabbard, with the ledge acting as a stop to hold the scabbard securely to the blade and the notch perhaps housing an unknown means of attachment. The effect of the ledge would have been accentuated by the edges of the ivory plates and the folded ends of the decorative edging metals; traces of both these elements can be seen to lie directly on top of the ledge on Side A of the sword, as discussed below.

The iron hilt's semi-circular iron flange is about 11 cm wide across the ledge and is thickest at its centre. The flange tapers from the centre towards its outer edges and as it extends towards the grip. The grip is roughly flat and rectangular, with scalloping on both edges. It is likely that these scalloped edges facilitated a secure and comfortable hold on the weapon. The iron end of the grip, according to Vonhoff, would have terminated in a fish-tail shaped tang (Vonhoff 2021, 303). The tang, in turn, may have been covered with a pommel made of a perishable material such as wood, as was the case with the typologically closest parallel to this sword found at Salamis Tomb 3 (Karageorghis 1967, 38, no. 95, 43, pls xlv: 95, cxxix: 95; Vonhoff 2019).

Decoration of the hilt: Metal edging

It is possible to see, even with the naked eye, that the perimeters of the iron hilt – including both the semi-circular flange and the hand-grip – were covered with metallic edging. X-Radiographs and images produced from micro-CT scans reveal that the edging is composed of layers of thin metal sheet which have been wrapped around the edges of the hilt. It is also clear that one of the broad, metal sheets has been applied intermittently, with large gaps especially visible on one edge of the grip (Fig. 5.4b). The ends of the edging sheets, where preserved, can be seen in X-ray and micro-CT images to be neatly folded into triangular shapes and arranged so that the

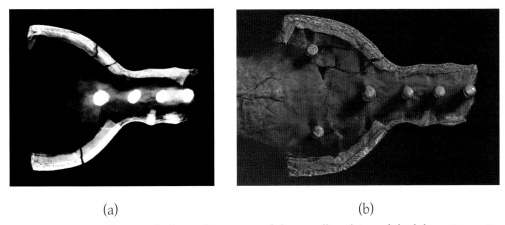

Figure 5.4. Images showing the layered structure of the metallic edging of the hilt; a. Composite image of X-Radiographs; b. image produced from micro-CT scans, by Graham Treece, University of Cambridge, using Stradview software (© Graham Treece, University of Cambridge 2023).

edges of the triangles align with the iron ledge marking the end of the blade and the start of the hilt (Fig. 5.4a).

SEM-EDS analysis of a break-edge of one of the fragments of the iron hilt produced further visualisation of the multi-metallic structure of the decorative edging and allowed mapping and characterisation of the layers' chemical compositions (Fig. 5.5). The broad, intermittent, lower layer of metal sheet was identified as tin, with an approximate thickness of 300 μm. Above this, two distinct layers of silver sheet were identified, each about 200 μm thick, possibly with different chemical compositions: copper was detected in one silver layer and not in the other.

These discoveries give rise to several technological questions: how were the layers of tin and silver foils attached to the iron hilt, and to each other? What was the purpose of applying a tin layer underneath the silver and, indeed, underneath the edges of the ivory plates where the tin would not have been visible? And why are the sheets of tin continuous on one side of the hilt but fragmentary on the other side?

Both mechanical and thermal processes were considered as possible means for attachment of the decorative metal sheets. The use of mechanical means can be clearly seen in both the SEM images and macroscopic examination of the object. The silver sheets have been manipulated and bent at approximately 90° angles to fit around the edges of the hilt by application of mechanical pressure, creating a box-like structure. Furthermore, microscopic examination of the surface of the metallic edging reveals that, just inside the hilt's edges, there are small indentations in the metal, suggesting that a clamping tool was used to ensure a tight fit between the decorative sheets and the iron hilt edge.

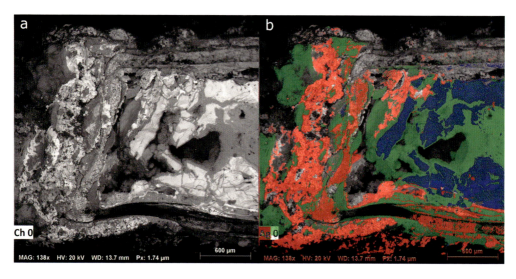

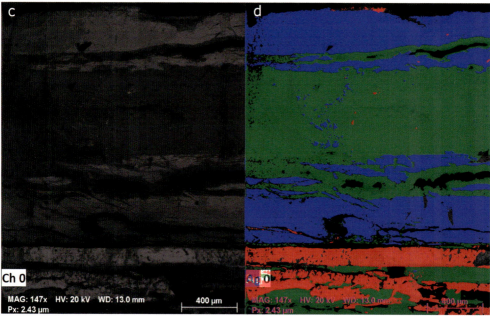

Figure 5.5. a–b. SEM-EDS images of break-edge of a hilt-fragment, revealing the application of metallic edging layers of silver (in red) and tin (in blue), and the iron core (in green); c–d. higher magnification detail of the same metallic layers at a spot close to the hilt-edge (© authors and The Fitzwilliam Museum 2023).

In addition to mechanical clamping, thermal methods may have been used to secure the decorative metals to the iron hilt. The SEM-EDS images of a break-edge indicate

that, towards the edges of the hilt, the two silver layers are well separated (Fig. 5.5b). High temperature methods were clearly not used to bind the silver sheets to the iron, nor to each other, or we would see fusion of the layers. However, further away from the hilt-edge, the stratigraphy of the ends of the metal sheets becomes less clear and layers of silver and tin appear to interchange. This may be due to corrosion of the metals, of course, but it may also be that a hot tool, such as a metal rod, was applied along the inner edge of the silver sheets to partially melt and seal the silver to the underlying tin and iron layers. There are no known parallels for this technological process in the literature, however, and this explanation is conjectural.

Next, we consider the nature and purpose of the layer of tin between the silver and the iron. The tin cannot have been a purely decorative element: at the edges of the hilt it would have been obscured by the silver sheeting and, further from the edges, the tin would have been obscured by the ivory plates. It is intriguing that the tin sheeting was not applied in a continuous strip; X-Radiographs clearly show that there are significant gaps in its application, leaving stretches of the perimeter with silver lying directly on iron. These characteristics suggest that the purpose of the tin sheets was functional rather than aesthetic.

One possibility is that the tin was intended as a solder. The use of tin and alloys of tin as soldering material was well established in the Aegean by the Cypro-Archaic period (Lefferts 1970; Collon 1982; Lang and Hughes 1984; Lopes *et al.* 2018). However, close examination of the SEM-EDS images of the hilt edge indicate that this is unlikely: the tin layer is clearly distinguishable and does not appear to be fused to either the iron or the silver (Fig. 5.5b). A more plausible explanation is that the tin was applied to help smooth and shape the surface of the iron before application of the silver. The properties of iron make it a relatively difficult material to work into shape and the soft, malleable tin sheets may have been used to help shape the delicate lines of the hilt and to cover imperfections in the iron's surface before the addition of the thin silver sheeting. Although this technological practice has not been reported from this period, as far as we are aware, it apparently was a technique used centuries later in the manufacture of Roman coinage (Zwicker *et al.* 1993). The fact that tin sheet was applied in intermittent strips on one hilt edge suggests that the metalsmith constructing the sword may perhaps have had to work within a temporary supply constraint, strategically spacing and placing pieces of tin sheets along the edges of the hilt before applying overlying silver sheets.

The analysis of the hilt edges presented here is the first of its kind to the best of our knowledge. Existing literature reports the presence of decorative edging on other Cypro-Geometric and Cypro-Archaic swords but rarely provides details of any analytical work that might support these conclusions. For instance, the famous sword from Salamis Tomb 3 is said to have a bronze, box-like edging around its tang, inserted into the iron by means of four 'teeth' which were covered with a thin silver (Karageorghis 1967, 38; 2002, 168). Similar edging has been reported for one of two unprovenanced example from the Cesnola Collection in New York (Karageorghis *et al.*

2000, 164, nos 268 and 270). However, the absence of published technical data hinders a detailed comparison of technologies employed to produce these features.

Decoration of the hilt: Ivory plates

Despite their fragmentary condition, it can be seen that the iron flange of the sword was once fitted on both sides with carved ivory plates. The plates appear to have been made of elephant ivory, based on the distinct structural pattern of intersecting arcs, although no further analysis to confirm this identification has been undertaken at this time. The ivory plates were held in place by means of six copper alloy rivets with silver heads and the dimensions and configuration of the rivets shed light on the size and shape of the plates (Fig. 5.6). Their extant, uppermost surfaces lie just under the rivet heads running along the central axes of the hilt (Rivets 1–4). Here, plate remains are about 15 mm thick. The plates then taper towards the two rivets located in the flanged section of the hilt (Rivets 5–6); these rivets are shorter than the others and the plates would have been correspondingly thinner. The ivory plates also appear to have tapered towards the outer edges of the hilt, where extant sections of ivory near the edges of the hilt indicate that about 5 mm of the silver edging would have been visible along the hilt's outer perimeters. The thickness of the ivory lying above the notched iron ledge on Side A is uncertain; however, a drawing of Side A, published soon after the sword's discovery by the German archaeologist Max Ohnefalsch-Richter, depicts a semi-circular notch cut out of the centre of the lower edge of the plate (the drawing is reproduced in Masson 1964, 229). This notch is now less distinct on the object itself, presumably because of the loss of ivory fragments over time.

Holes in the ivory to accommodate the rivets would most likely have been made using a drill (for ivory-working techniques in the ancient world, see for example Kryzskowska and Morkot 2000). No tool marks have been found on the ivory, however, nor is there any indication of an alternative form of attachment, such an adhesive.

The state of preservation of the ivory plates prohibits a clearer understanding of their original shape. It is impossible to know whether surfaces had been, for example, carved with mythological imagery, as seen on one of the wooden plates of a contemporary iron sword fragment found at Tamassos Tomb 11, which preserves a partial image of Herakles and the Nemean Lion (Matthäus 2014, 111, fig. 7). Nor is it clear how the ivory plates were shaped below the flange, such as whether or not their edges were scalloped to mimic the scalloping of the iron hand-grip.

Decoration of the hilt: Rivets

Six copper alloy rivets, each with two silver alloy heads, hold the remains of the ivory plates to the sword's iron structure. All the rivets are preserved in their original positions. Four lie in a line along the centre of the hilt and are of similar dimensions, ranging in length from approximately 33 mm to 37 mm. The two remaining rivets

pierce the flanged upper section of the hilt. These are shorter than the four central rivets, measuring ca. 26 mm in length, thus revealing the tapered profile of the ivory plates. While differences in the rivets' lengths are notable, the thicknesses of their pins are largely consistent, ranging between 7.5 mm and 8.5 mm in diameter.

Although not entirely clear, the rivets seem to be formed of cylindrical, copper (or copper alloy) pins with curved, circular, silver (or silver alloy) heads at each end (Fig. 5.6). Access to the rivets for carrying out compositional analyses proved difficult due to that fact the pins are mostly embedded in ivory and/or corroded iron and that both pins and heads are encrusted in corrosion products. However, patches of what appears to be silver halide corrosion can be seen on top of copper corrosion products on some of the heads (e.g. on Rivet 3, Side A and Rivets 2 and 3, Side B). There is also a smooth area of exposed silver coloured metal visible on Rivet 2, Side A where corrosion products seem to have broken away from the metal surface.

If the rivets are in fact copper pins with silver heads this poses intriguing technological questions regarding how and when in the manufacturing process the silver heads were attached. X-Radiographs and micro-CT images clearly indicate that the heads of the pins are made of a denser metal than the copper or iron (Fig. 5.6). They also show that the ends of some of the copper pins vary in shape – some are flat and square, while others convex, or even T-shaped – yet each appears to form a tight fit to the inner surfaces of the domed silver heads.

It is unlikely that hammering was used in the process of fixing the heads to the pins as this would have caused their deformation. Hammering might also have damaged the finished surface of the surrounding ivory. It also seems unlikely that a solder was used to attach the heads as there is no visible evidence of an additional, molten metal in X-Ray and micro-CT images. Attachment with use of an adhesive cannot be ruled out, although, used on its own, adhesive would, of course, have resulted in a weak bond. The most plausible explanation, supported by the micro-CT imaging (Fig. 5.6), is that a localised application of heat was used to allow fusion of the circular silver rivet heads to the cylindrical copper pins. Few parallels of such silvered rivets have been mentioned in the literature. However, a similar case was discussed by Boardman (1961), in which it was also suggested that diffusion welding might have been used to join silver heads to copper pins.

A further observation can be made about the rivets, based on micro-CT imaging. It appears that the rivets do not sit tightly in their rivet-holes. Some of the holes made to accommodate them appear to be oval shaped, whereas the rivets all seem to be roughly circular in cross-section. Two key methods for rivet-hole production are discussed in the literature: punching or drilling (see, for example, Penniman and Allen 1960; Bell 2016). Chiselling is also mentioned (Jung and Mehofer 2008). However, to date, only a few experimental or evidence based studies have been carried out to explain rivet-hole production in metal objects in antiquity and these have mostly been on copper alloy objects which may not be applicable to iron. Nevertheless, these studies do suggest possible techniques for the production of the rivet-holes in

Figure 5.6. Rivet structure: a. Micro-CT 'slice' indicating general shape and state of preservation of Rivet 6; b. rendered micro-CT image of Rivet 6; c. rendered micro-CT image showing only the silver heads of Rivet 6; d. Rendered micro-CT image showing all silver rivet-heads and silver edging metal of the hilt. Images produced from micro-CT scans by Graham Treece, University of Cambridge, using Stradview software (© Graham Treece, University of Cambridge 2023).

this sword. The relationship of the copper alloy rivets to the rivet-holes in the iron weaponry and bladed objects might be an interesting avenue for future study.

The scabbard

The extent and structure of the fragmentary remains of wood and mineralised wood embedded in the sword's corroded iron blade, particularly on Side A, suggest that the blade was enclosed in a scabbard at the time of its deposition in the tomb (Figs 5.1 and 5.2). The grain of the wood lies along the length of the blade. Additionally, the morphology of a small but distinct area of the iron blade, close to the hilt, suggests the presence of mineralised leather, perhaps from a cover or lining of a wooden scabbard. The remains of mineralised organic materials found on copper alloy and iron blades are often cited in the literature but rarely identified. It is remarkable that Socratous (2019, 246–248) was able to identify wood on a contemporary sword hilt from Palaeopaphos-Skales Tomb 277 as *Populus/Salix* (poplar/willow). A further attempt to characterise and identify the remains of wood on the Fitzwilliam sword deserves focused research but is out of the scope of this chapter.

Production and function

So far, we have looked at material and technical aspects of the sword and considered how its various elements were made and assembled. Questions arise, then, about who commissioned the sword, why it was commissioned, who made it, and where this work was carried out.

It is clear that the Fitzwilliam sword is a rare object type, yet it is also characteristic of the type of metal weaponry found in opulent burial assemblages of Cyprus's elite rulers in the Cypro-Archaic and Cypro-Geometric periods (Matthäus 2007; 2014; Vonhoff 2021). The materials used to make the sword were mostly imported and would certainly have been costly. Access to these would most probably have been controlled by the ruling classes. This suggests that the sword may have been produced in a 'royal workshop,' a hub for various specialised craft-work. A broad range of knowledge and skills would have been required to work different materials and to assemble the sword, suggesting close collaboration between several artisans.

The spread of iron technologies and the possible nature of the organisation of metalworking in the ancient world have been explored recently by Nathaniel Erb-Satullo (2019; 2020; 2022), who notes that, certainly in the transition from the Bronze to the Iron Age, organisation of ironworking production may well have been linked to the well-established copper based crafting landscape (Erb-Satullo 2019, 583–587; 2022). While it is generally agreed that copper production and trade were organised and managed by elites (if not strictly controlled by a central 'state'), production of metalwork was not necessarily spatially centralised in a few large workshops but

perhaps carried out in localised workshops, involving various social groups (Erb-Satullo 2019, 587–588).

The purpose behind commissioning the sword ties directly to its function. While the decorated sword clearly testified to the wealth and power of its owner, it remains uncertain whether it was intended to be used as a weapon. The sword type certainly features functional elements; its leaf shaped form and raised midrib are both key features of so-called cut-and-thrust weapons, suitable for offensive action (Catling 1957; Molloy 2010; Vonhoff 2013; 2021). However, Vonhoff suggested that, as the greater part of weapons encountered with Cypriot elite burials probably were designed for actual combat, weapons decorated with bone or ivory handles – including Naue II type swords like the one in the Fitzwilliam Museum but also certain other types of daggers and knives, might have served as status symbols 'amongst noble men' rather than used in combat (Vonhoff 2013, 206–207). It has also been suggested that elaborately decorated swords found in Cypriot elite burials may have been 'heirloom' objects and, as such, might have been of considerable age when buried (Waldbaum 1982; Macdonald 1992). Whether made for combat or not, the sword clearly had a strong symbolic role in displaying the wealth and prestige of its owner, in both life and death.

Excavation and post-excavation histories

The Fitzwilliam sword, as noted above, was found in Tomb 12 of the Royal Cemetery at Tamassos. The tomb was excavated in 1892 by the German excavator, Max Ohnefalsch-Richter and contained rich burial goods, despite having been disturbed by tomb robbers at some point in antiquity. Based on both published and unpublished excavation records, Matthäus was able to reconstruct the layout of tomb finds at their point of discovery (Matthäus 2007; 2014). He suggested that the sword was likely removed from within the stone sarcophagus to a location outside of it; the sword was found on the floor of the tomb, resting beside a copper-alloy helmet and a shield. It may be that the break across the sword's blade occurred during an episode of looting of the tomb or perhaps during excavation as there is, in any case, very little corrosion on the blade's break-edges.

The sword was transferred to the Fitzwilliam Museum soon after its discovery. It was allocated to the then Archbishop of Cyprus, on whose land the tomb lay, who then sold it to the Englishman, Sir Henry Bulwer, High Commissioner of Cyprus at the time (Christofilopoulou 2016, 13–19). Soon after, Bulwer gave the sword to the Fitzwilliam Museum, along with a significant number of other objects from Tamassos. There are no known records relating to the sword in Cambridge since it first entered the museum's collection in 1892. Records next show that, in 1947, the three main sections of the sword were transferred from the Fitzwilliam Museum (along with a large portion of the museum's Cypriot collection) to the university's Museum of Archaeology and Anthropology (then called the University Museum of Archaeology and Ethnology, where it was given inventory number Z.15151; Christofilopoulou 2016, 13–19). In 1964,

the French scholar Olivier Masson published an article on the sword and noted that the object had somewhat deteriorated since Ohnefalsch-Richter's original drawing, made in 1892; a portion of the hilt and some of the rivets were missing (Masson 1964). No further mention is made of the sword in any of the Cambridge Museums records (as far as the authors are aware) until 1997, when the three main sections were transferred back to the Fitzwilliam Museum for technical study, conservation, and display in a newly appointed Cypriot gallery (Karageorghis *et al.* 1999). Fortunately, the 'missing' hilt fragments noted by Masson were rediscovered in the museum's reserves at that time and conservation was undertaken to re-attach them. An in-depth study of the sword undertaken at the museum in 1998–2000 provided the basis for this current study. The sword was also a highlight of the *Being an Islander* exhibition held at the Fitzwilliam Museum in 2023 (Christophilopoulou, this volume Chapter 1 and https://islander.fitzmuseum.cam.ac.uk/islander/exhibition).

Conclusions

The composite nature and relatively good state of preservation of this rare, high-status object have provided an invaluable opportunity to investigate technical details of metalwork production in the Cypro-Archaic period. Analytical study of the life-history of the extraordinary sword from Tamassos Tomb 12 has led to a clearer understanding of the materials used to make it and how these were shaped and manipulated. Scientific analysis has also highlighted the technological complexity of the sword, providing clear evidence of cross-craft production; manufacture of the sword would have required a degree of communication and co-ordination between various craft specialists, such as the ivory carver, iron smith, and a scabbard maker. Regardless of whether it was produced to be used as a weapon, it was certainly a symbol of the status of its owner at the time of burial; with its shiny blade and impressive, silver-white hilt, the sword would have featured prominently amongst the burial goods deposited in Tomb 12.

This technological case study is, as far we are aware, the first to investigate a Cypriot iron sword and hilt structure using a comprehensive, multi-modal scientific analytical methodology. This approach – in particular, the application of micro-CT and SEM-EDS imaging and analysis – has revealed an unprecedented level of technological detail, contributing valuable data and evidence of metalworking practices used in the ancient Mediterranean. While there is currently a dearth of comparative technical data in the literature, there is great potential for future research. Comparative technological studies focussed on similarly composite, multi-metallic artifacts might, for example, lead to a better understanding of the tools and processes used to forge iron, clarify the role of tin in the application of decorative metalwork, or explain how silver-headed copper-alloy rivets were made and attached. Through exploring minute details of production, it may be possible to distinguish between local and regional making and metalworking practices, thus contributing to a deeper understanding

Acknowledgements

We dedicate this chapter to the late Christian Vonhoff, whose research on the Tamassos Tomb 12 sword and related weapons of the Mediterranean Bronze and Iron Ages inspired and fuelled our own work. We are also grateful to Dr Anastasia Christophilopoulou, Dr Jana Mokrišová, Professor Marcos Martinón-Torres, Professor Graham Treece and many others at the University of Cambridge and The Fitzwilliam Museum for their generous help and support.

Bibliography

Bell, D. (2016) Rivet-hole production in the Bronze Age. *Journal of Irish Archaeology* 25, 17–30.
Ben-Sholmo, D. and Dothan, T. (2006) Ivories from Philistia: Filling the Iron Age I gap. *Israel Exploration Journal* 56(1), 1–38.
Berger, D., Soles, J. S., Giumlia-Mair, A. R., Brügmann, G., Galili, E., Lockhoff, N. and Pernicka, E. (2019) Isotope systematics and chemical composition of tin ingots from Mochlos (Crete) and other Late Bronze Age sites in the eastern Mediterranean Sea: An ultimate key to tin provenance? *PLoS ONE* 14(6), e0218326 https://doi.org/10.1371/journal.pone.0218326 [accessed 1 March 2024].
Boardman, J. (1961) *The Cretan Collection in Oxford.* Oxford: Clarendon Press.
Catling, H. W. (1957) Bronze cut-and-thrust swords in the eastern Mediterranean. *Proceedings of the Prehistoric Society* 22, 102–125.
Christofilopoulou, A (2016) Re-examining the history of Cypriot antiquities in the Fitzwilliam Museum: A look at the collection's past and future. In G. Bourogiannis and C. Muhlenbock (eds), *Ancient Cyprus Today: Museum Collections and New Research*, 13–19. Uppsala: Studies in Mediterranean Archaeology and Literature Pocket-book 184.
Collon, D. (1982) Some bucket handles. *Iraq* 44, 95–101.
Erb-Satullo, N. L. (2019) The innovation and adoption of iron in the ancient Near East. *Journal of Archaeological Research* 27, 557–607.
Erb-Satullo, N. L. (2020) Archaeomaterials, innovation, and technological change. *Advances in Archaeomaterials* 1(1) 36–50.
Erb-Satullo, N. L. (2022) Towards a spatial archaeology of crafting landscapes. *Cambridge Archaeological Journal* 32(4), 567–583.
Gale, N. H. and Stos-Gale, Z. A. (2012) The role of the Apliki mine region in the post *c.* 1400 BC copper production and trade networks in Cyprus. In V. Kassianidou and G. Papasavvas (eds), *Eastern Mediterranean Metallurgy and Metalwork in the Second Millennium BC*, 70–82. Oxford: Oxbow Books.
Gale, N. H., Bachmann, H. G., Rothenberg, B. and Stos-Gale, Z. A. (1990) The adventitious production of iron in the smelting of copper. In B. Rothenberg (ed.), *The Ancient Metallurgy of Copper*,182–191. London: Institute for Archaeo-Metallurgical Studies, University College London.
Jansen, M., Hauptmann, A., Klein, S. and Seit, H.-M. (2018) The potential of stable Cu isotopes for the identification of Bronze Age ore mineral sources from Cyprus and Faynan: Results from Uluburun and Khirbat Hamra Ifdan. *Journal of Archaeological and Anthropological Sciences* 10, 1485–1502.
Jung, R. and Mehofer, M. (2008) A sword of Naue II type from Ugarit and the historical significance of Italian type weaponry in the eastern Mediterranean. *Aegean Archaeology* 8, 111–136.
Karageorghis, V. (1967) *Excavations in the Necropolis of Salamis. Salamis* Vol. 3. Nicosia: Department of Antiquities.

Karageorghis, V. (2000) *Early Cyprus. Crossroads of the Mediterranean.* Los Angeles CA: Getty Museum.

Karageorghis, V. (2002) La Nécropole 'royale' de Salamine: Quarante an après. *Cahiers du Centre d'Études Chypriotes* 32, 19–29.

Karageorghis, V., Mertens, J. R. and Rose, M. E. (2000) *Ancient Art from Cyprus. The Cesnola Collection in The Metropolitan Museum of Art.* New York: Metropolitan Museum of Art Publications.

Karageorghis, V., Vassilika, E. and Wilson, P. (1999) *The Art of Ancient Cyprus in the Fitzwilliam Museum Cambridge.* Nicosia: A. G. Leventis Foundation.

Kassianidou, V. (2009) May he send me silver in very great quantities. EA 35. In D. Michaelides, V. Kassianidou and R. S. Merrillees (eds), *Egypt and Cyprus in Antiquity*, 48–58. Oxford: Oxbow Books.

Kassianidou, V. (2012) The origin and use of metals in Iron Age Cyprus. In M. Iacovou (ed.) *Cyprus and the Aegean in the Early Iron Age. The Legacy of Nicolas Coldstream*, 229–259. Nicosia: Cultural Foundation of the Bank of Cyprus.

Kryzskowska, O. and Morkot. R. (2000) Ivory and related materials. In P. Nicholson and I. Shaw (eds), *Ancient Egyptian Materials and Technology*, 320–331. Cambridge: Cambridge University Press.

Lang, J. and Hughes, M. J. (1984) Soldering Roman silver plate. *Oxford Journal of Archaeology* 3(3), 77–107.

Lefferts, K. C. (1970) Technical examination of a Proto-Elamite silver figurine in the Metropolitan Museum of Art. *Metropolitan Museum Journal* 3, 15–24.

Lopes, F., Silva, R. J. C., Araújo, M. F., Correia, V. H., Dias, L. and Mirão, J. (2018) Micro-EDXRF, SEM-EDS and OM characterisation of tin soldering found in handle attachments of Roman *situlae* from *Conimbriga* (Portugal). *Microchemical Journal* 138, 438–446.

MacDonald, C. F. (1992) The iron and Bronze weapons. In V. Karageorghis, O. Picard, and C. Tytgat (eds), *La Necropole d'Amathonte. Tombes 113-367* VI, 43–99. Nicosia: Ecole Française d'Athènes Editions.

Maddin, R. (2011) The metallurgy of iron during the early years of the Iron Age. In P. P. Betancourt and S. C. Ferrence (eds), *Metallurgy: Understanding How, Learning Why: Studies in Honor of James D. Muhly*, 204–210. Philadelphia PA: INSTAP Academic Press.

Masson, O. (1964) Kypriaka I. Recherches sur les antiquités de Tamassos. *Bulletin de Correspondance Hellénique* 88, 199–238.

Matthäus, H. (2007) The Royal Tombs of Tamassos. Burial gifts, funeral architecture and ideology. *Cahiers du Centre d'Etudes Chypriotes* 37, 211–230.

Matthäus, H. (2014) Metal finds from the 'Royal Cemetery' of Tamassos. In V. Karageorghis, E. Poyiadji-Richter and S. Rogge (eds), *Cypriote Antiquities in Berlin in the Focus of New Research*, 103–135. Munster/New York: Waxmann.

McConchie, M. (2004) *Archaeology at the North-East Anatolian Frontier, V: Iron Technology and Iron Making Communities of the First Millennium BC.* Louvain: Peeters.

Molloy, B. (2010) Swords and swordsmanship in the Aegean Bronze Age. *American Journal of Archaeology* 114(3), 403–428.

Muhly, J. D. and Kassianidou, V. (2012) Parallels and diversities in the production, trade and use of copper and iron in Crete and Cyprus from the Bronze Age to the Iron Age. *British School at Athens Studies* 20, 119–140.

Muhly, J. D., Maddin, R. and Karageorghis, V. (eds) (1982) *Early Metallurgy in Cyprus, 4000-500 BC.* Nicosia: Pierides Foundation.

Muhly, J. D., Maddin, R., Stech, T. and Özgen, E. (1985) Iron in Anatolia and the nature of the Hittite iron industry. *Anatolian Studies* 35, 67–84.

Penniman, T. K. and Allen, I. M. (1960) A metallurgical study of four Irish Early Bronze Age ribbed halberds in the Pitt Rivers Museum, Oxford: A report to the Ancient Mining and Metallurgy Committee. *Man* 60, 85–89.

Sherratt, S. (1993) Commerce, iron and ideology: Metallurgical innovation in 12th–11th century Cyprus. In V. Karageorghis (ed.), *Cyprus in the 11th century BC*, 59–106. Athens: A. G. Leventis Foundation.

Sherratt, S. (2000) Circulation of metals and the end of the Bronze Age in the eastern Mediterranean. In C. F. E. Pare (ed.), *Metals Make the World Go Round: The Supply and Circulation of Metals in Bronze Age Europe*, 82–98. Oxford: Oxbow Books.

Snodgrass, A. M. (1980) Iron and early metallurgy in the Mediterranean. In T. A. Wertime and J. D. Muhly (eds), *The Coming of the Age of Iron*, 335–374. New Haven CO: Yale University Press.

Snodgrass, A. M. (1981) Early iron swords in Cyprus. *Report of the Department of Antiquities of Cyprus* 1981, 129–134.

Snodgrass, A. M. (1982) Cyprus and the beginnings of iron technology in the eastern Mediterranean. In Muhly *et al.* (eds), 285–294.

Socratous, M. A. (2019) Appendix: Analysis of wood specimens from Palaepaphos-Skales Tomb 277. In V. Karageorghis and E. Raptou, *Palaeopaphos-Skales Tomb 277*, 246–248. Stockholm: Svenska Institutet i Athen and Svenska Institutet i Rom.

Stech-Wheeler, T., Muhly, J. D., Maxwell-Hyslop, K. R. and Maddin, R. (1981) Iron at Taanach and early iron metallurgy in the eastern Mediterranean. *American Journal of Archaeology* 85(3), 245–268.

Stefani, E. and Volaris, Y. (2020) New evidence on the early history of the city-kingdom of Amathous: Built tombs of the Geometric Period at the site of Amathous-Loures. In A. Cannavò and L. Thély (eds), *Les royaumes de Chypre à l'épreuve de l'histoire: Transitions et ruptures de la fin de l'âge du Bronze au début de l'époque hellénistique*, 67–85. Athens: École française d'Athènes, new edition https://doi.org/10.4000/books.efa.2901 [accessed 13 March 2024].

Stos-Gale, Z. A. and Gale, N. H. (2010) Bronze Age metal artefacts found on Cyprus – metal from Anatolia and the western Mediterranean. *Trabajos de Prehistoria* 67 (2), 385–399 https://doi.org/10.3989/tp.2010.10046.

Vonhoff, C. (2013) Offensive weapons in Cypriot Early Iron Age elite burials (LC III B/CG) as indicators of autochthonous traditions and external cultural influences. *Pasiphae 7.* 193–204.

Vonhoff, C. (2019) Iron weapons from the Archaic Royal Tombs at Salamis. In S. Rogge, C. Ioannou and T. Mavrojannis (eds), *Salamis of Cyprus, History and Archaeology from the Earliest Times to Late Antiquity*, 177–194. Munster: Schriften des Instituts fur Interdisziplinare Zypern-Studien 13.

Vonhoff, C. (2021) The Silver-studded sword from Tamassos tomb 12 (Cypro-Archaic II) in the Cypriot Collection of the Fitzwilliam Museum, Cambridge – an Iron Age reflection of a Late Bronze Age hero burial. In G. Albertazzi, G. Muti and A. Saggio (eds), *Islandia - Islands in Dialogue*, 330–341. Rome: Artemide.

Waldbaum, J. C. (1982) Bimetallic objects from the eastern Mediterranean and the question of the dissemination of iron. In Muhly *et al.* (eds), 325–349.

Waldbaum, J. C. (1999) The coming of iron in the eastern Mediterranean: Thirty years of archaeological and technological work. In V. C. Pigott (ed.), *The Archaeometallurgy of the Asian Old World*, 27–57. Philadelphia PA: University of Pennsylvania Museum.

Wertime, T. A. and Muhly, J. D. (eds) (1980) *The Coming of the Age of Iron*. New Haven CO-London: Yale University Press.

Wood, J. R., Montero-Ruiz, I. and Martinón-Torres, M. (2019) From Iberia to the southern Levant: The movement of silver across the Mediterranean in the Early Iron Age. *Journal of World Prehistory* 32(1), 1–31.

Zwicker, U., Oddy, A. and La Niece, S. (1993) Roman techniques of manufacturing silver-plated coins. In S. La Niece and P. T. Craddock (eds), *Metal Plating and Patination: Cultural, Technical and Historical Development*, 223–246. Oxford: Butterworth-Heinemann.

Chapter 6

Island metallurgy: A case study of two Early Bronze Age toggle pins from the Cypriot Collection of the Fitzwilliam Museum

Jana Mokrišová, Susanna Pancaldo, and Ema Baužytė

The Being an Islander *project comprised several distinct sub-projects, one of which focused on ancient metallurgy and its links to island lifeways. Through an interdisciplinary study combining insights from archaeology, archaeometallurgy, and conservation, this research strove to elucidate relationships between objects, materials, and technologies and their relationship to the mobility and interaction of people. While 30 metal objects were examined closely as part of the research initiative, this contribution demonstrates the underlying method, applied to the case study of two toggle pins from Early Bronze Age Tomb 84 from Vounous on Cyprus. The pins were examined with a variety of scientific investigative methods (including stereomicroscopy, 3D microscopy, X-ray computed tomography, and X-ray fluorescence) to reconstruct the chaîne opératoire of their production. New insights include the elemental composition, reconstruction of the casting and decorating processes, and documentation of the mineralised thread wrapped around the pins. Overall, we believe that the pins were foreign-made and most probably fashioned in Anatolia, attesting to Vounous's elite connections during the Early Cypriot I–II periods.*

Introduction

A core objective of the Fitzwilliam Museum's *Being an Islander* research project was to offer a critical re-examination of the concept of island life and to investigate aspects of the methods of production and use of material culture from Cyprus, Crete, and Sardinia in a series of distinct sub-projects. This chapter presents some of the results of a research initiative specifically focused on the study of metallurgy from Cyprus.

Objects worked from various metals (primarily copper-alloy, iron, gold, and silver) and in various forms (weapons, tools, vessels, symbolic and cultic objects, as well as jewellery) were integral to ancient societies. Yet often a focus on typology, chronology,

and the provenance of materials of objects can be limiting. Our team therefore embarked upon an interdisciplinary programme of analyses aiming to understand not only the aspects of typologies and provenance, but also the manufacture and manipulation of metal artefacts in the past. Our aim was to elucidate relationships between materials and technologies and mobility and interaction of people, as outlined by the scope of the *Being an Islander* project (described in the introduction to this volume). As objects from Cyprus are particularly well represented in the collections of the Fitzwilliam Museum, conservation and scientific research focused primarily on metalware from this island. Close interrogation of individual objects allowed us to examine fundamental questions about connections between ways of making, the use of metal objects in everyday life and as part of funerary rites, as well as tools in expressing different types of identities.

The Fitzwilliam collection comprises over 180 metal objects from the island of Cyprus. Chronologically, these items span the Early Bronze Age (EBA) to the Roman period (ca. late 3rd millennium BC to 4th century AD). Most of them are made of copper-alloys and gold, followed by silver, lead, and iron. They can be divided into the following major functional categories: jewellery and items of personal adornment (e.g., bracelets, diadems, earrings, fibulae, pins, rings); weapons and tools (e.g., axes, daggers, spearheads, swords); utensils (e.g., candelabra, spatulas, spoons, tweezers); and figurines. Most of the objects were bequeathed to the Museum in the 19th and early 20th centuries and come primarily from Leondari Vouno, Vounous, and Tamassos, in addition to Marion and Paphos.

An initial conservation assessment of the Cypriot metals collection was undertaken to determine each object's condition and to plan any conservation treatment work necessary to prepare the collection for further research and possible display. At this stage, we noted interesting technological features which might be explored through scientific investigation and considered the degree to which our investigations might be inhibited by the condition of the objects – whether due to effects of archaeological burial, past conservation treatment, or other factors. We also gathered documentation about each object from the museum's records and from published literature.

Based on the results of this preliminary work and taking into consideration the desire to illustrate relevant aspects in the history of Mediterranean metallurgy from the EBA to the Roman period for the *Being an Islander* exhibition, 30 objects were selected from the collection for in-depth study. We then embarked on a programme to uncover the fullest 'biography' possible for each object, focusing on the choice of materials and methods of manufacture used by ancient metalsmiths. A variety of scientific investigative methods were employed in our research, including stereomicroscopy, 3D microscopy, X-ray computed tomography, X-ray fluorescence, and, for the study of an exceptional Cypriot Iron Age sword (Pancaldo *et al.*, this volume Chapter 5), micro-CT and SEM-EDS analysis.

In this chapter, we demonstrate our approach to the study of the Fitzwilliam's Cypriot metals collection by presenting a case study of two copper-alloy toggle pins

from the EBA cemetery at Vounous (for discussion on the misleading term 'toggle pin', see Henschel-Simon 1937, 169–170; Prell 2020, 495). These pins are rare finds dating to the Early Cypriot (EC) I period in Cyprus. Our investigations into the origins of the pins – from the raw metal used to make them to the application of various metalworking processes and a consideration of how the pins might have been used in ancient times – has afforded an opportunity to shed light on the ways of life of people and communities living on Cyprus's northern coast at the dawn of the Bronze Age.

Early Bronze Age Cyprus and metals – a brief overview

During the EBA, connections formed between communities along Cyprus's northern coast, Cilicia (southern Anatolia), and the Levant (Syro-Palestine), especially in its earliest phases (Knapp 2008; 2009; Gernez 2011, 331–332; Webb 2017, 129). Copper-alloys were increasingly worked on Cyprus during this period, but the island produced a relatively limited range of objects (weapons, tools, and personal items), at least in comparison to south-eastern Anatolia (Catling 1964; Philip 1991, 98). Yet copper-alloy objects were quite widespread in burial assemblages, suggesting a relatively good access to metal resources. While tin – either as part of minerals, semi-finished (ingots), or finished products (scrap material or fully preserved) – had reached Cyprus already in the EBA from Anatolia or northern Mesopotamia (Pigott 2011, 277–278; Bachhuber 2015), most of the objects produced on the island consisted of unalloyed or arsenical copper (Weinstein Balthazar 1990, 73 and 161; Webb *et al.* 2006; Webb 2018). In north Cyprus, most of the evidence for developments in metallurgy during this period comes from burial assemblages of extensive cemeteries such as Vounous and Lapithos, which have been recently examined by Laoutari (2023; see also Keswani 2004, 37–38).

Case study: toggle pins from Vounous Tomb 84

The cemetery of Vounous is located 2 km north-east of the modern village of Bellapais in the north-central coast. The chamber tombs were dug into the northern slope of hills rising not too far from the coast and the plateau on which they are located is delineated by ravines on the east and west. A deep valley separates this area from the lower northern slopes of the Kyrenia mountain range that dominates much of the northern part of the island. The extensive EBA cemetery was first excavated by P. Dikaios, the curator of the Cyprus Museum, followed by an excavation season in collaboration with C. F. Schaeffer, on behalf of the Louvre, in the early 1930s after reports of extensive looting at the site (Dikaios 1940). In 1937, J. R. B. Stewart directed the excavations sponsored by the British School at Athens (Stewart and Stewart 1950).

The excavated area consists of two zones, the date of which can be roughly assigned to the EC and the Middle Cypriot (MC) periods (ca 2200–1700 BC). The

chronologically earlier Site A (EC I–II) was located in the eastern extent of the site and excavated exclusively under J. R. B. Stewart's directorship. The chronologically later Site B (EC II–MC II), in the north-western extent, was dug primarily by the Cyprus Museum and the Louvre (Dikaios 1940). The cemetery fell out of use during the Middle Bronze Age (MBA), when Lapithos rose as the primary centre in the region, coinciding with the re-emergence of long distance maritime trade and increase in deposition of metal objects (Webb 2017, 132–135). Most of the tombs were oriented north–south and consisted of an entryway (*dromos*), a narrow entrance (*stomion*) and the tomb chamber. The amount and range of burial goods fluctuated between individual chamber tombs. Assemblages contained primarily pottery (polished bowls, storage jars, jugs, and pouring vessels) and only about half of the excavated tombs had metals (primarily knives and axes; Dikaios 1940; Stewart and Stewart 1950; Dunn-Vatouri 2003; Keswani 2004, 42–43).

Altogether, Stewart's team excavated 81 tombs ranging in date from EC I to EC III (which he dated to 2450–2000 BC). A part of the excavated objects was gifted to the collection of the Fitzwilliam Museum in 1939 by Stewart. This included two toggle pins GR.5i.1939 and GR.5j.1939 (Fig. 6.1), which were briefly published in 1940 by Stewart (1940, 204) and are now on display in the Museum. As with all of Stewart's bequest, the toggle pins have known provenance; they were found in Chamber Tomb 84 in Site A.

Tomb 84 dates to the EC Ia or early Ib period (currently dated to ca. 2400–2250 BC; Stewart and Stewart 1950, 62–65). The tomb had an oval chamber with rounded corners and vertical walls. The floor sloped toward north and was irregular rather than flat. It contained two bodies; one in the centre of the room lying parallel to the door and another placed to the left, closer to the *stomion*. Like many of the tombs on the site, the chamber had been disturbed by flooding episodes, which displaced the remains from their original location. The burial assemblage consisted of 32 vessels and two toggle pins. As available contextual information diminished because of post-depositional processes, the publication attributed the assemblages to the central burial as opposed to the body positioned closer to the *stomion*. The deceased was found in a crouched position, resting on their left side, with the two pins found on either shoulder, the pointed tips of the pins oriented toward the wearer's head (Stewart and Stewart 1950, 62–64; see also Douglas 2019, 246).

Three other burials at Vounous contained pins, two of which were found in similar position (Stewart 1940, 205). Although a rare object type in Cyprus in this early phase, toggle pins were found widespread throughout the Bronze Age at sites across Anatolia, Mesopotamia, and the Levant (Henschel-Simon 1937; Klein 1992; Prell 2020). Significantly, the object type also proliferated at the nearby Cypriot north coast site of Lapithos after the ECII period (Charalambous and Webb 2020).

In what follows we present a detailed description of the two pins found in Tomb 84 and the results of our investigations into the materials and methods of their manufacture.

6. Island metallurgy

Figure 6.1. The two toggle pins from Vounous Tomb 84, in the collection of The Fitzwilliam Museum (GR.5i.1939 and GR.5j.1939; © The Fitzwilliam Museum 2023).

Shape and form

The toggle pins have simple, nail-like forms. They measure 14.30 cm and 14.35 cm in length respectively (GR.5i.1939 = Stewarts' 84.29; GR.5j.1939 = Stewart's 84.30) and have roughly dome-shaped heads, each about 1.0 cm wide. The pinheads slightly overhang the funnel-shaped tops of the pin-shafts. The shafts taper to a point and are approximately circular in cross-section all along their lengths, except in the vicinity of the toggle holes. Here, the shafts bulge in concordance with the oval-shaped holes, or eyelets, positioned close to the top of the pin-shafts. The pin-shafts have decorative markings above and below the eyelets. The markings on the two pins are similar but not the same. Sets of recessed, thin horizontal bands are interrupted by a wide band with a single 'X' (in the case of GR.5i.1939) and two 'X' shapes (GR.5j.1939). The bands of fine lines give the impression of wrapped thread and the 'X's suggest crossed threads. A significant feature found on both toggle pins is the remains of mineralised thread, wrapped in and around each toggle hole. Stewart interpreted these as being made of wire, whereas Weinstein Balthazar (1990, 126) identified these as mineralised thread. The latter interpretation is now generally accepted and discussed further below.

Composition of the metal

In reconstructing possible steps taken in the manufacture of the toggle pins, the first matter to consider is the chemical composition of the metal from which they were made. Compositional analysis can determine the purity of the copper metal and sometimes reveal whether alloying has taken place, or whether metal from a particular ore source was chosen, perhaps to achieve certain working properties; particular amounts of arsenic and/or tin, for instance, will increase the hardness of the metal and can affect its appearance. Analysis of the chemical composition of the metal can also sometimes provide clues as to the source of ore from which it was extracted.

88 Jana Mokrišová, Susanna Pancaldo, and Ema Baužytė

Table 6.1. XRF results showing percentage of metallic elements present in each of the two toggle pins.

	Cu	Sn	Zn	Pb	As	Fe	Ni	Sb	Ag	Sum
GR.5i.1939	97.06	1.04	0.00	0.23	1.01	0.08	0.20	0.21	0.05	99.87
GR.5j.1939	97.98	0.81	0.00	0.27	0.57	0.00	0.08	0.15	0.02	99.89

Chemical analysis was undertaken at the Fitzwilliam Museum using XRF. Our results, provided in Table 6.1, show that the toggle pins are made of largely pure copper with only minor or trace amounts of other metallic elements. The non-copper elements – iron, nickel, arsenic, silver, tin, lead – are present in small concentrations at around, or less than, 1% (by weight).[1]

Extensive lead isotope analyses of copper ore sources – on Cyprus as well as surrounding regions of the Mediterranean and beyond – and studies on the compositions of EBA copper-alloy objects found on Cyprus, allow us to consider the chemical compositions of the Vounous Tomb 84 toggle pins in context (for example, Stos-Gale and Gale 2010; Webb 2018; Charalambous and Webb 2020; see also Craddock 1981). It is known that arsenic (As) is generally not found in Cypriot ore, except for very small percentages found in polymetallic ores from the Limassol Forest region, on the south-east side of the island (0.5–7.6 wt%; Charalambous and Webb 2020, 4). The detection of small amounts of As in the two toggle pins (1.01% and 0.57%) therefore raises several possibilities: that they may have been made from metal (1) extracted from ore from the Cypriot Limassol region (although there is very little evidence for the use of this resource in this earliest phase of the EBA; Webb 2018, 8); (2) extracted from a non-Cypriot ore (perhaps from Anatolia; Stos-Gale and Gale 2010, 395); or (3) made from recycled metal which contained metal from a non-Cypriot ore. Tin (Sn) is never found in Cypriot ore (Stos-Gale and Gale 2010, 392) and so its presence in the toggle pins can only be explained by the use of at least some metal from a foreign ore source. At low concentrations of 1.04% and 0.81%, however, the question of whether Sn was deliberately added or present unintentionally is also not easy to answer (as also suggested by Charalambous and Webb 2020, 10).

While the small quantities of As and Sn detected in the pins might have been noticeable to metalworkers in terms of appearance and properties, they are not of high enough concentration to argue definitively about whether their presence was intentional – i.e., they were deliberately added to make an alloy – or not (Charalambous and Webb 2020, 10). These quantities of As and Sn, as well as that of the other non-copper metallic elements detected in the pins, can more readily be attributed to natural impurities in metal extracted from a non-Cypriot ore.

To investigate the sources of metal ores used in the production of BA metal artefacts found on Cyprus, Stos-Gale and Gale undertook lead isotope analysis on a large number of metal artefacts (Stos-Gale and Gale 2010). These studies

have shown that while most finds from the earliest phases of the EC were made of copper metal extracted from Cypriot ore, those made from non-Cypriot ores were almost always made of copper extracted from ore sources in the Taurus Mountains of Anatolia (Stos-Gale and Gale 2010, 392). Lead isotope analysis of the two toggle pins from Vounous Tomb 84 was out of the scope of our research but, given the fact that the pins are both stylistically and technologically similar to toggle pins from regions in Anatolia and the Levant (discussed below) and, more broadly, the fact that there is ample evidence in the archaeological record illustrating the close cultural and economic ties at this time between inhabitants of the north coast of Cyprus and those of coastal Anatolia, only 100 km away by sea (Stos-Gale and Gale 2010, 391; see also Knapp 2008; Gernez 2011, 331–332; Webb 2017, 129 for the preceding Philia phase; we view this connection as a prolonged phenomenon that did not completely disappear in EC I=II, *contra* Webb 2017, 131), it is not surprising that the toggle pins have long been considered to be foreign imports (Stewart 1940, 205–208; Catling 1964, 70, n 1; 72; Weinstein Balthazar 1990, 73, 161; Webb 2018, 11).

Shaping and finishing the metal

X-ray CT images of the pins show that the heads and shafts are integral to one another. We could find no definitive evidence for casting nor finishing of the metal objects at this time; these could only be determined definitively through destructive metallographic analysis which was deemed unacceptable for these objects.

Technological comparison with stylistically similar toggle pins found in EBA and MBA contexts from Anatolia, the Levant, and Mesopotamia, however, offer insights. Metallographic studies of toggle pins from these regions show that at least some examples were made by casting, with open moulds, part-moulds, and moulding using lost-wax techniques all cited as possibilities (Khalil 1980; Klein 1992, 231–232; Selover 2010, 148; Shalev 2010, 47; Prell 2020, 497). Additionally, a large number of clay and stone moulds for the production of metal pins have been found across the region in Bronze Age contexts, with at least one an open mould for making toggle pins (Selover 2010, 148; Prell 2020, 497, n 33). Metallographic studies on Bronze Age pins also indicate that cast pins were sometimes further shaped through varying amounts of both cold working and annealing (Selover 2010, 154; Shalev 2010, 47).

The highly pure copper-alloy metal used to make the two Vounous toggle pins would have been quite soft and malleable and correction of any flaws that might have formed during casting could have been erased through further working. A notable feature, visible especially on GR.5i.1939 under magnification, is the presence of fine, parallel grooves or scratches, oriented in sections along the lengths of the pin's surface (Fig. 6.2).

It is unclear what may have caused these striations. The pattern could have formed during manufacture due to a coarsely finished surface on the interior of a casting mould. Equally, it may have been due to metal finishing processes post-casting, such as

Figure 6.2. 3D microscope image showing surface striations on GR.5i.1939 (© The Fitzwilliam Museum 2023).

Figure 6.3. Detail of the eyelet of pin GR.5j.1939, taken with a Dino-Lite digital USB microscope (© The Fitzwilliam Museum 2023).

sanding or polishing of the pin shaft. As the pattern seems to have been accentuated by subsequent corrosion processes in the archaeological burial environment, it seems integral to the pin's corrosion layers.

Methods for producing the holes, or eyelets, in these toggle pins allow further consideration of the working methods of ancient metalsmiths. It is possible that the eyelets were made, or partially made, during initial casting (already proposed by Stewart 1940, 205). Close inspection under magnification shows that the interiors of the holes are slightly concave (Fig. 6.3). This raises the possibility that a pebble or ball of clay was used to initially create the holes during casting, perhaps during a lost-wax casting. Alternatively, or in addition, the metalsmith may have made the holes by simply punching through the metal shafts after casting (Klein 1992, 236; Selover 2010, 148) and a tool then used to smooth and possibly shape the interior of the eyelets.

However they were formed initially, it is clear that the holes were shaped and expanded in both lateral and vertical directions after the pin-shafts were formed. The exterior surfaces of the pin-shafts bulge in correspondence with the shape of the oval slit-eye holes, indicating outward pressing from the interior sides of the toggle holes. Vertical notches visible at the top and bottom edges of the holes suggest a flat chisel or file was used, perhaps initially in punching the hole, and/or to shape and/or enlarge them. Widening of the toggle hole may have been accomplished with the addition of heat to make the metal more malleable, although, as noted above, this might not have necessarily been the case (Selover 2010, 148).

The decorative patterns found above and below the eyelets also provide an interesting technological case study (Fig. 6.4). The fine horizontal bands and 'X's

Figure 6.4. Detail of decorative pattern above the eyelet of GR.5i.1939, taken with a Dino-Lite digital USB microscope (© The Fitzwilliam Museum 2023).

Figure 6.5. Image showing twisted, mineralised plant-fibre strands of thread on GR.5j.1939; remains of burial dirt and post-excavation wax treatment are also visible here. Image taken with a Dino-Lite USB microscope (© The Fitzwilliam Museum 2023).

found above and below the eyelets might have been made as part of a casting process; the delicate precision with which these were made suggests that actual thread might have been used in making the pattern, perhaps by wrapping around a wax model which was then invested in clay and formed, as in a lost-wax casting method. After casting, further delineation of the pattern might then have been undertaken using a fine-point tool such as an awl or pointed chisel. However, the condition of the pins does not allow unequivocal interpretation.

Thread

Still attached to each eyelet are the remains of twisted, mineralised thread. Stewart (1940) identified these as extant wire but examination using high magnification microscopy shows that these are most likely pseudomorphs of a textile-based thread; thin fibrous strands can be seen to be twisted together to form the elements (Fig. 6.5).

The pins and their threads were examined by textile expert Dr Giulia Muti, who noted that the pseudomorph fragments in and/or around the eyelets all measure around 0.5–0.8 cm in length and 0.1–0.2 cm in diameter, and one of the fragments (GR5j.1939) appears to possibly have a knot in it (Muti 2022; pers. comm.).

Although a rarely preserved feature, the presence of threads in the eyelets of the toggle pins is not surprising as, in fact, the main purpose of the eyelet was most probably to enable the pin to be securely attached to a garment, either permanently or semi-permanently (Prell 2020, 495–497, 524). Rare instances from Cyprus in which toggle pins have been found still attached to textile or thread confirm these practices (Muti 2020).

Use and re-use of the objects in a burial context

Like many of the tombs from Vounous Site A, Tomb 84 had been disturbed over the years by episodes of flooding which had somewhat displaced the remains in the tomb from their original locations. Nevertheless, the excavators (Stewart and Stewart 1950, 62–64) attributed the assembled finds – including the two toggle pins – to the central burial in the tomb (see above for description of the burial).

Toggle pins have been found in a similar position and orientation in Bronze Age burials across the Near East and it has long been suggested that these were used to fasten mortuary clothing. S. Douglas's extensive research on Cypriot burial practices in the EBA and MBA has recently shed light on the function of both plain and toggle pins found in burial contexts (Douglas 2019, 235–257). She (2019, 240–242) and M. Marcus before her (1994, 3–15), suggested that the relative lengths of toggle pins found in burials may, in fact, point to different functions, with shorter pins (<13 cm) generally used to fasten funerary garments and longer pins (>13 cm) used for wrapping the dead in a shroud (see also Muti 2022). Both short and long metal pins have been found in EC and MC cemetery contexts at Vounous and Lapithos, suggesting that differing practices of dressing and wrapping the deceased might have been in use simultaneously at these cemeteries (Douglas 2019, 241–259).

Douglas categorises the two toggle pins found in Vounous Tomb 84 as short pins (despite their being just over 14 cm in length; 2019, 241–242). Found at the deceased's shoulders, the pins would likely have served as decorative fasteners for a textile garment, or possibly for a shroud, which would have been extended over the shoulders (Douglas 2019, 241; Muti 2020). The Tomb 84 toggle pins might thus be one of the earliest pieces of evidence testifying to this burial practice in Cyprus (Muti 2022).

While it seems clear that the deceased was interred with these toggle pins, it is intriguing to consider whether they might also have been worn in the wearer's lifetime, either for special occasions or on a regular basis. Further questions arise: did the person own the pins in their lifetime? Were they a personal gift or an item signifying social or political prestige, perhaps presented by survivors at the time of burial? We will, of course, probably never know but toggle pins were rare. It is more feasible, then, that they were prestigious objects at the time that they were buried with the deceased, and therefore it is likely that the person was of a high social status and/or one whose funerary rites were significant to the survivors.

The burial environment

The condition of the toggle pins reflects the nature of their archaeological burial environment at Vounous. Stewart noted that Tomb 84, as all burials from Site A, had been subjected to 'hydraulic action' (1940, 204). While in sound structural condition, both toggle pins have a pitted greenish-brown corrosion layer lying over a compact, dark layer embedded in the remaining metal core. While striations on the pin-shaft, visible on GR.5i.1939, may have been caused during manufacturing processes (as noted above), the main cause of corrosion and pitting is likely the fluctuation in the wet conditions in the tomb. The Fitzwilliam Museum collection has four dagger blades (GR.5m.1939, GR.5n.1939, GR.5o.1939, and GR. 5.r.1939) and three straight pins (GR.5l.1939, GR.5k.1939, and GR.8.1939) also excavated from ECI–II tombs at Vounous with similarly pitted and mottled-looking surfaces.

Conservation and care

The two toggle pins from Tomb 84 have survived remarkably well in the 85 years or so since their excavation. No museum records have been found which might have recorded their conditions and any interventive treatments over the years. Like most of the Cypriot archaeological metal objects in the Fitzwilliam Museum's collection, the pins have minor traces of burial dirt on their surfaces and traces of a thinly applied layer of wax applied at some point after excavation. The condition of the pins appears largely unchanged compared to photographs published by Stewart soon after excavation (1940, pl. ii), except for a few minute spots of light green corrosion around the eyelet area of GR.5i.1939. Care must be taken in future to minimalise handling of the pins and to continue to keep them in a stable environment.

Conclusions

While our investigation of the two metal toggle pins from Vounous Tomb 84 has provided limited new information about the manufacture of these rare objects, as a case study, our research was able to shine a light on metallurgical practices and the production and use of metal objects at the beginning of the EBA on the north coast of Cyprus. Our work resulted in new analyses of the chemical compositions of both toggle pins, confirming that they are unlikely to have been produced using only metal procured from a Cypriot ore source. It had been previously suggested that the toggle pins were foreign-made, and this was supported by stylistic comparisons with excavated examples of metal pins found in EBA contexts from sites in Tarsus in Cilicia (southern Anatolia) and the Levantine coast (for parallels see Goldman 1940; Egeli and Yalçın 1995; Iamoni 2012). New, high-resolution microscopy also allowed a clearer understanding of the nature of the tools used by ancient metalsmiths to shape the eyelets of the pins and to enhance (if not fully create) the decorative patterns. Overall, this work has allowed a reconstruction of the *chaine operatoire* of toggle pin manufacture, ultimately contributing to a fuller understanding of Cypriot preferences

for mortuary display in the EC period, and aspects of the identities of those interred in Vounous Tomb 84.

This research also underscores the value of an interdisciplinary approach to the study of ancient metallurgical practices within a museum setting. The broad scope of the *Being an Islander* project advocated a pragmatic, multidisciplinary approach, and our research benefitted from collaborative work of an archaeologist, a conservator, and an archaeological scientist. This, and further, case studies afforded an opportunity to consider a range of aspects of ancient material culture, from the nature of metallurgical practices to expressions of identities in a burial context, highlighting the value of integrating scientific and technical approaches to the material within the context of a public-facing exhibition. Close interrogation of the Cypriot metal objects in the Fitzwilliam Museum allowed a fresh look at the collection and contributed to our understanding of the relationships between Cyprus and its neighbours, whilst also addressing fundamental questions about connections between island identities, ways of making and the use of metals, for instance, in everyday life, as items of exchange and as symbolic elements of funerary practice. Although archaeological museum objects can be somewhat orphaned, having come into collections either as single items or in small groups, and often separated from their original assemblages, analytical research helps re-associate these with their original settings and to consider them more holistically, highlighting their wider value in archaeological and historical research.

Notes

1 The results were obtained using Bruker ARTAX micro-XRF instrumentation. The instrument was calibrated using CHARM copper standard set following procedures outlined by Heginbotham *et al.* (2014) and Heginbotham and Solé (2017). The results were normalised to a 100% and the most significant elements are reported in Table 6.1. Corrosion-free areas of metal were targeted but no special cleaning to expose metal surfaces took place. For a discussion on possible pitfalls using surface XRF, see discussion in Charalambous and Webb (2020, 3). Object GR.5j.193 was previously analysed and results are reported by Weinstein Balthazar (1990, 418), suggesting composition of Cu – main, As – 0.02, Sn – 2.0, Pb – 0.05, ZN – 0 wt%. Difference in analytical output is likely due to difference in analytical techniques used, effect of corrosion, and location of the sample on the object.

Bibliography

Bachhuber, C. (2015) The Anatolian context of Philia material culture in Cyprus. In A. Knapp and P. Van Dommelen (eds), *The Cambridge Prehistory of the Bronze and Iron Age Mediterranean*, 139–156, Cambridge: Cambridge University Press doi:10.1017/CHO9781139028387.012.

Catling, H. W. (1964) *Cypriot Bronzework in the Mycenaean World*. Oxford: Clarendon Press.

Charalambous, A. and Webb, J. M. (2020) Metal procurement, artefact manufacture and the use of imported tin bronze in Middle Bronze Age Cyprus. *Journal of Archaeological Science* 113, 105047 https://doi.org/10.1016/j.jas.2019.105047.

Craddock, P. T. (1981) Report on the composition of metal tools and weapons from Ayia Paraskevi, Vounous and Evreti, Cyprus. In *A Catalogue of Cypriot Antiquities in the Birmingham Museum and Art Gallery*, 77–78. Birmingham: Birmingham City Museum and Art Gallery.

Dikaios, P. (1940) *The Excavations at Vounous-Bellapais in Cyprus, 1931–2. Archaeologia 88.*

Douglas, S. (2019) Beyond Gender and Status: Rethinking the Burial Record of Bronze Age Cyprus (2500–1340 BC). Unpublished PhD thesis, University of Manchester.

Dunn-Vaturi, A.-E. (2003) *Vounous: C. F. A. Schaeffer's Excavations in 1933: Tombs 49–79.* Jonsered: Paul Åströms.

Egeli, H. G. and Yalçın, Ü. (1995) The metal pins from eastern and southeastern Anatolia during the third and the beginning of the second millennium BC. In G. Arsebük, M. J. Mellinek and W. Schirmer (eds), *Halet Çambel için, prehistorya yazıları, Readings in Prehistory. Studies Presented to Halet Çambel*, 175–216. Istanbul: Graphis.

Gernez, G. (2011) The exchange of products and concepts between the Near East and the Mediterranean: The example of weapons during the Early and Middle Bronze Ages. In K. Duistermaat and I. Regulski (eds), *Intercultural Contacts in the Ancient Mediterranean*, 327–341. Leuven-Walpole WA: Peeters.

Goldman, H. (1940) Excavations at Gözlü Kule, Tarsus, 1938. *American Journal of Archaeology* 44(1), 60–86.

Heginbotham, A. and Solé, V. A. (2017) CHARMed PyMca, part I: a protocol for improved inter-laboratory reproducibility in the quantitative ED-XRF analysis of copper alloys. *Archaeometry* 59, 714–730. https://doi.org/10.1111/arcm.12282.

Heginbotham, A., Bassett, J., Bourgarit, D., Eveleigh, C., Glinsman, L., Hook, D., Smith, D., Speakman, R. J., Shugar, A. and Van Langh, R. (2014) The copper CHARM set: A new set of certified reference materials for the standardization of quantitative X-Ray fluorescence analysis of heritage copper alloys. *Archaeometry* 57, 856–868 https://doi.org/10.1111/arcm.12117.

Henschel-Simon, E. (1937) The 'toggle-pins' in the Palestine Archaeological Museum. *Quarterly of the Department of Antiquities in Palestine* 1936–1937(6), 169–209.

Iamoni, M. (2012) Toggle pins of the Bronze Age: a matter of style, function and fashion? In G. B. Lanfranchi, D. M. Bonacossi, C. Pappi and S. Ponchia (eds), *Leggo! Studies Presented to Frederick Mario Fales on the Occasion of His 65th Birthday*, 349–363. Wiesbaden: Harrassowitz.

Keswani, P. (2004) *Mortuary Ritual and Society in Bronze Age Cyprus.* London: Monographs in Mediterranean Archaeology.

Khalil, L. A. H. (1980) The Composition and Technology of Copper Artefacts from Jericho and Some Related Sites. Unpublished PhD thesis, University of London.

Klein, H. (1992) *Untersuchung zur Typologie bronzezeitlicher Nadeln in Mesopotamien und Syrien.* Saarbrücken: Saarbrücker Druckerei und Verlag.

Knapp, A. B. (2008) *Prehistoric and Protohistoric Cyprus: Identity, Insularity, and Connectivity.* Oxford-New York: Oxford University Press.

Knapp, A. B. (2009) Metallurgical production and trade on Bronze Age Cyprus: Views and variations. In V. Kassianidou and G. Papasavvas (eds), *Eastern Mediterranean Metallurgy and Metalwork in the 2nd Millennium B.C.*, 14–125. Oxford: Oxbow Books.

Laoutari, R. (2023) There is This Island: Social Dynamics and Connectivity in Prehistoric Bronze Age Cyprus. Unpublished PhD thesis, University of Cambridge.

Marcus, M. (1994) Dressed to kill: Women and pins in early Iran. *Oxford Art Journal* 17(2), 3–15.

Muti, G. (2020) Tracing Ancient Textiles: Production, Consumption and Social Uses in Chalcolithic and Bronze Age Cyprus (2800–1450 BC). Unpublished PhD thesis, University of Manchester.

Muti, G. (2022) Comment on the significance of pins T. 84. 29 (GR.5i.1939) and T.84.30 (GR.5j.1939) from the viewpoint of textiles. Cambridge: unpublished Record Sheets and Notes, Fitzwilliam Museum.

Philip, G. (1991) Cypriot bronzework in the Levantine world: Conservatism, innovation, and social change. *Journal of Mediterranean Archaeology*, 59–107.

Pigott, V. (2011) Sources of tin and the tin trade in southwest Asia: recent research and its relevance to current understanding. In P. P. Betancourt and S. C. Ferrence (eds), *Metallurgy: Understanding*

How, Learning Why: Studies in Honor of James D. Muhly, 273–292. Philadelphia PA: INSTAP Academic Press.

Prell, S. (2020) Hard to pin down: Clothing pins in the eastern delta of Egypt and their diffusion in the Middle Bronze Age. *Ägypten und Levante/Egypt and the Levant* 30, 495–533.

Selover, S. (2010) Metallurgical analysis of clothing pins from the 2004 season. In K. A. Yener (ed.), *Tell Atchana, Ancient Alalakh. Volume 1: The 2003-2004 Excavation Seasons,* 147–159. Istanbul: Koç University.

Shalev, S. (2010) The metal objects from Fassuta. '*Atiqot* 62, 43–49.

Stewart, E. and Stewart, J. R. B. (1950) *Vounous 1937-38: Field-report on the Excavations Sponsored by the British School of Archaeology at Athens.* Lund: Gleerup.

Stewart, J. R. B. (1940) Toggle pins in Cyprus. *Antiquity* 14, 204–209.

Stos-Gale, Z. A. and Gale, N. (2010) Bronze Age metal artefacts found on Cyprus – metal from Anatolia and the western Mediterranean. *Trabajos de Prehistoria* 67(1), 385–399 https://doi.org/10.3989/tp.2010.10046.

Webb, J. M. (2017) Vounoi (Vounous) and Lapithos in the Early and Middle Bronze Age: a reappraisal of the central north coast of Cyprus in the light of fieldwork and research undertaken since 1974. In D. Pilides and M. Mina (eds), *Four Decades of Hiatus in Archaeological Research in Cyprus: Towards Restoring the Balance* 2, 128–139. Vienna: Holzhausen.

Webb, J. M. (2018) Shifting centres: Site location and resource procurement on the north coast of Cyprus over the longue durée of the prehistoric Bronze Age. In *Central Places and Un-Central Landscapes: Political Economies and Natural Resources in the Longue Durée. Land* 7(2) Special Issue 64, 40–69 https://doi.org/10.3390/land7020064.

Webb, J. M., Frankel, D., Stos, Z. A. and Gale, N. (2006) Early Bronze Age metal trade in the eastern Mediterranean. New compositional and lead isotope evidence from Cyprus. *Oxford Journal of Archaeology* 25(3), 261–288.

Weinstein Balthazar, J. (1990) *Copper and Bronze Working in Early through Middle Bronze Age Cyprus.* Gothenburg: Studies in Mediterranean Archaeology and Literature Pocket-book 84.

Chapter 7

Insularity and Mediterranean networks in the collections of the National Museums of Cagliari from prehistory to the contemporary age

Francesco Muscolino

This chapter turns our enquiry to the relevance and representation of museum collections in the field of Mediterranean island archaeology and the degree to which the formation, interpretation, and analysis of these collections has shaped the discipline. The chapter approaches the subject using the collections of the National Museums of Cagliari as a case study. A museum founded as early as 1800 comprising a collection of antiquities and objects of natural history from Sardinia, makes for a prime methodological case exemplifying the changing nature of island collections' narratives and their storytelling. The Cagliari collection was not conceived as a local or city museum – as it was quite common in that period – but from the outset it was meant to be a synthesis of Sardinia. For this reason, the museum's collections, which range from prehistoric to contemporary times, are an ideal reference point to offer a re-appraisal of Sardinia's insularity and the island's connectivity and its evolving relations with surrounding lands, over a longue durée. *These relationships, which have varied greatly over the millennia, are witnessed, and narrated by objects preserved in the museum collections. The chapter aims to offer a holistic outline of Sardinia's insular identity and trans-maritime connections by employing key museum objects and collection groups, from prehistory to the contemporary era.*

Italy includes about 800 islands, 80 of which are inhabited and, among these, the two largest islands in the Mediterranean, i.e. Sicily, the largest and more populated, and Sardinia, less populated but with an almost equivalent area Sicily is very close to the mainland (the minimum width of the Strait of Messina is just about 3 km and the mountains of Calabria are a familiar view from north-eastern Sicily), while Sardinia is much further from the peninsula, or 'Il Continente' (the Continent), as it is commonly referred to by modern inhabitants of the island. For these reasons, Sardinia is sometimes perceived as an island of idiosyncratic identity than others (from Sardinia you can see – at most – only the coasts of another island, Corsica). For

the ancient Greeks (at least during the Archaic and Classical horizon), Sicily does not always share the cultural characteristics of an island (Thuc. 6.1.1, Constantakopoulou, this volume Chapter 2), and could be defined, from the perspective of some ancient sources, as an 'improbable island' (Frisone 2009). In the case of Sardinia, the island's geographic remoteness implies 'otherness', sometimes generally referred to as an advantage and, in other times, as a barrier.

Let us consider, for instance, what Dante Alighieri says about Sardinia (Francioni and Sanna 2012; Ferroni 2019, 481–510). In the *Divina Commedia* the innermost part of Sardinia – the Barbagia, proverbially famous for the shamelessness of the women – is a term of comparison for the corruption of contemporary Florence (*Purg.* 23.91–6). The sorrows and sufferings of the deepest Hell are compared to those of Maremma and Sardinia (*Inf.* 29.46–9). Dante had an indirect knowledge of Sardinia, probably coming from his readings and the tales of some of his acquaintances, as Sardinia was partially ruled by the Pisans at the time. Among the barterers in the Hell, Dante mentions two Sardinians who are punished together but, even in the midst of hellish suffering, continue to speak of their beloved island and to cherish its memory ('and of Sardinia/To gossip never do their tongues feel tired', *Inf.* 22.88–90; transl. H.W. Longfellow), thus highlighting the islanders' deep love for their island. In his treatise *De vulgari eloquentia* Dante places both Sicily and Sardinia on the right-hand side of Italy (1.10.5) and, while he has word of high praise for the Sicilian language and for Sicilian poetry, considering them seminal to Italian literary tradition (1.12.2), he has harsh words for Sardinia:

> As for the Sardinians, who are not Italian but may be associated with Italians for our purposes, out they must go, because they alone seem to lack a vernacular of their own, instead imitating *gramatica* [i.e. Latin language] as apes do humans (*gramaticam tanquam simie homines imitantes*) ... (1.11.7, transl. S. Botterill)

But the closeness itself between Latin and Sardinian, although unpleasant to Dante, is a clear indication that this island was not always as 'far' and as 'different' as it is commonly considered since it had retained such a strong Latin influence. Here, I argue that, if for Dante Sardinia is a 'far' and 'different" island, an example of an island 'separated' in many respects; it is also for him a prototype of ancient Mediterranean geography. Describing, in fact, Odysseus's attempt to go beyond the Pillars of Hercules to discover the unknown, the 'mad flight' (*folle volo*) that constitutes the pagan man's most audacious attempt to seek knowledge, Sardinia is a cornerstone of the mythical geography of the western Mediterranean, the only one mentioned by name among the islands of that region. For the period Dante represents (the Middle Ages) and the geographical awareness of that time, the western Mediterranean appears bordered by the coasts of Africa and the Iberian Peninsula, with an unspecified group of islands in between, among which only Sardinia stands out ('Both of the shores I saw as far as Spain,/Far as Morocco, and the isle of Sardes,/And the others which that sea bathes round about') (*Inf.* 26.103–5).

7. Insularity and Mediterranean networks

Although less present than the other major Mediterranean islands in the mythological and historical traditions, Sardinia still has some important representations that reveal peculiarities of its insular identity (see Zucca 2004a, on ancient sources referring to Sardinia). Pausanias and Solinus for example describe the island's peculiarities, including references to poisonous snakes and herbs, including the one that causes 'sardonic' laughter (Hom. *Od.* 20.301–2; Paus. 10.17.12; Solin. 4.2–4). Pausanias compares the shape of Sardinian he-goat to that of the wild ram which an artist would carve in Aeginetan style (Paus. 10.17.12), that is in Archaic style. Sardinia is commonly portrayed as an island rich in resources, but sometimes or in some places inhospitable for its climate and the aggressive nature of its local populations (Strabo 5.2.7; Paus. 10.17.10–11). The above contribute to forming a picture of Sardinia's ancient identity as an island defined by otherness, and in contrast to other insular environments (such as Sicily) who were deemed by ancient writers as conforming more to the familiar ancient cultural milieux, Greek or otherwise.

The bronze statue of Sardus, their *eponymos*, sent by the Sardinians, considered as non-Greek westerners to Delphi is the starting point for a digression by Pausanias (10.17.1–13, transl. W. H. S. Jones; Bernardini 2004, 39–46), which encompasses most of the classical knowledge about Sardinia and is motivated precisely by the fact that 'it is an island about which Greeks are very ignorant', while, in a different context, Solinus (4.1), has opposite views: '*Sardinia* [...] *in quo mari sita sit, quos incolarum auctores habeat, satis celebre est*' ('As for Sardinia [...], the sea in which it lies and who the ancestors of its inhabitants were, are well known'). The two opposing statements can, in my opinion, demonstrate how, even in the imperial age, Sardinia may still have been virtually unknown in the eastern part of the Mediterranean or, at any rate, considered a remote land and, on the contrary, may have been much better known in the centre of the Empire. The Greek name of the island, *Ichnoussa*, because of the resemblance of its shape with a man's footprint (*ichnos*), was given by the Greeks 'who sailed there to trade', thus highlighting the first and foremost reason of the connections between Sardinia and the Greek world. This assertion by Pausanias remains plausible even if the first connections between Sardinia and the Greek world are much earlier than he seems to believe, since they are archaeologically attested already in the Bronze Age (Knapp 2008; Kassianidou and Papasavvas 2012, 14–125).

Both Pausanias and other classical writers present the history of Sardinia as a succession of peoples' arrivals up to the Roman period, sometimes connecting these arrivals with Greek personages. Although somewhat contradictory, these mythical accounts in any case preserve the awareness of settlers and conquerors who came from outside. After all, Sardinia is repeatedly considered as a possible destination for a Greek settlement. For instance, after the second Messenian war, the Messenians fugitives planned to settle in Zakynthos, thus 'becoming islanders instead of mainlanders', 'νησιώτας ἀντὶ ἠπειρωτῶν γενομένους', or in Sardinia, 'an island which was of the largest extent and greatest fertility' (Paus. 4.23.5; transl. H.A. Ormerod). I argue that this text by Pausanias demonstrates how insularity was perceived as a condition different from

living on the mainland and how it could be an expressly chosen condition. Sources like this must have definitely influenced people like the Sardinian politician Giovanni Maria Angioy, one of the protagonists of the Sardinian revolutionary uprisings of the late 18th century. In his *Memoriale* (1799 [2015], 63), he writes that

> If Sardinia in a state of languor, without government, without industry, after several centuries of disasters, possesses such great resources, we must conclude that well administered it would be one of the richest states in Europe, and that the ancients were not wrong in representing it to us as a country famous for its greatness, its population and the abundance of its production.

Sardus, the eponymous mythological hero of the Nuragic Sardinians, gave his name to the island. According to the myth, he arrived from Libya with sailors who were the first to cross to the island (Paus. 10.18.2; Zucca 2004b). More myths describe the arrival of different mythological personalities to the island and the influence they instilled to it, including toponyms and foundation myths associated with the emergence of settlements and sanctuaries. One example is the case of Iolaus, the Theban divine hero, who according to Greek mythology (Strabo 5.2.7; Solin. 1.61; Paus. 10.17.5; Bernardini 2004, 46–56), was honoured after his death with a temple, whose exact whereabouts are unknown, built in connection with his tomb (Solin. 1.61: '*Iolenses ab eo dicti sepulcro eius templum addiderunt*' 'The Iolians named after him, added a temple to his tomb') and worshipped in places called *Iolaïa* (χωρία τε Ἰολάια), still existing in Pausanias's time (κατ' ἐμὲ) (Paus. 10.17.5). The same Iolaus would have summoned from Sicily Daidalos, the architect of the Cretan labyrinth (and here is another connection among three major Mediterranean islands) and, in Sardinia,

> he built through him many great works which stand to this day (μέχρι τῶν νῦν καιρῶν) and are called 'Daedaleia' (Δαιδάλεια) after their builder. He also had large and expensive gymnasia constructed and established courts of justice and the other institutions which contribute to the prosperity of a state. (Diod. 4.30.1–2, transl. C.H. Oldfather; see also Paus. 10.17.4; Chiai 2004)

The sources, albeit sometimes in a clumsy way, show that for Sardinia, unlike Sicily, the status of an island was very clear and are also well aware of the island's extensive overseas connections.

The myth of Aristaios provides a connection between ancient sources referring to myths and settlement evidence (Diod. 4.82.1–6). Aristaios sets off on a series of journeys from one island to another, visiting Keos and then Libya. In the same manner as the mythical journey of Sardus, Aristaios sails from Libya to Sardinia and, impressed by the beauty of the island, he initiates cultivation in it, whereas formerly it had lain waste (Diod. 4.82.4). The foundation myth of the city of Caralis (modern day Cagliari) is attributed to him as well as its early reign (Paus. 10.17.3; Sall. 2, fr. 6 Maurenbrecher; Solin. 4.2). After Aristaios leaves Sardinia, he allegedly visits other islands, including Sicily, where he continues to behave like a benefactor who teaches useful things to mankind (Diod. 4.82.5). A bronze statuette from Oliena, dated to the

2nd–3rd century AD attributed to Aristaios, where he is depicted with bees resting on his naked body, may refer to him encouraging cultivation of beekeeping for the local communities (Fig. 7.1; Bernardini 2004, 56–58; Pianu 2004; Sanna 2004; Zucca 2016; Giuman and Parodo 2018). This statuette links the myths surrounding Aristaios with locally made material culture as well as with the long standing tradition of beekeeping in the island, which persists today.

I would like now to turn my attention to some aspects of Sardinia's connectivity with the rest of the regions of the Mediterranean, as exemplified by the material wealth of the collections of the National Museums of Cagliari. This, of course, is not an exhaustive account of Sardinia's connectivity and maintenance of Mediterranean networks; my aim is, rather to demonstrate how Sardinia's connectivity and how the mobility of its inhabitants, played out at different scales and intensities through the long history of the island, fluctuated between periods of inward looking local identities and outward looking expansions and trading activity.

Cagliari Museum was founded in 1800 by the viceroy Carlo Felice of Savoy (Santoni 1989; Pergola 2022) who later, as king of Sardinia, founded the Egyptian Museum in Turin. The museum was not conceived as one of local identity – as it was common in that period – but as one that will provide a synthetic representation of the cultures and environment of Sardinia, collecting and displaying *insulae partus et monumenta* (the natural productions and the antiquities of the island), as stated by the inscription originally placed in the museum. In 1810, the director of the Museum, Leonardo De Prunner, sent to the former American president Thomas Jefferson, who was also a scientist, specimens of Sardinian minerals, widely requested and appreciated in public and private collections (Founders Online, National Archives, https://founders.archives.gov/documents/Jefferson/03-02-02-0245-0001; original source: Jefferson Looney 2005, 297–8). Another example of how Sardinian mineral samples were sought after and disseminated in old geological collections is offered by two examples of copper ore, now part of the collection of the Sedgwick Museum of Earth Sciences in Cambridge (obj. no. 11617). These mineral specimens are covellite, blue copper sulphide. In

Figure 7.1. Bronze statuette of Aristaeus from Oliena (© Musei Nazionali di Cagliari 2024).

Sardinia many mining sites reveal that copper was mined in the island already during the Early Nuragic civilisation (1800 BC onwards). Together with metalworking, mining practices also developed allowing the mining of increasing amounts of minerals and metal ores. The mining asset of the island later attracted Phoenician and Carthaginian merchants who deeply exploited the mining resources of the island: silver, iron sulphide, copper, and lead. These specimens, together with an imported Cypriot ox-hide ingot, discovered at the site of Serra Ilixi (Storeroom, Ilixi), Sardinia (ca. 1300–1100 BC) and on loan from the National Museums of Cagliari (obj. no. 5485) were part of a section of the *Islanders: the Making of the Ancient Mediterranean exhibition* highlighting raw materials, production places, supply and trade networks, and identifying ancient metalworking techniques between Sardinia, Cyprus, and other regions of the Mediterranean. In the collections of the National Museums of Cagliari, objects forged from bronze, copper, iron, gold, and silver that were used for weapons, ritual objects, jewellery, and coins, testify to the important role of metalworking technologies on islands such as Sardinia and Cyprus. By examining the industries that lay behind their production, we can understand different expressions of island identity in Sardinia but also when and how new techniques were introduced into islands, revealing travel and connections across the Mediterranean (Christophilopoulou 2023, 80–81, nos 36–37).

Today the National Museums of Cagliari display a diverse and wide selection of Sardinia's material culture from the Neolithic period onwards, with a particular focus on pre- and proto-history. As an autonomous museum since 2019 it now incorporates the National Art Gallery (Pinacoteca Nazionale) thus greatly extending the material culture categories and the chronological span of its exhibitions from prehistory to contemporary art. In this new and expanded exposition, insularity naturally plays a key role as it is possible to see how Sardinia's has manifested itself differently throughout the ages. In Sardinia as in other islands, insularity can, at certain times, mean greater isolation and, at others, inclusion in a broad network of connectivity.

During the Neolithic and Copper Age (Moravetti *et al.* 2017a; Doria *et al.* 2021), Sardinia took an active part in the cultural development of the western Mediterranean world, within a framework of multi-directional relationships which mainly follow the routes of the wide circulation of Sardinian obsidian. For example, archaeometric analyses confirm that the volcanic glass of Monte Arci was traded widely (Lugliè 2007; 2009; Poupeau *et al.* 2010; Cossu and Lugliè 2020).

In the Bronze Age, the Nuragic communities of Sardinia (Moravetti *et al.* 2014; 2017b; Minoja *et al.* 2015; Cossu *et al.* 2018; Doria *et al.* 2021; Stoddart *et al.* 2021) were connected to Mediterranean trade and appear to have been directly reached by seafarers from Mycenaean Greece, Crete, and Cyprus. There is further evidence of Nuragic presence on Lipari, Sicily, Crete, and Cyprus. The previously accepted characterisation of Nuragic Sardinia as a culture passively receptive to external stimuli began to be reversed after the discovery of Nuragic pottery on the Acropolis of Lipari in the Aeolian Islands (Ferrarese Ceruti 1987; see now Cavalier and Depalmas 2008).

Subsequently, in Cannatello on the southern coast of Sicily, Nuragic pottery from the Late Bronze and Early Late Bronze Age was found together with pottery imported from the Aegean, Crete, and Cyprus (Knapp *et al.* 2022). Fragments of copper ox-hide ingots were found in the same sites – Lipari and Cannatello in Sicily and Kommos in Crete – proving that exchange of resources is a defining element of Mediterranean identity in the Bronze Age. The copper ox-hide ingots are very important for understanding the connection between Sardinia and Cyprus within the Mediterranean copper trade. In the Late Bronze Age, the relationship of Sardinia with Cyprus was not sporadic and random, as evidenced in the field of metallurgy by the spread of imported ox-hide ingots throughout Sardinia. These ingots, entire or fragmentary, are found isolated or in groups inside *nuraghi*, villages and sanctuaries, and can be dated between the 16th and 11th centuries BC. The Sardinian goods given in exchange for the copper were probably perishable products but one should not rule out the import of labour force, for instance specialised workers participating in the production of copper and bronze in Cyprus. In Hala Sultan Tekke, Cyprus, for instance, the discovery of Sardinian manufactured table and domestic wares integrated with genuine Cypriot cultic activities may further support the presence of Sardinians who arrived there with their personal vessels.

Ox-hide ingots were fundamental elements of Cypriot metalworking activity and exchange. Their import from Cyprus to Sardinia was probably combined with knowledge sharing on metalworking techniques and manipulation of materials and resources, resulting in the production of different types of bronze artefacts in Nuragic Sardinia. One of the techniques was the 'lost-wax' technique which reached a high level of skilfulness and led to the production of elaborated and specialised products, many represented in the various types of bronze statuettes at the Cagliari museum, which is home to the largest and most important collection of this type. Other types of material culture resulting from this *chaîne opératoire* are the Nuragic bronze tripod stands imitating Cypriot originals (Pusole 2019). Most of the tripods found in Sardinia originate from sanctuary contexts.

Sardinia in the Bronze Age had privileged relations with the eastern Mediterranean. These relations, of course, were two-way, as can be demonstrated to begin with by Sardinia's intense contacts with Cyprus and the Aegean world during this period, as is attested by pottery excavated in different sites of Sardinia. Thanks to the pioneering studies of Ferrarese Ceruti it is possible to distinguish between the imported Mycenaean ceramics and the local imitation of Mycenaean ceramics in Sardinia (Ferrarese Ceruti 1979; see now Spigno 2022). Mycenaean imports appear first in the 14th century BC at the Nuraghe Arrubiu, Orroli, where a Mycenaean alabastron (Vagnetti and Lo Schiavo 1993) was found scattered in fragments, perhaps for ritual reasons, in the foundation layer of the five-lobed bastion. Both Mycenaean imports and local imitations are most common at Nuraghe Antigori (Sarroch), where they are recorded until the 12th century BC. It is likely that the collapse of the Mycenaean systems allowed for a Cypriot expansion towards the west Mediterranean regions.

Connectivity with Cyprus and the Aegean world, was decisive for Sardinia, particularly during the Recent and Final Bronze Age, in terms of maritime transport and exchange of raw metal materials. These contacts are well documented with evidence emerging from sites such as Hala Sultan Tekke and Pyla-Kokkinokremos in Cyprus (Russell and Knapp 2017; Sabatini and Lo Schiavo 2020; Perra and Lo Schiavo 2021; Knapp *et al.* 2022). In Cyprus, Nuragic fine tableware bowls were found in Hala Sultan Tekke in a context dated to the 13th century BC, and Nuragic pottery was also found in Pyla-Kokkinokremos, a fortified settlement with a very short lifespan ranging from the last decades of the 13th century until ca. 1170 BC. The Sardinian origin of the pottery is confirmed by archaeometric analysis (Russell and Knapp 2017; Knapp *et al.* 2022). The presence in Cyprus not only of pottery serving for transport such as that of Pyla-Kokkinokremos, but also fine tableware in the cemetery of Hala Sultan Tekke, demonstrates good connections although, as known so far, not over a particularly long time. The fine tableware from Sardinia found in Cyprus, for instance, is of very limited quantity and the report from Pyla-Kokkinokremos, at least, says that the phase from which this material was recovered is characterised by brevity of occupation (see Sabatini and Lo Schiavo 2020). More evidence of Sardinia's expansion during this period comes from the discovery of Nuragic pottery from excavations of the port site of Kommos in Crete, also dated to the Recent Bronze Age. Nuragic askoid jugs (9th–8th century) were also found in Etruria (Vetulonia), Carthage, Sicily (Mozia and Dessueri), and Crete (Khaniale Tekke; Lo Schiavo 2005).

Perhaps the category of objects in the collection of the Cagliari Museums most indicative of Nuragic culture and identity are the numerous bronze boats, perhaps made to be used as lamps. A number of these, made with the lost-wax technique date from around 1300 BC onwards. They represent a period when Sardinia was probably arranged in territorial systems, organised around strategically placed *nuraghi* structures, such as villages and tombs, aiming at the control and common exploitation of the island's vital resources, harbours, rivers, routes and paths, ores, woodlands, and agricultural areas. Strong evidence suggests that people living in these areas were also engaged in maritime endeavours across the Mediterranean (Christophilopoulou 2023, 19, 38). One of these bronze miniature boats from Orroli, Sardinia (obj. no. 45038; Fig. 7.2), with its columns and central mast representing Nuragic towers, is a good example of the importance placed on seafaring, trade, and communication by these Nuragic communities in Late Bronze Age Sardinia and the way these practices are symbolically reflected in the creation of material culture. With the birds perched on the mast and on the sides, they seem to be peaceful, not battle boats. More examples were also found outside Sardinia, for example in the sanctuary of Hera Lacinia in Kroton, Calabria, Italy (Depalmas 2005, 98–99, no. 86, pl. 64), at Porto (Fiumicino; Depalmas 2005, 67, no. 36, pl. 29), in the temple of Hera in Gravisca (Depalmas 2005, 87–88, no. 69, pl. 54), and in Etruscan tombs in Vetulonia, Etruria, Italy (tomb *delle tre navicelle*, Depalmas 2005, 64–65, nos 32–33, pls 25–26, and 88–90, no. 71, pl. 56; tomb *del Duce*, Depalmas 2005, 67–9, no. 37, pl. 30; Lo Schiavo

2010; tomb *della navicella*, Depalmas 2005, 82–83, no. 59, pl. 46). Beside bronze boats, Sardinian Nuragic bronze statuettes are also found among Etruscan grave goods, as in the 'tomb *dei bronzetti sardi*' from the necropolis of Mandrione di Cavalupo near the territory of the ancient city of Vulci, Italy (Arancio *et al.* 2010).

In the Final Bronze Age Sardinia exchanged metal artefacts with the Atlantic regions of the Iberian Peninsula; at the same time, there was an increase of material exchanges and cultural contacts with mainland Italy and, later on in the Iron Age, with the Etruscans, while the Phoenicians took on Nuragic trade across the Mediterranean. The Phoenician presence (Guirguis 2017; Del Vais *et al.* 2019) took the form of real urbanisation after a first phase of settlements marked by the creation of trade centres (emporia). The settlements were usually located on islands or promontories that also guaranteed a safe landing with adverse winds. The importance of external influences in the construction of cities is also well recognised by the sources. Pausanias (10.17.2), for instance, says that in Sardinia: 'neither the Libyans nor the native population knew how to build cities. They dwelt in scattered groups, where chance found them a home in cabins or caves', and still at the times of Strabo (5.2.7) the mountain tribes dwelt in caverns and lived mainly by pillaging. The first city to be founded was probably Nora, by the Iberians, with other cities like Caralis and Sulci founded later by the Carthaginians 'at the height of their sea power' (Paus. 10.17.5 and 10.17.9). The creation of a large network of commercial emporia in the various regions affected

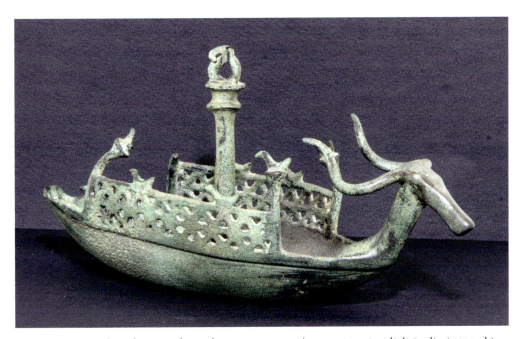

Figure 7.2. Bronze boat from Orroli, Sardinia, 1000-600 BC (© Musei Nazionali di Cagliari 2024, object inv: 45038).

by trade proved to be indispensable for the effective conduct of their commercial activity. Sardinia was certainly among the regions affected by both this first settlement phenomenon and the subsequent phase of colonisation. The resources present on the island that attracted the interest of the Phoenicians were of various types but certainly metal resources must have had particular importance.

Among the many Punic inscriptions that form part of the Cagliari Museums collections, the stele of Nora is of great importance, dated around the 9th–8th century BC. The stele is considered to be the first epigraphical attestation of the name 'Sardinia'. Smaller inscriptions exist on different types of objects, such as the little altar with a dedicatory inscription to Baal Hammon, dating to the 4th–3rd century BC, from the tophet of Sulci, on the island of Sant'Antioco. Baal Hammon, or 'Lord Hammon', was especially venerated in Carthage, whence the cult originally spread (Christophilopoulou 2023, 75).

Tharros was established in the 8th century near a Bronze Age Nuragic village called Su Muru Mannu, meaning 'the great wall'. A tophet was also built, close to this wall. From Tharros and especially from its rich necropolis – widely excavated since the 19th century – come many objects testifying to the complexity of interactions in the Mediterranean during Bronze Age. One example is the golden amulet pouch with two animal shaped heads, one of a ram and one of a lioness (the goddess Sekhmet), surmounted by a solar disc and two *uraei*; an ear-ring pendent with Horus and basket; and a gold earring with a cross shaped ornament very similar to the ancient Egyptian symbol for life (*ankh*) (Christophilopoulou 2023, 77 and 82). Ceramics, mostly found in tombs, also demonstrate the variety of interactions, as testified by Etruscan bucchero, Etrusco-Corinthian pottery, Ionic cups, and also Attic pottery, although this last product is not as commonly attested as one could expect given the widespread diffusion of these wares in the western Mediterranean. Attic wares come mainly from the principal Punic necropolises, such as Tharros (on the west coast of Sardinia), Nora (on a peninsula near Pula, Sardinia) and Caralis (modern day Cagliari, Sardinia). This last settlement can boast one of the most extended Punic necropolises, known as Tuvixeddu, in use since the 6th century BC, with rock-cut burial chambers containing rich grave goods, a great variety of Punic pottery, and some 'exotic' wares, such as an Attic skyphos (Christophilopoulou 2023, 76). The necropolis of Tuvixeddu had a long life, with impressive rock-cut graves also during Roman times. The most prominent example is the 'grotta della vipera', a tomb with a monumental façade and an elegant series of Greek and Latin metric inscriptions dedicated to Atilia Pomptilla by her husband L. Cassius Philippus, son of the jurist and politician C. Cassius Longinus who was exiled in Sardinia by Nero (Cugusi 2003, 63–71, 105–152; Atzori 2021). This fact allows us to hint at another cultural reality of islands, the fact that they were often used, from antiquity to the present day, as places of imprisonment and exile often for political opponents.

Nero also chose Sardinia as the place to confine his freedwoman and concubine Claudia Acte, who he was forced to exile as a result of court intrigues. However, islands for the exiled can also prove to be places where they can prosper. Acte

7. Insularity and Mediterranean networks

received large estates from Nero in the area of Olbia which allowed her to carry on various economic activities even after the emperor's suicide (Ruggeri 2004). Various epigraphic documents are linked to Atte's prosperous stay in Sardinia, including a dedication to Ceres and various funeral inscriptions of her freedmen, and probably also the rare bust of the young Nero kept in Cagliari Museums (Fig. 7.3; Opper 2021; Russo *et al.* 2023). This portrait comes from Olbia and survived the general destruction of portraits caused by the *damnatio memoriae* suffered by Nero after his death. Here, I argue that the preservation of this bust is also due to Sardinia's insular nature, as the remoteness of the island prevented the application of the political decision responsible for the destruction of other Neronian portraits; one could also argue that in this case insularity is a factor preserving memory. The use of islands as exile places continued in Italy until the modern times. The confinement of political opponents to islands was practised until the Fascist dictatorship, and until very recently, small and medium-sized Italian islands were favoured by the government as locations for maximum security prisons.

Near the Santa Gilla lagoon in Cagliari, an unknown sanctuary connected with healing god(s) contained an incredible series of votive clay objects, with anatomical members, monstrous beings, female and male masks, and heads (Fig. 7.4), some of them influenced by the iconography of Classical Greece, in a Punic context of the 4th–3rd century BC (Moscati 1991). The statues of the Egyptian god Bes, a benevolent and apotropaic dwarf god, are of various dimensions and come from different places, thus partially completing the composite pantheon of Punic Sardinia. The collection of the Santa Gilla votive objects, with their stylistic influences from other cultures of the period provides yet another example of cultural fluidity in Sardinia during this period, one that was not just characteristic of the Punic culture but also one that is more often seen in island settings than continental places. In Sardinia's case fluidity of styles and cultural hybridity seem to be defining elements influencing the island's identity for a long period of time.

For Hellenistic times it is more difficult to recognise different identity traits in Sardinia, as most of the surviving material speaks of a widespread Greek culture. A greater openness towards the Hellenic world is recorded from the 3rd century BC. In 238 BC Sardinia became a Roman province and it experienced intense agricultural and mining exploitation. For this reason commercial routes continued to thrive (Angiolillo *et al.* 2017; Carboni *et al.* 2021). The extraction of silver, for example, continued (Solin. 4.3: '*In metallis argentariis plurima est, nam solum illud argenti dives est*', 'It is most abundant in silver metals, because the soil is rich in silver'). Some areas in the interior remained, however, in the hands of local populations that often gave the Romans a hard time, as testified, among others, by Strabo (5.2.7):

> Now the military governors who are sent to the island resist the mountaineers part of the time, but sometimes they grow weary of it [...]; and so, having observed a certain custom of the barbarians (who come together after their forays for a general celebration extending over several days), attack them at that time and overpower many of them. (transl. H. L. Jones)

Figure 7.3. Marble bust of Nero from Olbia (AD 54–59) (© Musei Nazionali di Cagliari 2024, object inv: 35533).

Figure 7.4. Clay female protome, from Santa Gilla, Cagliari (3rd–2nd century BC) (© Musei Nazionali di Cagliari 2024, object inv: 24427.

In these religious rituals involving, over several days, populations from a wide area it is difficult not to see the ancestors of rituals that have continued and flourished even under Christianity and up to the present day, such as the *novenari*, places where the populations of different villages in an area gather for nine days before the religious festivity around a shrine in the open countryside, leading a community life in small rooms built around a church (Gallini 2003[1971]). And this continuity is also often demonstrated by the physical proximity between pre-/proto-historic and Christian places of worship, as for example at Santa Cristina di Paulilatino (one of the best preserved *novenari*, close to a Nuragic sacred well) or Santa Vittoria di Serri.

Rome took particular interest in the coastal cities founded by the Phoenicians and set up new ones. In all of them the Romans provided for the construction of new port structures. We know that in Ostia there must have been maritime transport contractors and tradesmen from Sardinia, as indicated by the mosaics with representations of ships and the legends *Navic(ularii) Turritani* (from Turris Libisonis, today Porto Torres) and *Navicul(arii) et negotiantes Kalaritani* (from Karales, today Cagliari) in the 'Piazzale delle corporazioni' at Ostia.

In the period of the crisis of the Roman Empire, Sardinia was ruled by the Vandals for about 80 years (AD 456–534) and it was conquered by Iustinianus, becoming one of the farthest territories of the Byzantine Empire (Angiolillo *et al.* 2017; Martorelli *et al.* 2021). Some letters by pope Gregory the Great (transl. by J. R. C. Martyn) bear an astonishing testimony to the continuity of paganism well into the 6th–7th centuries.

7. Insularity and Mediterranean networks

To Hospiton, *dux Barbaricinorum* (that is the inhabitants of the previously mentioned Barbagia, an inner region of Sardinia), he writes:

> Since nobody from your people is Christian, I know that you are better than all of your people, in that you are found to be a Christian among them. For while all of the *Barbaricini* live like senseless animals, and know not the true God, worshipping sticks and stones (*ligna autem et lapides*), by the very fact that you worship the true God, you show how much you surpass all the others. (*ep.* 4.27; see also *ep.* 4.23 and 4.25; 5.38; 9.124)

Pagan servants would even be in the service of bishops as the pope reproaches Ianuarius, bishop of Cagliari (*ep.* 4.26).

Both the letters of Gregory the Great and other evidence demonstrate how the connections between Sardinia and the Byzantine Empire were quite weak and they further weakened with the progressive expansion of the Arabs. Unlike Sicily, Sardinia was never permanently occupied by the Arabs although there are traces of an Arab presence (Pinna 2010; Cisci *et al.* 2021). However, an autonomous and peculiar form of government was born with numerous elements deriving from the Byzantine tradition. Sardinia, in fact, from the 10th to the 13th/14th centuries, was ruled in a most peculiar way by sovereigns called *iudices*, who ruled over four *giudicati*, gradually conquered by the Spanish, the Genoese, and the Pisans (Poisson 2001; Martorelli 2002; Martorelli *et al.* 2021; Cisci *et al.* 2023). In the collections of the Cagliari Museums, the period of the *iudices* is testified by objects of the utmost importance for their rarity and artistic quality, and also for the transmarine

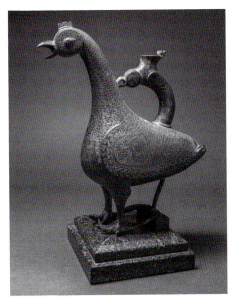

Figure 7.5. Aquamanile from Mores (12th century AD) (© Musei Nazionali di Cagliari 2024, object inv: SC13).

Figure 7.6. Pottery from Pula (© Musei Nazionali di Cagliari 2024, object inv: 397).

connections they testify. Dating to the 11th/12th centuries, the *aquamanile* from Mores (Fig. 7.5) is an exquisite example of luxury craftsmanship that can be referred to Arab artisans working in Spain (Siddi 1988, 129, OG11; Anedda and Pala 2014) and it is a clear attestation of the growing connections with the Iberian Peninsula, to the detriment of connections with the eastern Mediterranean. In the Middle Ages and in modern times Sardinia continued to be influenced by the Iberian Peninsula, a relationship built first on commercial and cultural reasons and later on political reasons too.

The pottery found in Pula (Fig. 7.6; Nissardi 1897; Porcella 1988, 177–179, 183–197; Porceddu 1998) is one of the most beautiful specimens of the refined handcrafted production implanted by the Arabs in Manises near Valencia and destined to a long development in modern times. The finds had been placed inside a pit lined with stone slabs; it was probably a hiding place to preserve the 'treasure' from possible pirate raids.

One of the closest links between Sardinia and the Iberian Peninsula is represented by monumental altar pieces (in Spanish *retablo*) (Fig. 7.7), often produced in Sardinia by Iberian painters or by local painters strongly influenced by Iberian art (Concas 1988; Maxia 1988; Scanu 2017; Virdis Limentani and Spissu 2018; Martorelli *et al.* 2021). This is not surprising because, in Sardinia during the Spanish period (1323–1713/1714), high prelates and aristocrats were Spanish or linked with Spain and tended to replicate Spanish artistic habits and tendencies in Sardinia, as archival records and recent scholarship demonstrate. For this reason, the island has an number of this kind of altar pieces unequalled in any other Italian region and the most important Italian collection is kept in the Cagliari Museums. These altar pieces are an incredibly communicative *biblia pauperum*, with many scenes immediately comprehensible also to the illiterate faithful. Only apparently archaic and outdated compared to contemporary painting in other areas, these altar pieces, with their medieval style gold backgrounds used up to the beginning of the 17th century, can instead be considered clear evidence of the island's tendency to remain faithful to tradition for a longer time, not for backwardness but for conscious identity choices. In contrast to the commonplace narrative that wants Sardinia to be isolated and backward, I argue that, on the contrary, it is possible to find in every period, albeit with varying intensity, consistent evidence of the island's connections with territories beyond the sea, but with a constant fidelity to its island identity.

Even in more modern times, as in classical, Sardinia continued to be a destination for exiled populations in search of a good relocation. This is the case, for example, of the Ligurian colony of Tabarka in Tunisia who, in 1738, seeking a better location in which to carry out their trades and with the permission of king Carlo Emanuele III of Savoy, founded Carloforte, where the Ligurian language known as 'tabarchino' is still spoken. The same king, in 1746, permitted to the descendants of Laconians, who had fled the Turkish occupation and settled in Corsica, to relocate in Montresta after being forced to flee Corsica as well. In the extremely rich and

7. *Insularity and Mediterranean networks* 111

Figure 7.7. Altar painting of Saint Bernardinus, AD 1455 (© Musei Nazionali di Cagliari 2024, object inv: 30/54).

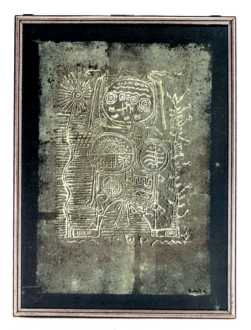

Figure 7.8. Painting by Giovanni Nonnis, 1970 (© Musei Nazionali di Cagliari 2024, object inv: DI 145).

varied field of contemporary Sardinian art, the links with the island's oldest history remain very strong (Martorelli et al. 2021). This is the case, for example, of the painter Giovanni Nonnis (1929–1975) (Cherchi 1990; Sgarbi 2021), who had Nuragic art as a constant source of inspiration. In 2023 three works with a 'Nuragic' theme were very appropriately donated by his daughter Cecilia to the Cagliari Museums (Fig. 7.8).

A recent change in the Italian Constitution, approved in 2022, addressed the issue of insularity in the Italian State and recognised the special characteristics of the Italian islands, as well as suggesting measures to address socio-economic differences noted between mainland and island Italy, deriving from insularity. The Chamber of Deputies and the Senate approved, by an absolute majority, Constitutional Law No. 2/2022, which introduces, in Article 119 of the Constitution, the paragraph: 'The Republic recognises the special characteristics of the Islands and promotes the necessary measures to remove the disadvantages deriving from insularity'. According to the reasoning behind the law, being an islander entails enormous additional costs that must be compensated for in the name of national cohesion, aiming at a concrete equality among all the Italian citizens. Hence the popular request to the Parliament: to eliminate the current structural disadvantages linked to insularity to allow Sardinians to compete with all other Italian citizens with equal opportunities. In Sardinia, the acknowledgement of insular conditions has collected the consent of civil society in all its forms. It is evident how, with the insertion of the principle of insularity in the Constitution, an epochal result has been obtained not only for the major islands but also for the numerous smaller islands of Italy, and it is not too hazardous to say that this principle can also be emulated from other European and non-European states in which similar situations occur. While this legislation had no particular scope of addressing cultural preservation and protection of cultural heritage on the Italian islands, it provides a stark reminder that insularity is a condition relevant to today's debates. For the past three years, the National Museums of Cagliari, have also been addressing the topics of insularity, connectivity, and hybrid identities expressed in Sardinia as emerging from the collections, through a pioneering programme of public engagement talks, events, and debates. Some examples include, in July 2022, as part

of the 'Afternoons of Landscapes' series of meetings, an in-depth look at 'The Island of Islands', with a focus on Sardinia and the small islands that belong to it. As part of the 'Dialogues of Archaeology, Architecture, Art, Landscape', another of the series of meetings promoted by the museum, numerous lectures were devoted to insularity in all its aspects. In December 2023, the documentary produced as part of the *Being an Islander* project was also screened in Cagliari at the museum's initiative. In so doing we recognise that active involvement and participation of our audiences to debates on the nature of island material culture and collections is also part of our interpretation of ancient island material culture and of the way we address insularity as a concept and condition in the modern world.

The institution of the recent legislation reflects how the modern state of Italy regards the concept of insularity and the opportunities or disadvantages it engenders to people living in the islands today, despite the increasingly interconnected modern world. In this chapter, I looked at various types of material culture evidence from prehistory to the modern day, providing a rich and non-linear account of the island's connectivity, fluctuating between periods of local expressions of identity and others testifying of expansion and the formation of hybrid identities. The picture emerging for Sardinia's identity over the centuries is one that fostered creativity, connectivity, and hybridisation. Even a partial examination of insular material culture shows how much of the ancient world evolution has taken place on islands – and also thanks to islands.

Bibliography

Anedda, D. and Pala, A. (2014) Acquamanili nella liturgia cristiana (IV–XVI secolo): Il bronzo della Pinacoteca Nazionale di Cagliari. *Anuario de Estudios Medievales* 44(2), 689–731.

Angiolillo, S., Martorelli, R., Giuman, M., Corda, A. M. and Artizzu, D. (eds) (2017) *La Sardegna romana e altomedievale. Storia e materiali.* Sassari: Corpora delle antichità della Sardegna.

Angioy, G. M. (1799 [2015]) *Memoriale sulla Sardegna, a cura di O. Onnis.* Cagliari: Condaghes.

Arancio, M. L., Moretti Sgubini, A. M. and Pellegrini, E. (2010) Corredi funerari femminili di rango a Vulci nella prima età del ferro. Il caso della tomba dei bronzetti sardi. In N. Negroni Catacchio (ed.), *L'alba dell'Etruria. Fenomeni di continuità e trasformazione dei secoli XII-VIII a.C. Ricerche e Scavi. Preistoria e protostoria in Etruria*, 169–213. Milan: Università degli Studi.

Atzori, M. (2021) La 'Grotta della Vipera' ou comment lire un cycle épigrammatique. In G. Labarre (ed.), *Sources, histoire et éditions. Les outils de la recherche formation et recherche en science de l'antiquité*, 19–50. Besançon: Presses universitaires de Franche-Comté.

Bernardini, P. (2004) Gli eroi e le fonti. In Zucca 2004a, 39–62.

Carboni, R., Corda, A. M. and Giuman, M. (eds) (2021) *Il tempo dei Romani. La Sardegna dal III secolo a.C. al V secolo d.C.* Nuoro: Ilisso.

Cavalier, M. and Depalmas, A. (2008). Materiali sardi nel villaggio di Lipari. I frammenti ceramici e le correlazioni. *Rivista di scienze preistoriche* 58, 281–299.

Cherchi, P. (1990) *Pittura e mito in Giovanni Nonnis.* Quartu Sant'Elena: Pittori in Sardegna 1.

Chiai, G. F. (2004) Sul valore storico della tradizione dei *Daidaleia* in Sardegna (a proposito dei rapporti tra la Sardegna e i Greci in età arcaica). In Zucca 2004a, 112–127.

Christophilopoulou, A. (ed.) 2023. *Islander. The Making of the Mediterranean.* Cambridge: Fitzwilliam Museum/Paul Holberton.

Cisci, S., Martorelli, R. and Serreli, G. (eds) (2021) *Il tempo dei Vandali e dei Bizantini. La Sardegna dal V al X secolo d.C.*, Nuoro: Ilisso.

Cisci, S., Martorelli, R. and Serreli, G. (eds) (2023) *Il tempo dei Giudicati. La Sardegna medievale dal X al XV secolo d.C.*, Nuoro: Ilisso.

Concas, R. (1988) La pittura del Quattrocento. In *Catalogo Pinacoteca. Pinacoteca Nazionale di Cagliari 1*, 13–38. *Catalogo*, Cagliari: Soprintendenza ai beni ambientali architettonici e artistici e storici di Cagliari e Oristano – Credito Industriale Sardo.

Cossu, T. and Lugliè, C. (eds) (2020). *La preistoria in Sardegna. Il tempo delle comunità umane dal X al II millennio a.C.* Nuoro: Ilisso.

Cossu, T., Perra, M. and Usai, A. (eds) (2018) *Il tempo dei Nuraghi. La Sardegna dal XVIII all'VIII secolo a.C.*, Nuoro: Ilisso.

Cugusi, P. (2003) *Carmina Latina epigraphica provinciae Sardiniae*. Bologna: Testi e manuali per l'insegnamento universitario del latino 74.

Del Vais, C., Guirguis, M. and Stiglitz, A. (eds) (2019) *Il tempo dei Fenici. La Sardegna dall'VIII al III secolo a.C.*, Nuoro: Ilisso.

Depalmas, A. (2005). *Le navicelle di bronzo della Sardegna nuragica*. Cagliari: Collana La Terra dei re 5.

Doria, F., Giuliani, S., Grassi, E., Puddu, M. and Pulcini, M. L. (eds) (2021) *Sardegna isola megalitica. Dai menhir ai nuraghi: storie di pietra nel cuore del Mediterraneo*. Milan-Rome: Skira/Il Cigno.

Ferrarese Ceruti, M. L. (1979) Ceramica micenea in Sardegna. Notizia preliminare. *Rivista di scienze preistoriche* 34, 243–253.

Ferrarese Ceruti, M. L. (1987) Considerazioni sulla ceramica nuragica di Lipari. In G. Lilliu (ed.), *La Sardegna nel Mediterraneo tra il secondo e il primo millennio a.C*, 431–442. Cagliari: Edizioni della Torre.

Ferroni, G. (2019) *L'Italia di Dante. Viaggio nel paese della Commedia*. Milan: La nave di Teseo.

Francioni, F. and Sanna, V. (eds) (2012) *Dante e la Sardegna. Invito a una nuova lettura*. Cagliari: Condaghes.

Frisone, F. (2009) L'isola improbabile. L'"insularità' della Sicilia nella concezione greca di età arcaica e classica. In C. Ampolo (ed.), *Immagine e immagini della Sicilia e di altre isole del Mediterraneo antico*. 149–156. Pisa: Seminari e convegni 22.

Gallini, C. (2003[1971]) *Il consumo del sacro: feste lunghe di Sardegna*. Biblioteca di cultura moderna 714. Bari, Laterza (2nd edition). Nuoro: Bibliotheca Sarda 91.

Giuman, M., and Parodo, C. (2018) Agreo e Nomio avrà nome e per altri Aristeo. Storie di api, oracoli e fondazioni. In M. P. Castiglioni, R. Carboni, M. Giuman and H. Bernier-Farella (eds), *Héros fondateurs et identités communautaires dans l'Antiquité entre mythe, rite et politique*, 327–347. Perugia: Quaderni di Otium. Collana di studi di archeologia e antichità classiche.

Guirguis, M. (ed.) (2017) *La Sardegna fenicia e punica. Storia e materiali*. Nuoro: Corpora delle antichità della Sardegna.

Jefferson Looney, J. (ed.) (2005). *The Papers of Thomas Jefferson, Retirement Series, vol. 2, 16 November 1809 to 11 August 1810*. Princeton NJ: Princeton University Press.

Kassianidou, V. and Papasavvas, G. (eds) (2012) *Eastern Mediterranean Metallurgy and Metalwork in the 2nd Millennium B.C.* Oxford, Oxbow Books.

Knapp, A. B. (2008) *Prehistoric and Protohistoric Cyprus: Identity, Insularity, and Connectivity*. Oxford-New York: Oxford University Press.

Knapp, A. B., Russel, A. and Van Dommelen, P. (2022) Cyprus, Sardinia and Sicily. A maritime perspective on interaction, connectivity and imagination in Mediterranean prehistory. *Cambridge Archaeological Journal* 32, 79–97.

Lo Schiavo, F. (2005) Le brocchette askoidi nuragiche nel Mediterraneo all'alba della storia. *Sicilia Archeologica* 38(103), 101–116.

Lo Schiavo, F. (2010) Dalla storia all'immagine: La navicella della tomba del duce di Vetulonia. In C. Gasparri, G. Greco, and R. Pierobon Benoit (eds), *Dall'immagine alla storia. Studi per ricordare Stefania Adamo Muscettola*, 43–62. Pozzuoli: Quaderni del Centro studi Magna Grecia 10.

Lugliè, C. (2007) Les modalités d'acquisition et de diffusion de l'obsidienne du Monte Arci (Sardaigne) pendant le Néolithique. Une révision critique à la lumière de nouvelles données. In A. D'Anna, J. Cesari and L. Ogel (eds), *Corse et Sardaigne préhistoriques. Relations et échanges dans le contexte méditerranéen*, 121–129. Paris: Documents préhistoriques 22.

Lugliè, C. (2009) L'obsidienne néolithique et méditerranèe occidentale. In M. H. Moncel and F. Frölich (eds), *L'homme et le précieux. Matières minérales précieuses*, 213–224. Oxford: British Archaeological Report S1934.

Martorelli, R. (ed.) (2002) *Città, territorio, produzione e commerci nella Sardegna medievale. Studi in onore di Letizia Pani Ermini, offerti dagli allievi sardi per il settantesimo compleanno.* Cagliari: Agorà 17.

Martorelli, R., Ladogana, R., Pasolini, A., Campus, S. and Salis, M. (eds) (2021) *La Sardegna medievale, moderna e contemporanea. Storia e materiali.* Sassari: Corpora delle antichità della Sardegna.

Maxia, A. G. (1988) La pittura del Cinquecento. In *Pinacoteca Nazionale di Cagliari. Catalogo 1*, 41–79. Cagliari: Soprintendenza ai beni ambientali architettonici e artistici e storici di Cagliari e Oristano – Credito Industriale Sardo.

Minoja, M., Salis, G. and Usai, L. (eds) (2015) *L'Isola delle torri. Giovanni Lilliu e la Sardegna nuragica. Catalogo della mostra (Cagliari, Roma, Milano 2014-2016).* Sassari: Delfino.

Moravetti, A., Alba, E. and Foddai, L. (eds) (2014) *La Sardegna nuragica. Storia e materiali.* Sassari: Corpora delle antichità della Sardegna.

Moravetti, A., Melis, P., Foddai, L. and Alba, E. (eds) (2017a) *La Sardegna preistorica. Storia, materiali, monumenti.* Corpora delle antichità della Sardegna. Sassari: Corpora delle antichità della Sardegna.

Moravetti, A., Melis, P., Foddai, L. and Alba, E. (eds) (2017b). *La Sardegna nuragica. Storia e monumenti.* Sassari: Corpora delle antichità della Sardegna.

Moscati, S. (1991) *Le terrecotte figurate di S. Gilla (Cagliari).* Rome: Corpus delle antichità fenicie e puniche.

Nissardi, F. (1897) Scavi in Sardegna. Scoperta di ceramiche medievali. *Le Gallerie Nazionali Italiane. Notizie e documenti* 3, 280–284.

Opper, T. (2021) *Nero, the Man behind the Myth.* London: British Museum.

Pergola, A. (2022) Le memorie del Regio Gabinetto di Storia naturale e Antichità (1801–1806). In M. Rapetti and E. Todde (eds), *Gli stabilimenti scientifici della Regia Università di Cagliari. Guida alle fonti 1*, 41–69. Torre del Lago: Collana di archivistica, documentazione e storia.

Perra, M. and Lo Schiavo, F. (eds) (2021) *Contatti culturali e scambi commerciali della Sardegna nuragica: La rotta meridionale (Sardegna, Sicilia, Creta, Cipro).* Cagliari: Arkadia.

Pianu, G. (2004) Il mito di Aristeo in Sardegna. In Zucca 2004a, 96–98.

Pinna, F. (2010) Le testimonianze archeologiche relative ai rapporti tra gli Arabi e la Sardegna nel medioevo. *Rivista dell'Istituto di Storia dell'Europa Mediterranea* 4, 11–37.

Poisson, J. M. (2001) Archéologie e histoire de la Sardaigne médiévale: Actualité de la recherche. *Mélanges de l'École française de Rome - Moyen Âge*, 113(1), 1–147.

Porceddu, R. (1998) *Il tesoro ritrovato. Le ceramiche ispano moresche del fondo Pula.* Cagliari: Sainas.

Porcella, M. F. (1988) La ceramica. In *Pinacoteca Nazionale di Cagliari. Catalogo 1*, 177-202. Cagliari: Soprintendenza ai beni ambientali architettonici e artistici e storici di Cagliari e Oristano – Credito Industriale Sardo.

Poupeau, G., Lugliè, C. and D'Anna, A. (2010) Circulation et origine de l'obsidienne préhistorique en Méditerranée. Un bilan de cinquante années de recherches. In X. Delestre and H. Marchesi (eds), *Archéologie des rivages méditerranéens. 50 ans de recherche*, 183–191. Paris: Errance.

Pusole, A. (2019) I tripodi bronzei nuragici: Un contributo. *Quaderni* 29, 53–80.

Ruggeri, P. (2004) Olbia e la casa imperiale. In A. Mastino and P. Ruggeri (eds), *Da Olbìa ad Olbia. 2500 anni di storia di una citta mediterranea*, 281–303. Sassari: Pubblicazione del Dipartimento di Storia dell'Università degli studi di Sassari 27(1).

Russell, A. and Knapp, A. B. (eds) (2017) Sardinia and Cyprus: An alternative view on Cypriotes in the central Mediterranean. *Papers of the British School at Rome* 85, 1–35.

Russo, A., Guarneri, F. and Borghini, S. (eds) (2023) *L'amato di Iside. Nerone, la Domus Aurea e l'Egitto*. Rome: Storia e civiltà.

Sabatini, S. and Lo Schiavo, F. (2020) Late Bronze Age metal exploitation and trade: Sardinia and Cyprus. *Materials and Manufacturing Processes* 35(13), 1501–5018.

Sanna, S. (2004) La figura di Aristeo in Sardegna. In Zucca 2004a, 99–111.

Santoni, V. (ed.) (1989) *Il museo archeologico nazionale di Cagliari*. Cinisello Balsamo: Amilcare Pizzi.

Scanu, M. A. (2017) *Il retablo di Tuili. Depingi solempniter. Uomini, viaggio e vicende attorno al Maestro di Castelsardo*. Ghilarza: ISKRA.

Sgarbi, V. (2021) *Giovanni Nonnis. L'arte della reinvenzione del mito*. Milan: Skira.

Siddi, L. (1988) L'Oggettistica. In *Pinacoteca Nazionale di Cagliari. Catalogo* 1, 121–130. Cagliari: Soprintendenza ai beni ambientali architettonici e artistici e storici di Cagliari e Oristano – Credito Industriale Sardo.

Spigno, F. L. (2022) Ceramica micenea in Sardegna: Stato delle ricerche e prospettive future. *Layers* 7, 1–30.

Stoddart, S., Aines, E. D. and Malone, C. (eds) (2021) *Gardening Time. Monuments and Landscape from Sardinia, Scotland and Central Europa in the Very Long Iron Age*. Cambridge: McDonald Institute for Archaeological Research.

Vagnetti, L. and Lo Schiavo, F. (1993) Alabastron miceneo dal nuraghe Arrubiu di Orroli (Nuoro). *Rendiconti dell'Accademia dei Lincei* 4, 121–148.

Virdis Limentani, C. and Spissu, M. V. (2018) *La via dei retabli. Le frontiere europee degli altari dipinti nella Sardegna del Quattro e Cinquecento*. Sassari: Delfino.

Zucca, R. (ed.) (2004a) *Λόγος περὶ τῆς Σαρδοῦς. Le fonti classiche e la Sardegna*. Rome: Pubblicazioni del Centro di studi interdisciplinari sulle province romane dell'Università degli Studi di Sassari, 24.

Zucca, R. (2004b) Sardos, figlio di Makeris. In Zucca 2004a, 86–95.

Zucca, R. (2016) Nuovi documenti sul culto di Aristeo in Sardinia. *Analysis Archaeologica* 2, 117–130.

Chapter 8

Being an Islander in the 3rd millennium BC Small Cyclades in the central Aegean: Connectivity, food networks, and sustainability of resources

Evi Margaritis, Michael J. Boyd, and Colin Renfrew

This chapter is dedicated to the unique 3rd millennium BCE congregation, ritual and craft-oriented proto-urban centre of Dhaskalio and Kavos at the western end of the island of Keros in the centre of the Aegean. Recent excavations have finally allowed us to understand the practices carried out at the extraordinary sanctuary on Kavos, which involved the deposition of broken, choice items, and the gathering of participants who came from all over the Cyclades and beyond. Excavations on Dhaskalio have also proven extremely interesting, uncovering dense proto-urban architecture and evidence for widespread craftworking, especially complex metallurgy (all stages from smelting to finished artefact production). This chapter reviews the evidence and asks how such a large site, with unparalleled access to far-flung resources and maritime connections, sustained a labour force on a local level as well as a sophisticated network of information flow and resources on the regional level. The solutions to sustaining such a complex site represent a unique case study of 'being an islander' in the 3rd millennium Aegean.

Introduction

Much has been written about the remarkable 3rd millennium BC ritual and craft-oriented proto-urban centre of Dhaskalio and Kavos at the western end of the island of Keros in the centre of the Aegean (Fig. 8.1; Renfrew 2013a; Renfrew *et al.* 2022). The importance of Keros to the understanding of the mid-3rd millennium has been clear since the early 1960s, when an episode of looting brought the site to the attention of the archaeological world; Colin Renfrew, in *The Emergence of Civilisation* (1972), even named the period after the site (the so-called 'Keros-Syros Culture'). Significant scientific excavation in 2006–2008 finally clarified the nature of the so-called 'special deposits' at Kavos and largely laid to rest the question of the nature of the deposits themselves. However, the nature of the site overall, including the now-islet of Dhaskalio (but promontory in the 3rd

millennium BC, due to sea level change), was much more complex than could be explained by the deposits themselves. The first excavations on Dhaskalio could be interpreted as indicating an ancillary status within the overall 'sanctuary' (Renfrew 2013a) but more extensive excavations in 2016–2018 have shown that it plays an important role in understanding the entire site-complex, and thus the general interpretation, which must now go further than was possible in 2008. A major part of this is the realisation of the role of large numbers of people involved in building the site, then working at it, and (to an extent not yet fully understood) living at it. For Dhaskalio and Kavos form a highly unusual site, one whose nature could hardly have been imagined before the excavations carried out until now. If a site like Skarkos on Ios (Marthari 2017; 2018) represents an archetypal settlement site where the functions of daily life are contained within the settlement, Dhaskalio and Kavos clearly represent something much more complex, a different organisational scope. This chapter will focus on the unusual nature of the site, and how it may have sustained itself over the course of some 500 years or more, especially in the framework of maritime connections and the concept and sustainability of a distributed taskscape, effectively responding to the challenges that this unusual island community had to face. This paper will examine the life cycle of a site, located in the heart of the Aegean archipelago, the survival of which depended on extensive networking between different islands: Keros' singular solutions represent a unique case study of 'being an islander' in the 3rd millennium Aegean.

Background

The history of research on Keros began with, and evolved around, the presence of Cycladic figurines. Prior to 1963, the donation to the Louvre in 1873 of the head of an almost life-size sculpture, followed by the recovery in 1884 of the famous pipe player and harpist, both now in the National Museum in Athens (Renfrew 2013b), indicated Early Cycladic presence on the island. In 1963, Renfrew reported 'catastrophic illicit digging' (Renfrew *et al.* 2024, 1) highlighting the urgency of proper archaeological study in the area. The first excavations focused on the Kavos area (Doumas 1964), now known as the 'Special Deposit North', and also included some preliminary work on Dhaskalio (Doumas 2013). Subsequent larger-scale excavations, led by Zapheiropoulou in the late 1960s (Zapheiropoulou 1968a; 1968b), yielded significant finds but within a narrow range of material types. Among the recovered artefacts were numerous fragments of marble figurines and vessels, and of vessels crafted from other stones such as Kouphonisi limestone or steatite. Additionally, the excavations unearthed a vast quantity of pot sherds, with sauceboats and conical necked jars being particularly prevalent. The specific nature of the recovered material sets it apart from typical settlement or cemetery assemblages (Sotirakopoulou 2004). The concentration of choice artefacts suggests a deliberate selection process, indicating that the site served

8. Being an Islander in the 3rd millennium BC Small Cyclades

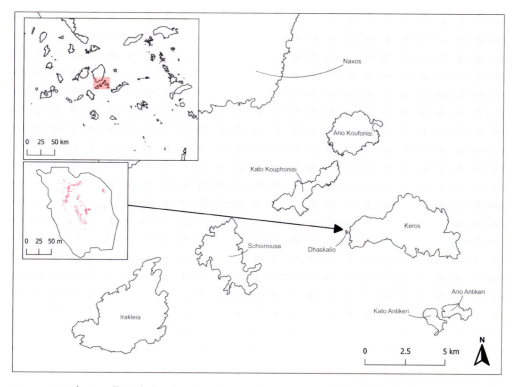

Figure 8.1. The Small Cyclades showing the location of Keros and Dhaskalio (© The Keros Project).

a specialised function distinct from everyday domestic or funerary activities. This unique assemblage underscored the significance of Keros as a site of cultural and possibly ritual importance in the Early Cycladic period.

The looting of the deposit made it extremely difficult to advance an adequate interpretation of an unmatched assemblage, leading to divergences of opinion between specialists as to the meaning of the material from Keros. In order to begin to solve this question, further work in 1987 (Renfrew *et al.* 2007) concentrated on limited renewed excavation in the Special Deposit North and a survey of the whole Kavos area (Whitelaw 2007). The work produced the significant confirmation that the material had been broken in antiquity (rather than during the looting process: Renfrew 2007). The survey found that the site was much larger than just the looted area with archaeological material scattered both to the north (in the area of the 'Kavos Promontory') and to the south. Moreover, the islet of Dhaskalio, some 90 m offshore, although not surveyed in 1987, was known to be the locus of settlement (Doumas 2013). Whitelaw (2007), along with Cyprian Broodbank (2007) who studied the pottery, came to believe that the whole area around the Special Deposit North, including Dhaskalio, was probably the location of a large settlement involved in

trading with other large Cycladic settlements. Without further work, however, this could only remain a hypothesis.

To resolve the ongoing problems of interpretation for Keros, a new excavation and research programme was initiated by Colin Renfrew in 2006. The focal point of the new excavation campaign was an area some 110m to the south of the looted area, and from the very first day of the excavation it quickly became clear that the area under excavation was, in fact, very similar in nature to the Special Deposit North: so similar, in fact, that the area is now referred to as the 'Special Deposit South'. Importantly, this area had not been discovered and plundered by the looters (Renfrew *et al.* 2015; 2018a).

The material content of the Special Deposit South was very comparable to that of the Special Deposit North: more than 500 fragments of marble figurines, of which 498 were of the 'folded-arm' form, with more than 2000 stone vessel fragments, and fragments of stone 'spools', small pestles perhaps used in grinding pigment and sometimes thought also to be used as weights. Along with stone, the deposit contained more than 50,000 pottery sherds and more than 3000 fragments of obsidian. Equally is the rarity of certain finds, such as worked stone tools for everyday tasks like grinding or hammering (only 14 examples), or objects of metal (only four items). It was clear again that the contents of the deposit were of limited categories of material and study of the pottery again showed it to be dominated by the sauceboat and the conical necked jar (Renfrew *et al.* 2018a).

While the antiquity of the breaks could be recognised as early as the 1987 work in the looted area, the most surprising fact about the assemblage could only be understood from the unlooted material from the Special Deposit South: the broken fragments were not found to rejoin with each other to make intact figurines or vessels. In fact, it seems to be that, in the great majority of cases, only a single fragment of each object was deposited on Keros, and this applied to the pottery as well as to the stone objects. Even where joins were found, they almost always simply joined up to make a larger fragment, rather than a whole object. It appeared that not only were the objects deposited already broken but that a selection took place and most of each object was not selected for deposition. Careful search for tiny fragments of marble during the excavation, without result, indicated clearly that the breakage did not take place within the Special Deposit South (Renfrew 2015). Micro-morphological study of the area of the deposit demonstrated that it was primary in nature (French and Taylor 2015).

This led to the interpretation that breakage took place elsewhere, on other islands, as part of local drinking or feasting ceremonies, and that the selected pieces were set aside for future transport to Keros and deposition there (Renfrew *et al.* 2012; Renfrew 2013a). In part we can understand this because all the artefacts were imported: none was made locally on Keros. The range of islands where the pottery was made shows that all the local islands (Naxos, Amorgos, and Ios) were involved, along with many more distant islands, and some material even came from the mainland. Thus, over a

8. Being an Islander in the 3rd millennium BC Small Cyclades　　121

centuries long period the west coast of Keros was the destination for boats and crews during long journeys, undertaken at least in part so as to participate in the rituals on Keros. For this reason, the site has been identified as a place for congregation of the Cycladic peoples, where they affirmed a particular identity in rituals of deposition of broken, choice material.

Located just 90 m off the coast of Keros, the former promontory of Dhaskalio (about 210 × 120 m in area and 34 m high), because of the causeway between it and Kavos, actually formed an excellent natural harbour, usable whether the wind blew from the north or from the south (Dixon and Kinnaird 2013). Five full seasons of work have now been carried out on Dhaskalio (2007–2008, and 2016–2018). In 2007 and 2008 work concentrated on the summit of the islet, revealing a series of buildings covering the summit area (Renfrew *et al.* 2013). Subsequent work has uncovered building remains on the north and east slopes and visible surface remains suggest that most of the east and north sides were covered in dense building remains (Fig. 8.2; Boyd 2013). Study of the pottery has suggested a three-phase chronology (Sotirakopoulou 2016) and radiocarbon dates allow us to suggest that the site was first occupied around 2750 cal BC or just a little earlier (Renfrew *et al.* 2012; Manning 2015). Phase A lasts until 2550 cal BC, with Phase B covering the period 2550–2400 cal BC, and Phase C 2400–2250 cal BC, or perhaps just a little later (new radiocarbon dates are currently under study). Thus, the islet of Dhaskalio was occupied over a span of five or six centuries and the evidence suggests that intensive use began from early in Phase A and lasted through Phase B, with Phase C being a period when only the summit area remained in use (Renfrew *et al.* 2022). Synchronising the Dhaskalio dates with the Special Deposit South ceramic suggests that the latter's main period of use was in Phase A, with some continuing use in Phase B and just a little activity in Phase C (Boyd *et al.* 2015).

The Phase C buildings on the summit of Dhaskalio occupied the only relatively flat space on the islet, which is otherwise very steep. The summit seems, however, to have been open space for much of the lifetime of the site before Phase C. From the earliest period, dense architectural space was facilitated by building a series of massive terraces on the eastern and northern slopes of the islet, creating level space between the terraces suitable for building (Renfrew *et al.* 2022; Floquet, PhD thesis in progress). Some of the terraces were themselves monumental in nature (by the standards of the time), creating façades that would have been visible from a distance when approaching by sea. Monumental entranceways were created, both at the bottom of the islet in the first terrace, and at the top near the summit. Complex systems for drainage were built in, suggesting advanced planning and an overview of a complete system. But most remarkable of all was the fact that the buildings were all constructed using marble imported from Naxos, 10 km distant. A minimum of 10,000 tonnes of marble was imported for this purpose, suggesting many hundreds of sea journeys between Keros and Naxos. The freshly cut marble would have glinted in the sun, enhancing the visual aspect of the site for those approaching from the north.

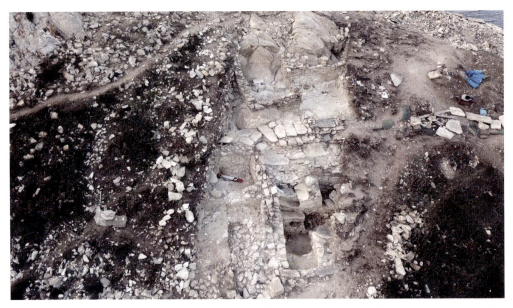

Figure 8.2. Dense architecture built of Naxian marble on the north-west slope of Dhaskalio (© The Keros Project).

The workforce required for transport and construction would have been significant, even if spread over many years.

The construction operation on Dhaskalio would have required a controlled master plan, involving the co-ordination of a substantial workforce operating under some form of authority. The scale and complexity of the construction project, such as the building of terrace walls and other architectural features, suggest the involvement of at least some skilled labourers and the need for organisational oversight. Given the challenges posed by the rugged terrain and limited resources on the island, the successful execution of such a project would have demanded careful planning, efficient resource management, and co-ordination among various labour teams. Moreover, the presence of elaborate architectural structures and infrastructure, as evidenced by the terrace walls and other built features, indicates a level of engineering expertise and sophisticated construction techniques. The existence of some sort of authority overseeing the construction efforts is implied by the cohesive and systematic nature of the building operations. Such an authority would have been responsible for devising the master plan, allocating resources, directing labour teams, and ensuring the co-ordinated completion of construction tasks.

Renfrew first defined the importance of metalworking for understanding what he termed 'the emergence of civilisation' in the Aegean in the 3rd millennium BC (Renfrew 1972). The importance of Keros for metalworking had been apparent for

8. *Being an Islander in the 3rd millennium BC Small Cyclades* 123

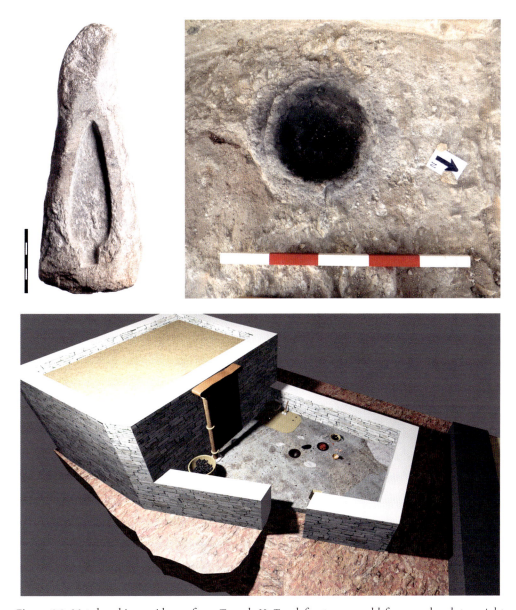

Figure 8.3. Metalworking evidence from Trench H. Top left: stone mould for spearhead; top right: hearth set into rock; below: sketch reconstruction of the open-air workshop (© The Keros Project).

some time, after the analysis of slags collected on the Kavos Promontory in 1987, north of the Special Deposit North (Georgakopoulou 2005; 2007a; 2007b; 2016; 2023). Surprisingly, these slags turned out to be the product of two different smelting processes: ore had been brought from wherever it had been mined (presumably in

the western Cyclades) and smelted on Kavos Promontory. This is the only known smelting site in the Cyclades located at a significant distance from ore sources: the normal practice was to smelt near the mines, thus reducing considerably the volume of material, from raw ore to smelted metal (Georgakopoulou 2016). That this was done on Kavos Promontory, in an open area suitable for people to gather, suggests a public performance of the metalsmiths' skill. Interestingly, Kavos Promontory was also the location of production of obsidian blades, also potentially in a public act, linking the production of obsidian and metal as resources imported mainly from the western Cyclades (Boyd and Renfrew 2018; Carter and Milić 2018). The evidence for metallurgy and obsidian working on Kavos Promontory further emphasised the highly connected nature of the site and its dependence on external resources for its principal functions.

The excavations on the slopes of Dhaskalio in 2016–2018 significantly expanded our understanding of the importance of metalworking on Keros, bringing to light a wealth of new evidence (Renfrew *et al.* 2022; Georgakopoulou 2023). Three workshops were identified (Fig. 8.3). The earliest dates to the first days of the settlement after 2800 BC, in a location close to the causeway between Keros and Dhaskalio where the entrance to the site was constructed. Here were excavated two rounded hearths in which copper and perhaps other metals were melted. Crucibles, moulds, and tuyères (blowpipe tips) were found, along with tools used in the processes. At a slightly later date the hearth was set next to a wall in the same area and in the careful screening of the detritus from this hearth was found a minuscule fragment of gold wire with clear toolmarks showing that it was used in complex decorative work on larger objects. A second workshop of Phase B was located higher on the slopes where, again, primarily copper metallurgy was practised but, in this case, with a different process using fragmented large ceramic plates ('baking pans'). Throughout Dhaskalio the evidence is that arsenical copper was being used but, in some cases, tin bronze is also evidenced. A third workshop for lead was found, where silver may also have been produced. Dhaskalio now has more gold (as well as clear evidence for goldworking) than the whole of the early Cyclades combined, as well as moulds evidently used for producing the most emblematic of Cycladic metal artefacts, the dagger.

Sustaining the Keros nexus

The surprising details of the finds on Dhaskalio raise as many questions as they answer. It is clear that Dhaskalio acted as a centre into which raw materials were brought and from which finished products would circulate. This makes it likely that a significant skill base for metallurgy (as well as obsidian production and perhaps for other craft activities not yet well evidenced) was maintained at Dhaskalio. The scale of production is matched at few other sites, none of which is located in the Cyclades: the site of Poros Katsambas on Crete (Doonan *et al.* 2008) and that of Çukuriçi Höyük on the Anatolian coast (Horejs 2017) are comparable in scale and overlap in chronology, though Keros

is mainly slightly later. But neither of these sites presents other strong similarities to Keros. In particular, the interplay between the ritual element of activity on Kavos and the productive activity on Dhaskalio is unprecedented, and underpins the unique nature of the site. Sites of a unique nature, however, present particular difficulties in understanding how they operated within different milieux and at different scales.

We begin with the contrast that while Keros was the site for the deposition of figurine fragments at the end of their life cycle, it was the site of production of Cycladic daggers, which began their life cycle there but went far and wide and may well have been recognisable in themselves as originating from Dhaskalio. The scale of construction at Dhaskalio was impressive, as we have seen, and while the evidence for metalworking was ubiquitous, it was not the case that (as at Çukuriçi Höyük) each building was dedicated to, or at least accommodated, metalworking. Other activities may be presumed to have taken place with the Dhaskalio complex. Besides metalworking and the production of obsidian artefacts, few specific activities have so far been detected. Evidence for quotidian activities such as cooking are limited: very few hearths have been identified and cooking vessels are also few. There is plenty of evidence for storage in the pottery on the site, though some at least of the available storage may have been used for water, that would be in high daily demand. The ceramics, along with all the other materials on site, were imported, mainly from the nearby islands (Hilditch 2018). Key questions in the ongoing analyses of materials and samples revolve around the activities that can be defined as happening at the site and how those activities could be supported in a place with so few obviously domestic contexts and on an island that, at first glance, seems exceptionally limited agriculturally (Renfrew *et al.* 2018b).

A comprehensive environmental sampling programme was implemented during all excavation seasons, aiming to gather a wide range of data on potential culinary practices, agricultural methods, animal husbandry, and the utilisation of natural resources. To achieve this goal, a variety of multi-proxy analysis techniques was employed to maximise the information obtained. The sampling programme encompassed the analysis of both macro- and micro-archaeobotanical remains, including wood and charcoal samples for macro-analysis, as well as starch and phytoliths for micro-analysis. Additionally, the programme involved the examination of animal remains, shell fragments, and fish remains, providing insights into animal management practices and the exploitation of marine resources. Data from the excavation is also being studied in tandem with data from the earlier Keros Island Survey (Boyd *et al.* in prep), including study of terracing systems, geomorphological analyses, and study of the modern day flora of Keros. By utilising these diverse analytical approaches, the research team aimed to gain a comprehensive understanding of past human-environment interactions, agricultural strategies, and dietary habits. This holistic approach allowed for the exploration of various aspects of ancient life, shedding light on the complexities of past societies and their reliance on the natural world for sustenance and livelihood.

The analysis of environmental data from Dhaskalio has demonstrated a variety of species such as cereals and pulses in small quantities with only limited evidence for processing at the site and a limited range of processed food (mainly from Phase C contexts on the summit), along with significant evidence for other plant remains such as wood and reed (for construction and basketry). The analysis of seeds and charcoal from the 2007–2008 excavations on Dhaskalio was able to show the importance of olive (Margaritis 2013a; Ntinou 2013) and vine (Margaritis 2013b), laying to rest a long-standing question over the importance of these two fruit trees in the 3rd millennium BC. Olive, along with juniper, is endemic to Keros and, while the extent to which domestication may have taken place by this period is still not clear, its cultivation is amply demonstrated. The natural distribution and the environmental preferences of a few other taxa found in smaller quantities, namely cypress (*Cupressus sempervirens*), black pine (*Pinus nigra*, ash (*Fraxinus* sp.), and poplar or willow (*Populus* or *Salix*), indicate that they are exogenous to the island or, in some cases, the broader Cycladic area. In the Aegean, cypress is native to Crete and the areas of its distribution are mostly confined to higher altitude. Black pine is a mountain conifer with a broad distribution in mainland Greece from the north to the southern Peloponnesian mountains but absent from the Aegean area and Crete (Ntinou 2013). These environmental data go hand-in-hand with the pattern described so far of materials coming to Keros from different areas of the Cyclades and beyond.

The archaeobotanical data from Dhaskalio in Phases A and B, primarily on the slopes of Dhaskalio, provide far more evidence for fruits and nuts (49% of seeds) than cereals (16%) or pulses (11%); the wild, weed, and indeterminate seeds accounting for the remaining 24% (Fig. 8.4). The pattern is different in Phase C (mainly on the summit), where cereals account for 43% of seeds, fruits and nuts 44%, pulses only 4%, and the rest 9% (Fig. 8.4). Among the charcoals, olive is dominant in all periods, with some presence of almond, fig, and (among the non-food wood) juniper. The fruits all have the potential to have come to Dhaskalio in processed form, suitable for storage and for consumption without preparation. The lack of cereal remains, especially in Phases A and B, probably also points to foodstuffs coming into the site already processed. And the animal bones also clearly point to consumption with minimum emphasis on processing: slaughter and butchery did not occur in any area excavated so far. The overall quantities of seeds, charcoal, and bones are perhaps more limited than might have been expected and the lack of evidence for processing makes it clear that only the final stage, consumption, occurred on Dhaskalio.

Domestic space might also be evidenced by cooking facilities. The general lack of such facilities stands in stark contrast to the site of Skarkos on Ios. There, many houses are equipped with an oven or dedicated cooking space. The range and quantity of food processing equipment far outstrips that of Dhaskalio where, among the worked stone, tools specifically identified as part of food processing are very rare: in Trench A, for example, lower grinding stones amount to 10% of identified tools and many of these will not have been used for food processing. Instead, the worked stone is

overwhelmingly identified with craft activities, perhaps in most cases part of the metalworking toolkit prevalent at the site (Fig. 8.5; Capra *et al.* forthcoming).

If very little food processing occurred at Dhaskalio, at least in Phases A and B, some consumption at least is indicated not only by the data outlined above but by the sheer scale of the site. Population estimates are difficult to produce and are usually based on concepts of domestic space rather than places with special functions. Moreover, at this stage of research, the full range of activities taking place on roof space (most, but not all, buildings were single storey with flat roofs suitable for activities) remains an open question. But even if the functions being carried out at the site are partly, or perhaps mainly, other than domestic, it is clear from the scale of the site that considerable numbers of people would require sustenance throughout the day. That there are so few clearly domestic spaces in the part of the site excavated so far simply intensifies the interest around how practical functions were sustained.

Apart from the inherent capacities of the building complex and the material culture within it, the other salient fact is import of almost all material to Dhaskalio and Kavos. While the material within the two special deposits is obviously imported, it is the case that all the ceramics, metals, stone tools, and other objects found within Dhaskalio itself are also imported. This points to an extremely high level of connectivity, going beyond the expectations of a 'normal' settlement site (perhaps like that at Skarkos).

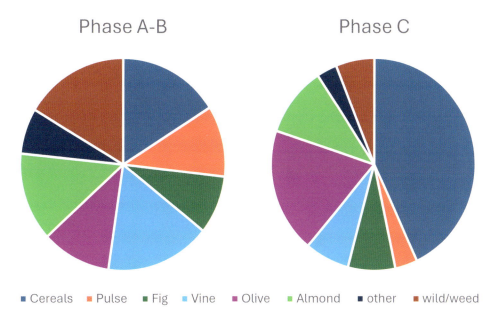

Figure 8.4. Species represented (%) among the seeds from Dhaskalio. Phase A & B represented by Trenches C, L, and H, along with all trenches from 2007–2008; Phase C represented by Trench F, along with all trenches from 2007–2008 (© The Keros Project).

In order to investigate the nature of this connectivity and the role of Dhaskalio and Kavos in a wider area, we undertook a series of investigations on Keros itself, in the form of a surface survey and subsequent test excavations, and then in the southern coastal area of Naxos (the Southeast Naxos Survey) and on the intervening island of Kato Kouphonisi.

The results of the survey on Keros were initially surprising (Boyd *et al.* in prep). A significant number of areas of human activity were detected, ranging far beyond the area of Dhaskalio and Kavos. The north-west coastal zone in particular seemed to be a focal area but places near the modern settlement of Konakia and areas on the southern side of the island were also repeatedly inhabited. Based mainly on the ceramics, three periods stand out: the Early Bronze Age, the late Roman and Early Byzantine period, and the early modern period (meaning the last couple of centuries). The same areas seem to have attracted human settlement in different periods, probably mainly due to the availability of water and agricultural potential. The, sometimes dense, terracing systems were mapped throughout the island: terracing in the Cycladic islands has always been a strategy to create viable agricultural potential and, based on different dating techniques, we are now sure that some of the terraces that still survive are indeed Early Bronze Age in date (though many others are much later). In 2016–2018, follow-up test trench excavations were effected in two of the areas of human activity identified in the survey. In one area in the north-west coastal plain a small site of the period immediately preceding the Kavos and Dhaskalio complex was discovered (Final Neolithic to Early Bronze I), thus showing for the first time that Keros was, in fact, inhabited before the sanctuary at its western end came to prominence. In a second area, some 400 m north along the coast from Kavos, test trenches produced evidence for Early Bronze Age metalworking in this area, showing – perhaps surprisingly – that this practice extended well beyond the area of Dhaskalio and Kavos Promontory. Overall, the survey showed that, rather than being isolated on an uninhabited island and reached only by sea, the Dhaskalio and Kavos complex was in fact part of a developed settlement hierarchy on Keros itself.

Although the question of terrace construction for agriculture has long been unclear for prehistoric periods, evidence for prehistoric terraces can now be found in several places (e.g. at Palaikastro in eastern Crete: Orengo and Knappett 2018, with references for further 2nd millennium BC sites in Crete). The massive architectural terraces built on Dhaskalio, with their associated drainage systems, show both the terracing concept writ very large and the availability of labour for their construction. The apparently prehistoric agricultural terraces on Keros are much more modest in scale and perhaps designed as much for water management and irrigation as for soil retention. Located primarily in the north-west coastal zone, where there is a modest gradient and into which water would have flowed in season from the hills above (Gkouma forthcoming), the remnants of these short terraces suggest an intricate complex over a large area, making it possible that the agricultural production capacity of Keros was somewhat larger than one might initially imagine.

8. *Being an Islander in the 3rd millennium BC Small Cyclades* 129

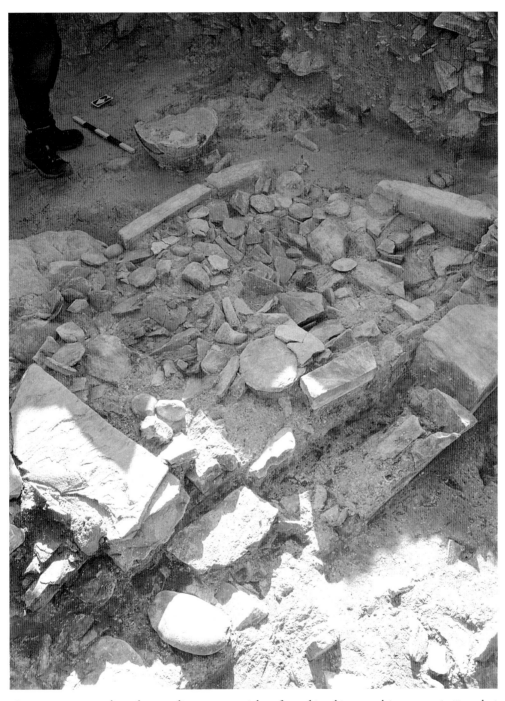

Figure 8.5. Stone tools and stone discs, a potential craft working kit, stored in a room in Trench A (Phase B) (© The Keros Project).

Despite this intriguing evidence for agricultural production and habitation on Keros, it remained clear that much of the food production for such a densely built complex as Dhaskalio must have taken place elsewhere. We consequently decided to extend our survey by covering the entire area of the nearby island of Kato Kouphonisi (in 2018) and part of the southern coastal area of the much larger island of Naxos (in 2015). Kato Kouphonisi is the nearest sizeable island to Keros, being some 3.3 km distant (from Dhaskalio to the beach at Nero on Kato Kouphonisi). The island is only 3.5 km² (compared to the 15.3 km² of Keros) but the surface potsherd density was considerably higher than that on Keros (or on south-east Naxos, described further below). A large Early Bronze Age site seems to have been located above the beach at Nero and, in the north-east of the island, the dense ceramics include both prehistoric and late Roman and Early Byzantine sherds. While study of the material is ongoing, it seems clear that Kato Kouphonisi (and, by implication, Ano Kouphonisi and perhaps other islands in the Small Cyclades, not yet surveyed) was indeed a significant source of agricultural production which could have been exploited by those working at Dhaskalio.

The pattern on south-east Naxos was rather different, where survey covered about 10 km² (Renfrew *et al.* in press). While this represents a small sample of the island overall, it includes the areas closest to Keros and two important harbours, at Panormos in the east and Kalandos in the west. The aim was to survey the coastal zone and inland from the Kalandos valley as far as possible, including the area around known sites such as Panermos (Angelopoulou 2014), Spedos, and the cemeteries at the western end of the area. Nonetheless, in this case the surface ceramic density was much lower than either Keros or Kato Kouphonisi. Early Bronze Age, late Roman, and early modern sites were again the most common: Panormos was an important harbour in the late Roman period. Perhaps most interesting was the site of Spedos in the middle of the survey area on the coast. This site was previously known from the excavation of the cemetery, in the valley floor, but Early Bronze Age architectural remains were visible on the promontory jutting out into the sea, perhaps somewhat similar in size to the nearby Early Bronze Age enclosure of Panormos.

The presence of a small site on Keros preceding the Dhaskalio and Kavos complex is very important in demonstrating that Keros was not uninhabited when the sanctuary was initially established, and that a small subsistence base on Keros itself was already in existence. But the strong indications for habitation on Kato Kouphonisi make it ever more likely that we should be imagining Keros and Kato Kouphonisi, perhaps along with Ano Kouphonisi and the other Small Cyclades, as part of a single system of small-scale circulation and thus as a dispersed *taskscape*, whereby different functions of daily life could be located in different places (Boyd *et al.* in prep). This could potentially explain the remarkable concentration of congregation, ritual, and craft activity in the area of Kavos and Dhaskalio, while the daily tasks of land management, agricultural production and processing, and food sustainability could be managed from locations on Kato Kouphonisi, central Keros, and elsewhere. The short distances involved (3.3 km

between Keros and Kato Kouphonisi is very manageable in reasonable weather) allow for circulation between task points by land or sea on a daily basis. This suggests we need to move beyond the concept of a 'settlement' as a single location encompassing all the tasks of life to a more distributed mode of habitation, where different tasks are located in different places, each with their own tempo and population requirements. While there remains much work to do to understand and investigate this concept, this may have been the secret of the success of Keros within the Small Cyclades, at least during Phases A and B.

These, then, are some of the components which must have been carefully combined to create and manage sustainability in resources, particularly food, forming a core part of the Keros nexus. This sustainability allowed the Dhaskalio and Kavos complex to function in a non-quotidian fashion, supporting construction on an unprecedented scale, and craft working at scale requiring rare skills and an array of imports from a variety of sources. But it seems clear to us that it also functioned very much as part of a larger whole, with activities more closely related to survival outsourced to different locations within a distributed mode of habitation. This allowed the sustainable supply of food for everyone inhabiting the core area between Keros and the Kouphonisia, a network of daily travel in which other islands such as Schinousa or Irakleia may also have been implicated. Intensification, diversification, and extensification in agriculture are primarily indicated by the use of terraces, perhaps primarily for irrigation, and a focus on fruit trees. The role of further flung zones such as south-east Naxos is not nearly as clear: several settlements on a scale below that of Dhaskalio are located there, and it is not clear to what extent (if at all) they may have contributed to the sustainability of Keros. Non-fresh products such as raisins, oil, or wine may have travelled longer distances, although the impetus for any such exchange is not clear at present. Nonetheless, given the transport to Keros of an entire array of non-local resources from all over the Cyclades and indeed beyond, and clear evidence for transport from Keros of products such as metal objects, it seems likely that sustainability, at least in part, included the import of food from beyond the Small Cyclades and perhaps the export of some products too.

The survey data also highlight another major question: why did the remarkable Keros nexus come to an end? The Phase C habitation of the summit of Dhaskalio is puzzling because it seems that most of the rest of the buildings on the promontory had been abandoned by this time and were in a state of collapse. It may indeed be that the summit buildings were constructed by re-using the abundant building material lying around, conceivably after a gap in habitation (we so far lack clear indications one way or another for this suggestion). The survey data also show considerable retrenchment around this time. Material of the Middle Bronze Age is found in all three surveys but in smaller quantities and in more limited locations than in the earlier period. It is clear that the habitation pattern in the Small Cyclades changed at this time, supporting a smaller population. Climate change may be involved here:

the so-called 4.2 ka event (Wiener 2014; Railsback *et al.* 2018), a dryer period around 2200 BC, may have made the agricultural systems of the 3rd millennium more prone to failure and less productive in general – perhaps the agricultural terraces of northwest Keros no longer received enough water to remain viable.

The archaeological and environmental evidence from Dhaskalio provides compelling insights into its role as a hub within a vast network of resources, crucial for sustaining its craft production and overall viability. Marble figurines, vessel fragments, metal ores, pottery, and obsidian were all imported from other regions to support the site's extensive craft activities, positioning Dhaskalio as a central node in an Aegean network for the movement of goods and people.

Furthermore, environmental data reveal that, while local landscapes were managed, wood resources from other areas were also transported to Dhaskalio to meet the demands of construction and other activities. Analysis of food remains indicates a variety of species present in the site's later phase, suggesting a diverse diet. However, in earlier phases, nuts and fruits predominated, indicating a more casual and quickly prepared food supply. These food sources likely originated from the surrounding landscape as well as from other nearby islands.

The agricultural land available on Keros and neighbouring islands such as Kato and Ano Koufonisi would have been shared among the inhabitants of the various sites located there. It is likely that people, potentially including those residing on Dhaskalio, moved between sites depending on their activities. This shared utilisation of agricultural land created food security through an intensive network of exchange systems. The disruption or destruction of these networks could have had significant consequences, potentially leading to the abandonment of Dhaskalio and other sites dependent on this intricate web of resource distribution. This underscores the interconnectedness of ancient communities and the importance of connectivity and exchange for their survival and prosperity.

Acknowledgements

The Cambridge Keros Project of 2006–2008 was directed by Colin Renfrew for the British School at Athens, with associate director Olga Philaniotou and assistant directors Neil Brodie and Giorgos Gavalas. Excavations on Keros were conducted with the permission of the Hellenic Ministry of Culture and thanks are due to the then director of the KA′ Ephorate, Marisa Marthari, and her colleagues. Special thanks are due to the Stavros Niarchos Foundation for funding the work of Michael Boyd as co-editor of the publication series (in memory of Mary A. Dracopoulos). The Keros Island Survey of 2012–2013 was a 'synergasia' (joint project) between the then KA′ Ephorate of Antiquities and the British School at Athens. It was directed by Colin Renfrew, Marisa Marthari, and Katerina Dellaporta, with assistant directors Michael Boyd, Neil Brodie, Giorgos Gavalas, Jill Hilditch, and Joshua Wright. The survey area was the island of Keros with its surrounding islets, with the exceptions of Dhaskalio

itself, and the Antikeria. The Keros-Naxos Seaways Project of 2015–2018 was directed by Colin Renfrew and Michael Boyd for the British School at Athens, with associate director Irini Legaki. Assistant directors for the excavations on Dhaskalio and on Keros were Evi Margaritis and Giorgos Gavalas. The latter acted as field director on Keros while field director on Dhaskalio was Ioanna Moutafi. The surveys of Kato Kouphonisi and Southeast Naxos were co-directed with Demetris Athanasoulis. Assistant directors for the surveys were Neil Brodie, Giorgos Gavalas, Jill Hilditch, and Joshua Wright. The fieldwork was conducted with the permission of the Hellenic Ministry of Culture and thanks are due to its director, Demetris Athanasoulis, and his many colleagues, in particular Stefanos Keramidas, who acted as the Ephorate representative in 2018 and oversaw the conservation works in 2019.

We are grateful to the following funders, who have enabled these projects to operate at a large scale and with efficient publication over the past 18 years: the Stavros Niarchos Foundation, the A. G. Leventis Foundation, the Institute for Aegean Prehistory, the Balzan Foundation, the Packard Humanities Institute, the McDonald Institute for Archaeological Research, the Research and Innovation Foundation of Cyprus (EXCELLENCE/1216/0463), the Cyprus Institute, the British Academy, the Leverhulme Trust, the National Geographic Society, the Society of Antiquaries of London, the Gerda Henkel Stiftung, Cosmote, EZ-dot, Blue Star Ferries, Creta Farms, and private donors.

Bibliography

Angelopoulou, A. (2014) *Κορφάρι Των Αμυγδαλιών (Πάνορμος) Νάξου*. Athens: TAPA.

Boyd, M. J. (2013) The structure and architecture of the settlement. In Renfrew *et al.*, 341–385.

Boyd, M. J. and Renfrew, C. (2018) The contrasting material worlds of Dhaskalio and Kavos. In Renfrew *et al.* 2018b, 533–546.

Boyd, M. J., Renfrew, C. and Sotirakopoulou, P. (2015) Pottery of Dhaskalio Phases B and C in the Special Deposit South. In Renfrew *et al.*, 209–288.

Broodbank, C. (2007) The pottery. In Renfrew *et al.*, 115–237.

Capra, D., Caricola, I., Lucarini, G., Mutrie, G., Boyd, M. J., Margaritis, E. and Renfrew, C. (forthcoming) Initials results of use wear analysis on macro-lithic tools from Early Bronze Age Dhaskalio in the central Aegean. *Journal of Archaeological Science: Reports.*

Carter, T. and Milić, M. (2018) The chipped stone industry. In Renfrew *et al.*, 522–523.

Dixon, J. and Kinnaird, T. (2013) Sea-level change and the early bronze age topography. In Renfrew *et al.*, 45–55.

Doonan, R. C. P., Day, P. M. and Dimopoulou-Rethemiotaki, N. (2008) Lame excuses for emerging complexity in Early Bronze Age Crete: The metallurgical finds from Poros Katsambas and their context. In P. M. Day and R. C. P. Doonan (eds) *Metallurgy in the Early Bronze Age Aegean*, 98–122. Oxford, Oxbow Books.

Doumas, C. (1964) Ἀρχαιότητες καὶ Μνημεῖα Κυκλάδων: Κέρος, Νάξος. *Archaiologikon Deltion* 19, 409–412.

Doumas, C. (2013) The Dhaskalio Excavations of 1963. In Renfrew *et al.*, 79–86.

French, C. and Taylor, S. (2015) Geoarchaeological analysis of the Early Bronze Age soil and sediment contexts at Kavos. In Renfrew *et al.*, 15–19.

Georgakopoulou, M. (2005) Technology and Organisation of Early Cycladic Metallurgy: Copper on Seriphos and Keros, Greece. Unpublished PhD thesis, University College London.

Georgakopoulou, M. (2007a) The metallurgical remains. In Renfrew *et al.*, 382–403.

Georgakopoulou, M. (2007b) Metallurgical activities within Early Cycladic settlements: The case of Daskalio-Kavos. In P. M. Day and R. C. P. Doonan (eds), *Metallurgy in the Early Bronze Age Aegean*, 123–134. Oxford: Oxbow Books.

Georgakopoulou, M. (2016) Mobility and Early Bronze Age southern Aegean metal production. In E. Kiriatzi and C. Knappett (eds), *Human Mobility and Technological Transfer in the Prehistoric Mediterranean*, 46–67. Cambridge: Cambridge University Press.

Georgakopoulou, M. (2023) Different scales of archaeometallurgical research at the sites of Dhaskalio and Kavos on Keros: Site survey, excavations, and island-wide survey. In N. Nerantzis (ed.), *Forging Values: Metals Technologies in the Aegean and Beyond from the 4th to the 1st Millennium BCE*, 23–39. Brussels: CReA-Patrimonie.

Gkouma, M. (forthcoming) A geoarchaeological study of the landscape and surface processes on Keros. In C. Renfrew, M. Marthari, A. Dellaporta, M. J. Boyd, N. Brodie, G. Gavalas, J. Hilditch and J. Wright (eds), *The Sanctuary on Keros and the Origins of Aegean Ritual Practice*, Vol. VI: *The Keros Island Survey*. Cambridge: McDonald Institute for Archaeological Research.

Horejs, B. (ed.) (2017) *Çukuriçi Höyük 1. Anatolia and the Aegean from the 7th to the 3rd Millennium BC*. Vienna: Austrian Academy of Sciences.

Manning, S. (2015) Radiocarbon dating and archaeology. History, progress and present status. In R. Chapman and A. Wylie (eds), *Material Evidence: Learning from Archaeological Practice*, 128–158. Abingdon: Routledge.

Margaritis, E. (2013a) Distinguishing exploitation, domestication, cultivation and production: The olive in the third millennium Aegean. *Antiquity* 87, 746–757.

Margaritis, E. (2013b) Foodstuffs, fruit-tree cultivation and occupation patterns at Dhaskalio. In Renfrew *et al.*, 389–404.

Marthari, M. (2017) Cycladic figurines in settlements. The case of the major EC II settlement at Skarkos on Ios and the schematic figurines. In M. Marthari, C. Renfrew and M. J. Boyd (eds), *Early Cycladic Sculpture in Context*, 119–164. Oxford: Oxbow Books.

Marthari, M. (2018) Architecture, seals and aspects of social organisation in the peak period of the Early Bronze Age Cyclades: The evidence from the major settlement at Skarkos on the island of Ios. In H. Meller, D. Gronenborn and R. Risch (eds), *Überschuss ohne Staat – Politische Formen in der Vorgeschichte*, 167–198. Halle: Landesmuseum für Vorgeschichte.

Ntinou, M. (2013) Wood charcoal: Vegetation and the use of timber at Dhaskalio. In Renfrew *et al.*, 417–428.

Orengo, H. and Knappett, C. (2018) Toward a definition of Minoan agro-pastoral landscapes: Results of the survey at Palaikastro (Crete). *American Journal of Archaeology* 122, 479–507.

Railsback, L. B., Liang, F., Brook, G. A., Voarintsoa, N. R. G., Sletten, H. R., Marais, E., Hardt, B., Cheng, H. and Edwards, R. L. (2018) The timing, two-pulsed nature, and variable climatic expression of the 4.2 ka event: A review and new high-resolution stalagmite data from Namibia. *Quaternary Science Reviews* 186, 78–90.

Renfrew, C. (1972) *The Emergence of Civilisation. The Cyclades and the Aegean in the Third Millennium B.C.* London, Methuen.

Renfrew, C. (2007) Thraumatology. In Renfrew *et al.*, 405–428.

Renfrew, C. (2013a) The Sanctuary at Keros: Questions of materiality and monumentality. *Journal of the British Academy* 1, 187–212.

Renfrew, C. (2013b) Keros and the development of the project. In Renfrew *et al.*, 3–18.

Renfrew, C. (2015) The Special Deposit South as a ritual deposit. In Renfrew *et al.*, 381–391.

Renfrew, C., Boyd, M. J. and Bronk Ramsey, C. (2012) The oldest maritime sanctuary? Dating the sanctuary at Keros and the Cycladic Early Bronze Age. *Antiquity* 86, 144–160.

Renfrew, C., Boyd, M. J. and Margaritis, E. (2018b) Interdisciplinary approaches to the prehistory of Keros. *Archaeological Reports* 64, 67–84.

Renfrew, C., Sotirakopoulou, P. and Boyd, M. J. (2024). *The Sanctuary on Keros and the Origins of Aegean Ritual Practice,* Vol. VII: *Monumentality, Diversity and Fragmentation in Early Cycladic Sculpture: The Finds From the Special Deposit North at Kavos on Keros.* Cambridge: McDonald Institute for Archaeological Research.

Renfrew, C., Doumas, C., Marangou, L. and Gavalas, G. (eds) (2007) *Keros: Dhaskalio Kavos, the Investigations of 1987-88.* Cambridge: McDonald Institute for Archaeological Research.

Renfrew, C., Philaniotou, O., Brodie, N., Gavalas, G. and Boyd, M. J. (eds) (2013) *The Sanctuary on Keros and the Origins of Aegean Ritual Practice,* Vol. I: *The Settlement at Dhaskalio.* Cambridge: McDonald Institute for Archaeological Research.

Renfrew, C., Philaniotou, O., Brodie, N., Gavalas, G. and Boyd, M. J. (eds) (2015) *The Sanctuary on Keros and the Origins of Aegean Ritual Practice,* Vol. II: *Kavos and the Special Deposits.* Cambridge: McDonald Institute for Archaeological Research.

Renfrew, C., Philaniotou, O., Brodie, N., Gavalas, G. and Boyd, M. J. (eds) (2018a) *The Sanctuary on Keros and the Origins of Aegean Ritual Practice,* Vol. III: *The Marble Finds from Kavos and the Archaeology of Ritual.* Cambridge: McDonald Institute for Archaeological Research.

Renfrew, C., Boyd, M. J., Athanasoulis, D., Legaki, I., Brodie, N., Gavalas, G., Hilditch, J., Wright, J., Gkouma, M., Herbst, J. and Krijnen, A. (in press) The Southeast Naxos Survey: The sanctuary at Keros and terrestrial and maritime networks of the Aegean Early Bronze Age. In *Cyclades through Time: Space and People*, 51–68. Athens: Society for Cycladic Studies.

Renfrew, C., Boyd, M. J., Athanasoulis, D., Brodie, N., Carter, T., Dellaporta, K., Floquet, M., Gavalas, G., Georgakopoulou, M., Gkouma, M., Hilditch, J., Krijnen, A., Legaki, I., Margaritis, E., Marthari, M., Moutafi, I., Philaniotou, O., Sotirakopoulou, P. and Wright, J. (2022) The sanctuary at Keros in the Aegean Early Bronze Age: From centre of congregation to centre of power. *Journal of Greek Archaeology* 8, 1–36.

Sotirakopoulou, P. (2004) Early Cycladic pottery from the investigations of the 1960's at Kavos-Daskaleio, Keros: a preliminary report. In E. Alram-Stern (ed.) *Die Ägäische Frühzeit. 2. Serie. Forschungsbericht 1975-2000. 2. Band, Die Frühbronzezeit in Griechenland mit Ausnahme von Kreta*, 1303-1358. Wien: Verlag der Österreichischen Akademie der Wissenschaften.

Sotirakopoulou, P. (2016) *The Sanctuary on Keros and the Origins of Aegean Ritual Practice,* Vol. IV: *The Pottery from Dhaskalio.* Cambridge: McDonald Institute for Archaeological Research.

Whitelaw, T. (2007) The objectives and methods of the 1987 surface survey at Dhaskalio Kavos. In Renfrew *et al.*, 9–78.

Wiener, M. H. (2014) The interaction of climate change and agency in the collapse of civilizations ca. 2300–2000 BC. *Radiocarbon* 56(4), S1–S16.

Zapheiropoulou, P. (1968a) Κυκλάδες: Ἀνασκαφικαὶ Ἔρευναι – Περιοδεῖαι: Κέρος. *Archaiologikon Deltion* 23B, 381–383.

Zapheiropoulou, P. (1968b) Cycladic finds from Keros. *Athens Annals of Archaeology* 1, 97–100.

Chapter 9

When our world became Christian: Crete and Cyprus during Late Antiquity

Salvatore Cosentino and Georgios Deligiannakis

This chapter addresses the parallel history of two large Mediterranean islands – Cyprus and Crete – which experienced during Late Antiquity a series of social and cultural transformations that affected their regional identities. As far as Cyprus is concerned, the spotlight is focused on the 3rd and, more particularly, the 4th century AD, showing how Cyprus's position in the Graeco-Roman oikoumene resets in this period. An attempt will be made to show how Cyprus moved from the margins to the mainstream (and back again) and consequently how Cypriot identities were rebranded in the period from the end of the Ptolemaic period until the beginning of the so-called treaty centuries. During this time, Cyprus grew into a highly connected province that was able to import and export goods by sea, based largely on its own skills and manpower, at an unprecedented level. Imperviousness to war, local opulence, and expanding commerce but limited access to the imperial power, also characterised Cyprus throughout this period. The strenuous elimination of the island's pagan past and the concomitant spread of Christianity were the most important developments in Cypriot identity since the end of the ancient Cypriot kingdoms.

The issue of Cretan regional identity is mainly addressed through evidence concerning its capital city, Gortyn. Still in the 4th century Crete was connected to Rome and Capua through patrimonial interests enjoyed in the island by high ranking Roman senators. Christianisation was another major transformation that affected Cretan society, a process opposed by part of the local ruling class. From the second half of the 5th century the church of Gortyn grew in importance, a growth reflected in an impressive season of ecclesiastical building in Gortyn itself and in other Cretan centres. The archbishoprics of Gortyn remained under the jurisdiction of the see of Thessalonica, whose primate was papal vicar in eastern Illyricum. Like Cyprus, throughout the period in question the economy of Crete grew within a highly developed network of maritime links with the whole Mediterranean, reaching important levels of wealth. Although not entirely overlapping – and indeed sometimes different – the socio-economic and cultural

processes that characterised Cyprus and Crete in Late Antiquity can be studied in parallel. This parallelism ceased from the mid-7th century, when Cyprus faced a much more invasive confrontation with Muslim expansion in the Mediterranean than Crete.

Introduction

Two of the biggest Mediterranean islands, Crete and Cyprus, are studied in tandem regarding the period of Late Antiquity (AD 300–700). This chapter focuses on aspects of political and economic life, natural phenomena and warfare, and important social changes, such as the Christianisation processes and the emergence of new identities in these two large Mediterranean islands. In the period examined here, in all these phenomena the two islands display many similarities. The time of Emperor Diocletian serves as a starting point of the narrative while the mid-7th century marks a new geostrategic reconfiguration of the two islands in the Mediterranean and a different organisation of their socio-economic structures.

Crete

Towards AD 297/298 Emperor Diocletian promoted an incisive re-organisation of the Roman Empire which resulted in a multiplication of the previously existing provinces and their framing into larger compartments called *dioeceses*. It was during this reform that the province of *Creta et Cyrenaica*, founded in 27 BC by Augustus, was divided into two autonomous districts. But while Crete was confirmed in its status as a province, belonging to the diocese of *Moesia* (*Lat*. Veron. V, 11), Cyrenaica was largely absorbed into the province of *Libya Superior*, within the diocese of *Oriens* (*Lat*. Veron. I, 3; Not. dign. Or. I, 81; II, 25). The new governor of Crete was of equestrian rank and bore the title of *praeses* (Cf. IC IV 282, 283 = LSA 63, 89). However, the administrative structure that the province received from Diocletian did not last long. Under Emperor Constantine, in fact, its governor was elevated to senatorial rank, receiving the title of ὑπατικός (*consularis;* one of the first *consulares* must have been Pyrrhus senior, mentioned in IC IV, 323 = LSA, 785; see also Tantillo 2012). At about the same time, Crete became part of the diocese of Macedonia, included in the Illyrian prefecture (Pol. Sil. Laterc. V, 17; Not. dign. Or. III, 10). This administrative arrangement did not change until the 6th century when, during the Justinian age, the Cretan governor was given the archaising title of *anthypatos* (*proconsul;* IC IV, 460; Bandy 1970, no. 31).

Throughout the 4th century, the activities of the Cretan governors had to consider the instances represented by the island *koinon* (κοινόν). The latter – whose existence is attested until the early 5th century (see IC IV, 325 = LSA, 787: statue erected in honour of the praefect for Illyricum, Leontios, around 412–413, decreed ἐνηεῖ δόγματι νήσσου 'for the 'benevolence of the island', an expression in which a reference to the koinon is to be seen) – constituted the assembly of the delegates of 16 Cretan towns, a body that during the Principate numbered an estimated 30–50 members (Cigaina

9. *When our world became Christian: Crete and Cyprus during Late Antiquity* 139

2020, 115; Karambinis 2022). Its functions between the 1st and 3rd centuries AD were related to the organisation of the main pagan festivals on the island and the promotion of the imperial cult, as well as the control of the governors' actions. The 4th century imperial legislation, progressively aimed at restricting the public role of paganism, emptied one of the *koinon*'s main functions from within. No friction between this body and the *consulares* is reported in the 4th century documentation. On the other hand, some of the most eminent members of this regional assembly served as governors in other provinces. This is certainly the case of Fl. Quintilius Eros Monaxius: he is attested, between AD 351 and 354 as *praeses* of Caria but had previously held the office of *krētarchēs* (κρητάρχης) or head of the Cretan *koinon* (PLRE I, s. v. Fl. Quint(ilius?) Eros Monaxius, 608). A connection with Aphrodisias of Caria had also the Cretan *consularis* Oikoumenios Dositheos Asklepiodotos (PLRE I, s. v. Oicumenius Dositheus Asclepiodotus 2, 115), who, before becoming governor of Crete in 382–383, had probably been *praeses* of the province of Caria, although some scholars deny this (Baldini 2010, 227–230 with further bibliography; LSA, 150, 151, by J. Lenaghan, who, based on an article by Charlotte Roueché cited there, is sceptical about the identification between the Ascepliodotos of Crete and that of Caria). A personage of the same name is also honoured in Cyprus (LSA, 869, J. Lenaghan).

On 21 July 365 there was a violent earthquake with its epicentre off the west coast of Crete that had devastating consequences for the island, Peloponnese, and Kythira. A seismic wave provoked damage also along the coasts of Sicily and Egypt. Archaeological evidence of it is documented in Gortyn, Eleutherna, Kissamos, and Chersonissos (Guidoboni 1994, 267–274; Steiros *et al.* 2002; Ambraseys 2009). The damage it caused was followed by a building activity that had to profoundly change the use of public spaces in Cretan towns and the ownership of urban surfaces.[1] The seismic event, in fact, occurred between the anti-pagan legislation of Constantius II (CTh XVI 10, 2, 4–5) and that of Theodosius I (especially CTh XVI 10, 7, 11, and 12), which prescribed the abolition of sacrifices and the closure of temples. The offensive against pagan festivals and rituals was not, however, just a matter of religious faith, but deeply invested the very identity of the Cretan population. In addition to the individual city traditions, three major Pan-Cretan sanctuaries existed on the island from the Hellenistic period: the Cave on Mount Ida that celebrated the cult of Zeus *Krētagenēs* ('native of Crete'), the sanctuary of the goddess Diktynna/Artemis on the eastern side of the Rhodopos peninsula (Gulf of Chania) and the temple of Asclepius at Lebena on the south-central coast of the island (Cigaina 2020, 150–181). These sanctuaries must have still been functioning at the beginning of the 4th century.

Among them was undoubtedly the first that, due to the political, cosmic, and astral implications of devotion to Zeus, experienced a process of hybridisation with the imperial cult (Cigaina 2020, 197).

Through the Roman power's assumption of the main indigenous religious traditions a 'Romanised' Cretan identity was formed during the Principate. As in Cyprus, the trend towards religious henotheism, characteristic of the 3rd and 4th

centuries AD, also gave some cults, such as that of *Theos Hypsistos*, the capacity to integrate themselves with Christianity (Mitchell 1999; for Gortyn see Rizzo 2005 603–615; the cult is attested also in Sybrita: IC II, XXVI, 3; for Cyprus see Deligiannakis 2018a, 25–46; 2018b). This led to the persistence of paganism among the island's population at least until the last quarter of the 4th century. The Idaean cave, where the cult of Zeus *Krētagenēs* was practised, was a place of pilgrimage still frequented by members of the elite in the 4th century, who also came from regions outside the island (Di Branco 2004, 12). The *consularis* responsible for the reconstruction of the Praetorium of Gortyn, the aforementioned Oikoumenios Dositheos Asklepiodotos, was almost certainly a pagan (Cosentino 2019a). But the reconstruction of the Cretan towns after the earthquake of 365 did not restore the function of the temples that had collapsed. Their crumbling structures were consolidated but they were closed for worship or used for another function. During the late 4th and early 5th century the ownership of buildings, shops, and urban areas in the urban centres of the island underwent considerable mobility, determined to a large extent by the divestment of temple property. Some of them, such as the Diktynnaion, had very rich endowments formed over the centuries from the offerings of the faithful which, for instance in the 2nd century AD, had been used by the Roman power to modernise the island's road network (Chaniotis 2013).

The spread of Christianity took advantage of the cultic overlap between pagan henotheism and Christian monotheism insofar as both were functional to imperial propaganda. There were therefore no episodes of violent conflict between the two religious groups in Crete. However, the monumental heritage and rituals of paganism suffered a silent and constant obliteration that affected temples, statuary, and cultic practices. It is possible that in the first half of the 5th century the island's Jewish community, which must have been of a certain size, also suffered forms of stricter religious control by the political authorities and, in some cases, expropriation and spoliation of their synagogues (Baldini 2018). The take-off of Christian religious building took place from the mid-5th century, reaching its peak in the following century. Archaeologically, the earliest Christian evidence on Crete consists mainly of inscriptions, the oldest of which date back to the end of the 4th century.[2] In the ecclesiastical tradition, the memory that Titus was bishop of Crete dates back to the Apostolic Age (Tit. I, 5–7) and appears to be well established by the time of Eusebius of Caesarea (Eus. Hist. eccl. III 4, 5). From the mid-5th century, devotion to the Ten Saints is documented, under whose protection the island of Crete had remained free from the *heretica blasphemia* (Miaphysitism), as expressed in the letter of Bishop Martyrios to Leo I in 457, which constitutes the first historical attestation of the cult.[3] However, the time when both the *Acts* of Titus and the *Passio* of the Ten Martyrs were composed goes back to the 6th century (see Halkin 1961, 241–256; Franchi de' Cavalieri 1946; 1946, 7–40). The *Acts* of Titus were probably written in Crete, perhaps in Gortyn itself. The literary model they are inspired by is Diogenes Laertius's *Lives of Philosophers* (Czachesz 2002, 200–212). The anonymous author of the *Passio* belonged to the circle of those 'educated' Christians

9. When our world became Christian: Crete and Cyprus during Late Antiquity

steeped in Hellenism, as he portrays a heroised and charismatic figure of a Christian prelate, the bearer of an esoteric wisdom that *enables* him to understand the language of statues and perform miracles. Their composition aims at exalting the jurisdictional prerogatives of the primate of Gortyn – who consecrates the other Cretan bishops – and, not by chance, the publication of the *Acta* coincides chronologically with the acquisition of the title of *archiepiskopos* by the Gortynian prelate in the mid-6th century. The *Passio* of the Ten Martyrs, instead, narrates the exploits of a group of fervent Christians who, in the age of Emperor Decius (249–251), preferred martyrdom rather than sacrifice to the gods. They came from various towns on the island: four from Gortyn; one from Hermaion, a suburb of the same metropolis; one from Knossos; another from Lebena; another from Panhormos; and the last two, from Kydonia and Heraklion (*Passio decem mart.* 3, 22–24, p. 390). The geographical provenance of this motley crew of martyrs appears to reflect a cult that tends to unify the whole island. It is a literary a metaphor that marks the transition from the Hellenistic-Roman *koinon* to the Christian *koinon*.

In terms of social hegemonies, the 5th and 6th centuries mark the rise of the bishop within the local aristocracies, while the latter experience a profound transformation within themselves. On the one hand some of their members disappeared as a ruling class, on the other hand they became a clientele of the bishops or, in the case of the wealthiest landowners, tried to obtain a position in the imperial administration. Our evidence does not allow us to draw a precise picture of such a new aristocracy. It is, however, a fluid class, mostly evidenced by seals designating their possessors, sometimes by name alone, sometimes with a title of rank probably acquired in Constantinople (Cosentino 2012, 244, ns 32–33). Temple properties and public lands, such as the *agri vectigales* of the city of Capua, were assigned to new owners (on the *agri vectigales* of Capua in Knossos' territory see Baldwin Bowsky 2004, 100). One can imagine that among them there were bishops and local notables; around Knossos there seems to be evidence of the economic role played by the monastery of St Theodota in the 7th century (Touratsoglou *et al.* 2006, 64–65).

Multiple hints indicate that the rural economy of the island in Late Antiquity was prosperous. While knowledge of the organisation of the Cretan countryside is still under-developed archaeologically, important studies have been made on transport containers (Romeo and Portale 2005; Vogt 2005; Yangaki 2005; 2016; Vitale 2008; Portale 2011; Marsili 2013, 287–290; Gallimore 2016). Between the 1st and 4th centuries AD exports from the island, mostly consisting of its famous raisin wine, far exceeded imports. The latter, during the Principate and the Constantinian age, originated largely from Africa and the Aegean. Italic or Spanish goods played little role while those from the Syro-Palestinian area seem to have been negligible. From the 3rd century onwards, the presence of Cretan amphorae in the Mediterranean declined but by no means disappeared. Late Antique Cretan amphorae have been found in southern Italy, Albania (at Butrint in particular), the East, and the regions bordering the Black Sea, here until the late 7th century. Except in the latter case,

the circulation of Cretan oil, wine, honey, and cheese seems to have been linked to private trade circuits rather than driven by the public sector and was favoured by Crete's position at the centre of the Mediterranean routes. From a geo-economic point of view, a slow shift of Crete's trade axis from the West to the East occurred in the 3rd and 4th centuries. This phenomenon was motivated by several factors, the most important of which were the administrative detachment of Crete from Cyrenaica and, above all, the emergence of Constantinople as a consumer centre.

The 7th century Muslim expansion made the Mediterranean a more unstable and turbulent maritime space than in the previous centuries. Its repercussions on the Aegean islands are a matter of debate but there is a strong tendency today to believe that the expeditions of the Arab navy did not bring about a radical transformation of the settlement fabric on the islands. On Crete, such a phenomenon is not proved. The rise of Heraklion or Chersonissos as strategically important ports over Matala or Lebena was due more to Constantinople's ability to attract the productive surpluses of the Aegean centres than to the Muslim threat. Crete remained a largely demilitarised region, although the attention of local communities towards the restoration of fortifications and defence works increased. The best archaeologically investigated Cretan centres, namely Gortyn and Eleutherna, show an evident persistence of social and economic life organised on Late Antique models until the second half of the 7th century.

Cyprus

The transition from Imperial times to Late Antiquity in Roman Cyprus appears to have been smooth. Yet, along with the many continuities, this period marked important transformations. Governed by a *praeses* and by the mid-4th century, a *consularis*, the late Roman province of Cyprus was assigned to the jurisdiction of the *comes* of the Orient based in Antioch (Metcalf 2009, 357). Beginning with the 4th century, Roman Cyprus grew in prosperity and significance for the Empire, in parallel with the general growth and rising importance of the East. In the last decade of Constantine I's reign and, again in the 360s, the island was hit by severe earthquakes that thwarted its increasing prosperity. Perhaps turning a crisis into an opportunity, in AD 333/334, a certain Kalokairos became the island's first and last usurper of Imperial power (Aurelius Victor, *Liber de Caesaribus* 41.11. PLRE I, s.v. Calocaerus, 177). Before 350 the city of Salamis was granted a new Imperial name, Constantia, and replaced Paphos as the provincial capital of the island, while the importance of Antioch as a military and economic centre in the East and the founding of the new capital in the Bosporus increasingly was pulling Cyprus away from the margins and into the mainstream (Malalas, *Chron.* 12.48; see also Deligiannakis 2019). Starting from the 4th and reaching a peak in the 6th century, economic activity and settlement growth expanded and even surpassed that of the Hellenistic and early Roman periods. Textual and material evidence indicate that the local economy relied mainly on agricultural produce and

9. When our world became Christian: Crete and Cyprus during Late Antiquity 143

maritime infrastructure (Amm. Marc. 14.8.14; *Expositio totius mundi et gentium*, 63, 204–207; Libanios, *Ep.* 1362; *Or.* 12.72; 2.5; Zos. 2.22.2; Palladios, *PA* 9.487; Synesios, *Ep.* 148; Corippus, *In laudem Iustini* 3. 91; Michaelides 1996; Papacostas 2001, 112). This was apparently combined with the revival of copper production in the foothills of the Troodos mountains, something that reached industrial levels from around the 4th until the end of the 7th century (Kassianidou 2022).

It is telling that whenever Late Antique texts refer to a local Cypriot worthy, he is always a wealthy businessman who owes his income to the ownership of land and ships (Halkin 1945, 62; 1964, 144; van den Ven 1953, 92; Rapp 1991; Palmer and Brock 1993, 176; Michaelides 2001, 51). Mosaic and other decoration of domestic buildings excavated in Nea Paphos and elsewhere (e.g. 'the House of Aion', 'the Eustolios House', 'the House of Theseus', 'the Hippodrome villa', etc.) open a window onto the mentalities of the local aristocracy in a way that no other category of the available evidence does (Michaelides 1992; Deligiannakis 2022, 47–106). The continuous upturn in the economic and logistical importance of the island was later attested by the inclusion in 536/537 of the island province into a newly-created prefecture, the *quaestura exercitus*, in which wealthy and highly interconnected provinces in the Empire's heartland supported the troops in the Danube regions with provisions (Nov. 41; Jones 1964, 280). This change also marked the end of Cyprus's political dependence on Antioch.

The strenuous elimination of the island's pagan past and the concomitant spread of Christianity, the uprooting of the Cypriot Jewry after the so-called Kitos or Diaspora War (115–117) aside, were the most important developments in Roman Cypriot identity since the end of the ancient Cypriot kingdoms. It is extremely difficult to get a real sense of the scale of preservation, destruction, or neglect in the pagan sanctuaries of Cyprus as we lack positive evidence for any of these processes. The 4th century earthquakes most probably marked, in Cyprus as elsewhere, the final abandonment of the very few pagan sites that still remained functional, with the possible exception of the sanctuary of Zeus Olympios at Salamis, while theatres, baths, urban palaces, and arenas all received orderly repairs thereafter. As a matter of fact, no incidents involving spectacular acts of violence against pagans and their temples are reported in our sources. A number of dedications to the Theos Hypsistos, traditionally dated down to the 3rd century, represents an aspect of similarly syncretic patterns of the religious landscape of Cyprus (Deligiannakis 2018b; 2022, 25–46). This material is connected to a Judaising pagan group of worshippers of the Highest God ('the Hypsistarians'), also known from elsewhere in the Empire, including Crete. They had been populous, especially in the southern part of the island but, in the course of the 4th century, they gradually shrank to an interstitial fringe sect. Be that as it may, it is unlikely that the local population had been converted to Christianity in great numbers before the mid-4th century.

The mosaic verse inscriptions of the Eustolios complex at Kourion have often been seen as key evidence regarding religious transition in Late Antique Cyprus

(Mitford 1971, 352–360, nos 201–206; Nasrallah 2020). They probably belong to the first decades of the 5th century and highlight the Christian faith, classical paideia, and the shifting aristocratic values of a prominent local family. The Christian Eustolios provided for Kourion 'as once did Phoibos' (no. 204) by building a bath cum reception hall complex. No religious animosity is displayed here, as the mythological past of the city is appropriated in order to exalt the virtues of Eustolios. In another epigram (no. 202) inside another room the 'great stones, iron, bronze and even adamant' are contrasted with 'the much-venerated symbols of Christ' that decorate the oikos. The phrase 'symbols of Christ' must refer to some kind of decorative programme, now lost. Alternatively, with this phrase the epigrammatist was referring to a group of virtues mentioned in another epigram in the same room; in this text (no. 203) Aidos (Reverence), Sophrosyne (Moderation), and a third, now lost, virtue all 'tend the exedra and this sweet-smelling inner hall'. However, these virtues can equally be understood as traditional aristocratic values without any obvious doctrinal connotations, perhaps addressed to the female visitors of this hall of the oikos. In the epigram no. 202, a contrast between materialism and spiritualism or an attempt on the part of Eustolios to temper his opulence with a profession of Christian moral values could also be recognised (Deligiannakis 2022, 42–45).

From a comparatively modest start at the beginning of the 4th century, Cypriot Christianity experienced notable growth in the course of the century and perhaps from as early as the 340s. Spyridon was one of the few Cypriot bishops of his period revered as a miracle worker and had become the subject of an elaborate Life before the end of the 4th century (Athan., Apologia secunda contra Arianos, 50.2; Gelasios HE 2.10–11; Rufinus HE 10.5; Sokrates HE 1.12; Soz. HE 1.11; IG 15 2,1 374). He was the most important Christian figure in early Christian Cyprus after Barnabas and before Epiphanios, whom contemporary sources refer to and who also signed as a bishop at the Councils of Nicaea and Serdica. On the other hand, Triphyllios of Ledra, the bishop of an insignificant see in the island's hinterland, was probably the author of a sophisticated Life of Spyridon that obviously addressed an educated audience (Jerome De viris illustr. 92; Ep. 70 (Ad Magnum); Sozom. HE 1.11.8; Sud. τ. 1032; van den Ven 1953). These two personalities, Spyridon and Triphyllios, seem to mark the opening up of the island to the Christian world: the wonder worker shepherd bishop Spyridon, and, after a generation or so, the bishop Triphyllios, a well-educated ex-lawyer, who nonetheless became bishop of an insignificant town.

The ecclesiastical realm gave late antique Cyprus her most celebrated personality since the philosopher Zeno of Kition (ca. 334–262 BC) and, perhaps until Makarios III (AD 1913–1977), Archbishop and first president of the Republic of Cyprus: Bishop Epiphanios of Salamis/Constantia (AD 310/15–403; Rapp 1991, 140–171; Kim 2015; Jacobs 2016). Though of Palestinian origin, Epiphanios was the most influential ecclesiastical figure on the island over a period of nearly four decades (367–403). His fame as a notable ascetic, defender of Orthodoxy, and able administrator spread far beyond the island's shores and he became famous in Palestine and Arabia, Egypt,

9. When our world became Christian: Crete and Cyprus during Late Antiquity

Asia Minor, and Constantinople. He succeeded in making Salamis/Constantia the most important see of the island and he was also a key figure in the promotion of monasticism in and around the city as well as the emergence of yet more episcopal sees across the island. On the other hand, Epiphanios's aversion to Graeco-Roman urban culture and ascetic morals failed to eradicate the classical past of Cyprus from the minds of his contemporaries and from the urban topography (Deligiannakis 2022, 131–139). After his death, his reputation was subsumed in hagiography, which led to the creation of an important cult site. His tomb became renowned for healings and exorcisms. More importantly, his legacy created the model for a new sort of island-wide competition, focusing on the proliferation of cults of local bishop saints involving the building of lavish churches, the spread of monasticism, and the production of hagiographical *Lives* between the 5th and 7th centuries AD.

The cults of Cypriot bishop saints, along with those of figures allegedly associated with the Apostolic period and the life of Jesus (e.g. Barnabas of Salamis, Herakleides of Tamassos, Auxibios of Soloi, Tychikos of Neapolis, Lazaros of Kition), become the trademark of Cypriot Christianity, each of them being associated with a particular city (Falkenhausen 1999; Efthymiadis 2020). In this way, Cypriot insular identity finds a new form of expression. The great seven-aisled episcopal basilica of St Epiphanios in Salamis/Constantia was built shortly after 403 to host Epiphanios's miraculous relics. Nearby, a sumptuous (pilgrimage and/or monastic) church, the so-called Campanopetra basilica, was erected towards the end of the 5th century or later, either as the *martyrion* of St Barnabas or as a shrine for a relic of the True Cross (Roux 1998; Megaw 2006). The new Christian identity of Salamis/Constantia is best captured in the fresco decoration of a Christian *hagiasma*, dated to the 6th century. Below the head of Christ, a certain Nikodemos invokes the name of 'Christ the Saviour' (*Χριστὸς ὁ Σωτήρ*) for his protection. The apostle Barnabas, St Epiphanios, and the Emperor Constantine are also cited here (ISalamine 236–238; Deligiannakis 2018a). The first two are described as 'our protector' (*στήριγμα ἡμῶν*) and 'our governor' respectively, while Constantine and his *signum*, i.e. the Cross, are invoked for their aid. Nikodemos, probably the bishop, is praying here on behalf of the community of Salamis/Constantia, acknowledging the two patron saints of the city to whom its two major pilgrimage sites were dedicated.

The impressive number of ecclesiastical sees around AD 400 (15 in total) and the apostolic pretensions of their founders were all apparently necessary, along with the miraculous discovery of the relics of St Barnabas, to gain for Cypriot Church the exceptional and highly prestigious status of autocephaly in 488. This dispute between the Churches of Cyprus and Antioch had remained unresolved for more than half a century. The Cypriot delegations at the Synods used to stress that never had the Antiochene Church or anyone else, since the time of the holy apostles, been involved in appointing the metropolitans or the other bishops of Cyprus; and that not only was the Throne of Cyprus an apostolic one but, unlike Antioch with regard to St Peter or St Paul, was it both the motherland and the burial place of an apostle, the Cyprus-

born Barnabas, whose tomb had only recently been discovered at the outskirts of Salamis/Constantia (Downey 1958; Chrysos 2019).

The period from the mid-6th to the mid-7th century was one of remarkable resilience and flourishing intellectual life for Cyprus (Krueger 1996, 11–18; Metcalf 2009, 163, 337; Rapp 2015, 398). The Arab raids on the island in 649 and 650, however, marked a watershed moment in its history (Panayides and Jacobs 2022). The inscription in the Soloi cathedral dated to AD 655 is a telling first-hand witness to the massive scale of disruption (Feissel 2013; Deligiannakis 2022, 1–2). Besides, according to the text issued by the (arch)bishop John, the attacks against the island 'the year 365 of the emperor Diocletian', had been 'provoked by our sins'. One possible explanation of the odd re-enactment of the *anno Diocletiani* in this important text – instead of the regnal years of the ruling Emperor Constans II (641–668) – may be that, in the mind of the bishop John, the Cypriot Christians at the mercy of the infidel Arabs had heroically become the heirs of the Great Persecution. A new Christianised time-reckoning of Cypriot history had come in place.

Conclusions

The processes of social and religious transformations that occurred in Crete and Cyprus during Late Antiquity showed converging and similar trajectories. In both islands, major social phenomena developed in a context of prosperous economic conditions that affected the conjuncture from the 4th to the first half of the 7th century AD. Such an economic prosperity depended on several factors, the most important of which were the absence of military conflicts on their territory, their strategic positions along the main maritime routes of the Mediterranean, and the fertility of their agriculture. The foundation of Constantinople had important repercussions on both islands in the long run. For Cyprus, the existence of the new capital on the Bosporus meant a lesser socio-economic dependence of the Cypriot towns from Antioch. The establishment of the *embolē* (the annual shipment of fiscal grain from Egypt to Constantinople), whose cargo ships called at Cyprus on their way to Constantinople, created new economic links between the island, northern Aegean, and Black Sea. The result of this progressive redirection of Cypriot agricultural products westwards and not only eastwards was institutionally sanctioned by the creation of the *quaestura exercitus* in 536. The redirection of the Egyptian grain from Rome to Constantinople had important consequences for Crete too. In the 4th and 5th centuries the presence of Cretan imports in Italy and Africa underwent a decrease. With the second half of the 6th century and the reconquest of Africa by the Roman Empire Crete became a major hub of the Mediterranean waterways both southwards (Africa) and northwards (northern Aegean and Constantinople; Zanini 2013). In brief, the settlement landscape, agricultural production, as well as geographic position made Cyprus and Crete two regions affected by important processes of human, cultural, and goods mobility in Late Antiquity.

9. When our world became Christian: Crete and Cyprus during Late Antiquity 147

Even more pronounced is the similarity with which in Cyprus and Crete paganism was supplanted by Christianity as public religion and the impact that the new religion had in shaping a new identity on both islands. In neither of the two regions – it seems – did the spread of Christianity provoke sharp contrasts between the two different religious groups, ending in violent actions aimed at obliterating the identity of the 'other'. The closure of pagan shrines took place without (as far as we know) any sensational acts of violence, while pagan statuary was dismissed in several cases suffering clear signs of effacement. Henotheistic cults, as that of the *Theos Hypstistos*, documented on both islands, may have favoured the diffusion of Christianity. Especially in Cyprus the ruling class continued to use, throughout the 4th and 5th centuries, a figurative language on floor mosaics in which the allusion to classical tradition and its mythology was relevant, as is evidenced in the domestic buildings excavated in Nea Paphos or at Kourion. In Crete, this phenomenon is less well documented. In any case, the use of decorative programmes in prestigious residences that refer to pagan cultural heritage is a widespread phenomenon throughout the late antique world. Few scholars today believe that such an artistic culture reflects the religious sentiment of its users. Rather, it is to be understood as a common expression of the self-representation of the ruling classes, regardless of their religious inclinations.

We would be wrong, however, if we thought that the spread of Christianity in Cypriot and Cretan societies did not influence the emergence of a new sense of collective identity. From the 5th century onwards, such an identity no longer manifested itself in the cult of Aphrodite in Cyprus or that of Zeus in Crete, but in holy bishops with particular spiritual gifts. In Cyprus, the figures of St Spyridon (Trimithous) and St Epiphanios (Salamis/Constantia) stand out; in Crete, those of St Kyrillos (Gortyn) and the Ten Martyrs, protectors of the entire island (for Cyprus see Deligiannakis 2022, 107–129). Christian patriotism that is formed around their cults is intertwined with the memory of the evangelisation undertaken on the two islands by the apostle Barnabas (born and died in Cyprus) and Titus, disciple of Paul (who died in Gortyn according to his spurious *Acts*) respectively.

The sanctuaries of the new Christian identity multiplied exponentially in both Cyprus and Crete. The islands in the early 5th century had 15 and 10 episcopal sees respectively. The impressive development of ecclesiastical building from the 5th to 6th centuries also profoundly changed the cityscape of Cypriot and Cretan centres, in which churches had become the hubs of new urban districts and bishops the exponents of a new elite. The discovery of the relics of St Barnabas in Cyprus conferred on his church, in AD 488, the prestigious status of ecclesiastic autocephaly. The bishop of Gortyn, in Crete, also elevated his rank by bearing the title of archbishop from the mid-6th century onwards but remained dependent on the Roman patriarchate.

Cyprus and Crete began to follow two different historical trajectories only from the second half of the 7th century AD. The greater pressure exerted on the former by Muslim power changed its socio-religious structure and settlement landscape to a more radical extent than the latter. They continued, even during the early Middle

Ages, to be relatively prosperous regional societies compared to many regions in Anatolia or the Balkans by virtue of their wealth in raw materials, the level of their agricultural production, and their maritime connectivity (for Cyprus see Zavagno 2017; for Crete see Tsigonaki 2012; Cosentino 2019b). Cyprus, for instance, continued to produce its own fine tableware until the early 8th century (Cypriot Red Slip Ware; see Armstrong 2009). Crete, in the 7th and 8th centuries, renewed the typology of its amphora vessels compared to Late Antiquity. The history of the two islands, however, appears more difficult to tell comparatively from the 8th century onwards in the context of a more 'regionalised' Mediterranean society with respect to Late Antiquity.

Acknowledgements

The contents of this chapter are the result of joint work by the two authors. That said, Salvatore Cosentino wrote the part on 'Crete' and the 'Conclusions'; Georgios Deligiannakis, the 'Introduction' and the part on 'Cyprus'.

Notes

1 Post-earthquake reconstruction on the island was managed by Oikoumenios Dositheos Asklepiodotos and is particularly well documented in Gortyn, where he was responsible for the construction of a new praetorium in AD 382–383. On this occasion, the Cretan *koinon* and the Gortynian *boulē* (town council) decreed to raise honorary statues to 11 important Roman senators who had held positions of the highest level (see Cosentino 2019a; Bigi and Tantillo 2020).

2 About one fifth of the Christian inscriptions collected by Bandy (1970) are broadly dated to the 4th and 5th centuries (cf. nos 10, 35, 54, 57, 64, 67, 68, 74, 76, 78, 80, 81, 93, 94, 99, 100, 101, 103).

3 See *ACO* II; Schwartz 1936, 38, 96–97: we learn from the letter that by the mid-5th century the following bishoprics existed in Crete, in addition to Gortyn: Eleutherna, Sybrita, Hierapydna, Knossos, Lappa, Chersonisos, Kantanos, Kydonia.

Bibliography

Ambraseys, N. (2009) *Earthquakes in the Eastern Mediterranean and the Middle East. A Multidisciplinary Study on Seismicity up to 1900*, 151–156. Cambridge: Cambridge University Press.

Armstrong, P. (2009) Trade in the East Mediterranean in the 8th century. In M. Mundell Mango (ed.), *Byzantine Trade, 4th–12th Century*, 157–178. London: Routledge.

Baldini, I. (2018) Ebrei, pagani e cristiani a Gortina nel V secolo. *Quaderni Digitali di Archeologia Post-Classica* 10(1), 17–50.

Baldini, I. (2010) La virtù dei governatori: monumenti onorari tardoantichi a Gortina e Afrodisia. In S. De Maria and V. Fortunati (eds), *Monumento e memoria, Dall'antichità al contemporaneo*, 219–232. Bologna: Bononia University Press.

Baldwin Bowsky, M. (2004) Of the two tongues: acculturation at Roman Knossos. In G. Salmeri, A. Raggi and A. Baroni (eds), *Colonie romane nel mondo greco*, 95–150. Rome: L'Erme di Bretschneider.

Bandy, A. (1970) *The Greek Christian Inscriptions of Crete*. Athens: Christian Archaeological Society 31.

Bigi, F. and Tantillo I. (eds) (2020) *Senatori romani nel Pretorio di Gortina. Le statue di Asclepiodotus e la politica di Graziano dopo Adrianopoli*. Pisa: Scuola Normale Superiore.

9. When our world became Christian: Crete and Cyprus during Late Antiquity 149

Chaniotis, A. (2013) Hadrian, Diktynna, the Cretan Koinon, and the roads of Crete. A new milestone from Faneromeni (Crete). In W. Eck, B. Feher and P. Kovacs (eds), *Studia epigraphica in memoriam Géza Alföldy*, 59–68. Bonn: von Habelt.

Chrysos, E. (2019) Some remarks on the autocephaly issue. In S. Rogge, C. Ioannou and T. Mavrojannis (eds), *Salamis of Cyprus. History and Archaeology from the Earliest Times to Late Antiquity*, 769–773. Münster-New York: Waxmann.

Cigaina, L. (2020) *Creta nel Mediterraneo greco-romano. Identità regionale e istituzioni federali.* Roma: Quasar.

Cosentino, S. (2012) Gortina nella prima età bizantina: potere e aristocrazia. In I. Baldini, S. Cosentino, E. Lippolis, G. Marsili, E. Sgarzi, Gortina, Mitropolis e il suo episcopato nel VII e nell'VIII secolo. Ricerche preliminari. *Annuario della Scuola Archeologica di Atene e delle Missioni Italiane in Oriente*, 90, 243–248.

Cosentino, S. (2019a) Un gruppo di iscrizioni celebrative poco note dal Pretorio di Gortina. *Bizantinistica* 20, 1–18.

Cosentino, S. (2019b) From Gortyn to Heraklion? A note on Cretan urbanism during the 8th century. *Byzantina Symmeikta* 29, 73–89.

Czachesz, I. (2002) Apostolic Commission Narratives in the Canonical and Apocryphal Acts of the Apostles. Unpublished PhD dissertation, Rijksuniversiteit Groningen.

Deligiannakis, G. (2018a) From Aphrodite(s) to saintly bishops in late antique Cyprus. In C. Breytenbach and J. M. Ogereau (eds), *Authority and Identity in Emerging Christianities in Asia Minor and Greece*, 326–346. Leiden-Boston: Brill.

Deligiannakis, G. (2018b) The last pagans of Cyprus: Prolegomena to a history of transition from Polytheism to Christianity. In M. Horster, D. Nicolaou and S. Rogge (eds), *Church Building in Cyprus (4th to 7th Centuries): A Mirror of Intercultural Contacts in the Eastern Mediterranean*, 23–44. Münster: Waxmann.

Deligiannakis, G. (2019) Imperial and ecclesiastical patrons of fourth-century Salamis/Constantia. In A. Rogge, C. Ioannou and T. Mavrojannis (eds), *Salamis of Cyprus. History and Archaeology from the Earliest Times to Late Antiquity*, 761–774. Münster-New York: Waxmann.

Deligiannakis, G. (2022) *A Cultural History of Late Roman Cyprus.* Nicosia: Cyprus Research Centre Texts and Studies of the History of Cyprus 90.

Di Branco, M. (2004) Pellegrinaggi a Creta. Tradizioni e culti cretesi in epoca tardoantica. In M. Livadiotti and I. Simiakaki (eds), *Creta romana e protobizantina*, 7–16. Padova: Ausilio.

Downey, G. (1958) The claim of Antioch to ecclesiastical jurisdiction over Cyprus. *Proceedings of the American Philosophical Society* 102(3), 224–228.

Efthymiadis, S. (2020) *Η Βυζαντινή Αγιολογία της Κύπρου. Οι άγιοι, οι συγγραφείς και τα κείμενα (4ος-13ος αιώνας).* Nicosia: Sources and Studies of Cypriot History 85.

Falkenhausen, V. (1999) Bishops and monks in the hagiography of Cyprus. In N. Patterson Ševčenko and C. Moss (eds), *Medieval Cyprus: studies in art, architecture, and history in memory of Doula Mouriki*, 21–33. Princeton NJ: Princeton University Press.

Feissel, D. (2013) Jean de Soloi, un évêque chypriote au milieu du VIIe siècle. In C. Zuckerman (ed.), *Constructing the Seventh Century*, 227–236. Paris: Travaux et mémoires 17.

Franchi de' Cavalieri, P. (1946) I dieci martiri di Creta, in *Miscellanea Giovanni Mercati*, V [Studi e Testi, 125], Vatican City, 7-40 (reprinted in Id., *Scritti agiografici*, II, Città del Vaticano [Studi e Testi, 222], Vatican City 1962, 367-400.

Gallimore, S. (2016) Crete's economic transformation in the late Roman empire. In J. E. Francis and A. Kouremenos (eds), *Roman Crete. New Perspectives*, 175–188. Oxford: Oxbow Books.

Guidoboni, E. (ed.) (1994) *Catalogue of Ancient Earthquakes in the Mediterranean Area up to the 10th Century.* Rome: Istituto nazionale di geofisica.

Halkin, F. (1945) *La vision de Kaioumos et le sort éternel de Philentolos Olympiou.* Brussels: *Analecta Bollandiana* 63.

Halkin, F. (1961) *Acta Titi, 'La légende crétoise de saint Tite'*. Brussels: *Analecta Bollandiana* 79(3–4), 241–256.

Halkin, F. (1964) *Les actes apocryphes de Saint Héraclide de Chypre, disciple de l'Apôtre Barnabé*. Brussels: *Analecta Bollandiana* 82, 133–169.

Jacobs, A. (2016) *Epiphanius of Cyprus. A Cultural Biography of Late Antiquity*. Oakland CA: University of California Press.

Jones, A. H. M. (1964) *The Later Roman Empire 284-602. A Social, Economic, and Administrative Survey.* Oxford: Blackwell.

Karambinis, M. (2022) The cities of Crete under Roman rule (1st–3rd centuries AD). *Journal of Greek Archaeology* 7, 233–268.

Kassianidou, V. (2022) Mining and smelting copper in Cyprus in Late Antiquity. In Panayides and Jacobs, 211–226.

Kim, Y. (2015) *Epiphanius of Cyprus. Imagining an Orthodox World*. Ann Arbor MI: University of Michigan Press.

Krueger, D. (1996) *Symeon the Holy Fool. Leontius's Life and the Late Antique City*. Berkeley CA-Los Angeles CA-London: University of California Press.

Marsili, G. (2013) Contenitori da trasporto: produzione locale e relazioni commerciali. In S. Cosentino, I. Baldini, E. Lippolis, G. Marsili and E. Sgarzi (eds) (2013), *Gortina, Mitropolis e il suo episcopato nel VII e nell'VIII secolo. Ricerche preliminari*, 280–290. Berlin: Annuario della scuola Archeologica di Atene e delle missioni Italiane in Oriente 90.

Megaw, A. (2006) The Campanopetra reconsidered: The pilgrimage church of the Apostle Barnabas? In E. Jeffreys (ed.), *Byzantine Style, Religion, and Civilization: In Honour of Sir Steven Runciman*, 394–404. Cambridge: Cambridge University Press.

Metcalf, D. (2009) *Byzantine Cyprus 491-1191*. Nicosia: Cyprus Research Centre.

Michaelides, D. (1992) *Cypriot Mosaics*. Nicosia: Department of Antiquities. Republic of Cyprus.

Michaelides, D. (1996) The economy of Cyprus during the Hellenistic and Roman periods. In V. Karageorghis and D. Michaelides (eds), *The Development of the Cypriot Economy. From the Prehistoric Period to the Present Day*, 139–149. Nicosia: University of Cyprus and Bank of Cyprus.

Michaelides, D. (2001) The ambo of Basilica A at Cape Drepanon. In J. Herrin, M. Mullett and C. Otten-Froux (eds), *Mosaic. Festschrift for A.H.S. Megaw*, 43–56. London: British School at Athens Studies 8.

Mitchell, S. (1999) The cult of Theos Hypsistos between pagans Jews, and Christians. In P. Athanassiadi and M. Frede (eds), *Pagan Monotheism in Late Antiquity*. Oxford: Oxford Academic, 81–148, https://doi.org/10.1093/oso/9780198152521.003.0005 [accessed 1 April 2024].

Mitford, T. (1971) *The Inscriptions of Kourion*. Philadelphia PA: American Philosophical Society.

Nasrallah, L. (2020) Introduction and an analysis of religion by means of the Annex of Eustolios. In L. Nasrallah, A. Luijendikjk and C. Bakirtzis (eds), *From Roman to Early Christian Cyprus*, 7–17. Tübingen: Wissenschaftliche Untersuchungen Zum Neuen Testament 43.

Palmer, A. and Brock, S. (1993) *The Seventh Century in the West-Syrian Chronicles*. Liverpool: Translated Texts for Historians 15.

Panayides, P. and Jacobs, I. (2022) (eds) *Cyprus in the Long Late Antiquity. History and Archaeology Between the Sixth and Eighth Centuries*. Oxford: Oxbow Books.

Papacostas, T. (2001) The economy of late antique Cyprus. In S. Kingsley and M. Decker (eds), *Economy and Exchange in the East Mediterranean during Late Antiquity*, 107–128. Oxford: Oxbow Books.

Portale, E. (2011) Contenitori da trasporto. In A. Di Vita and A. Rizzo (eds), *Gortina Agorà. Scavi 1996-1997*, 123–182. Padova: Studi di Archeologia Cretese 9.

Rapp, C. (1991) The Vita of Epiphanius of Salamis: An Historical and Literary Study. Unpublished PhD thesis, University of Oxford.

Rapp, C. (2015) Cypriot hagiography in the seventh century: patrons and purpose. In T. Yagkou and C. Nassis (eds), *Κυπριακή Αγιολογία. Πρακτικά Ά διεθνούς συνεδρίου. Παραλίμνι*, 397–411. Aghia Napa-Paralimni: Holy Metropolis of Constantia/Ammochostos.

Rizzo, M. (2005) L'altare di Gortina al Theos Hypsistos. In M. Livadiotti (ed.), *Creta romana e protobizantina* 3(2), 603–615. Padova: Ausilio.

Romeo, I., Portale, E. (2005) Gortina e il commercio mediterraneo: le anfore da trasporto tra l'età di Augusto e la conquista araba. In M. Livadiotti (ed.), *Creta romana e protobizantina* 3(1), 959–973. Padova: Ausilio.

Roux, G. (1998) *La Basilique de la Campanopétra.* Paris: Salamine de Chypre 15.

Schwartz, E. (ed.) (1936) *ACO II, Concilum universale Chalcedonense, V, collectio Sangermanensis, Berolini et Lipsiae* 3(2). Berlin: de Gruyter.

Steiros, S. K., Papageorgiou, S. and Markoulaki, S. (2002) Καταστροφή των κρητικών πόλεων το 365 μ. Χ. In M. Livadiotti and I. Simiakaki (eds), *Creta romana e protobizantina* 2, 427–444. Padova: Ausilio.

Tantillo, I. (2012) 'Dispensatore di governatori'. A proposito di una dedica a un prefetto al pretorio da Gortina (IC IV 323). *Rivista di Filologia e di Istruzione Classica* 140(2), 407–424.

Touratsoglou, I., Koltsida-Makre, I. and Nikolaou, Y. (2006) New lead seals from Crete. In J.-C. Cheynet and C. Sode (eds), *Studies in Byzantine Sigillography* 9, 49–68. Berlin/Boston: Teubner.

Tsigonaki, C. (2012) 'Πόλεων ἀνελπίστοις μεταβολαῖς'· ιστορικές και αρχαιολογικές μαρτυρίες από την Γόρτυνα και την Ελεύθερνα της Κρήτης. In T. Kiousopoulou (ed.), *Οι βυζαντινές πόλεις, 8ος-15ος αιώνας. Προοπτικές της έρευνας και νέες ερμηνευτικές προσεγγίσεις*, 73–100. Rethymo: University of Crete.

van den Ven, P. (1953) *La légende de S. Spyridon évêque de Trimithonte.* Louvain: Institut Orientaliste.

Vitale, E. (2008) *La ceramica sovradipinta bizantina di Gortina.* Padova: Studi di Archeologia Cretese 6.

Vogt, C. (2005) Echanges et économie proto-byzantines d'Eleutherna d'après les témoins céramiques. In M. Livadiotti (ed.), *Creta romana e protobizantina* 3(1), 923–944. Padova: Ausilio.

Yangaki, A. (2005) *La céramique des IVe-VIIIe ap. J.-C. d'Eleutherna, sa place en Créte et dans le bassin égéen.* Athens: University of Crete.

Yangaki, A. (2016) Pottery of the 4th–early 9th century AD on Crete: The current state of research and new directions. In J. E. Francis and A. Kouremenos (eds), *Roman Crete. New Perspectives*, 199–234. Oxford: Oxbow Books.

Zanini, E. (2013) Creta in età protobizantina: un quadro di sintesi regionale. In D. Michailides, P. Pergola and E. Zanini (eds), *The Insular System of the Early Byzantine Mediterranean: Archaeology and History*, 173–189. Oxford: British Archaeological Report S2523.

Zavagno, L. (2017) *Cyprus Between Late Antiquity and the Early Middle Ages (ca. 600-800): An Island in Transition.* London: Birmingham Byzantine and Ottoman Studies 21.

Chapter 10

Conclusions: Mediterranean rhapsody: Of island histories and identities

Helen Dawson

> The simplistic view that geographical and social isolation have been the critical factors in sustaining cultural diversity persists. (Barth 1969, 9)

The perception of islands as remote and isolated places has long provided the default explanation for their cultural divergence from the mainland. In the earlier part of the 20th century, the school of cultural anthropologists, following Franz Boas' historical particularism and relativism, had challenged the dominant racist ideals of unilinear evolution and strived to record the rich and diverse cultural phenomena of the far-flung islands of the Pacific before they were largely wiped out under colonial conditions. Margaret Mead, a student of Boas, is credited with first using the famous metaphor in a short paper entitled 'Introduction to Polynesia as a *laboratory* for the development of models in the study of cultural evolution' (Mead 1956, 145, my emphasis). The characterisation of islands, as natural and cultural systems with unique features linked to their isolation, was fully embraced by the so-called Processual or New Archaeology of the 1970s and 1980s. The trope of natural and cultural laboratories has since become a byword for islands, for better or worse (Dawson *et al.* 2023).

Today, 'island archaeology' is an eclectic field of study that owes a great debt to these earlier traditions. New perspectives have emerged as an alternative to the ecological and environmental focus typical of western academic spheres. A strong socio-cultural emphasis is re-emerging in island archaeology, inspired by the earlier anthropological work but, more so, by the communities with whom researchers collaborate (see Frieman 2023, 2). The idea that islands are pristine laboratories that can be studied as if under a microscope has recently been challenged as part of the broader decolonising movement in archaeology (Fricke and Hoerman 2022). This 'loss of innocence' (*sensu* Clarke 1973) of island archaeology views islands for what they really are, deeply entangled entities that are not easily reducible to controlled

analytical units (Dawson *et al.* 2023). Decolonisation in island archaeology is largely focused on the regions of the global south, mostly those with descendent indigenous populations such as the Pacific and Caribbean islands, but it has global ramifications. In a powerful speech[1] given at the inauguration of the Humboldt Forum in Berlin in 2021, Nigerian writer Chimamanda Ngozi Adichie denounced that while European art is showcased at art and history museums, African and Asian art is exhibited at 'ethnological' museums: who has the right to exhibit whom and to tell the story, whose story is being told, and whom does it benefit, she asked. The Luf boat (Fig. 10.1), one of the last surviving oceanic outrigger canoes from the Pacific islands, is a centrepiece of the Humboldt Forum, yet the fact that it was acquired at a time when Germany held the Pacific islanders under brutal colonial control is barely acknowledged in the galleries (Aly 2023). While important strides are being made in these areas (such as the Fitzwilliam Museum's recent *Black Atlantic: Power, People, Resistance exhibition*),[2] the story is still very one-sided and much remains to be done in terms of decolonisation.

We have reached the point where we need to rethink the premises and aims of island archaeology entirely and recast it as a 'very particular form of storytelling' (*sensu* Frieman 2023; see also Terrell 1990). Islanders around the world have been telling their stories for millennia but only recently have researchers started to acknowledge their importance as historical sources.[3] Archaeologists working with island communities in the Pacific on their oral histories have come to realise that they contain details of major environmental events (such as earthquakes and tsunamis) occurring thousands of years earlier – what Patrick Nunn aptly refers to as 'geomythology' (Nunn 2020). This kind of study exemplifies the huge potential of working with local communities in order to learn about the past (Christophilopoulou, this volume Chapter 1). Unfortunately, knowledge based solely on oral records and artefacts ('prehistory') is still not considered as reliable as written (i.e. mostly white European) history. Traditional accounts are of course not the only way to study islands, but we are missing out on a huge opportunity, and remain biased, if we do not include them in our enquiries. The *Being an Islander* documentary accompanying the exhibition and this book is an excellent example of this potential.[4]

Island archaeology in the Mediterranean has been completely absent from these debates until now. This is not surprising, since the communities living in the Mediterranean islands have not experienced colonialism; yet, history has not treated the islands and islanders well. Islands in the Mediterranean have long been used by mainlanders as places of exile and as prisons for political dissenters (Muscolino, this volume Chapter 7). They have been systematically marginalised and treated as expendable by mainland focused logics of power. The definition of islands, according to the European Union Council (2016), is that they are 'marginal territories' because of their 'outlying status' on the periphery of member states and their small size, which means they face numerous challenges (Dawson 2019). It is striking, as Muscolino states in his contribution to this volume, that it was only as recently as 2022 that the Italian constitution was amended to acknowledge the

10. Conclusions: Mediterranean rhapsody: Of island histories and identities

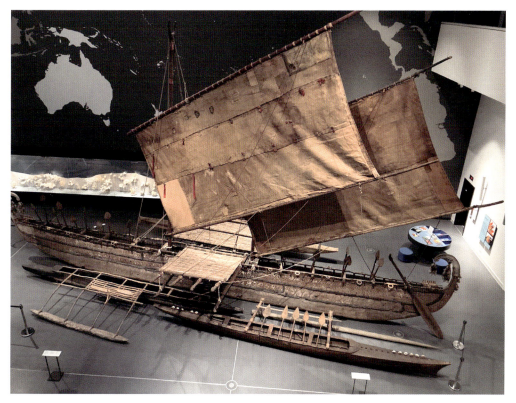

Figure 10.1. The Luf boat, an offshore sailboat from the island of Luf, Papua New Guinea, Western Islands, 1890-1895, brought to Berlin in 1904 and currently on display at the Humboldt Forum (© Ethnologisches Museum at the Humboldt Forum).

'disadvantages deriving from insularity' and introduce measures to tackle the arising inequalities (Muscolino, this volume Chapter 7). Decolonisation in the context of island archaeology in the Mediterranean faces different and less urgent challenges compared to the Pacific or Caribbean but still entails giving a voice to islanders and acknowledging their imposed subalternity and the persistence of a mainlander bias in telling their stories.

Being an islander

While simple definitions for island and insularity exist, there is no universal definition that fits 'islandness'. The experience of living on an island or 'being an islander' is ultimately subjective, context dependent, and problematically more often than not a label applied by external observers rather than an actual reflection of the worldview of the islanders (Foley *et al.* 2023, 1800). Islandness is ultimately 'a state of mind'

(Randall 2021, 100, quoted by Foiley *et al.* 2023, 1805). Insider and outsider perspectives are not necessarily mutually exclusive, and both contribute to its meaning, with different elements co-existing in different proportions (Foiley *et al.* 2023, 1808). This kind of dialectic thinking lies at the heart of islandness, as illustrated by the different contributions (see Christophilopoulou, this volume, Chapter 1).

Islandness has been interpreted as 'smallness' (Constantakopoulou, this volume Chapter 2), but also as a byword for 'culture' (e.g. resourcefulness, resilience), 'identity' (e.g. kinship), and 'other' (Muscolino, this volume Chapter 7; Foley *et al.* 2023, 1805). As Foley *et al.* explain 'the perception that islands are usually small remains widespread' (2023, 1801). The edge plays an important role on small islands, since a strong sense of community is derived by the presence of the shoreline and physical containment is thought to foster group identity (Hay 2006, 22). Islandness, then, can be thought as a particular type of place attachment and identification, which may be stronger on smaller than larger islands but is not a prerogative of small islands, as this volume focusing on large islands clearly shows. Social boundaries may match territorial ones but this is not a *sine qua non* (Barth 1969, 15). Thus, while islands have clear physical boundaries, their cultural identities are rarely coterminous with the island. The diffusion of Cypriot writing systems in Greece during the Early Iron Age is a case in point (Bourogiannis, this volume Chapter 4). Islandness can also be thought as 'other' or as a type of cultural diversification from the mainland, which may be greater at times of increased contact and interaction with the outside world. In this sense, we may consider islandness as 'a transitory, even unstable relation of difference' (Knapp and Van Dommelen 2010, 4).

The range of interaction, not just geography, matters: at the local, island scale; at the regional, archipelago scale; and at the broader, Mediterranean scale. Islands, whether small or large, fostered 'multi-layered, place-based identities' (Foiley *et al* 2023, 1805), which survived despite (or perhaps because of) islander mobility. Maritime activities and interaction were vital to sustain communities on small islands, while the largest islands could be more self-sufficient thanks to their greater supply of resources (Margaritis *et al.* and Bourogiannis, this volume Chapters 8 and 4). The task is to identify and map these interactions and their bearing on identity. The authors of this volume rise to this challenge, diving into the theme of islandness and presenting a diachronic, comparative, and interdisciplinary account of life on Cyprus, Crete, and Sardinia. These 'mega' islands are, after Sicily, the largest in the Mediterranean, each has its distinct environment and history and yet they also share physical and cultural elements. To what extent can their histories and material records be taken as manifestations of islandness? The contributions offer different answers to this question depending on their respective interpretations, which vary in relation to changes in historical conditions and environmental settings. Communities adapted to their island environments (Margaritis *et al.* this volume Chapter 8), were variably isolated or connected, inward- or outward-looking, more land or sea focused, their cultural trajectories unique at times and at others more in tune with their surrounding

10. Conclusions: Mediterranean rhapsody: Of island histories and identities

neighbours over time (Deligiannakis and Cosentino, this volume Chapter 9). These island communities went through multiple cycles of isolation and integration, developing (at times) distinct identities as a result of this process. Their practices reflect their changing attitudes towards land and sea, in terms of maritime activities, trading, farming, mineral extraction, and metalworking (see Christophilopoulou, this volume Chapter 1).

The earliest colonisation of the islands entailed the transfer of essential resources and gradual divergence from the mainland as communities adapted to newly found conditions, which are specifically insular, such as lack of resources, limited space, but also potential for connectivity and occasionally desirable mineral resources, such as obsidian and metal. Broodbank has defined this process as the 'island effect': 'islanders choose to deviate from, lose entirely, or preserve certain cultural features from the mainland' (Broodbank 2000, 20). Over time, this phenomenon facilitated a process of 'identification through interaction' rather than arising from isolation (Dawson 2020). This was probably not a conscious expression of an islander identity *per se*, at least not initially. Certainly, our ability to distinguish islandness in the archaeological record is greater at times of increased interaction in the Mediterranean, such as during certain periods of the Neolithic and the Bronze Age. From this moment onwards, we may reasonably ask: What does it mean to be an islander? How did islanders fashion their world and establish their identities (cf. Knapp 2007, 40)? These are the key questions at the heart of this book, where islandness emerges as a particular type of identity arising from the interaction between islanders and their island bases, other islanders, and mainlander communities.

Objects and places as vectors of islandness

Identity has been defined as a 'social construct' shaped by repeated 'encounter with others and relating flexibly to real and imagined space' (Mac Sweeney 2009, 104). Jenkins (2000, 8) makes a distinction between self or group identification (internally oriented) and the categorisation of others (externally oriented). Here we must consider that 'the material world can produce an impression of belonging together' (Bernbeck 2012, 161) and we 'cannot assume that any social group we distinguish from material culture patterning will necessarily have a conscious sense of "us"' (Mac Sweeney 2009, 121).

When did a 'conscious sense of us vs. them' (cf. Mac Sweeney 2009, 103) emerge in the history of the Mediterranean islands? To answer the question, we must be able to discern practices that indicate a deliberate distinction from other groups: 'Groups can rally around an almost infinite range of factors: ethnic, religious, linguistic, or other social criteria' (Mac Sweeney 2009, 102). External threats and instable times can foster a sense of group identity, as seen from people's efforts to promote cohesion and community by downplaying differences; at other times, people can stress internal status distinctions (Mac Sweeney 2009, 121). Constantakopoulou's (2005) work on the

Greek islands has showed that, in the Classical and Hellenistic periods, the inhabitants of islands with more than one city-state identified with their islands rather than with their individual cities; moreover, this island identity enabled islanders to overcome political fragmentation. Objects and practices can act as 'mediators of relations' (Harris 2012, 88) as can certain places. Islands facilitate interaction, mobility, trade, and thus can become powerful drivers or vectors for identity. Identity here is multi-scalar, based on agency and practices and emerging through places.

How then was islander identity expressed? As the contributions to this book demonstrate, settlement, burial, subsistence strategies, food choices, clothing, figurines, metalwork, architecture, all have the potential to communicate identity in prehistory. In later periods, written records, coins, and place names refer to community identity more explicitly (see contributions by Bourogiannis; Deligiannakis and Cosentino; Muscolino, this volume). Situating the micro-scale biography of objects within the macro-story of the Mediterranean, different forms of representations of island identities emerge in different times and places (see Mokrišová et al.; Pancaldo et al. this volume). These representations reflect a more conscious sense of islander identity arising from interaction over time. Sea, land, and above all movement emerge from the contributions to this volume as key aspects that can help us think about islandness in this dynamic way.

Mediterranean Rhapsody

The development of seafaring in the Mediterranean and consequent settlement of the islands are often seen as responses to environmental, economic, and demographic conditions, rather than, in social and cultural terms, as the manifestation of a way of life or *ethos*. The combination of underlying social and cultural factors (e.g. tendencies for prehistoric communities to either fission or aggregate, but generally to move and interact) and a geographical configuration conducive to maritime travel, were key elements that favoured cultural interaction in this region. Broodbank linked the earliest known sea-crossings in the Mediterranean (to Melos and Cyprus) to the development of a 'seafaring ethos', which reflected a 'change in attitude towards the sea, from simply a local provider of resources to a vector for travel' (Broodbank 2007, 210). We see tantalising glimpses of this in the Neolithic from the earliest representations of boats and the circulation of obsidian and shell used for symbolic practices (e.g. Spondylus shell). This seafaring ethos or mindset culminated in the Bronze Age, with the gradual occupation of most of the smaller islands (Dawson 2014). At this time, we can see complex networks of interaction strongly emerging from patterns in the distribution of material culture in the archaeological record. Moreover, there seems to be a much more conscious and concerted effort to depict maritime activities and landscapes than before.

The famous Minoan frescos from the island of Thera (Fig. 10.2), for example, may be taken to represent the islanders' worldview at a particular moment in time. Is

10. Conclusions: Mediterranean rhapsody: Of island histories and identities

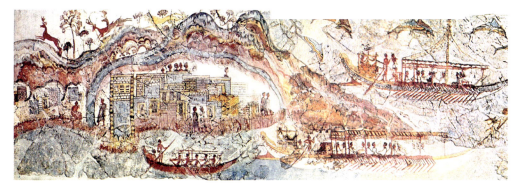

Figure 10.2. Islander worldviews? The Flotilla fresco from Akrotiri (Thera, Greece; 16th–15th century BC) (© Islanders: The Making of the Mediterranean exhibition, by permission of The Greek Ministry of Culture).

the purpose of this and similar representations to tell a story, to identify, or both? The Homeric epics have been scoured for information on Bronze Age morals, values, and ideology but in general we should be cautious when projecting impressions gained from later sources on the more distant periods of prehistory (Crielaard 2020). Thus, while a seafaring ethos may be traced back to the Neolithic pioneers who first settled the islands, it was only later that it was codified in art and literature and, moreover, associated with a warrior, elite ideology. Such a seafaring ethos was experienced only by a few, generally male, individuals or by specialised communities of seafarers and yet has come to dominate our view of the Bronze Age (Tartaron 2013, 125). This is where the study of islands can make a difference in this respect. On islands, small ones in particular, awareness of the sea would have permeated everyday life and extended into the terrestrial domain. The sea would have been experienced albeit differently by the entire community, such

Figure 10.3. Fisherwoman from Bozburun, Muğla (Türkiye) © Zafer Ali Kızılkaya (reproduced with permission).

as through place-naming, patterns of female vs male mobility and practices, such as access to food resources, boat building, fishing, and net-making, to name but a few examples.

There is a great deal to be learnt from ethnographic studies concerning how the sea affected entire communities (e.g. D'Arcy 2006); these views challenge the male-

dominated idea we gain from studies focusing on a seafaring ethos and contribute to the debate on decolonisation. Looking forward, island archaeology in the Mediterranean can highlight how 'being an islander' was experienced by different members of the community, by emphasising the role of women, children, and other underrepresented and marginalised categories (see Frangoudes *et al.* 2023), and build more diverse and inclusive characters that are meaningful in the present (Mylona 2021). While not all members of a community would have engaged with the sea directly or to the same extent, 'those who live by the sea take on the fusion, fluidity and flux characteristic of the sea' (Rainbird 2007, 173). All these mean an openness reflected in the 'rapidity of taking on change' (D'Arcy 2006, 1). Thus, we may think of islandness in this context of heightened mobility and interaction as both 'vulnerability and resilience' (Foley *et al.* 2023: 1808) but also as 'a sense of *belonging* together, of being bound to others' (e.g. a koine), of 'transcending the local' (Purcell 2003, 16) and linking local communities to the wider Mediterranean (Fig. 10.3). Islander identities expanded and contracted over time, linking local communities to the wider Mediterranean. The final impression emerging from this volume is that of islands as facilitating the coming and going of people, as catalysts for practices leading to identity creation, and as colourful improvisations in the rhapsody that is the long history of the Mediterranean.

Acknowledgements

I would like to thank Dimitra Mylona and Çiler Çilingiroğlu for making me aware of this important topic and the Akdeniz Koruma Derneği Mediterranean Conservation Society and Zafer Ali Kızılkaya for allowing the reproduction of Figure 10.3.

Notes

1 https://www.humboldtforum.org/en/programm/digitales-angebot/digital-en/keynote-spreech-by-chimamanda-adichie-32892/
2 https://fitzmuseum.cam.ac.uk/plan-your-visit/exhibitions/black-atlantic-power-people-resistance
3 A recent example of an exhibition narrative based on islanders' stories as told and preserved by Pacific communities' islanders, was reflected in the theme and interpretation of *Tidal Kin* exhibition, Chau Chak Wing Museum, University of Sydney, 2023 (https://www.sydney.edu.au/museum/whats-on/exhibitions/tidal-kin.html)
4 *Being an Islander* Documentary links: Trailer: https://vimeo.com/781221914, teaser: https://vimeo.com/777889894 and film website: https://islander.fitzmuseum.cam.ac.uk/resources/documentary.

Bibliography

Aly, G. (2023) *The Magnificent Boat. The Colonial Theft of a South Seas Cultural Treasure*. Cambridge MA-London: Harvard University Press.
Barth, F. (1969) *Ethnic Groups And Boundaries: The Social Organization of Culture Difference*. Boston MA: Little & Brown.

10. Conclusions: Mediterranean rhapsody: Of island histories and identities

Bernbeck, R. (2012) Multitudes before sovereignty: theoretical reflections and a Late Neolithic case. In T. Kienlin and A. Zimmermann (eds), *Beyond Elites*, 147–167. Bonn: Habelt.

Broodbank, C. (2000) *An Island Archaeology of the Early Cyclades*. Cambridge: Cambridge University Press.

Broodbank, C. (2007) The origins and early development of Mediterranean maritime activity. *Journal of Mediterranean Archaeology* 19(2), 199–230.

Clarke, D. (1973) Archaeology: The loss of innocence. *Antiquity* 47, 6–18.

Constantakopoulou, C. (2005) *The Dance of the Islands. Insularity, Networks, the Athenian Empire, and the Aegean World*. Oxford: Oxford University Press.

Crielaard, J. P. (2020) Homeric communities. In C. O. Pache, C. Dué, S. Lupack and R. Lamberton (eds), *The Cambridge Guide to Homer*, 227–244. Cambridge: Cambridge University Press.

D'Arcy, P. (2006) *The People of the Sea: Environment, Identity, and History in Oceania*. Manoa HI: University of Hawai'i Press.

Dawson, H. (2014) *Mediterranean Voyages. The Archaeology of Island Colonisation and Abandonment*. London: Routledge.

Dawson, H. (2019) As good as it gets? 'Optimal' marginality in the Longue Durée of the Mediterranean islands. *Journal of Eastern Mediterranean Archaeology & Heritage* 7(4), 451–465.

Dawson, H. (2020) Towards an island archaeology of the Phoenician and Punic Mediterranean. In E. Guillon and B. Costa (eds), *Insularité, îléité et insularisation en Méditerranée phénicienne et punique*, 323–330. Eivissa: Musée archéologique d'Ibiza et Formentera.

Dawson, H., Picornell-Gelabert, L., Calvo-Trias, M., Servera-Vives, G. and Valenzuela-Oliver, A. (2023) The 'Island laboratory' revisited: Integrating environmental and socio-cultural approaches. *The Journal of Island and Coastal Archaeology* 18(4) 547–556 https://doi.org/10.1080/15564894.2023.2235673.

European Union Council (2016) *Islands of the EU: Taking Account of their Specific Needs in EU Policy*. Available at http://www.europarl.europa.eu/thinktank/de/document.html?reference=EPRS_BRI(2016)573960 [consulted 10 April 2024].

Foley, A., Brinklow, L., Corbett, J., Kelman, I., Klöck, C., Moncada, S., Mycoo, M., Nunn, P., Pugh, J., Robinson, S., Tandrayen-Ragoobur, V. and Walshe, R. (2023) Understanding 'islandness'. *Annals of the American Association of Geographers* 113(8), 1800–1817 https://doi.org/10.1080/24694452.2023.2193249.

Frangoudes, K., Herry, J., Mylona, D., Vanlaer, C., Delaney, A. (2023) Gender, a key dimension for the future of maritime cultural heritage research: cases from Europe and East Asia. *Maritime Studies* 22, 30. https://doi.org/10.1007/s40152-023-00316-2

Fricke, F. and Hoerman, F. (2022) Archaeology and social justice in island worlds. *World Archaeology* 54(3), 484–489.

Frieman, C. J. (2023) *Archaeology as History. Telling Stories from a Fragmented Past*. Cambridge: Cambridge University Press.

Hay, P. (2006). A phenomenology of islands. *Island Studies Journal* 1(1), 19–42.

Harris, O. T. J. (2012) (Re)assembling communities. *Journal of Archaeological Method and Theory* 21, 76–97.

Jenkins, R. (2000) Categorization: Identity, social process and epistemology. *Current Sociology* 48, 7–25.

Knapp, B. (2007) Insularity and island identity in the prehistoric Mediterranean. In S. Antoniadou and A. Pace (eds), *Mediterranean Crossroads*, 37–62. Oxford: Oxbow Books.

Knapp, A. B. and Van Dommelen, P. (2010). Material connections. Mobility, materiality and Mediterranean identities. In A. B. Knapp and P. Van Dommelen (eds), *Material Connections and the Ancient Mediterranean. Mobility, Materiality and Identity*, 1–10. London-New York: Routledge.

Mac Sweeney, N. (2009) Beyond ethnicity: the overlooked diversity of group identities. *Journal of Mediterranean Archaeology* 22(1), 101–126.

Mead, M. (1956) Introduction to Polynesia as a *laboratory* for the development of models in the study of cultural evolution. *Journal of the Polynesian Society* 66(2), 145.

Mylona, D. (2021) What is fishing cultural heritage to you? In D. Mylona, M. Koutrakis, C. Goubili, A. Tsantiropoulos, A. Sapounidis (eds) *What is fishing cultural heritage to you?*, 1-8. Pericles: Maritime Cultural Heritage.

Nunn, P. D. (2020) In anticipation of extirpation: how ancient peoples rationalized and responded to postglacial sea level rise. *Environmental Humanities* 12(1), 113–131.

Purcell, N. (2003) The boundless sea of unlikeness? On defining the Mediterranean. *Mediterranean Historical Review* 18(2), 9–29.

Rainbird, P. (2007) *The Archaeology of Islands*. Cambridge: Cambridge University Press.

Randall, J. (2021) *An Introduction to Island Studies*. Charlottetown: Island Studies Press.

Tartaron, T. (2013) *Maritime Networks in the Mycenaean World*. Cambridge: Cambridge University Press.

Terrell, J. (1990) Storytelling and Prehistory. *Archaeological Method and Theory*, 2, 1–29. http://www.jstor.org/stable/20170203

Index

Page numbers in *italic* denote illustrations, those in **bold**, tables.

Adichie, Chimamanda Ngozi 154
Aegean islands 20–1, 22, 26–7
 see also Crete; Delos; Dhaskalio and Kavos;
 Kato Kouphonisi; Melos; Naxos; Samos;
 Sifnos; Thera
Aelius Aristeides 21
agriculture 128, 130, 131, 132
Alassa-*Palaiotaverna*, Cyprus 40
altar pieces 110, *111*
Angioy, Giovanni Maria 100
Apollonius Rhodius 22
aquamanile *109*, 110
Arab *iudices* 109–10, *109*
Arab raids 142, 146
archaeobotanical data 126, *127*
archaeological sciences 8, 79
 see also environmental sampling; lead
 isotope analyses; micro-CT images;
 microscope images; SEM-EDS images;
 X-Radiographs; XRF
Aristaios, myth of 100–1, *101*
aristocracies 141, 143
Arrian 26
art 4, 112, *112*
 see also altar pieces; Minoan frescoes
art film 13–14, *15*
Athenaeus 22
Athens, Greece *53*, 60–1, *61*
Atsonios, Antonios *10–11*

Bak, P. 42
Barnabas, saint 145–6, 147
basilicas 145
 see also churches
Bather, A. G. 60
Being an Islander project 2–5

documentary studies 8–12, *10–11*, 13, *13*
participation, community, and co-
 creation 12–16, *14–15*
resources, mobility, and interaction 6–8
bishops 141, 144, 145, 147
boat, from Papua New Guinea 154, *155*
boats/lamps 104–5, *105*
Bouras, Dimitrios 12
bowl 60–1
Braudel, F. 20–1
Briault, C. 39
Bronze Age Mediterranean 31–43
 'Belt and Road' globalisation 32–3
 collapse 42–3
 Crete (Palatial Era of 1900–1450 BC) 35–8,
 37
 Cyprus (Late Bronze Age) 38–42, *40–1*
 Sardinia (16th century to 509 BC) 33–5,
 36
Broodbank, C. 6–7, 157, 158
building stone 121
Bulwer, Sir Henry 78
Byzantine Empire 108–9

Cagliari museum collections 97–113
 altar pieces 110, *111*
 aquamanile *109*, 110
 Aristaios, myth of 100–1, *101*
 background, classical and medieval
 97–101
 boats/lamps, bronze 104–5, *105*
 bust of Nero 107, *108*
 cities and settlements 105–6
 contemporary art 112, *112*
 copper ox-hide ingots 103
 exiles 106–7, 110

insularity, exhibitions about 112–13
mineral samples 101
Neolithic and Copper Age 102
Nuragic networks 102–3
paganism 108–9
pottery networks 103–4, *109*, 110
Punic inscriptions and necropolis 106
religious rituals 107–8
votive clay objects 107, *108*
Callimachus 21
Casa Zapata, Sardinia 35, *36*
cemeteries 66, 78, 85–6
ceramics *see* clay objects, balls; pottery
children 12–13, 25, 26
Christianity
in Crete 140–1, 147
in Cyprus 143–6, 147
churches 108, 145, 147
Classical Cypriot *see* Cypriot Syllabary
Claudia Acte 106–7
clay objects
balls 53–5, *54*
votive objects 107, *108*
climate change 131–2
Cline, Eric 43
collapse 42–3
colonisation 25, 26
comparative projects 5, *6*
connectivity 6–8, 21
Constantakopoulou, C. 157–8
Constantine 138
Constantinople 146
contemporary art 112, *112*
copper alloy objects *see* boats/lamps; bowl;
rivets; toggle pins
copper ore sources 88
copper ox-hide ingots 103
Crete
Late Antiquity (AD 300–700) 138–42
Palatial Era (1900–1450 BC) 35–8, *37*
cults 139–40
cultural expression 4, 33–7, *36–7*
Cutler, J. 33
Cyclades *see* Delos; Dhaskalio and Kavos;
Kato Kouphonisi; Melos; Sifnos; Thera

Cycladic figurines 118, 120
Cypriot Syllabary 52, *53*, 58–63
amphora from Mende 59–60, *59*
Black-Glazed kylix from Athens 61, *61*
bronze bowl from Athens 60–1
tripod stand from Delphi 60
Cypro-Minoan writing system 39, 52–8, *53–4*
amphora 57
clay balls 53–5, *54*
jug handle 56–7
Tiryns, significance of 57–8
Cyprus
Iron Age sword *see* sword from Tamassos
Late Antiquity (AD 300–700) 142–6
Late Bronze Age 38–42, *40–1*
metal items in the Fitzwilliam collection 84
Sardinia, relations with 103–4
toggle pins *see* toggle pins

Dante Alighieri 98
Davis, B. *et al.* 57
decolonisation 15, 153–4, 155
Delos 21, 22, 27
Delphi, Greece *53*, 60
deposition, special 118–21
Dewan, R. 37
Dhaskalio and Kavos, Keros 7, 117–32, *119*
abandonment of Dhaskalio 131
connectivity of Keros 127–8, 131, 132
Dhaskalio excavations 121–2, *122*
environmental sampling 125–6, *127*
food processing 126–7
habitation, distributed (taskscape) 130–1
interpretation of the excavations 124–5
metalworking 122–4, *123*
Special Deposit North 118–19
Special Deposit South 120–1
surveys 128, 130
terraces 128
Diocletian 138
disadvantages of islands 112, 154–5
documentary studies 8–12, *10–11*, 13, *13*
domestic structures 38, 42, 126–7
Douglas, S. 92
Dust and Butterflies 13–14, *15*

Index

165

earthquakes 139, 142, 143
ecclesiastical buildings *see* churches
economic prosperity 146
Egetmeyer, M. 60, 61
Egyptian grain 146
Egyptian symbols 106
embolē 146
Enkomi, Cyprus 38–9, 54
environmental sampling 125–6, *127*
Epiphanios of Salamis/Constantia 144–5
Erb-Satullo, Nathaniel 77
Etruscan pottery 106
Etruscan tombs 104–5
exiles 106–7, 110

Ferrara, S. 55, 56, 57
Ferrarese Ceruti, M. L. 103
Fitzwilliam Museum, Cambridge 84
food processing 126–7
frescoes 158–9, *159*

Gale, N. 88–9
globalisation 32–3
Gortyn, Crete 137, 140–1
graffiti 56–7, 59–60, *59*, 61, *61*
grain tax 146
Greece *see* Cypriot Syllabary; Cypro-Minoan
 writing system
Greek language 62
 see also Cypriot Syllabary
Gregory the Great, pope 108–9

Hala Sultan Tekke, Cyprus 40–1
henotheism 139–40, 147
Hitchcock, L. A. 39
Horden, P. and Purcell. N., *The Corrupting Sea*
 20
horns of consecration 39
houses *see* domestic structures
Humboldt Forum, Berlin 154, *155*

identity 4–5, 6–7, 8, 16
 burials, expression of 94
 Cretan 139–40, 147
 cultural identities 156

Cypriot 54, 55, 143, 145, 147
 definitions of 157
 Sardinian 97–8, 99, 103, 107, 110, 113
 vectors for 157–8
 see also documentary studies; Nuragic
 culture
inequalities of islands 112, 154–5
ingots 34–5, 103
inscriptions *see* Cypriot Syllabary; Cypro-
 Minoan writing system; mosaics
insularity 1, 19–27
 connections 21
 control and subjugation 24–5, 27
 definition of island 19–20
 disappearing islands 22
 emerging islands 22
 exhibitions about 112–13
 floating islands 22
 fragmentation 20
 insularity 20–1
 island-like places 25–6
 size of islands 22–4, 26–7, 156
 'spatial turn' 20
interaction of islands 5, 7, 35, 62, 106, 156–7
international style 40, 41
Iron Age
 Sea Peoples 38
 trade with Cyprus 39–42
 trade with Sardinia 35, 105
 see also Cypriot Syllabary
iron sword *see* sword from Tamassos
'island archaeology' 153–4
'island effect' 6–7, 157
'islandness' 155–6, 157, 160
islands 2–3
 definition of 19–20
 island-like places 25–6
 as laboratories 153
Italian Constitution 112, 154–5
ivory, hilt plates 67, 74, *76*

Jenkins, R. 157

Kalavassos-*Ayios Dhimitrios*, Cyprus 40, *40-1*
Karnava, A. 60, 61

Kato Kouphonisi 130
Keros *see* Dhaskalio and Kavos
Kition, Cyprus 39
Knapp, A. B. 38, 39
Knossos, Crete 37
Kolodny, E. 22
Kourion, Cyprus 143–4

LaBianca, Sten 43
lamps *see* boats/lamps
Lang, M. 61
languages *see* Cypriot Syllabary; Cypro-Minoan writing system; writing systems
Late Antiquity (AD 300–700) 138–48
 conclusions 146–8
 Crete 138–42
 Cyprus 142–6
lead ingots 34–5
lead isotope analyses 88–9
leather 77
loom weights 33
Luf boat 154, *155*

Maa-*Palaeokastro*, Cyprus 42
marble 121
Marcus, M. 92
Matthäus, H. 78
Mead, Margaret 153
Mediterranean islands 154
Mediterranean Sea 20
Melian dialogue 25
Melos 24–5, 27
Mende, Greece *53*, 59–60, *59*
metallurgy 8
metalworking
 at Dhaskalio and Kavos, Keros 122–4, *123*
 sword from Tamassos 66–7, 69–70, *69*, 75, *76*
micro-CT images 69, *69*, 70–1, *71*, 74, 75, *76*
microscope images 89, 90, *90–1*, 91
migration 7–8, 14–15, 33
mineral samples 101
mineralised organic materials 77, 87, 91–2, *91*
miniatures 37
Minoan frescoes 158–9, *159*

Minoans
 cultural package 36–7, *37*
 mobility of women 33
 symbolism of 40–1
 see also Cypro-Minoan writing system
mobility 6–8, 33
mosaics 108, 143–4
museum collections *see* Cagliari museum collections; Fitzwilliam Museum
museum practice 15
Muslim expansion 142, 146
Mycenaeans 37, 38

natural disasters *see* earthquakes
Naxos 121, 130
Nero 106, 107, *108*
Nonnis, Giovanni 112, *112*
novenari 108
Nunn, Patrick 154
nuraghi 5, 33–4, 35, *36*
Nuragic culture *3*, 5, 7, 33–5, *36*
 boats/lamps, bronze 104–5, *105*
 communities and networks 102–3
 Iron Age reuse 35
 metals 34–5
 pottery 34, 103

object biography approach *see* sword from Tamassos
obsidian working 124
Olivier, J. P. 51, 55, 56, 57
oral histories 154
organic materials 77
 see also ivory
otherness of islands 1, 98, 99, 156

Pacific islands 153
paganism 108–9, 139
Pausanias 99–100, 105
Peloponnesian war 23–7
peninsula sites *see* promontory sites
Petrou, Yorgos 13–14
Philostratus 22
Phoenicians 35, 105–6
phryctories 9, *11*

Index

Pindar 22
Pirosu-Su Benatzu Cave, Sardinia 35
pottery
 Aegean/Aegean style 34, 39, 40
 Arab, from Manises *109*, 110
 Attic 106
 Etruscan 106
 graffiti on 56–7, 59–60, *59*, 61, *61*
 Late Antique Cretan amphorae 141–2
 Mycenaean 38, 39, *40*, 41, 53–4, 103
 Nuragic 34, 104
 Phoenician/Phoenician style 39–40, *41*
 see also clay objects
pottery industry 9–11, *13*
prisoners 13
promontory sites 26, *37*, 38, 42
provinces 107, 138, 142, 143
public engagement 12–15, *14–15*
Punic inscriptions 106
Punic necropolis 106
Pyla-*Kokkinokremos*, Cyprus 42

refugees 14–15
religion *see* Christianity; henotheism
religious rituals 107–8, 139
Renfrew, Colin 117, 118, 120
rivers 20
rivet-holes 75, 77
rivets 67, 74–5, *76*, 77
Roman Empire
 Crete 138–9
 exiles in Sardinia 106–7, 110
 provinces 107, 138, 142, 143
 religious rituals in Sardinia 107–8
 re-organisation under Diocletian 138
 trade with Sardinia 107, 108

Samos 14
sanctuaries 36–7, 60, 139
Sardinia
 Bronze Age (16th century to 509 BC)
 33–5, *36*
 exiles in 106–7, 110
 historic background 97–9
 identity 97–8, 99, 103, 107, 110, 113

religious rituals 107–8
trade 34–5, 102–3, 104, 105–6, 107, 108
 see also Cagliari museum collections;
 Nuragic culture
Scione, Greece 26
sea 3–4, *4*
Sea Peoples 38
'seafaring ethos' 158–9
Self-Organized Criticality 42–3
SEM-EDS images 71–3, *72*
Sicily, Peloponnesian war 23–4, 27
Sifnos 9–12, *10–11*, *13*
silver
 hilt edging 67, 71–3, *72*
 rivet heads 75, *76*
Sissi, Crete *37*, 38
size of islands 22–4, 26–7, 156
Small Cyclades *see* Dhaskalio and Kavos
smallness of islands 23, 156
smelting 123–4, *123*
Socratous, M. A. 77
Solinus 99
Spain 110, *111*
'spatial turn' 20
special deposits 118–21
Sphacteria, Peloponnese 23, 24, 27
Spyridon, saint 144
Steel, L. 39
Stewart, J. R. B. 85–6, 91, 93
stone imports 121
stone tools 126–7, *129*
Stos-Gale, Z. A. 88–9
Strabo 22–3, 105, 107
sword from Tamassos 65–80
 Cypriot Iron Age metalwork production
 66–7
 description 67, *68*
 excavation of 65–6, 78
 function 78
 hilt 70
 hilt edging 70–4, *71–2*
 hilt ivory plates 74, *76*
 hilt rivets 74–5, *76*, 77
 materials 67
 post-excavation histories 78–9

production 77–8
rivet holes 75, 77
scabbard 70, 77
structure 68–70, *69*
symbolically entangled artefacts 39, 40,
41–2
syncretism 139–40, 143

Tamassos, Cyprus *see* sword from Tamassos
taskscapes 130–1
temple complexes 39, 140
Ten Martyrs of Crete 140–1
terraces 128, 131, 132
textiles 33, 91–2, *91*
Tharros, Sardinia 106
Thera 158–9, *159*
thread, mineralised 91–2, *91*
Thucydides 23–6, 27
Tidal Kin project 5, 6
tides 20
tin, hilt edging 67, 71–3, *72*
Tiryns, Greece 53–8, *53-4*
Titus, saint 140
toggle pins 83–94
 burial context 86
 burial environment 93
 cemetery at Vounous 85–6
 conservation 93
 decoration 90–1, *91*
 description 87, *87*
 distribution of 86
 eyelets 90, *90*
 metal composition 87–9, **88**
 metals in Cyprus 85
 shaping and finishing 89–91, *90-1*
 thread, mineralised 91–2, *91*

use 92
towers *see nuraghi*; phryctories
trade
 Crete 37, 141–2, 148
 Cyprus 39–42, 54, 59, 103–4, 142–3, 148
 Sardinia 34–5, 102–3, 104, 105–6, 107, 108
transition, Bronze to Iron Age 42–3
Triphyllios of Ledra 144
tripod stand 60
Tuvixeddu, Sardinia 106

Ugaritic texts 54, 56

Vandkilde, H. 32
Vetters, M. 55
Visual Anthropology 12
Vonhoff, C. 67, 70, 78
votive offerings 60–1, 62–3, 107, *108*
Vousnous, Cyprus 85–6
 see also toggle pins

weapons 33
 see also sword from Tamassos
weaving technology 33
women 25, 26, 33
wood 77
workshops *123*, 124
writing systems 36, 37, 39
 see also Cypriot Syllabary; Cypro-Minoan
 writing system

X-Radiographs 70–1, *71*
XRF 88, **88**, 94n1

Zeus 139–40